50 Fast Digital Photo Techniques with Photoshop® Elements 3

GREGORY GEORGES

50 FAST DIGITAL PHOTO TECHNIQUES WITH PHOTOSHOP® ELEMENTS 3

WILEY
Wiley Publishing, Inc.

50 Fast Digital Photo Techniques with Photoshop® Elements 3

Published by
Wiley Publishing, Inc.
111 River Street
Hoboken, NJ 07030-5774

www.wiley.com

Copyright © 2005 by Wiley Publishing, Inc., Indianapolis, Indiana

Library of Congress Control Number: 2004112347

ISBN: 0-7645-7212-1

Manufactured in the United States of America

10 9 8 7 6 5 4 3 2 1

1V/RX/RR/QU/IN

Published by Wiley Publishing, Inc., Indianapolis, Indiana
Published simultaneously in Canada

WILEY

*To my wife, Linda, for the constant support
you have given me for the past 25 years.*

PREFACE

This book is appropriately named *50 Fast Digital Photo Techniques with Photoshop® Elements 3* because it presents 50 relatively simple, yet useful digital photo techniques that can be done quickly — and because it offers 50 new techniques to supplement those in the original, best-selling *50 Fast Digital Photo Techniques.* There is considerable variety in the 50 techniques and while they have been created with Adobe Photoshop Elements 3.0 in mind, most of the techniques can be used with any of the more advanced image editors such as Adobe Photoshop (versions 4, 5, 5.5, 6, 7, and CS), Adobe Photoshop LE, Corel's Photo-Paint, Corel's Painter, JASC Software's Paint Shop Pro, or Ulead's PhotoImpact.

This book is for anyone who shoots pictures with a digital camera, uses a desktop or film scanner to scan film or photographs, or gets digital images from a local or online photofinisher. It is for those that want to make the best possible images for printing or for sharing online. It is for those with or without a photo-quality printer. It is for those that want to post digital photos to a Web page or want to share their digital photos via e-mail. It is for beginners through advanced digital imagers. It is for those who want to create fine-art prints suitable for selling in a gallery. It is for personal images or for business images.

WHY THIS BOOK WAS WRITTEN

Many years ago when I first began using digital image editors, I quickly became astounded at how amazingly powerful they were and how many things you could do with them. Sadly though, I also became aware of how long it took me to get a good understanding of what all the filters, commands, and tools were capable of doing. The learning curve was way too steep and too time-consuming; yet I really, really (yes, that badly) wanted to obtain the incredible results these tools were capable of providing.

After deciding I needed help and lots of it, I did what most people in my situation do. I visited local bookstores and looked for books that would help me learn how to do all the things that I wanted to do. In the bookstores, I found many books. Unhappily, I found that nearly all the available books were nothing much more than short, medium, or long versions of the equivalent of a good user manual. They methodically cover each and every menu item, tool, and feature ad nausea.

Admittedly, much of the content was good to know, but all the books lacked the crucial element I was looking for — step-by-step techniques for doing real-world things. These books were also, and remain today, very expensive — ranging from $35 to over $70. I then turned to the Internet and found hundreds of "Photoshop" technique sites. Initially, I was excited at how many sites the search engines returned. Before long, I couldn't bear looking at another site showing how to make rusted metal, a drop shadow, neon-lit text, rounded pipes, or similar techniques. After several years of unsuccessful searching for a good technique book, I decided that I would develop 50 useful techniques and write a book myself. My first *50 Fast* book, *50 Fast Digital Photo Techniques,* was the book that I wished I had had several years ago. This second edition, *50 Fast Digital Photo Techniques with Photoshop Elements 3*, is a follow-up book to the first one, and it is, I hope, the book you are looking for now.

THIS BOOK IS NOT LIKE MOST OTHER "PHOTOSHOP" TECHNIQUE BOOKS

Many excellent books on Photoshop and the other leading digital image editors are available. They typically have anywhere from 250 pages to over 1,200 pages. Yet, the next time you get a chance, count the number of actual usable step-by-step techniques you find in these books — especially those with "technique" in their titles. When you sit down to edit a digital photo, you usually want to do something specific to it. You may want to turn it into a watercolor painting, or into a line drawing. Your goal may be to radically change the color, to make a hand-colored black-and-white print, or simply to make the photo look as good as it can. See if any of the other "Photoshop" technique books offer anywhere near as many practical and usable techniques as you can find in this book.

This book offers the following for a very reasonable price:

- Fifty, that's "50," fast step-by-step techniques for doing useful and cool things to your digital photos
- Thirty-two pages of color "before" and "after" images
- Over 180 full-size, unedited "royalty-free" original digital photos created from a variety of digital cameras and included on the companion CD-ROM
- Over 25 useful Tips and Warnings
- Special text formatting that allows you to read just the actions needed to complete the technique without having to read all the other informative text thereby allowing you to complete each technique quickly
- Over 600 images including screenshots
- Companion Web site where readers can get online updates, find digital photo resources, and submit their work for possible inclusion in an online Readers' Gallery
- Author-moderated online forum for discussing techniques and sharing tips with other readers to further advance your image editing knowledge
- Occasional online chat access to the author of the book via AOL Instant Messenger

NOTES TO MAC USERS

The great news for Mac users is that Adobe has historically offered both Windows and Mac versions of all their products. The differences between the Windows and Mac version of Adobe Photoshop Elements 3.0 are minimal with the main exception being that the Mac version does not have a Photo Organizer feature. Where there are differences between the two operating systems' versions, those differences will be pointed out in the text. Shortcut keystrokes for both Windows and Mac OS are included throughout the text; when shortcut keys are provided, a forward slash character (/) separates the Windows keystroke from the Mac keystroke. In short, this book is equally useful to PC and Mac users.

WHAT COMPUTER HARDWARE AND SOFTWARE WILL YOU NEED?

When it comes to digital image editing, the axiom "the more the better" applies. Digital image editing is an activity that can consume lots of disk space, RAM, monitor pixels, and computer processing cycles. Fortunately, the computer industry has been good to us these past few years as the cost of having power and storage to spare has dropped sharply. Powerful computers with lots of RAM, enormous hard drives, and quality monitors are getting less and less expensive. At a minimum, you'll need a computer that meets the requirements specified by Adobe for use of Adobe Photoshop Elements 3.0.

If you use a computer that matches Adobe's minimum requirements, you may find you'll enjoy doing the techniques in this book much more if you have 512MB or more of RAM, and 5GB or more of available disk space. The cost of adding additional RAM or adding an additional hard drive can be relatively inexpensive in today's competitive computer marketplace. An 80GB internal hard drive sells for under $120 and, depending on the type of RAM you need, you can buy 128MB of RAM for as little as $50. If you have a relatively slow processor, adding additional RAM can significantly increase the processing speed and help you to avoid the long waits that can occur when digitally editing images. If you spend much time editing digital photos, you'll find the investment in more RAM to be more than worthwhile. If you shoot using the RAW file format and use 16-bit images, having more RAM is more of a necessity than it is a luxury.

Besides having a fast computer with enough RAM and hard drive space, a rewriteable CD-ROM or DVD-ROM drive can be one of the most useful (and in my view essential) peripherals for those doing digital image editing. A rewriteable CD-ROM drive allows you to easily back up your digital photos, to share them with others, and to make space on your hard drive. Rewriteable CD-ROM drives can be purchased for under $60. Remember that when you begin to store your digital photo collection on your computer hard drive, it is possible to lose everything if you have problems with your hard drive. If you value your digital photos; you need to back them up on a removable storage device of some type such as a CD-ROM.

The monitor and graphics card you use is also very important to successful and enjoyable image editing. Several of the Adobe Photoshop Elements 3.0 dialog boxes have been

designed to display at a minimum of 1,024 x 768 pixels, so you need a monitor and a graphic card that can display at least 1,024 x 768 pixels or more. While there are larger monitors than 19" monitors, I was extremely happy with the 19" monitor that I used until I got a 24" monitor! It is so wonderful being able to view and edit images with the necessary tools and palettes on your screen and still be able to see most of the image. You can also buy graphics boards that use multiple monitors at once, which is becoming increasingly common. Having two or even three monitors enables you to put your images on one screen and all the palettes on the other screen.

For those of you that might wonder whether it's better to use a PC or a Mac, my answer is that the computer that you have or know how to use is the better one. Without a doubt, there are differences between the two platforms, but there aren't any clear-cut reasons why the PC or the Mac is better for digital image editing. Therefore, have it your way and enjoy using the computer that you will be most comfortable and successful using — that is the best one for *your* digital image editing. Or, if you are like me — you can use both.

CONVENTIONS USED IN THIS BOOK

To make this book truly a book of 50 fast techniques, considerable effort and thought was put into the format so that each technique could be completed as quickly as possible, while still providing you with all the necessary content to help you understand what it is you are doing.

The first page of each technique shows "before" and "after" images and gives you details about the original photo(s). The "About the Image" section like the one that follows gives you valuable information about the camera, the lens, and the exposure. It also provides information on the image file type and size.

The 32-page color insert shows full-color "before" and "after" images for 32 of the 50 techniques demonstrated in this book. Each page offers a technique title and a brief description of the technique. Each image has a color plate number such as CP 21 and they are cross-referenced in the text throughout the book.

ABOUT THE IMAGE

"Blue-Eyed Jill," Canon EOS 1D Mark II, 300mm f/2.8 IS, f/5.6 @ $\frac{1}{60}$ sec, ISO 800, RAW format, converted, edited, and cropped to be a 1,200 x 1,680 pixels, 423Kb .jpg

As you go through the techniques, you'll find that each technique has numbered steps with headings telling you exactly what you will accomplish in each step. All "actions" (steps you must take) are shown in bold type, indicating they are things that you need to choose, type, press, or click.

A step may have substeps to make the step easier to follow. Any informative content that does not include things the reader must do is not indented.

Each time a command, menu, or tool needs to be selected and there is a keyboard shortcut for it, the keystroke is shown in parentheses immediately following the bold type. For example, the shortcut for the following command would be to press the **L** key while holding down the **Ctrl** key. Alternatively, you could choose **Enhance**, then **Brightness**, and finally the **Levels**.

■ Choose **Enhance** ➤ **Brightness/Contrast** ➤ **Levels** (**Ctrl+L**) to get . . .

ACKNOWLEDGEMENTS

Writing the acknowledgements for my first book was far easier than it was for this book because far fewer people directly contributed to that book than have contributed to this one. However, now that I have become a successful full-time author and photographer I feel more compelled than ever to take the time and space in this book to thank those who have helped me get to where I wanted to be and to be able to write this book. I offer a hearty "Thank you!" to the following people:

My wife, **Linda,** who is always first in my eyes and in my heart.

Readers of my books, members of my forum, and attendees of my workshops. Without a doubt, my books would never be what they are without my having had the interaction with, and the support from, those that have joined me in pushing the boundaries of photography in our new digital world.

David Rogelberg. Managing Partner and CEO of StudioB, and the creator of the wonderful "computer book author" mailing list, which was immensely helpful to me in learning how to become an author. If you have similar aspirations, visit `www.studiob.com`.

Ed Tittle. An extraordinary and prolific author who took a few minutes out of his busy writing schedule one day in 1999 to write and send me an e-mail after I made a post to the StudioB mailing list. He introduced me to his agent, Carole McClendon. Without this key introduction I might never have managed to get out of what seemed to me at the time to be a never-ending process of sending book proposals to publishers and getting rejection letters.

Carole McClendon. The Waterside (`www.waterside.com`) book agent who not only got me my first book contract (a huge feat in my mind), but who was also responsible for guiding my writing career through my first six books.

Andy Lipman. The founder of Muska & Lipman, my first publisher, who took a risk and gave me — a "wanna-be" author — my first book contract. Not only did he give me a book contract, but he also paid for me to fly to Las Vegas and attend a large photo show where I got focused on writing on the topic of photography, my lifelong passion, instead of computers. A big thanks to you, Andy!

Mike Roney. Acquisitions Editor at Wiley who has given me seven book contracts and is always there to offer invaluable guidance and insight.

Lauren Georges. My daughter and coauthor of our soon-to-be published, *50 Fast Digital Photo Projects* book, for not only reading and testing each and every technique in this book, but also for allowing me to take and use photos of her smiling face in the book, too.

Richard Lynch. A friend, author, Photoshop expert, and the Technical Editor for this book who asked many questions that helped me present 50 useful techniques that work.

Tim Borek. The Project Editor for this book, and for my best-selling book, *Digital Photography Top 100 Simplified Tips & Tricks.*

Nancy Rapoport. The Copy Editor who made sure all my sentences were clean and concise.

In order of their appearance: Lauren, Graham, Kitty, Jill, Dan's baby, Jessica and her son, Julia, Liz, Emily, Annie, Jean, the Oprey House family, the Chapel Hill HS lacrosse team, the Boysen's horses, and Cheryl for her wonderful scrapbook pages.

CONTENTS AT A GLANCE

CONTENTS

CHAPTER 1: LEARNING ESSENTIAL FUNDAMENTALS 1

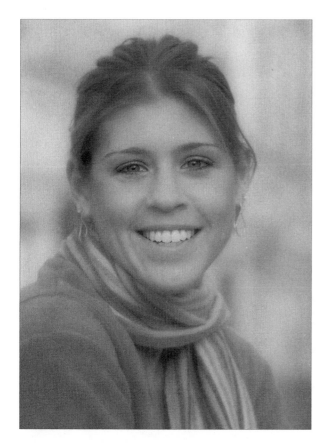

Chapter 4: Working with People Pictures 123

Technique 23
Putting the same person into a photo more than once 131

Technique 24
Converting a color portrait to high-key black and white 137

Technique 25
Adding a soft-focus glamour effect 145

CHAPTER 5: CREATIVE EDITING TECHNIQUES 179

CHAPTER 8: CREATING SCRAPBOOK ALBUM PAGES 275

INTRODUCTION

I have been passionate about photography for over 30 years — so much so, that when it was possible to turn my passion into a full-time career — I jumped at the chance. During the past thirty years I have taken photographs with a medium format camera, multiple 35mm film cameras, several point and shoot film cameras, the wonderfully fun disposable cameras, and a whole string of digital cameras. During my college years I spent time in a darkroom making prints using the traditional chemical process. For the past six years I have exclusively taken photographs with a digital camera and have edited them with digital image editors and have watched my skills grow and my enjoyment increase each year. During all this time, I now claim to have learned one single important point — photography is all about enjoying the process and the subjects!

If there were to be just one point I could pass on to you as begin this book it would be to follow your heart and do what you enjoy doing. This world of ours is too full of critics. There are those that say that digital photography is an "inferior photography" although there are less of those than there were a few years ago. There are those that say that it is not right to "digitally manipulate" your photos. Some critics even go far as to say it is wrong to increase color saturation, or to control the tonal range as much as is possible with today's digital image editors. To all those critics, I say "phooey!"

Photography is an art form and art is all about the creation process and doing your own thing. So, push the boundaries of this new digital world. Take photographs and edit them as you choose. Be honest about what you do, but be creative and most importantly — enjoy the process and the subjects!

ABOUT THE IMAGES ON THE CD-ROM

Having ready access to the digital photos on the CD-ROM will save you time and make it easier to do each of the techniques. If you have room on your hard drive for these photos, I recommend that you copy the entire "\techniques" folder and subfolders to your hard drive. **Please note that any time you copy files from a CD-ROM to a hard drive using a Windows PC, the files are tagged with a Read Only attribute. This is okay if you want to keep those original files for later use without the possibility of overwriting them. However, if you want to save your work over those files, you have to remove the Read Only attribute. To do so in Windows, right-click on a folder or file to get a pop-up menu. Select Properties to display the Properties dialog box — then uncheck the Read Only attribute. You can change attributes for a single image or an entire folder of images and/or folders all at once.**

To fit all the photos that are needed for the 50 techniques on the companion CD-ROM, most of the "after" images have been saved as compressed .jpg image files. To get the best possible prints or to view the best possible images on your screen, you should complete each technique and use the completed images instead of the .jpg versions of the "after" images found on the companion CD-ROM. In many techniques, when an original photo was taken using a RAW file format, the original RAW file is provided. However, a .jpg version is also available so that you do not have to have a RAW conversion tool to be able to work with the images.

A FEW THINGS TO CONSIDER BEFORE BEGINNING THE TECHNIQUES

This section includes valuable tips that will make your digital imaging more successful and just may save you from ruining a favorite digital photo.

Digital photo editing is both an art and a science.

The highly complex mathematical engines that power digital image editors may make it seem like using one of them is more science that art. But, that is not the case. The driving controls or user interfaces of these advanced image editors provide so many possible combinations and permutations of filters and commands that it makes these tools capable of creating an almost limitless variety of images. The more you use a product such as Adobe Photoshop Elements 3.0, the more you will be amazed at what you can do — and what you do not yet know how to do.

Therefore, I believe that using Adobe Photoshop Elements 3.0 is more art than science! If you have ever painted with watercolors, you know that some watercolor papers work better than others. You also know that some different colors of watercolor paint blend differently. As you experiment with watercolors, you get many unexpected results — some of which are wholly unacceptable and others are very exciting. Using a digital image editor is very much like using a natural media such as watercolor paints. The successful watercolor painter is one that works hard, thinks creatively, and continually experiments with techniques, tools, and media. The successful digital photo editor does, too!

One caveat is in order here. Tastes are different — you may not like the settings I've chosen for these techniques. Remember that you have the control of the variables. If the settings that I have suggested don't match your tastes, then change them. Creating great digital images, like creating a fine art painting or fine art photograph, is a matter of the tastes of the creator *and* of the viewer.

By this time, you may have the notion that it will take lots of time and energy to master an image editor. Yes, it will, to *master* one; but this book is about doing 50 useful and *fast* techniques. Therefore, you are quite likely to find plenty of success no matter what goals you have.

Some techniques won't work well on some digital photos.

Each digital photo has a number of key characteristic that may (or may not) make it possible to get good results when using one of the techniques in this book. Image size matters. Level of file compression matters. Image sharpness and contrast also usually matter. Depending on what you are trying to do and what filters, commands, or tools you are using, you will get varying results with different digital photos.

On lower resolution images, many special effects filters such as Poster Edges or Watercolor will make details disappear entirely, whereas on high resolution images, the effect may be so subtle that it's unnoticeable. Therefore, be aware that you may not get the results you want or expect when following techniques like those in this book when you use them on your own digital photos — they may be better, or they may be worse.

As you become more experienced with the many filters, tools, and commands, you will learn how you can compensate for such changes as image size, image contrast, or brightness. This is one of the reasons why this book includes such a wide range of images. You'll find small 50KB images suitable for use only online, 3MB images taken with a consumer-level digital camera, and large 8–14MB files that were created with a professional digital camera or a high-resolution film scanner.

An experiment worth trying is to take one of the larger images on the companion CD-ROM and apply a filter like the Sumi-e brush or Dry Brush. Then, reduce the image to a much smaller size that would be appropriate for use as an attachment to an e-mail or for a Web page, and study the difference. Then reduce the same large image, apply the same filters to the reduced image, and compare the differences between the same full-size image with the same filters applied.

The frequently used sharpen filters are also very susceptible to producing undesirable results when used on an image that is later resampled (enlarged or reduced). Image size really does matter.

For photo-realistic images, you usually get best results working at the resolution of your original image (which should be high enough for your final planned use) and then downsampling at the end for online use if necessary. For techniques involving artistic filters, you may get better (or at least more dramatic) results by downsampling to 100 dpi before applying the filter and then resampling back up to 240 dpi or so if you're going to print the image, before proceeding with subsequent steps. This approach, too, will have its limitations. Any time you increase the size of an image by over 150 to 200 percent, you begin to lose the clarity you had in the original image and you begin to see pixelation where there once was detail.

Color management is important.

Some people are just not as picky about colors as I am. Any shade of green for a forest is okay for them. Others (like me) care a lot if there is even a tiny change from the desired color. Depending on where you fit in this spectrum, you may (or may not) want to spend time setting up your computer to properly manage color before doing the techniques in this book.

In simplistic terms, color management is a process in which all of your hardware is adjusted so that colors remains consistent everywhere, from your scanner or digital camera, to the computer screen, and to your color printer or printing service. If you are *not* using color management, and you adjust the controls on your computer monitor, you will see how substantially you can change colors. Now imagine how those colors might turn out on a color printer. Obviously, changing the colors on your monitor will have absolutely no effect on the colors that will be printed on your printer, yet you'll make color changes to your digital photos based upon what you see on the screen and therefore your prints may be printed in all kinds of unexpected colors. In contrast, when you use color management, changes to your monitor will closely match the colors that you will get from your printer, enabling you to get the colors from your printer that you see on your screen.

Another important point to make here is that I have created the images for this book using a color-managed workflow. Unless you use color management, you may not see the same colors I saw when creating the images. If your system is significantly different from mine, then you may think one of us is crazy when you use the settings suggested in the book. In particular, be wary of any odd colors you may get when making subtle color changes like you do in the gradient forest atmosphere in Technique 14. For this reason alone, I suggest you do two things. First, turn on color management in Adobe Photoshop Elements 3.0 by selecting **Edit ➢ Color Settings** (**Shift+Ctrl+K**) to get the Color Settings dialog box. Select **Full Color Management**. Click **OK** to apply the setting.

Second, I suggest that you use Adobe Gamma if you are using a Windows PC. If you are using a Mac, use the Apple Display Calibrator Assistant. Color management can be a complex topic even for professionals and as this is not a book on color management, I suggest you learn more about this topic by choosing **Help ➢ Help Contents** (**F1**) to get the **Help** screen. After clicking **Search** to get the search box, type **color management** in the **Find Pages Containing** box, and then click **Search** to list all of the topics covering color management. You can also learn more about the Adobe Gamma utility on Adobe's Web page at `www.adobe.com/support/techguides/color/gamma/main.html`.

If you turn on color management and you properly adjust your monitor using Adobe Gamma or the Apple Display Calibrator Assistant, you are much more likely to see images on your screen that match the images that I saw on my screen. We will then have similar results and you will be less likely to think one of us is crazy!

Always save your original images.

One of the most common errors made by those new to digital imaging is to open original digital photo files and begin making changes directly to them. When they have completed their editing, they save the file, thereby making it impossible to ever again get the original digital photo.

The fact is that even though your original digital photo may not look good to you, it has the most "picture data" that you will ever have. Once you begin applying filters, you begin destroying some of the original picture data. Granted, your image may look better to you

after your editing, but you still have destroyed some picture information that you may want later. What you think looks good today, may not look good to you tomorrow. As you complete more of these techniques and begin to master your digital image editor, you will get better at making your digital photos look better. Destroying your original file is like destroying the negative used to make a photographic print. Any future copies will always be less good than they could have been.

My strong recommendation to you is to always save your original digital photos — do not edit them and then save the file over the original file. After opening an original image, save it to a new different folder, or rename the photos so that you can always return to the original digital photo as you get more competent with your image editor and you refine your techniques. You'll be glad you did.

Be careful when saving a file.

Whenever you select **File ➢ Save (Ctrl+S/Command+S)** or **File ➢ Save As (Shift+Ctrl+S/ Shift+Command+S)**, you run the risk of losing something! While this may be exactly what you want to do, you also run the risk of doing something you don't really want to do. Here are a few cases in which you need to be especially careful when saving a file:

- If you open a file and edit it, and then save it using the same filename, you will write the new file over the original file. If the file you opened was your original digital photo, you may have lost some picture data that you can never recover as noted previously.

- Any layers that you may have created in an image will only be preserved if the file is saved in the Photoshop file format (.psd) or in the TIFF format (.tif). In each case, make sure that there is a check in the **Save Layers** box. Saving your file in any other format causes the image to be flattened and you will lose the layers permanently. To enable the layers capabilities when using the TIFF format, you may need to select **Edit ➢ Preferences ➢ Saving Files**, and then place a checkmark in the **Enable Advanced TIFF Save Options** box.

- When using a compressed file format such as .jpg, you will degrade the quality of your image. Consequently, you should also save and keep an uncompressed file format such as .psd, .bmp, or .tif.

- If you increase your file size to make a print, make sure you save your original image first. After making the print, you can just close the enlarged file. If you were to save it, you would have a file that included interpolated data and consequently it would be less good than the original image at full size.

Use the Internet — you live in a digital world, take advantage of it.

There are all kinds of online digital photo-sharing sites, online digital photo contests, digital photo galleries, and much, much more. Use your favorite search engine and search using the word "photography" to find a myriad of Web sites that will help you to do more with your digital photos. Digital photos and the Internet were made for each other — so, get more enjoyment from your image editing by using the Internet.

Learning to edit digital photos takes time and effort.

"In every human endeavor, what you invest in is what you get. Trying to do something is what creates the ability to do it . . . So it is the willingness to surrender to the struggle, not talent that defines an artist." — Connor Cochran

Connor Cochran's quote is particularly appropriate for those who aspire to become competent with their digital image editor and to be able to create artistic work. It can be done by almost anyone; however, it takes time and perseverance. My hope is that this book provides you with the inspiration and some basic techniques to get you started on a long and fun path to successful digital photo editing. Have fun with the techniques!

CHAPTER 1

LEARNING ESSENTIAL FUNDAMENTALS

I ncreasingly sophisticated digital photography technology makes it increasingly important for you to know more—just to have fun editing your digital photos. While the first seven techniques in this first chapter may not be as much fun as the rest, they are useful for helping you to be successful with the 43 techniques that follow. All 7 techniques are well worth the time it takes for you to complete them.

Technique 1 will considerably shorten the time it will take for you to learn your way around the new Adobe Photoshop Elements 3.0 Editor interface. Technique 2 covers the most important aspects of image size, file format, bit-depth, and color profiles. In Technique 3, you will learn the workflow steps you should take to get the best possible images. Converting RAW files and making initial image adjustments is the topic of Technique 4. Learn how to enlarge and reduce the size of your images in Technique 5. Learn how to properly sharpen your images in Technique 6 and how to archive your digital photo collection in Technique 7.

GETTING AROUND THE ELEMENTS WORKSPACE

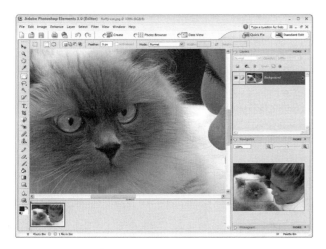

1.1

ABOUT THE IMAGE

"Eye-to-Eye with Fluffy Kitty," Canon EOS 1D Mark II, 70–200mm f/2.8 @ 200mm, f/8 @ ¹/₂₅₀ sec, ISO 200, 16-bit RAW format, 2,336 x 3,504 pixels, converted to 8-bit, 1,600 x 1,067 pixels, 157Kb .jpg

With Adobe Photoshop Elements 3.0 sporting a new interface, there is no better place to start than learning your way around. In this technique, you learn how to get more work done with greater speed and efficiency, so please don't skip this first technique. Your knowledge of what is included in this technique will make it much easier to follow the other 49 techniques. So, please read on and go through each step as you read; the information will be very beneficial.

STEP 1: LEARN WHAT'S WHAT

Adobe Photoshop Elements 3.0's new editor interface has the elements shown in **Figure 1.2**.

STEP 2: OPEN FILES

Adobe Photoshop Elements 3.0 offers three different ways to open files. To open the **fuzzy-cat.jpg** image, you can take any of the following approaches.

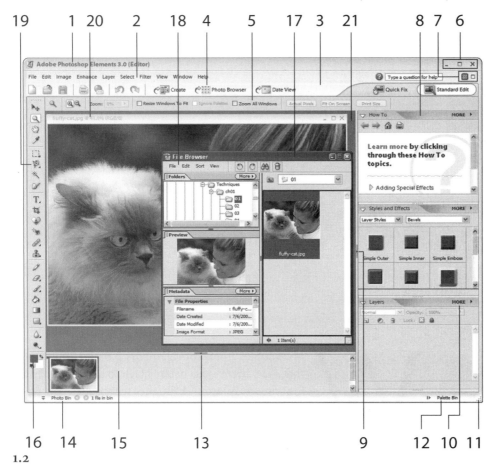

1.2

1 Elements application title bar
2 Elements Menu Bar
3 Shortcuts bar
4 Photo Browser icon (PC only)
5 Options bar for the currently selected tool
6 Windows system buttons for Minimize, Maximize, Restore, and Close (PC only)
7 Minimize, Maximize, Restore, and Close buttons for active document window (slightly different on a Mac)
8 Palette title bar
9 Click to open or close the Palette Well
10 Palette menu

11 Application sizing handle (PC only)
12 Palette Bin Switch for turning all the palettes on or off (PC only)
13 Click to open or close the Photo Bin
14 Photo Bin Switch for opening and closing the Photo Bin (PC only/Mac has separate palette)
15 Photo Bin for accessing open images
16 Foreground and background colors
17 File Browser
18 File Browser menu bar
19 Toolbox
20 Document window title bar
21 Workspace

■ Select **File ➤ Open** (**Ctrl+O/Command+O**) to display the Open dialog box. Find the **\ch01\01** folder and double-click it to open it; then click the **fluffy-cat.jpg** file to select it. Click **Open** to open the file.

■ Select **File ➤ Browse Folders** (**Shift+Ctrl+0/Shift+Command+0**) to get the File Browser shown in **Figure 1.3**. Click in the **Folders** tab to find the **\ch01\01** folder. After clicking on the folder, you are then presented with a thumbnail image. Double-click the **fluffy-cat.jpg** image to open it. If you choose, you can now close the **Browse Folders** dialog box by selecting **Window ➤ File Browser**. Or, on a PC, you can click the **Close** box in the upper-right corner of the **File Browser** title bar (on a Mac, click the **Close** box in the upper-left corner of the **File Browser**).

■ An image can be opened on a PC by clicking the **Photo Browser** icon in the **Shortcuts** bar to launch the Photo Organizer. You can then locate the image using Photo Organizer, which is a sophisticated image-management application that is not covered in this book with a focus on image editing. The Mac version of Elements 3.0 does not have a Photo Organizer, but somewhat similar capabilities are found in the Mac iPhoto application, which has drag-and-drop facilities that allow you to find and load images into Elements 3.0.

If you want to open a previously opened file, you can access the recent file list by selecting **File ➤ Open Recently Edited File** and then selecting the filename. The number of recently opened files that can be seen in this list is dependent on the number of files selected in Preferences, which may be accessed by selecting **Edit ➤ Preferences ➤ Saving Files**. A good value is a baker's dozen — that is, a dozen plus one, or thirteen for those of you who never worked in a bakery. Type **13** in the box following **Recent file list contains**.

So, which approach is best? Use the one that suits your immediate needs. I use the File Browser when I need thumbnail images to identify the images, or to get access to the *metadata,* which is information about the image such as exposures settings, keywords, and date created. When I know the file or files I need to open, and I know where they are, **File ➤ Open** is my preferred approach. When I want to create a Web page, select photos to e-mail, or upload images to an online print service I use Photo Organizer. However, if you have chosen the Photo Organizer as your primary image manager, it may be more appropriate to use it to open your images. So be efficient and have it your way!

STEP 3: MANAGE PALETTES

If you thought there were lots of options for opening files — wait until you see how many options there are for working with the palettes. Not to worry though — I'm just going to cover the easy ways to control those much-needed palettes and also how to get rid of them when they get in the way.

■ **Figure 1.4** shows the default palette locations, which you can always get to quickly by selecting **Window ➤ Reset Palette Locations**. Most of the time, I don't need these palettes. I do have a preferred set of palettes but, before you set up palettes the way you want them, first make sure they will stay put when Elements is closed and opened as the new "default" layout. Select **Edit ➤ Preferences ➤ General** (**Ctrl+K/Command+K**)

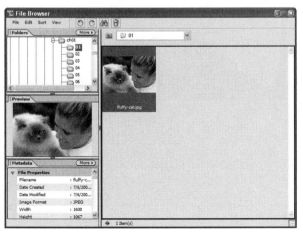

1.3

to get the Preferences dialog box shown in **Figure 1.5**. Make sure there is a checkmark next to **Save Palette Locations**. Click **OK** to close the dialog box. Just so we start the same way, select **Window ➢ Reset Palette Locations**.

■ Now you can set up the palettes as you want them. Start by closing two of the three palettes that are already open. First you need to know a little trick. You cannot close a palette if the palette menu has a checkmark next to **Place in Palette Bin**. To access that menu item, click the **More** button in the title bar of the palette you want to close and make sure it is not selected. Now you can drag the entire palette out of the **Palette Well**. If **Place in Palette Bin** were checked, the palette would close to the **Palette Bin** when you clicked the **Close** button in the palette title bar. With that tip in mind, drag off and close the **How To** and **Styles and Effects** palettes. Leave the **Layers** palette open.

■ Select **Window ➢ Navigator**. Click the **Navigator** tab (not the title bar) and drag the **Navigator** palette onto the **Palette Bin** and it will dock itself nicely. If you want it located above the **Layers** palette as I do, just click the **Navigator** palette title bar and drag it up above the **Layers** palette.

■ As you will learn in some of the later techniques in this book, I am a big fan of keeping my eye on the histogram during the editing process. So, let's add the Histogram palette to the Palette Bin, too. Select **Window ➢ Histogram**. Click the **Histogram** tab (not the title bar) and drag it to the bottom of the **Palette Well**. You should now have a **Palette Bin** that looks like the one shown in **Figure 1.6**. Now when you close the Elements Editor and reopen it later, your palettes will look the same.

■ Now zoom in on the **fluffy-cat.jpg** image. Select **View ➢ Actual Pixels** (**Alt+Crl+0/ Option+Command+0**). This shortcut is well worth remembering. On a PC you can double-click the document title bar to **Maximize** an image. On a Mac, you can click the bottom corner of the document window and drag the image to expand it.

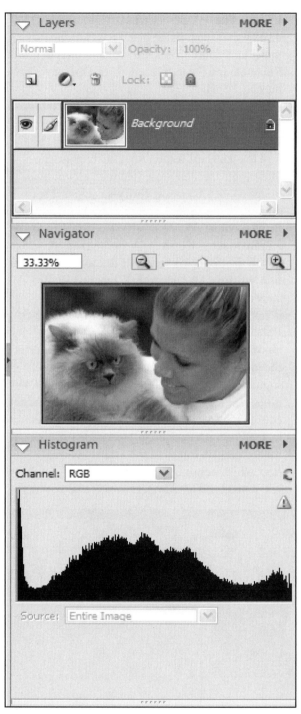

1.4

- The **Palette Bin** is now covering a good bit of the image. To hide the **Palette Bin** you can click the **Close Palette Bin** icon in the middle of the left side of the **Palette Bin** and it closes. Or, on a PC (not on a Mac), you can click the **Open Palette Bin** icon in the bottom-right of the application window. Or, you can select **Window ➢ Palette Bin**. Or — and this is my favorite method — simply press **F11**. If you are going to remember just one, go for the **F11**.

- Any time you want to float a palette, you can simply click the palette title bar and drag it off the **Palette Bin**. If you want to see all or none of a palette when it is docked in the **Palette Bin,** click the triangle icon that is on the top-left of each palette to expand or contract the palette. If you want to hide most of a palette when it is not docked, double-click the palette's title bar to compact the palette if it is open, and to open it if it is compacted. **Figure 1.7** shows my favorite palette configuration. You can leave more space for other palettes if you collapse the Histogram palette at the bottom of the Palette Bin. Whenever you need to see it, it can easily be expanded by clicking the triangle icon just to left of the palette title bar.

1.5

1.6

STEP 4: MANAGE OPEN FILES

One of the truly cool new features that helps you keep track of any open files is the **Photo Bin** that is found at the bottom of the application window. Any file that is open in the Elements 3.0 workspace will have a thumbnail showing in the Photo Bin.

■ To bring an open image to the front of the workspace, just click the appropriate thumbnail in the **Photo Bin**.

■ To close the Photo Bin, you can click the **Photo Bin** handle found on the top of the Photo Bin in the middle (on the Mac, double-click the bar at the top of the **Photo Bin** title bar or click the upper-left red X icon). There is also an Open/Close Photo Bin icon just to the bottom-left of the Photo Bin on the PC.

■ If you like automatically opening and closing things, you can right-click the **Photo Bin** where there is a thumbnail showing and this opens a pop-up menu; select **Auto Hide** (PC only). Now when you drag your cursor toward the bottom of the application window, the **Photo Bin** automatically opens. It will also close as you move your

cursor away from the **Photo Bin** following a slight time-delay (PC only).

■ On a PC you can right-click a thumbnail to get another pop-up menu, which gives you the options shown in **Figure 1.8**. To get a similar menu on the Mac, hold Control and click a thumbnail. Notice that you can even duplicate or rotate images from this menu.

■ On the pop-up menu you can also select **Show Filenames**. On the Mac you can view the filename by placing your cursor over a thumbnail.

1.7

| Close |
| Minimize |
| Restore |
| File Info |
| Duplicate |
| Rotate 90° Left |
| Rotate 90° Right |
| ✔ Show Filenames |
| Auto-hide |

1.8

LEARNING ABOUT IMAGE SIZE, FILE FORMAT, AND BIT-DEPTH

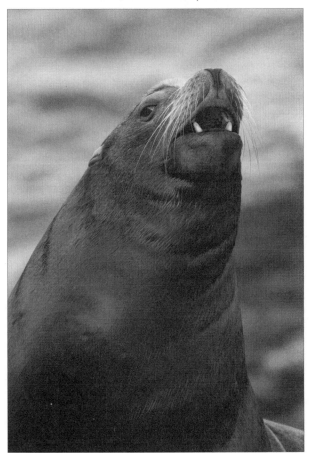

2.1

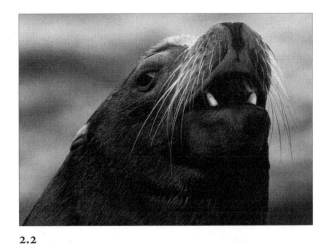

2.2

ABOUT THE IMAGES

"San Diego Sea Lions,"
Canon EOS 1D, 70–200mm
f/2.8 IS @ 200mm with 2X II
Extender, f/8.0 @ ISO 1600,
16-bit RAW format, 1,648 x
2,464 pixels, ¹⁄₅₀₀ sec.

When you start opening, editing, cropping, saving, uploading, e-mailing, archiving, copying, and printing your digital photos you need to know all about image size, file format, bit depth, and image resolution. If you crop the image shown in **Figure 2.1** to be like the one shown in **Figure 2.2** and you perform major tonal and color corrections to the image, do you know the implications of those actions?

9

Many digital photographers never take the time to learn about image size, file format, and bit depth, and they struggle with these topics every time they see or have to use these terms. This is sad because photography should be fun, and for me, struggling takes the fun out of just about anything. In this technique, you learn all you need to know about digital image files. This will help make every step in your digital photography workflow fun and easy. If you already know about these topics, please flip forward a few pages to the next technique. If not, this is a good technique to study in detail.

STEP 1: LEARN ABOUT IMAGE SIZE AND IMAGE RESOLUTION

Pixel dimensions. 1,600 x 1,200 pixels. Resolution. Megapixels. dpi. ppi. MB and KB, or megabytes and kilobytes. These are just a few words, phrases, and acronyms that get associated with "image size." If someone were to ask you what size image you get from your digital camera, how would you answer? Part of the confusion over the right answer has to do with the fact that the right answer depends on why the question was being asked and in what terms the answer should be given. All of the previously listed words, phrases, and acronyms are appropriate for describing image size. To start this technique, let's cover a few important basic definitions.

Pixel dimensions: The number of pixels along the height and width of a digital image. There is usually a one-to-one relationship between the pixels in an image and the pixels on the image sensor in your digital camera. For example, two common pixel dimensions for digital photo files are 1,600 x 1,200 pixels and 2,560 x 1,920 pixels.

File or image resolution: The resolution of an image is the total number of pixels that it contains and it is usually more helpful to express it as pixel dimensions. A 1,600 x 1,200 pixel image has a resolution of 1,920,000 pixels (1,600 x 1,200 = 1,920,000). A 2,560 x 1,920 pixel image has a resolution of 4,915,200 pixels (2,560 x 1,920 = 4,915,200).

Megapixel: The term used to describe the number of pixels in an image or the number of pixels that an image sensor can record, expressed in terms of millions of pixels. A digital photo image with 1,600 x 1,200 pixels would, for example, be a 1.9-megapixel image ($1,600 \times 1,200 / 1,000,000 = 1.9$). A camera with a 2,560 x 1,920 pixel image sensor would be a 5-megapixel camera ($2,560 \times 1,920 / 1,000,000 = 4.915200$).

Megabytes (MB): A megabyte is one of the most commonly used units to measure file size. Technically, it is 2^{20} bytes or, 1,048,576 bytes. Or rounded off, it is approximately one million bytes. In simple terms, a byte is a unit of storage capable of holding a single character. Most CD-ROMs have a storage capacity of 640MB or 700MB.

Kilobytes (KB): A kilobyte is a thousand bytes and it is used to describe file size. It takes a thousand kilobytes to make one megabyte. Kilobytes are a good measurement for Web images as they generally need to be much, much smaller than a megabyte.

dpi: Generally, dpi (**d**ots **p**er **i**nch) is the acronym used for describing the number of dots per inch used to make a print. This term is often the source of much confusion as it is used to describe both the dots (or pixels) in an image and the dots that a printer makes on a print. The confusion comes from the simple fact that many printers lay down multiple dots for each actual image dot. For example, some of the new Epson printers make such tiny dots that they lay down 5,760 x 1,440 dots for each pixel in an image.

ppi: The acronym *ppi* (**p**ixels **p**er **i**nch) is often incorrectly interchanged with dpi even though ppi is the more accurate term for digital images and dpi for the resolution of a printing device. Pixels/Inch is the increment setting for many of the dialog boxes in Adobe Photoshop Elements 3.0. An image that is 1,600 x 1,200 at 300 ppi will

print at a size of 5.3 x 4 inches. Or, printed at 180 ppi, it would make a print size of 8.89 x 6.67 inches. Up to a certain point, the higher ppi value, the better quality of print you will get. There are diminishing returns above 240 to 300 ppi when printing with an inkjet printer.

Now let's put those definitions to practical use.

■ Select **File ➢ Open** (**Ctrl+O/Command+O**) to display the Open dialog box. Double-click the **\ch01\02** folder to open it and then click the **sealion8.tif** file to select it. Click **Open** to open the file. This file is a JPEG file that was saved using the JPEG Medium compression setting.

■ Select **Image ➢ Resize ➢ Image Size** to display the Image Size dialog box shown in **Figure 2.3**. You can now read the dimensions of the image in the **Pixel Dimensions** area. The image is **1,648** x **2,464** pixels. Notice **11.6M** (**Mb**) just after **Pixel Dimensions** at the top of the dialog box. This is an approximation of the size of the image file when the image is saved as an uncompressed image in the .tif, .bmp, or .psd formats, covered in Step 2. You can calculate the exact number by multiplying the pixel width by the pixel height and then multiplying that by 3. You multiply by 3 because it takes 1 byte of storage for each pixel for each of the three color channels: red, green, and blue. This is true only if it is an 8-bit RGB image, which is covered in Step 3. Once again, the math is: $1{,}648 \times 2{,}464 \times 3 = 1{,}048{,}576$. Then, divide that number by 1,000,000 to get megabytes and you get 12.2MB.

■ With **Resolution** set to 240 pixels/inch the image file makes a print sized 6.867 x 10.267 inches. Mathematically this makes good sense because you can divide the width in pixels (1,648) by 240 pixels per inch to get the width in inches (6.867). You can do the same thing with height. If you want to increase the size of a print beyond the pixels you have, you will have to "make up" or interpolate pixels where there were previously none. You learn more about this process in Technique 5.

■ Click **Cancel** to close the Image Size dialog box.

STEP 2: LEARN ABOUT FILE FORMAT

In Step 1, you learned about image resolution and file size. But, as you will now learn, file size is greatly dependent on file format. There are many file formats, but they all fit into two broad categories: compressed and uncompressed.

An uncompressed file is a file format in which every pixel is saved as it was recorded. The most commonly used uncompressed file formats are: .TIFF (.tif), Photoshop (.psd), and Windows (.bmp). Unless you are creating wallpaper for a Windows computer, you are not likely to use .bmp. The .psd file is the Photoshop's native file format and it allows you to save the image with information that is not savable in some other formats such as layers, adjustment layers, layer styles, and so on. Uncompressed files are good because they contain all of the original picture information. The downside is that a uncompressed file will be larger than a compressed file made from the same image.

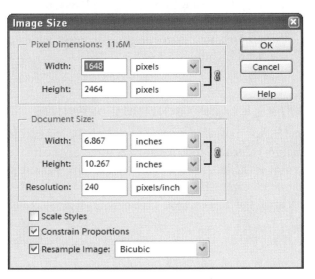

2.3

A compressed file is a file format that can store simplified picture information to make a smaller file. Mathematical algorithms that simplify picture information lose some picture quality in the process of simplifying the picture information to make a small file. For this reason, compressed files are often called "lossy" files, and uncompressed files are called "non-lossy" files. The most common compressed or "lossy" file format for digital photos is the JPEG (.jpg) format, which is the most common file format used by digital cameras and on Web pages. The good news is that today's compression algorithms are so good that it is hard to see a difference between a large non-compressed file and a much smaller compressed file if the compression level has not been too severe. Without today's advanced in-camera compression algorithms, you would be able to store far fewer digital photos on your digital photo storage media and on your computer's storage devices, too.

- Now save the file you opened in Step 1 in the compressed JPEG (.jpg) file format. Select **File ➤ Save As** (**Shift+Ctrl+S/Shift+Command+S**) to get the Save As dialog box. Choose a folder to store a temporary file. Click in the **Format** box and choose **JPEG**. Click **Save** to get the JPEG Options dialog box shown in **Figure 2.4**.
- Click in the second box after **Quality** and choose **High**. Using the **Baseline Format Option** notice that **Size** is noted as **645.3K**. Now click in the same box again and choose **Medium** and notice that the file size is now **358.37K**. What you are doing is making a choice between high image quality and large file size versus lower image quality and lower file size.
- Click **OK** to save the file using **Medium Quality**. You now have a 358.37Kb image file, which is much smaller than the one you opened in

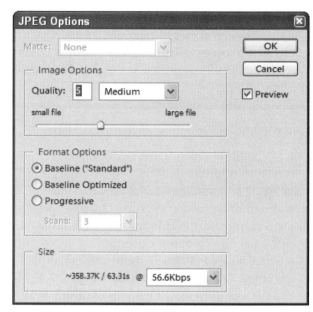

2.4

Step 1. That non-compressed TIFF (.tif) file was 12.2MB, or 34 times as large! Now you know the value of compression. If you once again open the **sealion8.tif** file and compare it to the JPEG version, you are not likely to notice much difference. You may even want to try using the **Low Quality** setting and see what differences you can find. To learn more about increasing and decreasing file size, read Technique 5.

STEP 3: LEARN ABOUT BIT DEPTH

When you take a picture with a digital camera, the picture information is usually captured by the image sensor in 12-bit format. What that means is that the camera is capturing 12 bits of picture information for each of the three color channels (red, green, and

blue), which results in 4,096 (2^{12}) brightness levels per channel. How this vast amount of picture information gets written to an image file is determined by user selectable options. Some, but not all, digital cameras allow all of the captured information to be saved in a 16-bit file format without applying user-selectable camera settings (that is, white balance, sharpening, contrast, and so on). These files are called RAW files.

RAW files have several advantages. Most notably RAW files have far more picture information than the more common 8-bit file formats, which record only 256 tonal levels (2^8) per channel. They also allow you to work with the image as it was captured without any of the camera's settings being applied.

There are several negative aspects to RAW files. While they are compressed files, they are substantially larger than JPEG files. They require a special software converter to convert them and those that are provided by camera vendors are typically not worth using. However, that is okay because Adobe Photoshop Elements 3.0 has one of the best RAW converters currently available. Finally, RAW files take much more computing power to process, especially if you choose to convert the image to a 16-bit image and edit it in 16-bit mode.

To clarify all the information you have learned so far in this technique, let's now look at a few more files featuring the sea lion.

■ Select **File** ➢ **Open** (**Ctrl+O/Command+O**) to display the Open dialog box. Double-click the **\ch01\02** folder to open it and then click the **sealionRAW.TIF** file to select it. Click **Open** to open the Camera RAW Converter shown in **Figure 2.5**. Click the **Rotate Left** icon and make sure **Depth** is set to **16 Bits/Channel**. Click **OK** to open the image.

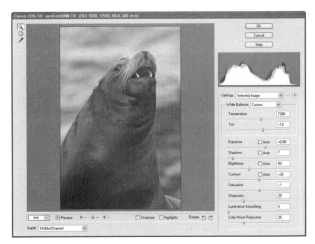

2.5

■ Select **Image** ➢ **Resize** ➢ **Image Size** to get the Image Size dialog box. Note that **Pixel Dimensions** at the top shows the approximate file size is now **23.2MB**. Click **Cancel** to close the dialog box. Select **File** ➢ **Close** (**Ctrl+W/Command+W**) to close the file.

■ Select **File** ➢ **Open** (**Ctrl+O/Command+O**) to display the Open dialog box. Double-click the **\ch01\02** folder to open it and then click the **sealionRAW.TIF** file to select it. Click **Open** to open the Camera RAW Converter. This time set **Depth** to **8 Bits/Channel**. Click **OK** to open the image.

■ Select **Image** ➢ **Resize** ➢ **Image Size** to get the Image Size dialog box. Note that **Pixel Dimensions** at the top shows the approximate file size is now **11.6MB** instead of the 23.2MB file size that you got when you converted the file to a 16-bit file a little earlier. Click **Cancel** to close the dialog box.

A digital image can be ruined if you apply severe changes to correct color and tonal range. This is one of many reasons why it is best to try and take good photos that need less image editing. Severe changes using tools such as Levels, Shadow/Highlights, and Hue/Saturation can transform desirable smooth tones or color gradations into undesirable posterization or banding effects. When editing an image, you can watch for banding by viewing the histogram. Adobe Photoshop Elements 3.0's new Histogram palette can be left open so that you can see the effect that your editing is having on the histogram as you make changes to the settings. One way to reduce the chance of your images showing banding effects is to shoot using RAW mode; then, convert the image into a 16-bit image. Figure 2.6 shows the histogram after a Levels change (Input Levels were 22, 1.48, and 231) was made to an 8-bit version of the sea lion photo. Figure 2.7 shows the histogram after the same Levels settings were applied, but they were applied to a 16-bit image. Notice how the extra picture information in the 16-bit image allows the same edits to be made without showing banding as indicated by the "comb-tooth" histogram in Figure 2.6.

2.6

With that background knowledge, let's see how valuable it can be for your everyday photography.

The Nikon Coolpix 5400's image sensor captures a 2,592 x 1,944 pixel image. It is therefore a 5-megapixel camera, as you can calculate $2,592 \times 1,944 / 1,000,000 = 5.0$ megapixels. If you were to open and save one of the files as an 8-bit, non-compressed image in the .tif format, you would have a 15-megabyte (MB) file.

If you save all of your edited images as 8-bit .tif files, how many could you archive on a CD-ROM or a

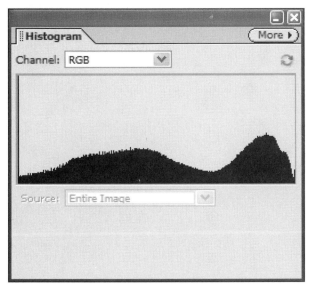

2.7

If you double the height and width dimensions of a 2,592 x 1,944 pixel image, how large a print can you make using a printer that has a recommended 300 dpi print specification? If you calculated that you would have a 5,184 x 3,888 pixel image, your math is correct. Just multiply each of the dimensions by 2. If you divide 5,184 pixels by 240 dpi you would get 21.6 inches. Dividing 3,888 by 240 dpi you get 16.2 inches. So, a reasonable conclusion is you could make a nice 16" x 20" print. But, the best answer is — it depends! Make a print and see for yourself. Don't let the mathematics of photography take precedence over your creative skills and talent.

DVD-ROM? If you record to 640MB CD-ROMs, you could archive about 42 edited images. 640MB / 15 MB = 42 images. Or, when saving to a DVD-ROM with a 4.77GB capacity, you could save (4.77GB × 1,000) = 4,770MB. 4,770MB / 15MB = 318 images.

If you shoot with a 5-megapixel camera using JPEG as the file format and the average file size is 1.7MB, how many photos can you take before you run out of storage space on a 512MB digital photo storage media card? 512MB / 1.7MB = 301 photos.

TIP

It is unwise to save an image as a JPEG file, and then edit it and save it again. Each time you save a file using JPEG compression, you will lose some picture information. The process is similar to taking a photocopy of a photocopy. Each time you compress an image you will have a lesser quality image. This means that you should always save any file that you may later edit as a non-compressed file such as .psd or .tif.

PHOTO-EDITING WORKFLOW

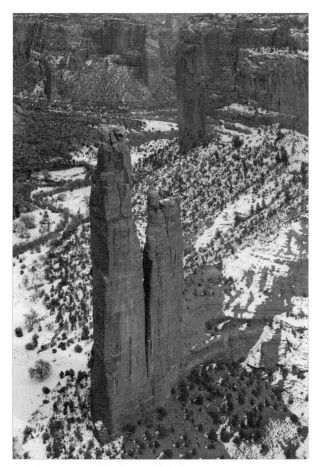

3.1

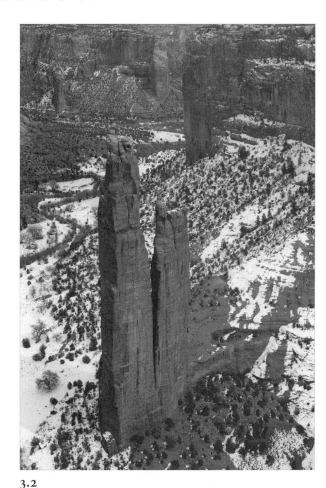

3.2

ABOUT THE IMAGE

"Spider Rock in Canyon De Chelly National Mounument," Canon EOS 1Ds, 28–70mm f/2.8 @ 60mm, f/11 @ 100 sec, ISO 100, 16-bit RAW format, 2,704 x 4,064 pixels, 12MB RAW plus converted .tif

T alk about cold! The photo shown in **Figure 3.1** was taken in the afternoon on a chilly November day. I had gotten up early that morning to shoot this same scene with the sun coming up but the horribly cold and fierce wind made the wind chill factor about –40 degrees F. My lens fogged up and I could not see through the viewfinder. My fingers felt frostbitten after just a few minutes — the time it took to open up my tripod and walk 50 feet from my car. So, I jumped back in the car and toured around the park until it got to be 20 degrees F; then I tried again.

17

Just as there are many variables that must be considered when taking a photo, there are also lots of steps and variables to take into account in order to determine the order of the editing workflow to create a successful image. The purpose of this technique is to provide you with the knowledge needed to create an appropriate workflow for each image you edit. Each of the steps in the editing process is important but some tasks take priority over others.

STEP 1: OPEN FILE

When you want the best possible photo, you should shoot in RAW mode (if your camera has that capability). Then, use Camera RAW in Adobe Photoshop Elements 3.0 to convert the RAW file to a 16-bit image for further editing. In this technique, you look at the sequence of steps you should take to edit your digital photos. Consequently, there isn't much detail about the conversion process, which I cover in Chapter 4.

It is important to note that the sequence of editing steps is entirely different when you start with a RAW file. With RAW files, you should attempt to make as many corrections to color and tonal range with the Camera RAW converter before actually performing edits with the Editor. As a result, you will benefit from working with the original picture information before it gets converted and loses some of the original image data.

■ In this technique, I assume that a RAW file was not available. If it was, I would have the option of making changes to the image before it was converted. This is shown in Step 1A. Instead, you get to work with an image file that was already converted and then saved as an 8-bit .tif file. Choose **File ➢ Open** (**Ctrl+O/Command+O**) to display the Open dialog box. Double-click the **\ch01\03**

folder to open it and then click the **spider-rocks-before.tif** file to select it. Click **Open** to open the file. Notice that the top of the document window shows (RGB/8) and the same thing is shown in the Elements application title bar. This means that you have opened and are working on an 8-bit image.

STEP 1A: CONVERT RAW

Figure 3.3 shows the settings that were made with the Camera RAW converter to get the **spider-rocks-before.tif** image you just opened. You learn more about using the Camera RAW converter in the next step.

STEP 2: PERFORM BASIC IMAGE EDITS

Now is the time to make the simple edits to the image. Such edits include rotating an image in order to straighten a vertical line such as a building, or rotating an image in order to flatten a horizontal element such as the horizon in a seascape. It is your

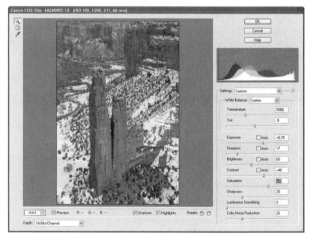

3.3

choice as to when you crop the image, but I usually prefer to do it early on, as it often reduces the size of the image and therefore makes the editing steps quicker. The downside to cropping the image at this point is that if you wanted to crop your image to a different height-width proportion later on in your editing process, the cropping of the image earlier in the workflow may hinder your ability to get the new crop proportions. You learn more about sizing, leveling, and cropping in Technique 8.

TIP

Adobe Photoshop Elements 3.0 presents you with a quandry. If you open an image in 16-bit mode, you have all the benefits of performing many of your editing steps in 16-bit mode, which at times can result in a decidedly better image. Elements also has the wonderful adjustment layers that allow you to make changes and then later return to the same features to adjust those changes. This is known as non-destructive image editing as your edits are never finally applied until you flatten the image. You can create adjustment layers for Levels, Brightness/ Contrast, Hue/Saturation, Gradient Map, Photo Filter, Invert, Threshold, and Posterize. However, there is a catch — you can't use adjustment layers if you are working on a 16-bit image. So, you have to decide if you want the flexibility you get when working with adjustment layers, or you want the better quality image you may get by editing a 16-bit image. Now that is a tough quandry, heh? If you want both, you need to upgrade to Adobe Photoshop CS.

STEP 3: CORRECT COLOR

The next step is to correct color. Adobe Photoshop Elements 3.0 offers a myriad of features to help you create an image with whichever colors, hues, shades, or tones you want. To learn more about color correction, read Techniques 12 and 13. Because most of the color corrections were done with the Camera RAW converter, you will not make any edits in this step.

STEP 4: ADJUST TONAL RANGE

You will now make a simple change in the tonal range to increase contrast and darken the shadows.

■ Select **Enhance ➢ Adjust Lighting ➢ Levels** (**Ctrl+L/Command+L**) to get the Levels dialog box shown in **Figure 3.4**. Click the **Shadow** slider and drag it toward the right to about **21**. Click the **Midtone** slider and drag it toward the right to about **0.95**. Click **OK** to apply the settings.

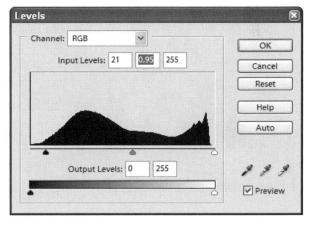

3.4

■ After a close look at the image, I decide that the red channel needs a bit of tweaking as well. Select **Enhance ➢ Adjust Lighting ➢ Levels** to get the Levels dialog box once again. This time click in the **Channel** box and select **Red** (**Ctrl+1/ Command+1**). Click the **Shadow** slider and drag it toward the right to about **11**. Click the **Highlight** slider and drag it toward the left to about **247**, as shown in **Figure 3.5**. Click **OK** to apply the settings.

■ I like the way the image is looking, but the last edit makes me want to reduce the yellow tone a slight amount. Select **Enhance ➢ Adjust Color ➢ Hue/Saturation** (**Ctrl+U/Command+U**) to get the Hue/Saturation dialog box. Click in the **Edit** box and choose **Yellows** (**Ctrl+2/Command+2**). Click the **Saturation** slider and drag it toward the left to about **−23**. Nice but still needs some change. Click in the **Edit** box and choose **Red** (**Ctrl+1/ Command+1**). Click the **Saturation** slider and

drag it toward the left to −8. Click **OK** to apply the settings. The image looks much more like the scene looked when I took the picture.

To learn more about adjusting tonal range, read Techniques 9 through 11.

STEP 5: CONVERT TO 8 BITS WHEN NEEDED

If you began with a 16-bit image and want to use a feature that cannot be used on a 16-bit image such as layers, you need to convert the image to 8-bit. Just make sure that you have taken advantage of all the 16-bit features before converting.

■ To convert an image from 16-bit to 8-bit, select **Image ➢ Mode ➢ Convert to 8-Bits/Channel**. When you have converted to 8-bit, you cannot go back to edit a 16-bit image.

STEP 6: SAVE FILE

When you have completed all of your editing except for image sizing, possibly cropping, and sharpening, you are ready to save your file. If you have used regular or adjustment layers, and think you may want access to them later, you should save your file in .psd format. If you are sure you will not need to access the layers in the future, you can flatten the image and then it is best to save the file in the .tif format, which is a much more useful format than the .psd format, which is a proprietary Adobe file type. To learn more about image files and formats, read Technique 2.

If you are wondering why you did not sharpen the image before you saved it, you are to be commended for thinking about the overall workflow. The next Tip explains why you have not yet sharpened the image.

3.5

TIP

The very last step you should take when editing a digital photo is to sharpen it. You should sharpen an image only when you are certain of the final use, or uses, of the image. Because you sharpen differently for images of different sizes, such as those that will be displayed on a Web page, and also differently for different sized prints and target printers, you should sharpen only after the image has been sized for its final use.

STEP 7: SIZE IMAGE FOR TARGET USE

The wonderful thing about the image you have been editing is that it was taken with the magnificent 11-megapixel Canon EOS 1D digital camera. The image is huge! It is 2,704 x 4,064 pixels. If you were to use an Epson printer that makes excellent prints with as few as 240 dpi, you could make an 11¼" x 17" print.

Now suppose that after editing this image you like it enough that you decide that you want to make a 5" x 7" print, an 800-pixel tall image for displaying in your Web gallery (see Chapter 9), and the largest print possible on a new fine art matte paper you have, which is 13" x 19". You should now understand the value of knowing image-editing workflow. If you have already cropped or resized your image, you may have dramatically limited the sizes you can make. If you have already saved your image with sharpening applied, you will not be able to get optimal sharpening without re-editing the image from the very start. In simple terms, you would have only a single image file suited for a single purpose that is not very practical.

I am all for taking full advantage of the large image file you have here so let's agree to size this image as large as possible for the largest paper that fits in the Epson 1280 and Epson 2200 printers. That size is 13" x 19". Please note that you should have saved your file as specified in Step 6 if you want to use it for several different purposes later on.

- Select **Image ➤ Resize ➤ Image Size** to get the Image Size dialog box shown in **Figure 3.6**. Make sure **Resample Image** is checked and that **Bicubic Smoother** is set as the interpolation method. Make sure there is a checkmark next to **Constrain Proportions**. To learn more about increasing and decreasing image size, read Technique 5.
- To leave a .5" border on a 19" tall paper, type **18** in the **Height** box and make sure it is set to **inches**. **Width** automatically changes to **11.976 inches**, which is about as close to a 12" print as you can

3.6

get, which leaves you with a .5" border on the
sides, too. Notice that you are slightly increasing
image size from **31.4MB** to **35.5MB** as shown at
the very top of the Image Size dialog box.

■ Click **OK** to resize the image.

STEP 8: SHARPEN IMAGE

Now it is finally time to sharpen the image. All the
editing has been completed, the image has been sized
for the target use, and you know the kind of printer
that will be used.

■ To sharpen the image, select **Filter ➢
Sharpen ➢ Unsharp Mask** to get the Unsharp
Mask dialog box shown in **Figure 3.7**. Set **Amount**
to **225%**, **Radius** to **0.3 pixels**, and leave
Threshold at **0 Levels**. Click **OK** to sharpen the
image. To learn more about sharpening an image,
read Technique 6.

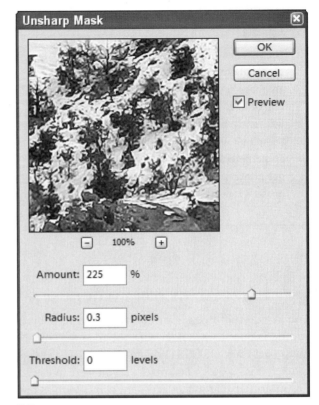

3.7

If you know that you will be making more prints of this image at this size, you may want to save the image using a filename that makes it clear that the image has been edited, sharpened, and sized for making a 12" x 18" print. My choice of filenames would be spider-rock_es12x18.tif, where "e" means edited, "s" means sharpened, and "12x18" indicates the image is sized for a 12" x 18" print.

STEP 9: MAKE OR ORDER PRINTS

Your image is now ready to be used to make a 12" x 18" print on an inkjet printer at 240 dpi.

Notice how few edits you had to make in this entire workflow. The reason for this is that most of the major changes to the image were done in the Camera RAW dialog box at the time the image was opened. Shooting and editing RAW images is good, but surely not essential.

TIP

The order of the steps you take when editing a digital photo matters. A good workflow is as follows:

1. Open image file. If the file is a RAW file, perform as much of the color and tonal correction that is possible. Convert the image to a 16-bit image instead of an 8-bit image as you will have more picture information to work with and will have less risk of getting a posterized image due to severe changes in the image.

2. If you are editing a 16-bit image, make as many of the edits that you can while in 16-bit mode, and then convert to 8-bit mode. Many filters and features work only in 8-bit mode.

3. Use adjustment layers when possible so you are able to go back and make further adjustments to the settings.

4. Make color corrections before you make tonal corrections.

5. Usually it is best to make all the edits you want before changing image size.

6. If you plan on making multiple sizes of images, save the final edited image in its original size; then, make new images for each additional size you want and save accordingly.

7. Sharpen images after all edits have been made and sharpen them only when they are sized for their target use.

8. Save files in appropriate file formats and with layers when you think you may want to take additional editing steps.

4

CONVERTING RAW FILES

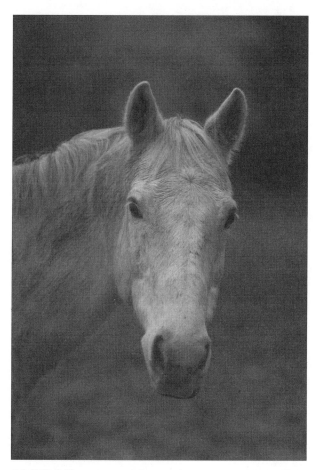

4.1 (CP 4.1)

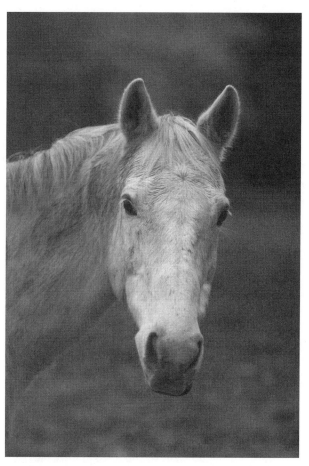

4.2 (CP 4.2)

ABOUT THE IMAGE

"Candid Shot of an $80,000 Hunter Jumper," Canon EOS D60, 70–200mm f/2.8 IS @ 125mm, ISO 100, f/2.8 @ ¹⁄₈₀ sec, RAW file setting, 2,048 x 3,072 pixels, 5.7MB .CRW

S hooting in RAW mode and then converting RAW files to 16-bit images gives you many advantages over non-RAW files when you want to get the ultimate image. What is a RAW file and what makes it so special? In simple terms, a RAW file is an image file that is saved to a camera's digital storage media without having any of the camera settings applied to it, and the images are saved as 16-bit files instead of 8-bit files. This means that you have up to 65,000 plus tonal levels to work with for each of the three channels instead of only 256

per channel. This greatly reduces the chance that you will have a posterized image after performing moderate to severe changes to the image. In this technique, you learn how to convert the RAW image shown in **Figure 4.1 (CP 4.1)** using Adobe Photoshop Elements 3.0's Camera RAW converter. **Figure 4.2 (CP 4.2)** shows the results of the conversion process.

STEP 1: OPEN FILE

■ **Select File ➢ Open (Ctrl+O/Command+O)** to display the Open dialog box. After locating the **\ch01\04** folder, double-click it to open it. Click **horseRAW.CRW** file to select it; then, click **Open** to open the file. The file is then displayed in the Camera RAW converter dialog box, as shown in **Figure 4.3**.

> **NOTE**
>
> The RAW file format is not available on some digital cameras. Some digital cameras ship without that capability, but they are able to capture in RAW format after a firmware update is downloaded and installed from the camera vendor's Web site. If you want to shoot using RAW files but can't find a way to change the file format to RAW, check the documentation that came with your camera and check on the vendor's Web site for any updates that may be available.

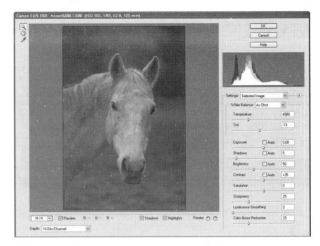

4.3

Before you begin choosing settings, let's first be clear about how the image will be used so that you can choose optimal settings specific for that purpose. Let's assume that your end objective is to make the largest possible print without increasing image resolution. Because the image was shot using the RAW file format, you definitely want to take advantage of the extra picture information that is available in a 16-bit image. Also, let's assume you will be doing some advanced editing to the final image that you get when this technique is completed. You want to be careful to not "blow-out" any highlights (push the highlights to a pure white tone) when choosing settings. Because great effort was taken to photograph this horse in rich fall colors in ideal light conditions, you want to avoid making changes to the color that remove the intentional warm and desirable color cast. Okay, with those assumptions in mind—see what you can do with the Camera RAW converter.

TIP

The Camera RAW converter dialog box has been created to be used with a minimum display size of 1,024 x 768 pixels. If your display is smaller than this, you may have a difficult time choosing settings and viewing the image. If you can't see the entire dialog box, check to see if your computer screen can display a 1,024 x 768 pixel or larger workspace. On a computer running Windows, right-click on the desktop and choose Properties from the pop-up menu. Click the Settings tab in the Display Properties dialog box. In the Screen resolution area, there is a slider that allows you to choose screen settings. On a Mac, select Apple ➢ System Preferences and then double-click Displays. Choose the screen resolution you want by clicking the appropriate size in the Resolutions box.

STEP 2: CHOOSE CAMERA RAW CONVERTER IMAGE SETTINGS

■ Because the image was taken in portrait mode, click the **Rotate Image 90° Counter Clockwise** (**L**) icon that is just to the bottom-right of the preview window to rotate the image if it has not already been rotated.

■ Click in the **Depth** box and select **16 Bits/ Channel**. This doubles the size of the image file over the **8 Bits/Channel** options, and it increases the computer processing power requirements that are needed to edit the image. But, that is a minor

downside considering that you are able to perform much more drastic color and tonal changes before you see any posterization in the image.

STEP 3: CORRECT COLOR

There are five approaches you can take to correct image color. You can choose one of the preset **White Balance** settings, you can make adjustments using the **Temperature** and **Tint** sliders, you can use the **White Balance** tool, you can use the Auto adjust features, or you can use any combination of those approaches. For this image, you will attempt to bring back the rich, evening, warm fall color that lit the scene when the photo was taken.

■ Because the horse head contains white hair, first try to correct color using the **White Balance** tool. To get a good white point, zoom in on the image to 100 percent. Click in the **Select Zoom Level** box below the preview image and choose **100%**. Click the **Hand** tool (**H**) in the upper-left corner of the **Camera RAW converter** dialog box and click and drag the image where you can see a good sample of hair that should be white. I suggest you try looking at the area over the eye on the left of the image.

■ Click on the **White Balance** tool (**I**) in the upper-left corner of the **Camera RAW converter** dialog box. Drag the **White Balance** tool over the brightest spots on the horse's head while watching the **R**, **G**, and **B** values just below the preview image. Some of the lightest tones have **R**, **G**, and **B** values that are around **184**, **197**, and **210** respectively. From those numbers, you have also learned

the image has a considerable blue cast, as the blue values are substantially larger (**210**) than that of the red (**184**) and green (**197**) values. Click a white area to restore the white area to white and bring back in the warm evening sunlight. Click in the **Select Zoom Level** box below the preview image and choose **Fit in View**. With one click you have wonderful rich colors!

If the initial color correction had not been as good as it was using the **White Balance** tool, you could make further adjustments to the colors using the **Temperature** and **Tint** sliders. Or, you could also try some of the **White Balance** settings and then make final adjustments with the **Temperature** and **Tint** sliders.

STEP 4: ADJUST EXPOSURE

Now that you have warm fall colors, see if you can improve the exposure so that you see more details in the horse without making the forehead too bright. Once again the Adobe engineers have given you plenty of choices for correcting exposure. You can click the **Auto** feature for **Exposure**, **Shadows**, **Brightness**, and **Contrast** to have the Camera RAW converter automatically adjust the exposure. Or, you can make adjustments to those settings manually. In this step, first try the **Auto** settings and then make adjustments to those settings to get the results you want.

■ In the process of increasing the brightness level of the image, you want to make sure that you do not lose detail in the white parts of the horse head by pushing the tonal range to pure white. To visually see the pixels that get pushed to **R**, **G**, and **B** values of **255**, **255**, and **255** respectively, click the

Highlights (**O**) feature below the image preview. With this feature turned on, the pure white pixels will get painted red. The **Shadow** (**U**) feature works in a similar manner, only it turns those pixels that have **R**, **G**, and **B** values of **0**, **0**, and **0** respectively to blue.

■ Click inside the **Zoom Level** box and select **Fit in View** to show the entire image once again. Click in the **Exposure Auto** box to turn it on. It will use a value close to **+1.4**, which in my opinion is too much, so click the **Exposure** slider and drag it to the left to about **+0.90**, which is similar to the low light level of the scene when the photo was taken.

As you make changes with the various sliders in Camera RAW converter, watch the image and the histogram carefully. As the right side of the histogram is pushed off the end of the scale, you will notice that hair on the horse's head becomes pure white and detail is lost. To get a more accurate understanding of where you are losing detail, press **Alt** on the PC (**Option** on the Mac) while clicking on and moving the **Exposure** slider. You will see the clipped colors in the preview window, which should look similar to the one shown in **Figure 4.4**. You may want to zoom in on the horse's face once again to get a more precise view of the image as you move the **Exposure** slider.

■ To increase contrast between the horse and the background, you can darken the shadows by clicking the **Shadows Auto** feature. It sets a **Shadows** value of **9** and that setting is just fine.
■ Click the **Brightness Auto** feature to get a setting of **30**. I like that setting, too, as it again increases the image contrast somewhat.
■ The auto features have worked well so far. Now click the **Contrast Auto** feature to see if it

4.4

improves the image, too. As it increases to the setting of **+37**, too much contrast is created for my taste. I suggest dragging the **Contrast** slider to the left to about **+30**.

STEP 5: ADJUST COLOR SATURATION

■ To adjust color saturation, use the **Saturation** slider. Many photographers new to digital image editing have a tendency to over-saturate an image. Be careful to keep your images looking realistic, but use your own judgment to get the creative results you want. Boosting **Saturation** to **+7** provides about as much rich orange color in this image as you would get if you had taken the photo with Fuji's Velvia slide film.

STEP 6: SHARPEN IMAGE

■ The Camera RAW converter also offers an image sharpening feature. The **Sharpness** slider gives you control of how much you want to sharpen an image. Unless your goal is to rapidly edit an image, I suggest that you set **Sharpness** to **0** and use the sharpening technique covered in Technique 6. If you set **Sharpness** to a value other than **0**, it is best not to do additional sharpening after the image has been converted.

■ Leave **Luminance Smoothing** and **Color Noise Reduction** set to **0** and **25** respectively. The **Camera RAW converter** should now have settings similar to the ones shown in **Figure 4.5**.

■ Click **OK** to convert the image using the selected settings and open it in Adobe Photoshop Elements Editor. **Figure 4.2** (**CP 4.2**) shows the results of the conversion process. You are now ready to perform additional editing steps if you need.

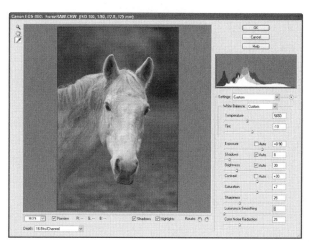

4.5

INCREASING AND DECREASING IMAGE SIZE

5.1

5.2

Having the right image size (or image resolution) for your intended use is important. Sometimes, you need a large image to make a large print, and at other times you need a small image to make a small print, or even a tiny image for use on a Web page. In this technique, you learn how to increase (upsample) or decrease (downsample) your image files to be the size you need. A simple and useful way to look at changing image size is to think of the process as either tossing out picture information, or creating new picture information where there previously was none.

As you might suspect, when you downsample an image, you are applying a mathematical algorithm to reduce the number of pixels in an image — which is not too far away from simply tossing out some of the pixels. In sharp contrast is the process of upsampling an image, where a mathematical algorithm is applied to create new pixels where they are needed. The more upsampling you do, the less likely the new image will look as good as the original image. In this technique, you first take the small image shown in **Figure 5.1** and enlarge it to make a large print suitable for framing. Then, you decrease the image size to make a tiny image for a Web page, as shown in **Figure 5.2**.

STEP 1: INCREASE IMAGE SIZE

Adobe Photoshop Elements 3.0 makes it easy for you to enlarge an image. The mathematical algorithms that are provided in the Image Size dialog box are called *interpolation methods*. Their sole purpose is to either create new pixels between existing pixels in order to make larger resolution images, or to remove pixels. There are limits to how much larger you can make an image before you find unacceptable image degradation. The limits are imposed by many variables. Some of these variables include the quality of the image, the initial resolution of the image, lens quality, the ISO setting that was used when the photo was taken, the shutter speed that was used, the softness of the image, and the level of detail in the image — just to name a few. Plus, I should add, your acceptance level. Some people are just more demanding when it comes to determining how their images look.

The photo of the iris shown in **Figure 5.3** was taken with a 3.1-megapixel Canon EOS D30 digital camera and an exceedingly good 300mm f/2.8 IS lens. The light was perfect, there was no wind, and the camera was mounted on a solid tripod. Artistically, the image was taken to get a sharp iris against a very soft blurred background. How large a print do you think could be made from such an image? Remember that the image resolution is only 1,440 x 2,160 pixels. Following the

mathematics you learned earlier in Technique 2, you could make a 6" x 9" print using the recommended "optimal" dpi setting of 240 dpi for an Epson photographic inkjet printer such as the 1280 or 2200.

I asked Calypso Imaging, Inc. (www.calypsoinc.com) to make a series of increasingly larger prints on a Lightjet 5000 printer until the image degradation was noticeable. They stopped after making a wonderful 22" x 32" print, which is a full 1,300 percent larger than a 6" x 9" print.

When you take into consideration the fact that you don't view a 22" x 32" print from the same distance that you view an 8" x 10" print, an even larger print could have been made — maybe as large as 30" x 40"!

5.3

The iris photo was an exceptional photo and the Lightjet 5000 printer is considered by many to be the best printer to use for quality photographic prints. So, you should not always expect to be able to get a 1,300 percent increase in image size, but this example does clearly reinforce an earlier point. Many variables determine how much you can enlarge an image. Do not get caught up in the mathematics and think that you must always use the optimal dpi setting as required by the target printer to get a good print. If you would like to experiment with the iris print, you can find it in the **\ch01\05** folder. It is named **iris.tif**.

■ Choose **File ➢ Open** (**Ctrl+O/Command+O**) to display the Open dialog box. Double-click the **\ch01\05** folder to open it and then click the **pelican-before.tif** file to select it. Click **Open** to open the file.

■ Select **Image ➢ Resize ➢ Image Size** to get the Image Size dialog box shown in **Figure 5.4**. This image is 1,200 x 1,680 pixels as you can see in the **Width** and **Height** boxes in the Pixel Dimensions area. Below that in the Document Size area, you can see that at **240 pixels/inch**, you can make a 5" x 7" print.

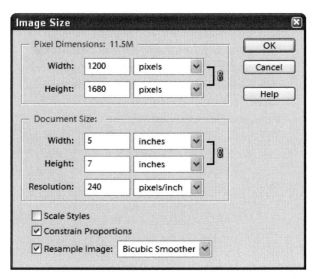

5.4

Let's assume that you now want to increase the image size to make the largest print that can be made on 13" x 19" paper, which is the maximum size paper that fits in many desktop inkjet printers.

■ Make sure that **Constrain Proportions** is checked. This keeps the height and width proportions the same. Make sure there is a checkmark next to **Resample Image** and then click in the box to pick an interpolation algorithm. The best algorithm to use for increasing image size is the new-to-Elements 3.0 **Bicubic Smoother**, so pick that method.

■ To get a 0.5" border on a 13" wide paper, type **12** in the **Width** box in the **Document Size** area and make sure increments is set to **inches**. **Height** automatically changes to **16.8 inches**. Notice that the image is now 2,880 x 4,032 pixels and 33.2MB instead of the earlier 5.77MB. Click **OK** to increase the image size.

This upsampled image is now ready for sharpening. To learn more about sharpening an image, read Technique 6. To understand why you should sharpen an image after you have increased image size, read Technique 3.

Figure 5.5 shows a portion of the image enlarged to 200 percent. Notice how you can see some visible artifacts along the edge of the pelican. These were created during the upsampling process. The question now is: Do you care? Once again, you have to decide if this image is acceptable to you or not. The best way to decide is to make a print and then carefully examine it. This is especially true if you have done some sharpening. What looks like unacceptable upsampling or excessive image sharpening on a computer screen can look wonderful when printed. You will also notice that the use of a matte or glossy paper can dramatically affect how an image turns out. Matte paper is sometimes more forgiving than the glossy paper, which can show incredible detail including upsampling artifacts, or sharpening effects.

After I printed a sample piece of this image on 8" x 10" matte paper, I concluded that this was a very acceptable enlargement as it made a nice print. So, making a 12" x 16.8" print from the original image would be just fine. Is there that much difference in image quality between the 12" x 16.8" print and a 5" x 7" print made from the original image before any upsampling took place? Try it and decide for yourself. As I mentioned earlier, everyone has different standards for what makes a good image. If you like it, then you will have been pleased to have taken and edited the photo, and that is the whole point of photography in my opinion — to take photos, edit them, and then, enjoy them.

5.5

TIP

When increasing the size of an image, do not make a final decision as to the acceptablity of the upsampling until you make a print on the target printer at the target resolution on the target paper. The reason for this is that what may appear as unacceptable on your computer screen may be just fine as a print. Printing a test print on the paper that you plan on using for a final print is the only way to really determine how an image will look. Images often look worse on-screen than they do on a print. Glossy paper generally shows more defects in an image than matte paper.

STEP 2: DECREASE IMAGE SIZE

Now assume that you know to decrease the image size to make an image that fits within a 640 x 480 pixel space on a Web page.

- To start with the original file, close the file you currently have open and select **File ➤ Open** (**Ctrl+O/Command+O**) to display the Open dialog box. Double-click the **\ch01\05** folder to open it and then click the **pelican-before.tif** file to select it. Click **Open** to open the file.
- Select **Image ➤ Resize ➤ Image Size** to get the Image Size dialog box. This image is 1,200 x 1,680 pixels, as you can see in the **Width** and **Height** boxes of the **Pixel Dimensions** area.

- Make sure that **Constrain Proportions** is checked. This keeps the height and width proportions the same. Make sure there is a checkmark next to **Resample Image** and then click in the box to pick an interpolation algorithm. The best algorithm to use for decreasing image size is the new-to-Elements 3.0 **Bicubic Sharper** method, so select it.
- Because the photo is taller than it is wide, type **480** in the **Height** box in the **Pixel Dimensions** area and **Width** changes to **343**. The **Image Size** dialog box should now look like the one shown in **Figure 5.6**. Click **OK** to reduce the image size to be a 343 x 480 pixel image.

Your image is now ready to be sharpened. To learn more about sharpening images for displaying on a Web page, read Technique 6.

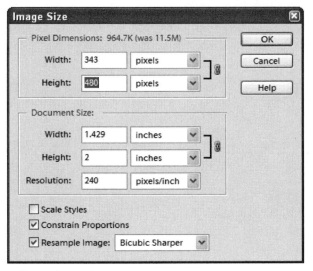

5.6

TIP

When increasing the size of a photographic image, you should use the Bicubic Smoother interpolation algorithm found in the Image Size dialog box. When decreasing image size, you should use Bicubic Sharper. Whenever you choose a tool that automatically resizes an image, such as the Crop tool, the interpolation method that will be used is Bicubic—not necessarily the best choice—but, the only choice.

SHARPENING DIGITAL PHOTOS

6.1 (CP 6.1)

6.2 (CP 6.2)

ABOUT THE IMAGE

"Toad on a Log," Canon EOS 1D Mark II,180mm Macro f/3.5, f/16 @ ⅙ sec, ISO 400, 16-bit RAW format, 3,504 x 2,336 pixels, edited and converted to an 8-bit, 2,324 x 1,664 pixel 11.1 MB .tif

Nearly all digital photos need to be sharpened. The amount of sharpening that needs to be applied depends on many factors. Image size, sharpness of the lens, image contrast, ISO setting, the photographer's artistic intent, and the target output are just a few of the more important factors to consider. In Technique 3, you learned the importance of performing various steps in your workflow in the correct order. In this technique, you start with the image shown in **Figure 6.1** (**CP 6.1**), which has already been edited, sized, and converted to an 8-bit image and is now ready to be sharpened. After sharpening, the image will look decidedly better, as shown in **Figure 6.2** (**CP 6.2**).

STEP 1: OPEN FILE

■ Choose **File ➢ Open** (**Ctrl+O/Command+O**) to display the Open dialog box. Double-click the **\ch01\06** folder to open it and then click the **frog-before.tif** file to select it. Click **Open** to open the file.

STEP 2: EXAMINE IMAGE AND DETERMINE SHARPENING STRATEGY

I highly recommend that you always take time before beginning any editing process to examine the image and carefully determine a strategy. It is easy to get caught up in an editing routine and do the same thing to every image when every image is unique. Taking a customized approach to each photo can often yield better images.

■ Because high ISO settings can more often than not produce digital noise that can get very ugly when sharpened, it is always wise to check the ISO setting, the shutter speed (long shutter speeds result in more digital noise), and the camera model. Some digital cameras produce lots of digital noise at any setting, while others produce very little. To determine the camera model, ISO setting, and shutter speed, select **File ➢ File Info** (**Alt+Ctrl+I/Option+Command+I**) and then click **Camera Data 1** to get the dialog box shown in **Figure 6.3**. From this dialog box you can learn that the photo was taken with a Canon EOS 1D Mark II that is known for its low level of digital noise at most ISO settings. The 400 ISO setting makes some digital noise, so you should look carefully at the image to determine the extent of the digital noise. The dialog box also shows that the shutter speed was set at ⅙ of a second because

the photographer appeared to be shooting to get a maximum depth-of-field as f/16.0 was used. Click **OK** to close the dialog box.

■ Let's now look more carefully at the image. Select **View ➢ Actual Pixels** (**Ctrl+0/Command+0**) to zoom in at **100%**. Press the **Spacebar** to get a temporary **Hand** tool (**H**) and click and drag on the image to look at the frog and at the background. Notice that while most of the frog is in focus, the texture looks soft as you would expect from a digital photo. A little sharpening will dramatically improve the texture. When looking at the soft out-of-focus background at 100 percent, you can see a slight amount of digital noise. **Figure 6.4** shows a detail image of that noise. What you don't want to do is sharpen the noise and make it more pronounced because great effort was taken to shoot the photo to get a nice, soft, blurred background.

6.3

■ With that knowledge you can now determine that your sharpening strategy should be to sharpen just the frog and the part of the log that he is sitting on that is in focus.

STEP 3: SELECT AREAS TO SHARPEN

The areas that you want to sharpen could be selected with the **Lasso** tool or the **Selection Brush** tool. Because the frog is only partially in focus, as is the case with the log due to the shallow depth-of-field, the **Selection Brush** tool will result in a better selection. If you choose the right-sized, soft edged brush, you can select an area that feathers off as the focus drops off.

■ Click the **Selection Brush** tool (**A**) in the **Toolbox**.
■ Click in the **Brush Presets** box in the Options bar and select **Airbrush Soft Round 200** by clicking it in the **Brush Presets** palette shown in

Figure 6.5. Click the **Mode** box and choose **Mask** so that you can see where you have painted. Leave **Hardness** set to **0%** and **Overlay Opacity** to **50%**.

> **TIP**
>
> Some digital cameras have user-selectable settings for sharpening images. If you shoot using RAW images, the settings for sharpening images will not be applied. If you shoot using JPEG the sharpening will be applied before the file is saved. When you learn how to sharpen an image, as shown in Technique 6, you will be able to produce a much better image than if the image were sharpened in the camera. Therefore, it is generally not wise to use any in-camera sharpening. If you attempt to sharpen an image with an image editor that has already been sharpened in a camera, you will get sharpened sharpening effects, which are usually not acceptable.

6.4

6.5

The Options bar should look like the one shown in **Figure 6.6**.

■ You can now paint the frog taking care not to paint outside of the frog because you don't want to select any of the nicely blurred background. The soft edge of the selection brush will create a feathered selection that will make the sharpening that you do in the next step fade off as the image gets soft due to the depth-of-field. When you have painted around the edges of the frog, you can fill in the center. Also, paint a horizontal area across the log where the image is in focus. When the painting is complete, the selection should look similar to the one shown in **Figure 6.7**.

6.6

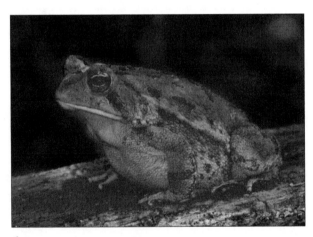

6.7

STEP 4: APPLY SHARPENING

■ You are now ready to apply the sharpening. To make it easier to choose the best sharpening settings, you should first zoom in to 100 percent and turn the red mask into a selection marquee. Select **View ➤ Actual Pixels** (**Alt+Ctrl+0/Option+Command+0**) to zoom to **100%**. Click in the **Mode** box in the Options bar and choose **Selection** to remove the red mask. Select **Select ➤ Inverse** (**Shift+Ctrl+I/Shift+Command+I**) to invert the selection as the mask was protecting the area that you want to sharpen.

■ Click the **Hand** tool (**H**) in the **Toolbox**. Click in the image and drag the cursor so that you can see the eye of the frog and as much of the texture on the side of the frog as possible.

■ Select **Filter ➤ Sharpen ➤ Unsharp Mask** to get the **Unsharp Mask** dialog box shown in **Figure 6.8**.

The **Unsharp Mask** has the following three settings:

Amount: This control determines how much the contrast increases in percentage terms ranging from 0 percent to 500 percent. This setting might also be considered as the intensity or effect strength setting.

Radius: Measured in pixels, Radius determines how wide the "sharpening effect" is. You can choose a setting between 0 pixels and 250 pixels and even in parts of a pixel, which is important when you are using values under 5 pixels, which you do most of the time.

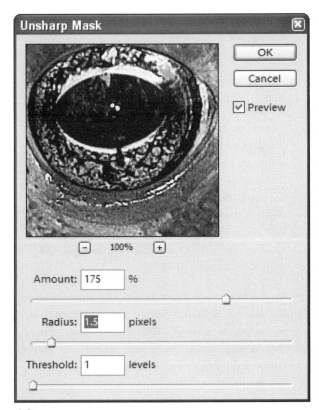

6.8

Threshold setting, you can usually prevent digital noise or important image texture from being sharpened.

The Unsharp Mask is actually creating a halo effect around the edges. It creates a lighter shade on one side of what it thinks is an edge, and a darker shade on the other side, thereby creating the illusion of a sharp edge. Amount determines how bright the halo is, Radius determines how wide the halo is, and Threshold is the minimum shade difference required before a halo is created.

A good approach for getting optimal settings when working with high-resolution images is to set **Amount** to **175%**, **Radius** to **2**, and **Threshold** to **0**. Most high-resolution images require an **Amount** setting in the range of 150 percent to 200 percent. Generally, **Radius** values are less than 2.0 and each tenth of a pixel can be significant. Setting **Threshold** to 0 means that every edge gets sharpened and, for now, that is okay as it is the easiest setting to adjust after the other two settings are determined. The tricky part is determining the right combination of **Amount** and **Radius**.

- Set **Amount** to **175%**, **Radius** to **2**, and **Threshold** to **0**.
- Depending on the image, it may be better to define the edges with a narrower but brighter halo. Other images may look better with a wider but less bright halo. See what you think looks best for this one by sliding the **Amount** from **100%** to **200%** and lower **Radius** to around **1.5** to **1.8**.

Threshold: This control lets you set the starting point for when sharpening occurs. You can choose from 0 to 255 levels of difference between two touching shades. When Threshold is set to 0, everything gets sharpened. When Threshold is set to 255, nothing gets sharpened. Using the optimal

These settings can dramatically alter how realistic the texture on the frog looks. Sadly, in spite of how good you think the sharpening effect looks, the best way to determine the success of your settings if you are going to be making a print — is to make a print. When you get used to the settings that make good prints, you will be able to more accurately judge the settings you see on a computer screen.

■ As you change settings, click the **Preview** box in the **Unsharp Mask** dialog box to view the image with and without the sharpening effect. Also, click inside the **Preview** box to get the **Hand** tool. Click and drag the image around to view areas where you want to make sure the settings work.

■ As soon as you have a good combination of settings for **Amount** and **Radius**, look around the image for an area where there is other fine texture. You can now slowly slide the **Threshold** slider toward the right until you remove the unwanted sharpening effect on the smoother areas.

■ For this image, I set **Amount** to **175%**, **Radius** to **1.5**, and **Threshold** to **1**. A quick print confirmed that these were pretty good settings.

■ Click **OK** to apply the settings. Your image should now look like the one shown in **Figure 6.2**.

NOTE

The best way to get sharp images is to use a high-quality, high-resolution digital camera with a sharp lens — you still usually need to sharpen the image digitally. Although it would be nice, I am sad to report that there is no way to sharpen an out-of-focus digital photo. In fact, when using the sharpening technique you learned here, you'll quickly realize that you are not really sharpening an image. Instead, you are creating the illusion that the image is sharp by digitally emphasizing "edges" in the image by making one side of an edge lighter and the other side darker.

As you learned in Technique 6, the effect that is used to make an image appear sharp is resolution-dependent. This means that you should not apply sharpening effects to an image until you know what your final output will be. A sharpened, high-resolution image won't have the optimal amount of sharpening if it is down-sized to be used as a low-resolution image on a Web page or vice versa. Therefore, sharpening ought to be one of the last steps in your workflow. One other reason to make sharpening as one of the last steps (if not the last step) in your workflow is that the "sharpening effect" will likely be removed or damaged if you first sharpen your image and then use a variety of other commands and filters. Read Technique 3 to learn more about image-editing workflow.

PROCESS A BATCH OF FILES

7.1 7.2

ABOUT THE IMAGE

"Iris From the Twins' Garden" Canon EOS D60, 300mm f/2.8 IS, variety of exposure settings, ISO 100, 16-bit RAW format, sized, cropped, edited, converted to .jpg

The tedium of renaming image files, sizing, editing, and saving digital photos in large quantities can be horrific. In fact, I know many photographers that take countless wonderful photographs that they would like to share — but, they don't share them because of the tedium involved in processing them so that they can be shared in a slide show, e-mailed, or uploaded to an online photo- or print-sharing service. In this technique you learn how you can batch process all your photos easily and quickly. After you learn about Adobe Photoshop Elements 3.0's Process Multiple Files feature — you will have no reason *not* to enjoy and share all of your best digital photographs. Batch processing the photos shown in **Figure 7.1** to get the photos shown in **Figure 7.2** is a one-minute affair! Batch-processing a folder of a hundred images won't take you that much longer although it will be a bit more work for your computer.

STEP 1: SELECT IMAGES YOU WANT TO BATCH EDIT

Before you can batch-process a collection of photographs, you must first choose the photos and make them available to Adobe Photoshop Elements 3.0's Process Multiple File feature. There are several ways you can do this. You can create a new folder for the selected images and place them (or a copy of them) in the folder, you can open them in Adobe Photoshop Elements 3.0's Editor, you can select them in File Browser, or you can even scan them in from a scanner. For this technique, assume that the goal is to process the batch of eight iris photos that are found in the **\ch01\07** folder.

Also assume the goal is to create eight photos that are sized so that the height is 400 pixels and that the images are to be renamed and saved as JPEG Medium Quality image files. Image like these can be used on Web pages and placed in e-mails, or shared via online photo-sharing sites.

STEP 2: PROCESS MULTIPLE IMAGES

■ Select **File ➤ Process Multiple Files** to get the Process Multiple Files dialog box shown in **Figure 7.3**.

■ Click in the **Process Files From** box and choose **Folder**. Note that you have other options such as Import, Open Files, and File Browser.

■ Click on the Source **Browse** and choose the **\ch01\07** folder in the Browse for Folder dialog box. Click **OK** to choose the folder.

■ You now need to choose a destination folder to store the processed image files. Click Destination **Browse** and select the folder you want to use to store the images. If you want to create a new folder, click **Make New Folder** in the Browse for Folder dialog box and create a new folder. Click **OK** to choose the folder.

■ If you have reason to rename the image files from the cryptic filenames assigned by your digital camera to a more understandable name, you can easily do so by clicking in the box next to **Rename Files** in the **File Naming** area. To name these files *Iris* followed by a two-digit number, click in the first box and type **Iris**. Click in the second box and choose **2 Digit Serial Number**. Type **1** in the **Starting Serial #** box to start numbering the images at 1. This wonderful file-renaming feature can be very handy when all you want to do is renumber image files. You have lots of renaming options, including sequential numbers, original document names plus a serial number, serial letters, dates, and more.

■ The next area of the dialog box enables you to resize images. Click in the **Resize Images** box to turn the feature on. Type **400** in the **Height** box and make sure **pixels** is chosen. Click in the **Resolution** box and choose **72 dpi** for screen resolution. Make sure there is a check mark in the **Constrain Proportions** box.

■ Click in the box next to **Convert Files to** to place a check mark. Click in the box and choose **JPEG Medium Quality** as this is a good setting for creating images to be attached to e-mail, or for use on a Web page.

■ As the goal of this technique is to create images that can be shared electronically, it is wise to add a watermark to identify them as your images. Click

in the box beneath the **Labels** tab and choose **Watermark**. Type your name and a copyright date in the **Custom Text** box. To make the (c) symbol, press and hold **Alt** and type **0169** on a PC. On a Mac, type **Option+G**. Click in the **Position** box and choose **Bottom Left**.

■ Click in the **Font** box and choose **Arial**. Click in the **font size** box and choose **12**. Click in the **Opacity** box and choose **100**. Click in the **Color** box and choose white from the **Color Picker** by clicking in the color box and dragging the cursor to the upper-leftmost corner; click **OK**.

■ At this point you are set to batch-rename the files, resize them, add a watermark, and save them as a .jpg image. If you want, you can also turn on the Quick Fix features that include Auto Levels, Auto Contrast, Auto Color, and Sharpen. To learn

more about these features, read Technique 9. For this technique click in the box next to **Sharpen** to turn on the sharpen feature only.

■ Click **OK** to begin processing the eight images. Once the processing is complete, you can view all of the files in the folder you choose earlier in this step. Your photos should now look like the ones shown in **Figure 7.2**.

If you have completed each of the seven techniques in this chapter, you are well on your way to having a solid understanding of the essential fundamentals of digital photo editing. In the next chapter, you will learn eight basic image correction techniques to help you to dramatically improve your digital photographs.

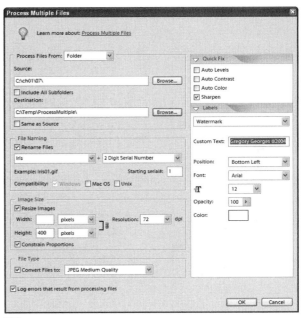

7.3

CHAPTER 2

BASIC IMAGE CORRECTION

I f you want to be an expert digital photo editor, you need to be a master of the basic image correction techniques that are found in this chapter. Technique 8 offers excellent tips and techniques for sizing, leveling, and removing unwanted spots and specks. You learn how to use Quick Fix to quickly edit images in Technique 9. Technique 10 shows you how to add density to an image and adjust contrast. You learn more about making contrast and tonal range adjustments with Levels in Technique 11. Technique 12 provides you with the steps you need to correct color. Changing targeted colors is the topic of Technique 13. Performing fully editable dodging and burning is the topic of Technique 14. Technique 15 shows you how you can edit in a nondestructive manner, which means you can go back and make changes to earlier settings.

SIZING, LEVELING, CROPPING, AND MUCH MORE

8.1 (CP 8.1)

8.2 (CP 8.2)

ABOUT THE IMAGE

"Golden-Tipped Dragonfly," Canon EOS 1D Mark II, 300mm f/2.8 IS with two 25mm extension tubes, f/11 @ ¹/₅₀ sec, ISO 100, 16-bit RAW format, 3,504 x 2,336 pixels, edited, converted, cropped to 1,920 x 1,356 8-bit 240Kb .jpg

As you learned in Technique 3 there are many steps you must take when editing an image and this process is called "workflow." In this technique, you learn about some of the first steps you need to take when editing an image. You learn how to straighten and crop an image, eliminate unwanted spots and specks, and remove unwanted elements.

Once again, I strongly recommend that you complete this technique as you must perform most of these steps on each image that you edit and you will learn several good tips that will be useful on just about all photos you edit. The goal is to take the photo in **Figure 8.1** (**CP 8.1**) and make it look like the one in **Figure 8.2** (**CP 8.2**), which has been cropped, rotated, and sized to make a 5" x 7" print.

STEP 1: OPEN FILE

■ Select **File** ➢ **Open** (**Ctrl+O/Command+O**) to display the Open dialog box. Double-click the **\ch02\08** folder to open it and then click the **dragonfly-before.jpg** file; click **Open**.

STEP 2: STRAIGHTEN THE IMAGE

There are all kinds of reasons why you may want to straighten an image. If you shoot a seascape and your camera is not level, the ocean will appear to drain toward the lower part of the image. Likewise, if you take a photo of a building and the walls are not straight — you've got some straightening to do. Even though the dragonfly is nicely composed, straighten the image so that the wings are horizontal on the page to create a nice specimen photo.

■ Before you begin straightening the image, you need to first turn on the grid so that you can have some guidelines. Select **View** ➢ **Grid**. If the grid is hard to view or use, you can change the settings that determine how the grid is displayed by selecting **Edit**➢**Preferences**➢**Grid**. The Grid dialog box allows you to choose the color of the grid lines, the number of gridlines per inch, and the number of subdivisions.
■ Select **View** ➢ **Fit on Screen** (**Ctrl+0/Command+0**); then, select **View** ➢ **Zoom Out** (**Ctrl+-/Command+-**) to make the image small enough to give you a full view of the image when you begin rotating it.
■ Select **Select** ➢ **All** (**Ctrl+A/Command+A**).
■ Select **Image** ➢ **Rotate** ➢ **Free Rotate Selection**. You should now see a selection marquee with eight handles. As you move the cursor just outside one of the corner handles, the cursor changes to a two-headed curved arrow. Click and drag the cursor to rotate the image until the top of the golden tipped wings are lined up on the same line as is shown in **Figure 8.3**. Press **Enter/Return** to commit the rotation.

8.3

■ Select **View** ➢ **Grid** to turn the grid off as it is no longer needed.

STEP 3: CROP THE IMAGE

Depending on what you intend to do with your image you may want to crop early in your workflow. If, however, you don't know what the final proportions of the image should be, you should crop after you have completed all the editing and you know how the image will be used. Because this image is now rotated leaving part of the image colored in the Background Color, crop it to be a 5" x 7" image now.

■ Click the **Crop** tool (**C**) in the **Toolbox**. In the Options bar click **Preset Options** and choose **Crop Tool 7 in x 5 in**. Notice that the settings you selected from the presets have been placed in the boxes in the Options bar shown in **Figure 8.4**.
■ If you assume that you want to print on a printer that has an optimal dpi of 240, you would want to type **240** in the **Resolution** box. If there is any value in the **Resolution** box, committing a crop forces the image to be sized during the crop to meet the **Resolution** setting. My preference is to clear any value in **Resolution**, make the crop, and then use **Image Size** to change resolution as needed. You can also specify the interpolation

8.4

method within the Image Size dialog box. So, for now, clear any value that is in the **Resolution** box.

■ Using the **Crop** tool, click in the upper-left corner of the image and drag the selection marquee down toward the right until the part of the image you want selected is shown. **Figure 8.5** shows a crop selection. If you want to enlarge or reduce the crop, click one of the corner handles and drag the selection marquee until it is the size you want. If you want to reposition the crop, click inside the selection marquee and drag the entire selection to where you want it. You can also tap the arrow keys to move the selection marquee up and down, or right or left, 1 pixel at a time. Press **Enter/Return** to commit the crop.

STEP 4: SIZE IMAGE

■ Select **Image ➤ Resize ➤ Image Size** to display the Image Size dialog box. You have cropped the image so that it has fewer pixels than the needed

240 dpi; hence, you have to upsample the image. Make sure that **Constrain Proportions** and **Resample Image** are both checked. Click in the box next to **Resample Image** and choose **Bicubic Smoother**. To learn more about changing image size, read Technique 5.

■ Type **240** in the **Resolution** box. Notice that **Width** and **Height** have changed to approximately **1680** and **1200** respectively depending on how you cropped the image. The Image Size dialog box should now look similar to the one shown in **Figure 8.6**.

■ Click **OK** to apply the settings.

STEP 5: ELIMINATE UNWANTED SPOTS AND SPECKS

If you have scanned film using a film scanner, you likely have experienced the nasty chore of having to digitally remove all of the marks caused by dust and

8.5

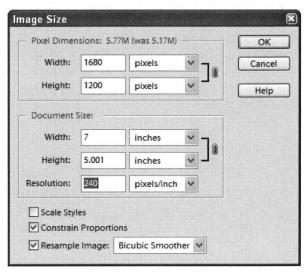

8.6

other unwanted particles on the film when it was scanned. You will find that digital SLRs are particularly noted for their ability to get spots on the sensors as the lenses are removable and unwanted particles often get on the sensor when changing lenses. This "stuff" on the image sensor will create unwanted spots and specks that need to be removed, too. The dragonfly photo used in this technique has lots of those spots.

- To make it easier to see and remove all the spots and specks caused by material on the image sensor, select **View ➢ Actual Pixels** (**Alt+Ctrl+0/ Option+Command+0**) to zoom in at **100%**. Press the **Spacebar** to display a temporary **Hand** tool (**H**) and click and drag the image so that you can see the upper-left corner.
- Click the **Healing Brush** tool (**J**) in the **Toolbox**. Click in the size box and drag the cursor to select a brush size of about **30 px**. Set **Mode** to **Normal** and make sure **Source** is set to **Sampled**. The Options bar should now look like the one shown in **Figure 8.7**.
- Press the **Spacebar** to display the temporary **Hand** tool (**H**) and drag the image so that you can see its upper-left corner.
- Press and hold the **Alt/Command** key and click near a spot you want to remove to set the source. Now click the spot to remove it. When you have all the spots removed in the part of the image that you can see, press the **Spacebar** to display the **Hand** tool (**H**) and drag the image to a new area.

Make sure that you readjust your source point each time because the background and image colors vary throughout the photo. Keep clicking until you have removed all the unwanted spots and specks from the entire image. Alternatively, you can use the Spot Healing Brush tool.

STEP 6: REMOVE UNWANTED ELEMENTS

When you have Adobe Photoshop Elements 3.0, you've got amazing powers—amazing powers that let you put in and take out elements in your images. In this step, you use two of the more capable tools for removing unwanted elements in order to get rid of (or minimize) the soft shadow behind the branch and to remove the distracting spider web that can be seen in **Figure 8.8**.

- You can use either the **Healing Brush** tool or the **Clone Stamp** tool to remove the spider web. The **Clone Stamp** tool clones from one area to another area. The Healing Brush attempts to match the selected area with the surrounding area. Because you have already set up the Healing Brush tool, use it for the spider web and then use the **Clone Stamp** tool for the shadow.
- To make it easier to see the spider, select **View ➢ Actual Pixels** (**Alt+Ctrl+0/ Option+Command+0**) to zoom in at **100%**. Press the **Spacebar** to display the temporary **Hand** tool (**H**) and click and drag the image so that you can see as much of the spider web as possible.

8.7

■ Using the **Healing Brush** tool, hold down **Alt** and click near the spider web to set the source image and then continue clicking on the spider web until it is completely gone. It is much better to make multiple clicks than it is to click and drag as the new pixels will blend better. Also, you need to keep changing the source so that the source image matches the replaced area as much as possible.

■ Now, click the **Clone Stamp** tool (**S**). The strategy for the shadow behind the branch is to diminish, but not remove it. This approach results in a more realistic image without the distraction that the more pronounced shadow causes.

■ Click in the **Size** box and drag the slider to about **120 px** so that the brush size is large enough to cover the entire width of the shadow. You can also type **120 px** in the box to select a **120 px** brush. Set **Mode** to **Normal** and **Opacity** to about **50%**, and uncheck **Aligned**. The low **Opacity** setting helps to minimize but not eliminate the shadow as you will see. The Options bar should now look like the one shown in **Figure 8.9**.

■ Press **Alt/Option** and click near a part of the shadow you want to minimize to set the source. To minimize the shadow, keep clicking it. When you have diminished all of the shadows in the part of the image that you can see, press the **Spacebar** to display the **Hand** tool (**H**) and drag the image to a new area if you cannot see all of the shadow area. Keep clicking until you have diminished all of the unwanted shadows. When you are finished, your image should look similar to the one shown in **Figure 8.2** (**CP 8.2**). This image makes a nice 7" x 5" print with no spots or distracting shadows.

The tips you learned in this technique for removing specks and spots and unwanted elements can be used with great results on many photos. Besides removing distracting elements such as wires, telephone poles, and cars, you can also remove people that you no longer want to be in the picture! The more you learn about the Healing Brush tool, the Spot Healing Brush tool, and the Clone Stamp tool, the less you have to put up with unwanted "stuff" in your photos.

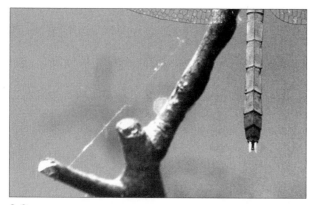

8.8

8.9

FIXING IMPROPERLY EXPOSED IMAGES WITH QUICK FIX

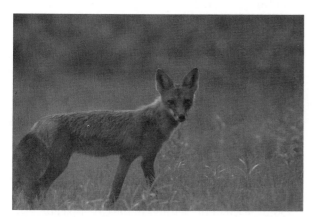

9.1 (CP 9.1)

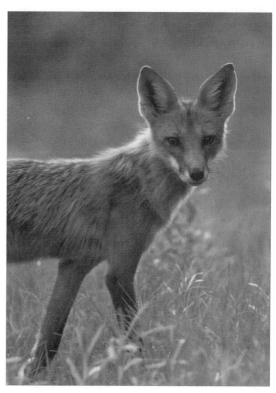

9.2 (CP 9.2)

ABOUT THE IMAGE

"R. Fox in Maine," Canon EOS D60, 300mm f/2.8 IS, f/4.0 @ $\frac{1}{60}$ sec, ISO 200, JPEG format, 3,072 x 2,048 pixels, 2MB .jpg

No matter how good a photographer you are or how much money you have spent on digital photography equipment, you are certain to have photos that you highly value that were improperly exposed. The photo of the red fox in **Figure 9.1** (**CP 9.1**) is a good example of such a photo. Not only is it underexposed, but it is also slightly out-of-focus. However, it was one of those rare moments where a red fox was within camera range. My daughter was sitting on the side of the car where the fox could be seen and she quickly snapped two photos hand-holding a heavy 300mm f/2.8 lens before the fox ran off into the woods. Along with many moose, this was one of our favorite animal sightings on a four-day trip to Maine. **Figure 9.2** (**CP 9.2**) shows that it is possible to apply the magic of Adobe Photoshop Elements 3.0 and make a nice 5" x 7" photo. In this technique, you learn how that image was edited.

STEP 1: OPEN FILE

Unfortunately, the photo of the fox was taken using the JPEG file format because of a lack of quality RAW file converters at the time this photo was taken. Therefore, this is an 8-bit image and it will require considerable care to avoid getting banding caused by severe tonal and color changes.

■ Select **File ➢ Open** (**Ctrl+O/Command+O**) to display the Open dialog box. Double-click the **\ch02\09** folder to open it and then click the **rfox-before.jpg** file; click **Open**.

■ If the Histogram palette is not already visible, select **Window ➢ Histogram** so that you can monitor the state of the histogram while making changes to the settings in various dialog boxes.

STEP 2: CROP IMAGE

■ To crop the image, click the **Crop** tool (**C**) in the **Toolbox**. In the Options bar, set **Width** to **5 in** and **Height** to **7 in**, and remove any value in **Resolution**. Click in the image and drag the selection marquee to crop an image like the one shown in **Figure 9.2**. A quick look at the Image Size dialog box confirms that you have enough pixels remaining to make a good 5" x 7" photo at 240 dpi.

STEP 3: TRY QUICK FIX

I'm not usually a big fan of most "auto" fix tools. However, each year, the ones that are added to Adobe products such as Adobe Photoshop Elements 3.0 do an increasingly remarkable job. You never know how well an auto feature will work until you try it on a specific image. To introduce you to the new Quick Fix feature, test it on this image. I've been quite surprised at the results I have gotten with this new feature.

■ Select **View ➢ Fit on Screen** (**Ctrl+0/Command+0**).

■ Click the **Quick Fix** icon near the upper-right corner of the Editor. This Editor screen should now look like the one shown in **Figure 9.3**. If you don't see a before and after image, click in the **View** box below the preview window and select **Before and After** (**Portrait**).

■ The Smart Fix Auto button in the General Fixes box attempts to fix everything at once. Click **Auto** to try it out. A nice try maybe, but click the **Reset** button above the **After** image preview to return to the original image because you have to do better than that.

■ Click the **Auto** buttons following both **Levels** and **Contrast**. Click and drag the **Lighten Shadows** slider toward the right about one-half of the way between the far left and the first mark on the scale (about ⅛ of the entire scale) to lighten the shadows. That setting made a substantial improvement in the image.

■ Click the **Auto** button in the Color palette. I don't like the color changes that were applied. Now adjust each of the settings in the Color palette. Because there are no numbers on the sliders, you'll have to match the settings I used by looking at them in **Figure 9.4**. I really like the way the image turned out. Nice, rich, accurate colors and the fox is well contrasted against the green background!

9.3

- Apply the settings by clicking the **Standard Edit** icon near the upper right of the **Elements Editor** application window.
- Click once on the **Uncached Refresh** button near the right side of the **Histogram** palette to update the histogram. The histogram as shown in **Figure 9.5** is in pretty good shape. That means that you have not edited so much that you have caused banding in the image.

STEP 4: MAKE FINAL IMAGE ADJUSTMENTS

After editing thousands of images, I've learned that even though I like an image just as it is, I can often improve it by making small changes to the image using various tools and comparing before and after results. I do like this image as it is, but I want to see how it looks with slight changes in contrast and color.

- Select **Enhance ➢ Adjust Lighting ➢ Levels** (**Ctrl+L/Command+L**) to display the Levels dialog box. Click the **Highlight** slider below the

9.4 9.5

histogram and move it slowly toward the left to about **247**. While you are moving the slider, watch the Histogram palette to see how the changes affect the histogram. You don't want to make edits that cause gaps to appear in the histogram because you will end up seeing single tone areas where you expected to see a smooth tonal range.

■ Move the **Midtone** slider toward the right to about **0.98**. Even this small numerical change creates a nice improvement in the contrast of the fox. The Levels dialog box should now look like the one shown in **Figure 9.6**. Click **OK**.

■ Click once more on the **Uncached Refresh** button near the right side of the Histogram palette to update the histogram. You are now beginning to see a few gaps in the histogram. If you had made larger numerical changes with the Levels tool, the histogram would have more gaps and you would be close to possibly noticing some banding when the image was printed.

■ See if you can improve the color now as the color looks good, but it does not have the warm glow that existed when the shot was taken in the late evening. Instead of choosing **Hue/Saturation**,

see if you can use the white part of the fur on the fox's face to get the desired glow. Select **View ➢ Actual Pixels** (**Atl+Ctrl+0/Option+ Command+0**). Press the **Spacebar** to display a temporary **Hand** tool. Click in the image and drag it until you see the fox's face.

■ Select **Enhance ➢ Adjust Color ➢ Remove Color Cast** to display the Remove Color Cast dialog box. Notice that the cursor has changed to an eye dropper. Click once on the whitest fur you can find on the fox. I like the color change. Click **OK** to apply the settings.

■ In spite of my fondness for the rich colors that I used to get when shooting with Fuji's wonderful Velvia slide film, I think that this image is a bit on the rich color side. Tone down the green and yellow a small amount. Select **Enhance ➢ Adjust Color ➢ Adjust Hue/Saturation** (**Ctrl+U/Command+U**) to display the Hue/Saturation dialog box. Click in the **Edit** box and choose **Yellows** (**Ctrl+2/ Command+2**). Drag the **Saturation** slider toward the left to about **-12**. Click in the **Edit** box and select **Greens** (**Ctrl+3/Command+3**). Click the **Saturation** slider and drag it back to about **-20** to make the image look accurate to the scene when the photo was taken. Click **OK** to apply the settings and make the image look similar to the one shown in **Figure 9.2** (**CP 9.2**).

Because of the success you have had with the Quick Fix feature, I'll end this technique here. You should, however, take a few minutes and attempt to edit this image without Quick Fix. Try using Levels, Hue/Saturation, and Shadow/Highlights. When using the Levels tool, click in the Channels box and make individual changes to the separate color channels when needed. When possible, use adjustment layers so that you are able to go back and make changes to your earlier settings.

9.6

ADDING DENSITY AND CONTRAST TO AN IMAGE

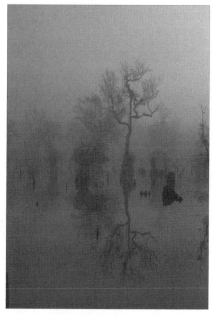

10.1 (CP 10.1)

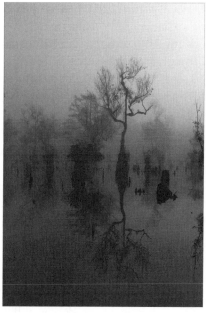

10.2 (CP 10.2)

ABOUT THE IMAGE

"Great Dismal Swamp," Canon EOS D30, 28–80mm f/2.8 @ 35mm, f/18 @ ¹/₈₀ sec, ISO 100, 16-bit RAW format, 2,160 x 1,440 pixels, 16-bit 2.7MB .CRW

One winter I went to the Great Dismal Swamp in eastern North Carolina in hopes of finding fog so that I could get a few soft-focused foggy swamp images. Just when I was convinced that I would not get the photos I wanted, I watched as this wonderful fog-like smoke rolled in and I got a series of photos like the one shown in **Figure 10.1** (**CP 10.1**). The weather gods had not granted my wish; instead, a local farmer had attempted to smoke out a black bear family from his property and had started a large forest fire.

This smoky swamp photo was chosen for this technique as it is monochromatic, which makes it easy to learn about image density and contrast without being concerned about color. **Figure 10.2** (**CP 10.2**) shows a darker more contrasty version of the original photo that was the result of a few editing steps you learn in this technique.

STEP 1: OPEN IMAGE

■ Select **File** ➢ **Open** (**Ctrl+O/Command+O**) to display the Open dialog box. Double-click the **\ch02\10** folder to open it and then click the **dismalRAW.CRW** file; click **Open** to open the image in the Camera RAW converter.

■ Uncheck any **Auto** settings, set **Settings** to **Selected Image**, and make sure that **White Balance** is set to **As Shot**. Make sure that **Depth** is set to **8 Bits/Channel** as you will be working with layers, which are not supported when working with 16-bit images. The Camera RAW Converter dialog box should now look like **Figure 10.3**.

■ Click **OK** to open the image.

STEP 2: INCREASE IMAGE DENSITY WITH A BLEND MODE

If you are wondering why the goal in this step is to increase image density or even what image density is, you are questioning the right things. Increasing image density simply makes an image darker and usually richer in color. If you attempted to darken the image and increase contrast using **Levels,** you often would be performing such severe changes to the image that you would end up turning soft, smooth gradations into bands of tones — normally an unwanted effect. Using the Multiply blend mode you are effectively multiplying the brightness values in the image by a constant value, which simply makes all the pixels darker. This approach generally does not cause as much of the unwanted posterization that may occur if Levels is used.

■ You could duplicate the **Background** and change the new layer's **Blend** mode to **Multiply**; however, adding a duplicate layer doubles the file size. A better approach is to create an adjustment layer and not choose any settings; just change the layer's **Blend** mode. Select **Layer** ➢ **New Adjustment Layer** ➢ **Levels** to display the New Layer dialog box. Click **OK** to display the Levels dialog box. Click **OK** to create a new adjustment layer without making any changes to the settings.

■ Click in the **Blend Mode** box in the **Layers** palette and choose **Multiply**. Notice that the image gets very dark. Click the **Opacity** slider in the **Layers** palette and slide it toward the left to about **40%**. The Layers palette should now look like the one shown in **Figure 10.4**. The entire image is darker.

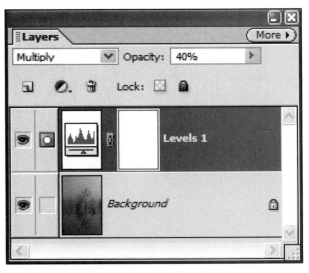

10.3

10.4

TIP

When you want to darken an image, you can do so by duplicating the image and then changing the blend mode to Multiply and setting the darkness level by using the Opacity slider in the Layers palette. If you want to lighten an image, choose the Screen blend mode and then use the Opacity slider to control how light you want the image. If you don't get an image that is as dark as you want when using the Multiply blend mode and with Opacity set to 100%, or light enough when using the Screen blend mode and Opacity set to 100%, you can copy the layer one or more times until you get the results you want. The blend modes Soft Light and Overlay will darken the dark tones and lighten the light tones thereby increasing contrast. Using blend modes in this manner is often a safer way to lighten or darken an image than using Levels, which can cause image degradation resulting in a posterized image.

STEP 3: INCREASE CONTRAST

■ To increase contrast, click in the **Blend Mode** box in the **Layers** palette and choose **Hard Light**. The Hard Light blend mode is a variation of the Multiply mode in that it changes each pixel value, but in varying amounts depending on the beginning pixel value. Brightness values are lowered if they are less than 128. They stay the same if they are 128, and they get darker if they are more than 128. A softer version of this is the Overlay blend mode.

■ As the image does not yet have sufficient contrast, click and slide the **Opacity** slider toward the right to about **75%**.

■ I like the image better now, but let's say you want the dark tones to be closer to pure black and

the light tones a little lighter as well. Select **Layer** ➤ **New Adjustment Layer** ➤ **Levels** to display the New Layer dialog box. Click **OK** to display the Levels dialog box. Click the **Shadow** slider and drag it toward the right to about **31** to pull the darker tones toward pure black. Click the **highlight** slider and drag it toward the left to about **237**. Click **OK** to apply the settings. Notice that the Layers palette now has an adjustment layer for Levels and one Levels layer that you used just to apply the Hard Light blend mode, which allows you to go back and make changes when needed (see **Figure 10.5**). For example, click the left thumbnail in the **Levels 1** layer in the **Layers** palette. You can now make further adjustments to the blend mode or to **Opacity**. Double-click the left thumbnail in the **Levels 2** layer and you display the Levels dialog box again enabling you to

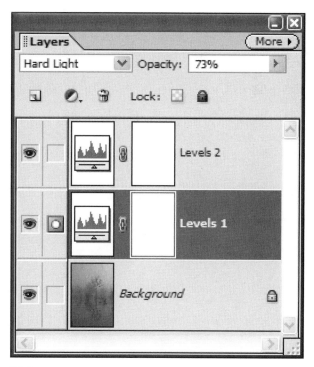

10.5

make changes to the **Levels** settings that were made earlier. Click **OK** to close the dialog box. To learn more about adjustment layers and nondestructive image editing, read Technique 15.

In spite of the rather poor histogram, which can be viewed in the Histogram palette after flattening the image, this image produces a nice print. This once again proves the point made throughout the book — the quality of any image is best determined by making a print on the target printer. Use numbers and histograms as guidelines, but let your artistic intent and a test print be the final determining factors of whether you have edited well, or not so well.

CHANGING TONAL RANGE WITH LEVELS

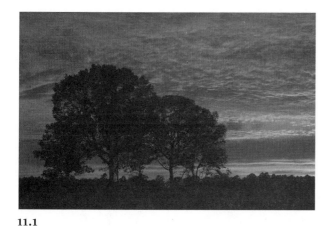

11.1

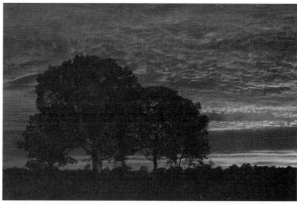

11.2

ABOUT THE IMAGE

"Carolina Sunset," Canon EOS D30, 28–70mm f/2.8 @ 47mm, f/5.6 @ ¹⁄₅₀ sec, ISO 100, 16-bit RAW format, 2,160 x 1,440 pixels, converted to an 8-bit 363Kb .jpg

Controlling tonal range is what photography is all about. Ansel Adams was so thoroughly into tonal range that he created an entire system to help him get the photos and make the prints that made him one of the most notable photographers of all time. His system was known as the Zone System and it is well worth your time learning about it if you have the inclination. Some of the better current model digital cameras have a histogram feature that allows you to view the tonal range of an image graphically. While this is a wonderful tool to use to help you capture images, you will want to learn how to further control tonal range when editing with Adobe Photoshop Elements 3.0.

The most important tool for controlling tonal range in Adobe Photoshop Elements 3.0 is the Levels tool. In this technique, you learn about artistic intent, tonal range, and how to control tonal range independently of color by using the Levels tool.

STEP 1: OPEN FILE

The vast majority of digital photographers set their digital cameras to save images in the JPEG format instead of RAW format and for that reason, you use an 8-bit .jpg image for this technique. However, I suggest that you follow the steps in this technique first using an 8-bit image; then, open up the RAW file and perform as many adjustments to it as you can using Camera RAW Converter and finish using the Elements Editor on the converted 16-bit image. This extra work will provide you with further proof of the value of shooting RAW and editing in 16-bit mode. To learn more about the differences between the two file formats read Technique 2. To learn more about converting RAW files using the Camera RAW Converter, read Technique 4.

■ Select **File ➢ Open** (**Ctrl+O/Command+O**) to display the Open dialog box. Double-click the **\ch02\11** folder to open it and then click the **sunset-before.jpg** file; click **Open**.

STEP 2: DETERMINE ARTISTIC INTENT

One of the most common mistakes I see amateur photographers make when they edit their photos is to quickly pull out various tools and apply them in the same manner to *all* of their photos. The most powerful and most often used tool is the **Levels** tool. I bet that it gets applied in the same way to 90 percent of all photographs that get edited by those that have yet to learn about artistic intent and how to let your vision of the photo determine which tools get used and how the settings are chosen.

A common approach to provide your image with more "pop" is to increase contrast using Levels. Increasing contrast is as simple as making sure that your image includes the full tonal range from pure black to pure white. However — making every photo exhibit a full tonal range is not always the way to go! So, if you *always* or nearly *always* grab the Levels tool and move the shadow and highlight sliders in toward

the toes of the histogram, stop doing that until you first decide what you want the photo to look like!

Figure 11.3 shows a photo of the Great Dismal Swamp National Refuge in eastern North Carolina. Notice that it is a wonderful photo just as it is with a narrow tonal range. The darkest tones are a long way from being pure black and the lightest tones are a long way from being pure white — and that was my intent when I drove several hundred miles to shoot in fog, but found only smoke. You can read more about a similar photo in Technique 10. With that point in mind, take a good look at **Figure 11.1**. What would you like to do with this image? My intent when shooting it was to get a nice black silhouette of the foreground against the dramatic sunset. So, see how you can use Levels to further edit with that artistic intent in mind.

STEP 3: ADJUST TONAL RANGE

■ While you could just apply the Levels command directly to the image, you have several reasons in this technique to use the more flexible approach of applying **Levels** with an adjustment layer. Select **Layer ➢ New Adjustment Layer ➢ Levels** to display the New Layer dialog box. Type **Global Tone** in the **Name** box and click **OK** to display the Levels dialog box.

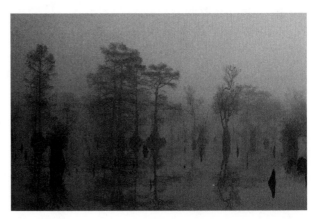

11.3

■ Click the **Shadow** slider (the black triangle found near the bottom left of the histogram) and drag it toward the right to about **7**. This forces all pixels in the image that were 7 or less to become pure black or **0**. This makes a very nice black silhouette. Now click the **Highlight** slider (the white triangle found near the bottom right of the histogram) and drag it toward the left to the right edge of the first group of pixels in the histogram at about **210**. This forces all the pixels that were higher than 210 to pure white. You can also darken the midtones of the image by sliding the **Midtone** slider (the gray triangle found just below the middle of the histogram) toward the right to about **0.84** as shown in **Figure 11.4**. When adjusting Levels with the Midtone slider, you are adjusting the brightness of the middle tones without affecting the shadow and highlight values.

■ Click **OK** to apply the settings and create a new adjustment layer.

STEP 4: REMOVE CHANGES MADE TO COLOR SATURATION

At this point you have achieved your initial objective, which was to increase contrast by spreading the tonal range to include pure black and pure white. However,

as you can see in the image, you have also increased the saturation of the colors because when working in RGB mode, an increase in tonal range usually affects color also. So, how do you adjust contrast using Levels without changing color saturation? I got the answer to that nagging question from the wonderful photographer and expert printer Charles Cramer. You can learn more about him and his work on his Web site at `www.charlescramer.com` or you can view his work at `www.anseladams.com`. In particular I suggest you look at his black-and-white photographs at `www.charlescramer.com/pages/bwgalleryindex.html`. Here you can see how well he controls tonal range and how it is not always the right thing to have as much contrast as you can get using Levels or other tools.

So, with that background, take a look at Charles' tip on splitting the control of tonal range from color.

■ Limiting the Levels setting you made in the earlier step to adjust tonality and not color is as easy as just changing the blend mode of that layer to **Luminosity**. Click in the **Blend Mode** box and select **Luminosity**. You can now see that the image has the same change in tone, but the increased saturation is now gone.

■ While the contrast in the image looks more like I wanted it to look when I took the photo, I do want to be able to adjust the color saturation as well to reflect the brilliant and rich blues and oranges that were in the sky. To control color separately from tonality, select **Layer ➢ New Adjustment Layer ➢ Hue/Saturation** to display the New Layer dialog box; click **OK** to display the Hue/Saturation dialog box.

■ You can now make very precise adjustments to color and saturation. You can either change **Hue**, **Saturation**, and **Lightness** to all colors at once by selecting **Master** in the **Edit** box, or you can click in the **Edit** box and make the same changes to one or more of the **Reds**, **Yellows**, **Greens**, **Cyans**, **Blues**, or **Magentas**. In an attempt to mirror the

11.4

11.5

11.6

colors I saw when taking this photo, I chose to make changes only to the **Master** channel by setting **Hue** to +7 and **Saturation** to +33, as you can see in **Figure 11.5**. This is the more obvious dramatic approach to editing this photograph. Obvious or not, I'm happy with it because it has rich sky colors like the original scene. To limit these changes to color and not have them affect luminosity, click in the **Blend** mode box in the Layer palette and select **Color**.

■ Once again I'd like to point out the value of having made these simple changes to the image by using adjustment layers. By double-clicking the **Global Tone** layer in the **Layers** palette I can change my earlier tonality settings to "fit" better with the now more richly saturated image. In fact, I liked the effects of setting **Input Levels** to **8, 0.80**, and **231**. These settings make the photo look like it was taken a little later in time than the earlier settings. If you had applied the **Levels** settings directly instead of with an adjustment layer, any changes you made would most likely cause more damage to the photo than they would help it. **Figure 11.6** shows the final **Layers** palette and **Figure 11.2** shows the final image.

CORRECTING COLOR

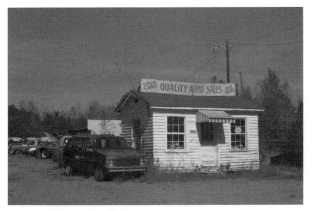

12.1 (CP 12.1)

12.2 (CP 12.2)

ABOUT THE IMAGE

"Quality Auto Sales," Canon EOS D30, 28–70mm f/2.8 @ 42mm, f/16 @ ¹/₁₂₅ sec, ISO 100, 2,160 x 1,440 pixels, converted to an 8-bit 1.4MB .jpg

Correcting color to yield accurate color is one of, if not the most, complex topics in digital photography. While it is a complex topic, it is usually quite simple to get fairly accurate color and that is what you learn in this technique. You'll be working with the photo of the Quality Auto Sales office building shown in **Figure 12.1** (**CP 12.1**). After taking a few quick color measurements to ascertain exactly what color cast the image currently has, you then try out a couple of different "quick" approaches to correcting color and choose the best one. **Figure 12.2** (**CP 12.2**) shows the image with corrected color.

STEP 1: OPEN IMAGE

■ Select **File** ➢ **Open** (**Ctrl+O/Command+O**) to display the Open dialog box. Double-click the \ch02\12 folder to open it and then click the **sales-office-before.jpg** file; click **Open**.

STEP 2: ANALYZE IMAGE

Before you attempt to correct color, you first take a few measurements to determine what color cast currently exists in the image. You then monitor those measurements to confirm that the color corrections that you make actually do correct the color.

■ One of the easiest and most scientific ways to correct color is to find neutral tones and make changes to the color so that the **R** (Red), **G** (Green), and **B** (Blue) values are equal. If an image has a color cast, it is usually most pronounced in areas that should be white. Not all images have white and in those cases you have to look for other neutral tones such as grays or even black. Even a tiny, tiny white area is all that you need to make color correction easy. When correcting colors in a portrait, you normally can use the white part of the eye if you can't fine a better white. Choosing the "best" white in an image is important. If you are not sure, you can try any whites in the image that you find, as you do in Steps 3 and 4, to see which one works better when correcting color. Take a careful look at the Quality Auto Sales office building photo and see if you can find a good white. My guess is that the building was at one time painted with a very near-white color. What do you think? Or, was it painted yellow and it faded after years of being in the hot North Carolina sun? If you look in the window on the right-side of the door, you can see a sign with NMC written on it. My bet is that this is the best white in the picture.

■ Zoom in by selecting **View** ➢ **Actual Pixels** (**Alt+Ctrl+0/Option+Command+0**). Press the **Spacebar** to display the temporary **Hand** tool (**H**) and click and drag the image so that you see the front of the building and the NMC sign in the window.

■ Click the **Eye Dropper** tool (**I**) in the **Toolbox**. Click in the **Sample Size** box in the Options bar and select **3 x 3 Average**. This helps you get a more accurate reading of the colors you sample.

■ Make sure the **Info** palette is visible by selecting **Window** ➢ **Info** if it is not visible.

■ Using the **Eye Dropper** tool, drag the cursor over the white part of the NMC sign. As you move the cursor over the white parts of the sign, you will get **R**, **G**, and **B** readings in the Info palette that will be close to **223**, **218**, and **201** as shown in **Figure 12.3**. These values indicate that there is much more red and green in the image than there is blue. If the white sign were truly white, the **R**, **G**, and **B** values would all be equal. For example, they might be **223**, **223**, and **223**. You now know that there is a decided color-cast in the image that needs to be corrected as there is about a 22-point

12.3

spread between the lowest value and the highest value. From those numbers you learn there is more red than there is green, and more green than blue.

■ Now click in the lightest area of the exterior part of the building that you thought might have been painted with a near-white color at one time. In one area I got readings of **249, 226**, and **200** indicating that this is surely not white now, as there is a 50 point difference between the red and blue values!

STEP 3: TRY QUICK COLOR CORRECTION TOOLS

Adobe Photoshop Elements offers many tools for correcting color. The automatic tools such as those found in Quick Fix, Auto Color Correction, and Remove Color Cast can often do a pretty good job and at other times they are utterly worthless. Take a look at how they are used and see how well they work on this image.

■ Select **Enhance ➢ Auto Color Correction** (**Shift+Ctrl+B/Shift+Command+B**) to correct the color. Is it correct? Does it look better to you? How can you prove your answer? I agree if you said that the image looks more correct than it did. If you take **R, G**, and **B** readings on the walls of the sales office, you will find that they are nearly equal. But this may not be good because the sign in the window appeared to be much whiter than the walls of the building, and when you take a reading at this spot, you will get **R, G**, and **B** values that are close to **230, 233**, and **246**. That is a 16-point spread between the lowest and highest values. So, you can conclude that this was not a good correction as there is now a blue cast in the image. Press **Ctrl+Z/Command+Z** to undo **Auto Color Correction**.

■ Select **Enhance ➢ Adjust Color ➢ Remove Color Cast** to display the Remove Color Cast dialog box shown in **Figure 12.4**. This is looking like a more useful tool already because it allows you to visually pick the white point. Click on the white part of the NMC sign. Click **OK** to apply the settings. Now as you might expect, the **R, G**, and **B** values on the white part of the NMC sign are very close to being equal. So, you can conclude that you have a much better color correction here than when you used Auto Color Correction. Press **Ctrl+Z/Command+Z** to undo **Remove Color Cast**.

■ Click the **Quick Fix** icon near the top-right corner of the Elements application window to display the Quick Fix dialog box shown in **Figure 12.5**.

12.4

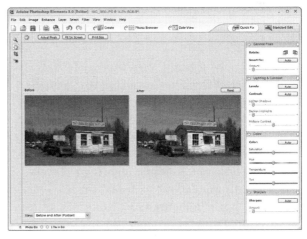

12.5

Click the **Auto** button in the **Color** part of the dialog box on the right side. Click the **Standard Edit** button near the top-right of the Elements application window to apply the changes and return to the image. Once again, you can use the **Eye Dropper** tool and the **Info** palette to determine how successful this tool was. My conclusion is that it took a very similar approach to the Auto Color Correction tool (if not exactly the same approach). However, if you look at the choice of sliders that you have in the Color part of the dialog box (see **Figure 12.5**), you can see that you have plenty of tools to fine-tune the image — the most useful ones being Temperature and Tint. This approach however requires that you have an "eye" for correcting the colors. Press **Ctrl+Z/Command+Z** to undo Quick Fix.

STEP 4: CORRECT COLOR WITH LEVELS

Depending on how picky you are about the color in your images, you may have already found a satisfactory correction. If not, here is an even more sure way of getting accurate color after you have found a neutral tone in the image. By accurate color I mean color where there is no colorcast as you might have in a photo taken in warm sunlight, or a photo taken in front of a roaring fire.

■ Zoom in by selecting **View ➢ Actual Pixels** (**Alt+Ctrl+0/Option+Command+0**). Press the **Spacebar** to display the temporary **Hand** tool (**H**) and click and drag the image so that you see the front of the building and the NMC sign in the window once again.

■ Select **Enhance ➢ Adjust Lighting ➢ Levels** (**Ctrl+L/Command+L**) to display the Levels dialog box shown in **Figure 12.6**. Double-click the **Set White Point** eye dropper (the rightmost eye dropper) to display the Color Picker palette. Using the Color Picker in this manner you can precisely determine the exact **R, G,** and **B** values for the

12.6

12.7

target color in the image. In this case, you will set the **R, G,** and **B** values to **250**, as shown in **Figure 12.7**. You use **250** because you don't want the white color in the sign to be pure white where the **R, G,** and **B** values are **255, 255,** and **255**. Pure white on a print shows no detail. Click **OK** to close the Color Picker.

■ Click in the white area of the NMC sign to force that area to have **R, G,** and **B** values of **250** and to color correct the image. If you had a neutral medium-gray toned area in the image you could do the same thing but you would double-click the **Set Gray Point** eye dropper and use **R, G,** and **B**

values of **128** to further correct the color. Click **OK** and a dialog box asks, "Save the new target colors as defaults?" Click **No** to close the dialog box and apply the **Levels** settings. The image has now been color corrected and it should look like the image shown in **Figure 12.2 (CP 12.2)**.

You have now learned four different ways you can color correct in an image if it contains any neutral tones. What if no neutral tone can be found in an image? If you have not yet taken a photo, you can insert something white or neutral-toned in the image and follow Technique 38. If there is no neutral-tone or white in the image and the photo has already been taken, you should first try the "auto" features that were just covered. If they get you pretty close to what looks like correct color, you can then use the individual channels in Levels to fine-tune the color. If the "auto" features don't work at all, then you will be forced to use Levels and correct visually by "eye."

When you shoot in RAW mode you can use the **White Balance** tool (**I**) found in the Camera RAW Converter, which works in a similar manner to the Levels' Set White Point eye dropper. You also have Temperature and Tint sliders to fine-tune your color. When working with RAW photos, it is best to do as much color correction with the Camera RAW Converter before the image is converted. Read Technique 4 to learn more about converting RAW files. With a little practice you will find that it is not that difficult to correct the colors in most of your images. Admittedly, you will occasionally take photos that are simply difficult.

12.8

CHANGING TARGETED COLORS

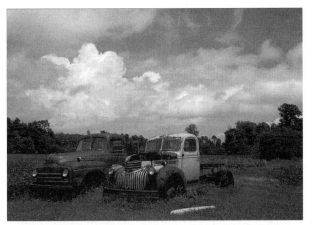

13.1 (CP 13.1)

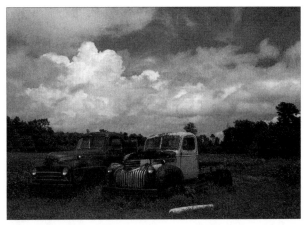

13.2 (CP 13.2)

ABOUT THE IMAGE

"Farm Trucks in a Field," Canon EOS 1D, 16-35mm f/2.8 @ 26mm with circular polarizer, f/16 @ ¹⁄₂₀₀ sec, ISO 200, 16-bit RAW format, 2,160 x 1,440 pixels, converted and edited, 8-bit 1,680 x 1,200 pixel 415Kb .jpg

Sometimes you don't want to adjust all colors. Instead, you may want to change just some of the colors. The goal of this technique is to show you how you can target specific colors and change them to be the colors you want them to be. You'll be using the photo of the two trucks shown in **Figure 13.1** (**CP 13.1**). It has a good range of colors and it lends itself to a variety of color adjusting techniques. Your goal is a simple one. You will use several of the color changing tools to transform the photo into the one shown in **Figure 13.2** (**CP 13.2**).

Before you begin experimenting, I want to point out that Technique 38 covers the topic of "accurate" color. In this technique you are less concerned with numerically accurate color than with getting color that meets your artistic requirements.

STEP 1: OPEN FILE

■ Select **File ➢ Open** (**Ctrl+O/Command+O**) to display the Open dialog box. Double-click the **\ch02\13** folder to open it and then click the **trucks-before.jpg** file; click **Open**.

A polarizing filter was used to take this photo. The filter not only increased the contrast of the clouds against the sky, but it also increased the saturation of the blue and green colors, too. The image has already been edited and cropped to make a 7" x 5" print at 240 dpi and has been sharpened for printing on an inkjet printer. These steps were taken to make it easy to experiment with color and quick to make prints should you want to do so.

STEP 2: CHANGE RED TRUCK TO A BLUE TRUCK

■ When you want to perform selective color adjustments, it is often wise to limit the area where you may want to change color. In this case, use the **Lasso** tool. Click the **Lasso** tool (**L**) in the **Toolbox**.

■ Zoom in on the red truck by selecting **View ➢ Actual Pixels** (**Alt+Ctrl+0/ Option+Command+0**). Press the **Spacebar** to display the temporary **Hand** tool (**H**). Click and drag the image so that you can see the entire red truck.

■ Click and drag a selection marquee around the red parts of the truck on the left side of the image using the **Lasso** tool (**L**), as shown in **Figure 13.3**.

■ Select **Enhance ➢ Adjust Color ➢ Replace Color** to display the Replace Color dialog box shown in **Figure 13.4**. You can either click the red part of the truck in the image or in the preview box in the **Replace Color** dialog box to select the color you want to change. Once you have selected the red color, click the **Hue** slider and drag it to about **–111**; then, click the **Saturation** slider and drag it to about **+5**. Your color settings may

vary slightly depending on the point you choose to pick the initial color. Click **OK** to apply the settings. You now have a blue truck. How much easier could it be? Click **OK** to apply the settings.

■ Now do the same thing to the other truck only go for a lavender color. Select **Select ➢ Deselect** (**Ctrl+D/Option D**) to remove the selection marquee. Using the **Lasso** tool (**L**), make a tight selection around the light yellow parts of the truck on the right side of the photo. If you want to make an even more accurate selection, you may want to alternate between the **Lasso** tool (**L**) and the **Magnetic Lasso** tool and use the **Add to Selection** or **Subtract from Selection** features that can be found in the Options bar.

■ Select **Enhance ➢ Adjust Color ➢ Replace Color** to display the Replace Color dialog box. Click on the door panel on the right side of the truck to pick the color you want to change. Click the **Hue** slider and drag it to about **–111**; then, click the **Saturation** slider and drag it to about **+6**. Click **OK** to apply the settings. You now have a lavender truck. Click OK to apply the settings. Select **Select ➢ Deselect** (**Ctrl+D/Option D**) to remove the selection marquee.

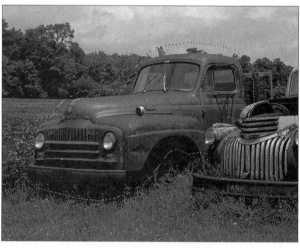

13.3

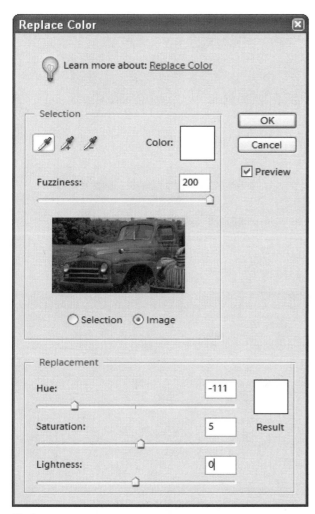

13.4

13.5

Replace Color is a wonderfully powerful tool that makes it easy to select by colors and make changes to those colors. By using the **Fuzziness** setting and experimenting with different selection points on a colored area, you can usually get excellent selections that make it easy to change colors. Want a different colored sweater? Use Replace Color. Want a slightly bluer sky? Use Replace Color. Want to make your subject's blue eyes green? Use Replace Color.

When you are experimenting with different colors you may find that you change one color to a color you later decide you don't like. An easy way to go back to that step is to use the **Undo History** palette, which is shown in **Figure 13.5**. To go back one step, simply click the state that you want to return to.

STEP 3: TRY DIFFERENT COLOR VARIATIONS

Sometimes you will want a greener image, or maybe a bluer image. Or possibly you may want to make only the highlights greener or the shadows a darker blue. In those and many other cases you will want to use **Color Variations,** as you will now see.

■ Try adding blue in the highlights of the truck image. Select **Enhance ➤ Adjust Color ➤ Color Variations** to display the Color Variations dialog box. Changing color is a three-step process. First, click next to **Highlights** to choose that setting. I prefer making small subtle changes, so I suggest dragging the **Amount** slider to the first stop to the left. There are no stop markings, but as you move the slider left and right you can see it stick to certain even distanced locations, indicating stops. Then, click the **Increase Blue** thumbnail until the **After** image in the Color Variations dialog box is as blue as you want it. I clicked it three times. **Figure 13.6** shows the Color Variations dialog box.

■ Now boost the overall color saturations by clicking the **Saturation** box and then clicking **More Saturation** three times. If you want to start all over, you can click **Reset Image**. Click **OK** to

apply the settings. You now have a much richer colored image with extra blue in the sky.

■ To take a quick look at the before and after images click in the **Undo History** palette on the **Open** state and then the **Color Variations** state. This was a nice improvement in the image if you want a richly saturated photo like you might get shooting Fuji Velvia slide film. Make sure the **Color Variations** state is the active state before going on to the next step.

STEP 4: DRAMATICALLY ALTER COLOR SCHEME

■ Now take a quick look at the Hue/Saturation feature. This feature is used throughout the book to make mostly serious color corrections. However, for now use it on this photo for fun and to explore what it can do. Select **Enhance** ➢ **Adjust Color** ➢ **Hue/Saturation** (**Ctrl+U/ Command+U**) to display the Hue/Saturation dialog box.

■ Click the **Hue** slider and drag it toward the left to about **–13**. This makes the sky a bit more sky-blue and it makes the greens in the field and trees look a little browner. Bump **Saturation** up to +4. The Hue/Saturation dialog box should now look like the one shown in **Figure 13.7**.

■ Now click in the **Edit** box and select **Greens** (**Ctrl+3/Command+3**). Click the **Saturation** slider and slide it toward the left to about **–66**. Now push the sky-blue sky toward a more natural deep blue sky color by clicking the **Edit** box and selecting **Cyans** (**Ctrl+4/Command+4**). Click the **Hue** slider and drag it to about **+35**. You can bump **Saturation** up to about **+14** and drag the **Lightness** slider to about **–75**. Those are pretty arbitrary changes, but they should give you a good idea of the incredible control you have over color with Elements 3.0.

■ Click **OK** to apply the settings.

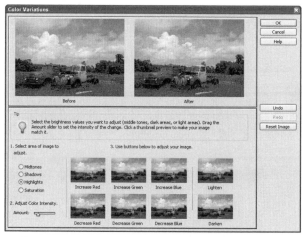

13.6

13.7

STEP 5: ADD UNIFYING WARM TONE

■ To add a unifying warm tone to the image, you will now apply color in a similar manner as you would using a "warming" or "cooling" filter on a camera. Select **Filter** ➢ **Adjustments** ➢ **Photo Filter** to display the Photo Filter dialog box. Make sure there is a checkmark next to **Preserve Luminosity** to ensure that image brightness is maintained.

■ Click in the **Filter** box and choose **Deep Yellow**. Click the **Density** slider and slide it about **21%**. **Figure 13.8** shows the Photo Filter dialog box.

■ Click **OK** to apply the settings. The image now looks similar to the one shown in **Figure 13.2** (**CP 13.2**) and very different from the one in **Figure 13.1** (**CP 13.1**).

TIP

When experimenting you should use the Undo History palette. Not only does it allow you to revert back to the original image with a simple click, but you can back up one or more steps by clicking on the state you want. The Undo History palette is a fantastically useful tool that you should use often when experimenting or for just your normal workflow to compare each setting you make to ensure that you are constantly improving your images. Figure 13.9 shows the complete Undo History palette for the steps that were taken in Technique 13.

13.8

13.9

PERFORMING FULLY EDITABLE DODGING AND BURNING

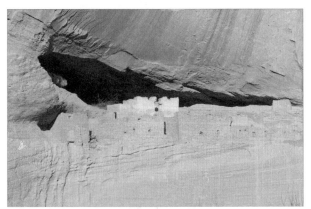

14.1

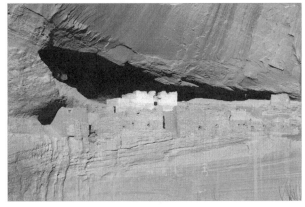

14.2

ABOUT THE IMAGE

"White House Ruins in Canyon de Chelley" Canon EOS 1Ds, 70–200mm f/2.8 IS @ 200mm, f/11 @ ¹/₃₂₀ sec, ISO 100, 16-bit RAW format, 2,160 x 1,440 pixels, converted to an 8-bit 2,048 x 1,363 pixel .jpg

"Dodging and burning" is a phrase used to describe the process of darkening and lightening selected areas of a photographic print in a wet darkroom. When the light from an enlarger is blocked from a specific area it is known as *dodging*, which causes that area to be lighter than the rest of the print. Burning is the opposite process where light is allowed to fall on a selected area longer than the rest of the print, which makes the area appear darker.

Dodging and burning can also be accomplished when editing digital photographs digitally. In this technique you learn how to dodge and burn the photo shown in **Figure 14.1** to make it look like the one shown in **Figure 14.2**. The technique you learn here allows you to easily dodge and burn without destroying the underlying pixel information; thus, it allows you to go back and make any changes you want at any time during the editing process.

I have twice visited the White House Ruins and both times I was there when the sun was very bright, or there was an undesirable mid-morning or late evening shadow across the ruins that was caused by the sun dropping below the rim of the canyon. The challenge presented by this photo is to make it look less flat and to add some drama to it. To accomplish this you will be mostly dodging and burning — digitally.

STEP 1: OPEN FILE

■ Select **File ➤ Open** (**Ctrl+O/Command+O**) to display the Open dialog box. Double-click the **\ch02\14** folder to open it and then click the **whitehse-before.jpg** file; click **Open**.

STEP 2: CREATE DODGE & BURN LAYER

Adobe Photoshop Elements 3.0 has a sophisticated **Dodge** tool and **Burn** tool that can be found in the **Toolbox**. Both these tools have many user-selectable settings that can be accessed from the Options bar. The reason why you will not be using these tools is that they are, in my opinion, unnecessarily complex and they destroy the original image when used. The approach you take here allows you to make changes or reverse any dodging and burning that you do without damaging the image.

■ To create a special layer for dodging and burning select **Layer ➤ New ➤ Layer** (**Shift+Ctrl+N/Command+Shift+N**) to display the New Layer dialog box shown in **Figure 14.3**. Type **Dodge & Burn** in the **Name** box. Click in the **Mode** box and select **Overlay**. Click in the box next to **Fill with Overlay-neutral color** (**50% gray**) to turn the feature on. Leave **Opacity** set to **100%**. Click **OK** to create the new layer. You now have a new layer in the **Layers** palette, as you can see in **Figure 14.4**.

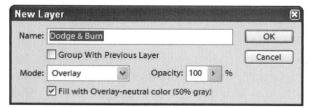

14.3

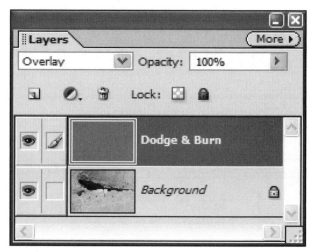

14.4

STEP 3: BURN TO DARKEN

■ Click the **Brush** tool (**B**) in the **Toolbox**. You will soon find out for yourself that dodging and burning is best done with very subtle strokes, so click in the **Opacity** box in the Options bar and set it to **10%** at most. You could click in the **Size** box and select a brush size, but I prefer to use shortcut keys and match the size of my brush against what is needed visually. To enlarge the brush size, keep tapping on the] key. The [key reduces the size of the brush. For your first bit of dodging use a large brush and darken the bottom face of the cliff to bring out the hieroglyphics. The **Size** box in the Options bar shows that I selected a **600 px** brush.

■ It is essential that the **Foreground** be set to **black**. Click the **Default Foreground** and **Background Colors** icon (**D**) at the bottom of the **Toolbox**.

■ Make a couple of smooth strokes across the bottom of the image. The dodging is so subtle that you may not notice much change — and, this is good. You don't want to be able to notice what part of the

image was dodged and what part was not. To get a good idea of the improvement you made, click the **Layer visibility icon** that is to the left of the **Dodge & Burn** layer in the **Layers** palette to turn off the effects. Turn the layer back on to continue. Or, you can also use the **Undo History** palette to compare one history state with another and confirm that each stroke accomplishes what you want. These two simple strokes make a good amount of improvement in the image and you can see the hieroglyphics more easily.

■ Now slightly darken all four corners of the image to create vignetting that might occur with some camera lenses. This effect helps to focus attention on the ruins. Reduce the brush size to about **400 px**. Click and drag the cursor over all four corners. Start off making a long stroke around the corner and make each of three or four successive strokes shorter; darken the corner the most.

■ You may want to reduce the brush size and paint inside the cave to darken the shadows to make the white house in the cave contrast more against the dark cave.

■ Notice that you can see the effects you are painting represented in grayscale in the thumbnail in the Layers palette.

STEP 4: DODGE TO BRIGHTEN

■ To brighten selected parts of the image, you simply need to paint with white. Switch the foreground and background colors by clicking the **Switch Foreground and Background Colors** icon (**X**) at the bottom of the **Toolbox**.

■ I'm not keen on brightening very much of this image except for the white house. You want to make only a subtle change as too much burning could remove all of the detail in the walls.

■ Reduce your brush size to about **100 px** and zoom in on the image to **100%**. Click and paint once or twice over all of the white walls. If you want to back up a stroke or two, you can do so by pressing **Ctrl+Z/Command +Z** or you can click one of the previous strokes in the **Undo History** palette. After the detail brightening of the White House walls, my workspace looked like the one shown in **Figure 14.5**.

STEP 5: MAKE GLOBAL ADJUSTMENTS

You may want to make other subtle dodging and burning strokes, but stop for now and look at how you can make some global changes. Using an **Overlay** layer as you have done in this technique leaves the original layer intact, thus making any dodging and burning that was done reversible. One other major advantage is that you can now make global changes to the **Dodge & Burn** layer.

■ To make global changes to the **Dodge & Burn** layer, click in the **Opacity** box and slide the slider to reduce the overall effects of the layer. For now, leave the **Opacity** at **100%**.

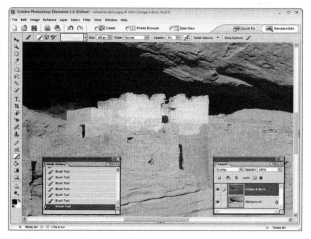

14.5

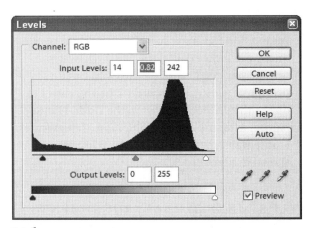

14.6

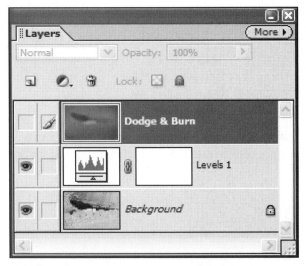

14.7

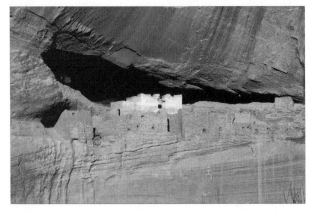

14.8

- If you want to make the changes that you made even more subtle you can change the **Blend Mode** of the **Dodge & Burn** layer to **Soft Light**. Try it. Turn off the layer by clicking the **Layer Visibility** icon at the left of the **Dodge & Burn** layer in the **Layers** palette to see the before and after effects. Click the **Layer Visibility** icon once more to turn it back on. Change the **Blend Mode** back to **Overlay**.

- Now make one last global change using a **Levels** adjustment layer. Click the **background** in the **Layers** palette to make it active. Select **Layer ➢ New Adjustment Layer ➢ Levels** to display the New Layer dialog box; click **OK** to display the Levels dialog box. I liked the overall effect of setting the **Input Levels** to **14**, **0.82**, and **242** as shown in **Figure 14.6**. Click **OK** to apply the settings. The image should now look similar to the one in **Figure 14.2**.

Want to see how important the dodging and burning was? Turn off the **Dodge & Burn** layer by clicking the **Layer Visibility** icon in the **Dodge & Burn** layer as shown in **Figure 14.7**. **Figure 14.8** shows the image with dodging and burning, and **Figure 14.9** shows the image without it. Because all the dodging and burning was done on a layer separate from the original photo, you have complete control over it. Likewise, you used an adjustment layer that allows you to make any changes to those settings, too. You can learn more about the art of nondestructive image editing in the next technique.

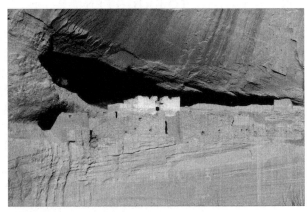

14.9

NONDESTRUCTIVE IMAGE EDITING

15.1 (CP 15.1)

15.2 (CP 15.2)

ABOUT THE IMAGE

"Ummmm — Let Me Think About That For a Minute," Canon EOS 1Ds, 300mm f/2.8 IS with 2X-telextender, f/5.6 @ ¹/₈₀₀ sec, ISO 100, 16-bit RAW format, 4,064 x 2,704 pixels, cropped and converted to an 8-bit 2,048 x 1,363 pixel 264Kb .jpg

When my photographer friend John Boggess showed me this picture of a California brown pelican (see **Figure 15.1**) scratching his head, I laughed and said, "That has to go in one of my books!" John is one of the growing number of people who have full-time careers outside photography who love taking photos every time they get the chance. John, like the pelican in the photo shown in **Figure 15.2** (**CP 15.2**), often scratches his head as he carefully thinks about each shot he takes. It is the love of being outside, his reverence for wildlife, and his constant effort to take better photographs that will help him to one day become a first-rate nature photographer.

This technique is the last technique in this chapter on basic image editing and it serves two important and significant purposes. First, it shows you how to combine some of what you have learned in the first two chapters and apply it in such a way that you can go back and make changes to earlier settings — this is why the technique is called "nondestructive" image editing. The technique also serves as one final reminder that shooting in RAW mode and editing in 16-bit mode is a very good thing if you have that option.

STEP 1: OPEN FILE

Once again you will be working with an 8-bit JPEG image as that is by far the most common file format used by most digital photographers. The original photo was saved in the RAW file format. As it was taken with an amazing 11-megapixel camera, should you wish to open and convert the 4,064 x 2,704 pixel image into a 16-bit image and edit it, you can find the file on the companion disk in the **\ch02\15** folder. It is named **pelicanRAW.TIF**. Converting this RAW file with the Camera RAW Converter yields a decidedly better image than you can get by following the steps in this technique and working on an 8-bit JPEG image.

- Select **File ➢ Open** (**Ctrl+O/Command+O**) to display the Open dialog box. Double-click the **\ch02\15** folder to open it and then click the **pelican-before-.jpg** file; click **Open**.

STEP 2: ADJUST TONAL RANGE

The **Levels** tool is the first tool that you will use to adjust the tonal range. Instead of choosing **Enhance ➢ Adjust Lighting ➢ Levels** and making the adjustments directly to the image, you will create an adjustment layer so the setting will not be applied permanently until the image is flattened.

- Select **Layer ➢ New Adjustment Layer** to display the menu shown in **Figure 15.3**. All those Elements 3.0 features on the menu can be applied as an adjustment layer. Click **Levels** to display the New Layer dialog box. Type **Global Levels** in the **Name** box and click **OK** to display the Levels dialog box. Assuming you are in agreement that the goal is to increase image contrast, you could make a single change to all the channels by using the **RGB** channel. Instead, adjust each channel

separately and see if you can correct the color at the same time.

- Click in the **Channel** box and select **Red** (**Ctrl+1/Command+1**). For each of the three channels move the **Shadow** slider toward the right until it stops just short of the toe of the histogram. Do the same thing for the **Highlight** slider, too — only move it to the left. Click the **Shadow** slider and drag it to about **28**. Click the **Highlight** slider and drag it toward the left to about **219**. The Levels dialog box should now look like the one shown in **Figure 15.4**.
- Click in the **Channel** box and select **Green** (**Ctrl+2/Command+2**). Click the **Shadow** slider and drag it to about **22**. Click the **Highlight** slider and drag it toward the left to about **217**.
- Click in the **Channel** box and select **Blue** (**Ctrl+3/Command+3**). Click the **Shadow** slider and drag it to about **16**. Click the **Highlight** slider and drag it toward the left to about **202**. The image looks much more like what we saw when John and I were shooting in La Jolla, California, on that day. While this approach worked well for this image, I should point out that this may not

15.3

always work on every image. If you don't like the results you get at this point, you can simply press the **Reset** button to start over.

■ Click **OK** to apply the settings as an adjustment layer.

If you look at the Layers palette you will see that there is a new layer named **Global Levels**, as shown in **Figure 15.5**. Double-click the leftmost **Levels** thumbnail in the **Global Levels** layer and the Levels dialog box appears. If you click each of the three channels as you did earlier in this step you will see that the **Input Levels** are set as you set them earlier. If you want to make any changes to those settings you can do it now, or later. That is a huge advantage! If you had simply applied the settings using Levels without using an adjustment layer, you would have permanently destroyed some picture data as the tonal changes were rather severe for an 8-bit image that does not have enough picture information to tolerate such severe tonal changes. Click **Cancel** to close the Levels dialog box.

Take a look at the histogram. If the Histogram palette is not showing, select **Window ➤ Histogram**.

Click the **Uncached Refresh** button in the upper-right corner to update the histogram. It should now look like the one shown in **Figure 15.6**. Sadly, a quick look

15.5

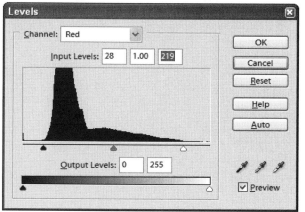

15.4

15.6

will confirm that you have a very "gappy" histogram, which may give you a photo with a posterized effect instead of the smooth gradients that you expect from a wonderful photograph like this one.

At this point you have a couple of options. You can continue on with your settings, or you can go back to the **Global Levels** adjustment layer and make your tonal range corrections less severe. Or, you can continue on with your editing and make a print to see how the image looks. Because it is a good lesson to learn how gaps translate into posterization in a print, I say you go on. You may soon learn as I have that one filter can fill in the gaps that were created by an earlier filter.

STEP 3: ADD WARM TONE

Our pelican that is seen scratching his head was photographed in the late day and there was a warm tone to the image, so try to warm the colors up a bit. How would you warm up the image? If you read Technique 13, you ought to know part of the answer. If your choice of tools was the **Photo Filter,** you are correct. Remember that you are performing a nondestructive workflow on this image, so the full answer is a **Photo Filter** adjustment layer.

■ Select **Layer ➢ New Adjustment Layer ➢ Photo Filter** to display the New Layer dialog box. Type **Warm Tone** in the **Name** box and click **OK** to display the Photo Filter dialog box. You don't always have to name each layer, but it is a good practice because you may forget what each layer does if you end up with many layers.

■ Click in the **Filter** box and choose **Warming Filter (81)**. Make sure that **Preserve Luminosity** is checked to maintain image brightness. Click the **Density** slider and pull it toward the left to about **15%**. Subtle changes are good. Inexperienced image editors often over-apply an image effect. In this case, you want to just warm the tone enough to make the California brown pelican look brown instead of gray. The **Photo Filter** should now look like the one shown in **Figure 15.7**. Click **OK** to apply the effect as an adjustment layer. Look in the **Layers** palette and see the **Warm Tone** layer.

STEP 4: MAKE MINOR COLOR ADJUSTMENTS

Even though the image looks pretty good to me, you should see if it can be improved with the **Hue/**

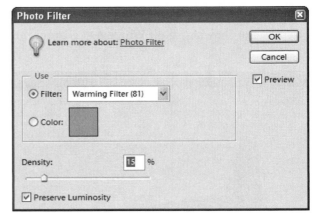

15.7

Saturation tool. If you like the results you get, you can apply them—if not, you can **Cancel** and abort the effort.

- You know the drill. Select **Layer ➢ New Adjustment Layer ➢ Hue/Saturation** to display the New Layer dialog box. Type **Global Color** in the **Name** box and click **OK** to display the Hue/Saturation dialog box.

- You may be able to warm the image up a bit more if you boost the saturation of yellow. Click in the **Edit** box and select **Yellows** (**Ctrl+2/Command+2**). Click the **Saturation** slider and move it toward the right to about **+15** to provide a bit more yellow color to the feathers and to the bill. The Hue/Saturation dialog box should now look like the one shown in **Figure 15.8**.

- Click **OK** to apply the settings.

The Layers palette should now look like the one shown in **Figure 15.9**. You can now double-click any of the layers to open up the effect dialog box so that you can adjust the settings. Once the image is as you want it, you can select **Layer ➢ Flatten Image** to flatten all the layers while applying the settings to the image.

With much of the editing complete, take another look at the histogram in the Histogram palette. Remember to click the **Uncached Refresh** button to update the histogram. **Figure 15.10** shows the new histogram and it looks better than it did before. The only way to truly determine the extent of any possible posterization is to make a print and examine it. When

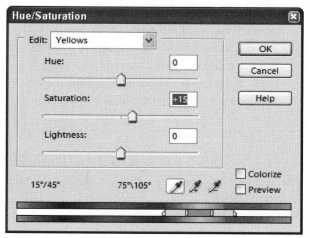

15.8

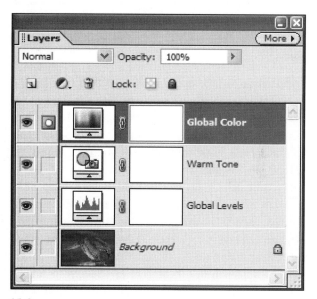

15.9

15.10

I printed the image on an Epson 2200 printer I concluded there was no posterization, but the image was too contrasty for my taste. Because adjustment layers were used, it was an easy thing to double-click the **Global Levels** layer and readjust the end points to reduce the overall image contrast. Without those lovely adjustment layers, I would have had to perform all of the edits over again to make the print I wanted, which is annoying and time-consuming. Adjustment layers are a good thing — use them when they are appropriate.

Why would you not want to always save your image file with adjustment layers? Each time you add an adjustment layer you increase the size of the image file. You should save files with adjustment layers only in the Photoshop .psd file format, which is an uncompressed file format. You cannot save layers in the standard .jpg file format, which is destructive in

When should you use adjustment layers? You should use adjustment layers any time you edit an 8-bit image with Adobe Photoshop Elements 3.0 and use two or more of the filters that can be applied via an adjustment layer. Levels, Brightness/Contrast, Hue/Saturation, Gradient Map, Photo Filter, Invert, Threshold, and Posterize can all be applied on an adjustment layer. Using adjustment layers allows you to go back at any time and make changes to the settings. Sometimes the application of one filter will make you want to modify an earlier setting and adjustment layers allow you to make the changes in a nondestructive manner. You cannot use adjustment layers on a 16-bit image as they are not supported in Adobe Photoshop Elements 3.0. One significant reason to upgrade to Adobe Photoshop CS is that it supports 16-bit layers. However, if you have a RAW image file, you can perform most of your image corrections using the Camera RAW Converter and you are likely to get even better results than if you applied the needed changes to an 8-bit image.

any case. Usually it is best to make all the corrections you want in this nondestructive manner and then flatten the image.

Now that you have completed this chapter and assuming that you have already read Chapter 1, you have all the basics you need to successfully complete *and* understand the rest of the techniques in the book. The time you spent on these first two chapters will help you immensely on the rest of the book and with your digital photography in general.

CHAPTER 3

JUST FOR THE FUN OF IT TECHNIQUES

Y ou've learned the fundamentals that were covered in the first two chapters, and you are now ready for some fun. After you work on these techniques, my bet is you will quickly head off to try them on your own images. If you think Las Vegas and its neon lights have some bold colors, Technique 16 will raise your standards for photos with bold colors. One of the fun new trends is to have parts of an image "pop" out of the photo, which you learn in Technique 17. In Technique 18 you learn a useful technique for toning images with multi-color gradients. Getting better effects from common filters is the topic of Technique 19. Get a few laughs by distorting pet photos in Technique 20 while learning how to make useful adjustments to people portraits. In Technique 21, you learn about Elements 3.0's features for placing text on an image.

POESIE LYRIQUE

DRAMATICALLY ALTERING COLOR

16.1 (CP 16.1)

16.2 (CP 16.2)

ABOUT THE IMAGE

"Las Vegas Water Fountain Statues at Night," Canon EOS 1D, 70–200mm f/2.8 IS @ 90mm, f/5.6 @ ⅕ sec, ISO 200, 16-bit RAW format, 2,464 x 1,648 pixels converted to an 8-bit .tif

Color is often the dominant feature of a good photograph. Many well-known photographers such as Jay Maisel (www.jaymaisel.com) have become known for their vibrant color photography that often features color as the main element. While it is possible to capture dramatic, bold colors, you can also take photographs of ordinary subjects that have little color and jazz them up using one or more of the features found in image editors such as Adobe Photoshop Elements 3.0.

In this technique, you learn how to take the photo shown in **Figure 16.1** (**CP 16.1**) and transform it into the rich colorful photograph shown in **Figure 16.2** (**CP 16.2**). In the process of completing this technique you will use color layers, blend modes, and levels. The use of these features should spark your imagination and get you started dramatically altering the color of many of your own images.

STEP 1: OPEN FILE

In this technique, you start with an 8-bit .tif file instead of a RAW file because this technique uses layers, which cannot be used on a 16-bit image. However, if you want to convert the image yourself, the RAW file has been included in the **\ch03\16** folder. It is named **statues-beforeRAW.TIF**.

■ Select **File ➢ Open** (Ctrl+O/Command+O) to display the **Open** dialog box. Double-click the **\ch03\16** folder to open it and then click the **statues-before-.tif** file; click **Open**.

STEP 2: DUPLICATE LAYER AND CHANGE BLEND MODE

■ Select **Layer ➢ Duplicate Layer** to get the **Duplicate Layer** dialog box; click **OK**.
■ The reason for adding a second layer and then choosing a blend mode is to give the image some extra "punch." You'll now be looking for a blend mode that increases contrast and alters the colors in an exciting way. Click in the **Layer Blend Mode** box in the upper-left corner of the **Layers** palette and try each of the blend modes. I liked the effects of using **Overlay** mode and leaving **Opacity** set to **100%**. The **Layers** palette should now look like the one shown in **Figure 16.3**.

STEP 3: ADJUST COLOR

■ To adjust color, use an adjustment layer so that you can later change the settings if you decide they need to be changed. Select **Layer ➢ New Adjustment Layer ➢ Hue/Saturation** to get the **New Layer** dialog box; click **OK**.

■ Click the **Hue** slider and move it to the left and right until you find a new color combination you like. I liked the colors when **Hue** is set to **–99**. Decrease **Saturation** to **–9**, as shown in **Figure 16.4**.

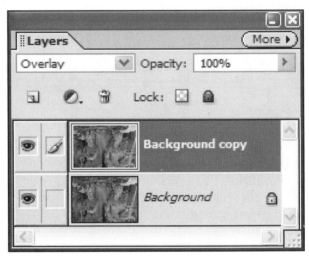

16.3

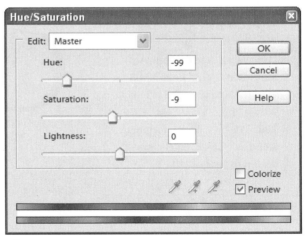

16.4

■ Notice that you can also adjust each color channel individually, by clicking the **Edit** box and selecting: **Reds**, **Yellows**, **Greens**, **Cyans**, **Blues**, and **Magentas**. Click **OK** to apply the settings and create an adjustment layer.

STEP 4: ADD FILL LAYER

■ To add some warmth and increase image density, now add a color layer. Select **Layer ➢ New Fill Layer ➢ Solid Color** to get the **New Layer** dialog box; click **OK** to get the **Color Picker** dialog box shown in **Figure 16.5**. Type **247** in the **R** box, **245** in the **G** box, and **104** in the **B** box to select a bright yellow color, as shown in **Figure 16.5**. Click **OK**.

■ To blend the yellow layer with the rest of the image click in the **Layer Blend Mode** box in the **Layers** palette and choose **Multiply**. I like the image, as it is, so let's leave **Opacity** set to **100%**. If you wanted to reduce the effects of the yellow color, you could reduce **Opacity**. The **Layers** palette should now look like the one shown in **Figure 16.6**.

STEP 5: INCREASE IMAGE BRIGHTNESS

■ Now increase the brightness of the image in the midtones and highlights. Once again, use an adjustment layer so you have the option to make changes to your settings. Select **Layer ➢ New Adjustment Layer ➢ Levels** to get the **New Layer** dialog box; click **OK**.

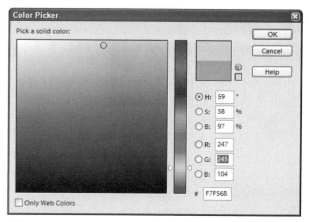

16.5

16.6

■ To increase image brightness in the midtones, click the **Midtone** slider in the **Levels** dialog box and drag it toward the left to about **1.16**.

■ To increase image brightness in the highlights, click the **Highlights** slider and drag it toward the left to about **243**. The **Levels** dialog box should now look like the one shown in **Figure 16.7**. Click **OK** to apply the settings.

STEP 6: FLATTEN AND SHARPEN IMAGE

The Layers palette now shows three adjustment layers and the background. Although you can sharpen the image by sharpening the background, *flattening* (merging) all the layers into the background will reduce the file size and allow superior sharpening.

■ Before you flatten and sharpen the image, take a good look at it. If you want to make any tonal adjustments, you can double-click on the **Levels 1** layer to change the settings. Likewise, you can go back and change the yellow color fill layer, or make adjustments using **Hue/Saturation**. You have this choice because you applied all these settings as adjustment layers.

■ When you are happy with your image, select **Layer** ➤ **Flatten Image**.

■ Select **Filter** ➤ **Sharpen** ➤ **Unsharp Mask** to get the **Unsharp Mask** dialog box. Set **Amount** to **175**, **Radius** to **0.7**, and leave **Threshold** set to **0**.

16.7

■ To learn more about image sharpening, read Technique 6.

■ Click **OK** to apply the settings and complete the image.

This simple technique illustrates how several important Elements 3.0 tools can be used to alter color. When your intent is to dramatically alter color, never underestimate the wonderful effects you can get by simply changing blend modes. You can also get some useful effects by duplicating a layer, then making color adjustments to one layer and then choosing an appropriate Blend Mode and Opacity setting. Your imagination is the only limit to what you can create when you begin applying various combinations of the color adjustment tools.

MAKING SUBJECTS APPEAR TO JUMP OUT OF A PHOTO

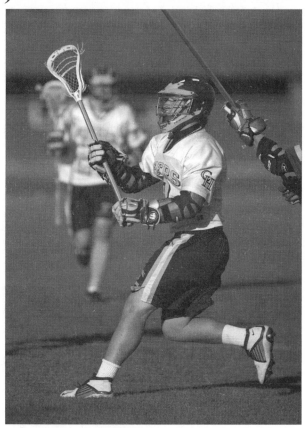

17.1

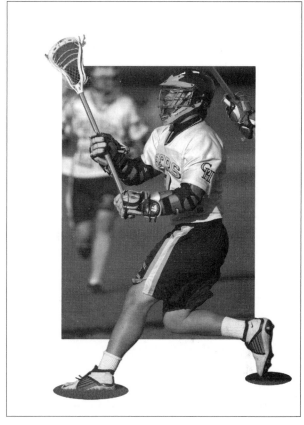

17.2

ABOUT THE IMAGE

"Making the Pass," Canon EOS 1D Mark II, 300mm f/2.8 IS, f/2.8 @ ¹/₆₄₀₀ sec, ISO 100, 16-bit RAW format, 2,336 x 3,504 pixels, cropped, edited, and converted to an 8-bit 1,828 x 2,564 pixel .tif

There are many ways to use your digital photographs. Simply making the best possible print that represents what you thought the scene or subject looked like is just one approach to photography. You also may want to transform your photos into something that looks more like it was actually painted. In this technique you start with the photograph shown in **Figure 17.1** and make the lacrosse player look as if he is playing lacrosse outside the photo, as shown in **Figure 17.2**. In this technique, you learn how to precisely select parts of an image and place them on their own layer. The objective is to make a 240dpi image that can be used to make a print that fits in a standard 5" x 7" photo frame.

95

STEP 1: OPEN FILES

■ Select **File ➢ Open** (**Ctrl+O/Command+O**) to display the Open dialog box. Double-click the **\ch03\17** folder to open it. Click the **player-before.tif** file; click **Open**.

STEP 2: DUPLICATE LAYER

■ Because you will need a layer for the player and a layer for the background, select **Layer ➢ Duplicate Layer** to display the Duplicate Layer dialog box. To create a second layer named Background copy, click **OK**.

STEP 3: CROP IMAGE

Assume the goal is to make a print that fits in a standard 5" x 7" frame and that you will need an image that has 240 dpi.

■ Click the **Rectangular Marquee Tool** (**M**) in the Toolbox. In the Options Bar click the **New Selection** icon (the first of four sets of icons just to the left of Feather). **Feather** should be set to **0 px**. Click in the **Mode** box and select **Fixed Aspect Ratio**. Type **5** in the **Width** box and **7** in the **Height** box. The Options Bar should now look like the one shown in **Figure 17.3**.

■ Click once near the bottom-right of the photo and drag the selection marquee up toward the left to select an area similar to the one shown in **Figure 17.4**.

■ Select **Select ➢ Save Selection** to get the **Save Selection** dialog box. Type **Player** in the **Name** box and then click **OK**. This step saves the selection for later use.

player-before.tif @ 16.7% (Background copy,...

17.4

■ Select **Select ➢ Inverse** (**Shift+Ctrl+I/Shift+Command+I**) to invert the selection.

■ Select **Edit ➢ Cut** (**Ctrl+X/Command+X**) to cut the selection. If you click the **Layer Visibility** icon (the eye icon) just to the left of the Background layer in the Layers palette, you can see the remaining image. Click once more on the **Layer Visibility** icon to turn the Background layer back on.

Feather: 0 px Anti-aliased Mode: Fixed Aspect Ratio Width: 5 Height: 7

17.3

STEP 4: CROP BACKGROUND

- Click the **Layer Visibility** icon for the Background copy in the **Layers** palette to turn it off.
- Click the **Background** layer in the Layers palette to make it the active layer.
- Select **Select** ➤ **Load Selection** to get the Load Selection dialog box. After choosing **Player** in the Selection box and clicking **OK**, you will once again see the selection marquee.
- Click the **Default Foreground and Background Colors** (**D**) icon, which is the icon that shows a black-and-white square all the way at the bottom of the Toolbox. This sets the background to white, which is the color you want to use for the background where there will be no image.

The Background cannot show transparency like layers. When you cut part of the Background, it takes on the same color as the current Background Color that is shown at the bottom of the Toolbox. In contrast, when part of an image layer is cut, you get a transparent space that looks like a white and gray checkerboard pattern. Transparent areas allow any visible pixels below to show through.

- Select **Edit** ➤ **Cut** (**Ctrl+X/Command+X**) to cut the selection.

STEP 5: CREATE LAYERS FOR FEET AND STICK HEAD

You are nearly done. All that is left is to precisely cut out the player's two feet and the lacrosse stick head.

- Click the **Lasso** tool (**L**) in the Toolbox. For parts of the selection you may also want to try the Magnetic Lasso tool (L) and the Eliptical Marquee tool.
- Click the **Add to Selection** icon (the second icon in the group just to the left of Feather) in the Options Bar. This enables you to keep adding to

your selections as opposed to just starting a new selection with each.

- Click and drag a selection marquee around the two feet, the lacrosse head, and some turf below the feet. To get a more accurate selection, select **View** ➤ **Actual Pixels** (**Alt+Ctrl+0/ Option+Command+0**) to view the image at actual size. If you unintentionally select something, click the **Subtract from Selection** icon in the Options bar and remove the selection by selecting the area you want to remove.
- Select **Select** ➤ **Inverse** (**Shift+Ctrl+I/ Shift+Command+I**) to invert the selection.
- Select **Edit** ➤ **Cut** (**Ctrl+X/Command+X**) to cut the selection. The image should now look like the one shown in **Figure 17.5**.

17.5

STEP 6: FLATTEN IMAGE

■ Click the **Indicates Layer Visibility** icon to the left of the **Background copy** layer in the Layers palette to turn the layer back on.

■ Select **Layer ➤ Flatten Image**. Your image should now look similar to the one shown in **Figure 17.2**.

TONING IMAGES WITH MULTICOLOR GRADIENTS

18.1 (CP 18.1)

18.2 (CP 18.2)

ABOUT THE IMAGE

"Poesie Lyrique Vegas Style," Canon EOS 1D, 70–200mm f/2.8 IS @ 95mm, f/11 @ ¹/₂₀₀ sec, ISO 200, 16-bit RAW format, 2,160 x 1,440 pixels, converted to an 8-bit, 1MB .jpg

D o you have a few hours? You may get through the few steps in this technique quicker than any other technique in the book. However, you are going to find out about some features that offer unlimited potential for toning or coloring images, and my hope is you will be so excited that you will spend hours investigating the full potential of this technique.

When you design your own color gradients to tone images and you apply them with blend modes, you enter a whole new realm of toning digital photographs. Why am I so excited about this? Well — think about what you can do with such a technique. You can, for example, take an ordinary black-and-white image and make the darker tones a cool color and the lighter tones a warm color. If you are toning portraits, you could have a nice cool color image with a warm face tone. Now imagine being able to make gradients that have more than just two colors — one color for dark tones, one color for the midtones, and a third color for the light tones. But there is no reason to stop at three colors if you want even more. You can even precisely control how the tones blend between two colors.

In this technique, you take the color image of the façade of a hotel in Las Vegas shown in **Figure 18.1** (**CP 18.1**) and tone it using a gradient to make it look like the photo shown in **Figure 18.2** (**CP 18.2**). After that, I bet you'll have fun experimenting for hours with your own photographs.

STEP 1: OPEN FILE

■ Select **File ➤ Open** (**Ctrl+O/Command+O**) to display the **Open** dialog box. Double-click the **\ch03\18** folder to open it and then click the **façade-before.tif** file to select it. Click **Open** to open the file. If you want to work with this file in RAW format, it can also be found in the \ch03\18 folder. It is named **facade-beforeRAW.TIF**

STEP 2: DUPLICATE LAYER AND REMOVE COLOR

This is an excellent technique for toning black-and-white photos as well as monochromatic images like the original you will use in this technique. So that you can view the differences, make an extra layer for the original color version.

■ Select **Layer ➤ Duplicate Layer** to get the Duplicate Layer dialog box. Type **Desaturated** in the **As** box and then click **OK**.
■ Select **Enhance ➤ Adjust Color ➤ Remove Color** (**Shift+Ctrl+U/Shift+Command+U**) to convert the image to a black-and-white image.

STEP 3: ADD GRADIENT LAYER

■ Select **Layer ➤ New Adjustment Layer ➤ Gradient Map** to get the New Layer dialog box. Click **OK** to get the Gradient Map dialog box shown in **Figure 18.3**. Click in the gradient toward the right side of the gradient square to open the

Gradient Editor shown in **Figure 18.4**. If your Gradient Editor does not look like this one, click the menu button in the upper corner of the now open dialog box to get a pop-up menu. Click **Small List**. Click the menu button again and choose **Pastels**. Click the scroll bar and drag it down so you can select **Brown, Tan, Beige**.

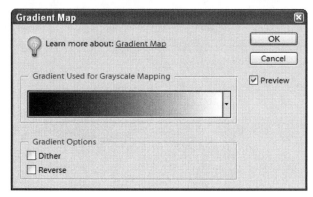

18.3

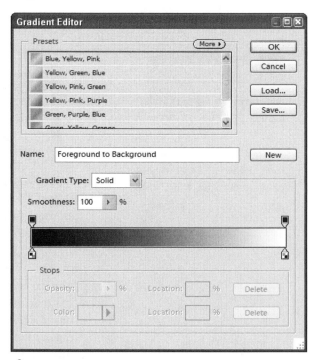

18.4

Before you go further, let's dig a little deeper into the features found in the **Gradient Editor** dialog box, which should now look like the one shown in **Figure 18.5**. From this dialog box you can choose from presets as you did earlier. To get the same pop-up menu listing the various gradient sets, click the **More** button. You can also change the **Gradient Type** from **Solid** to **Noise**, which opens up a whole new group of settings that even allow you to change to the intuitive **HSB Color Model**. Notice there is a **Randomize** button, which you can click to get random color combinations. After a minute or so of using the **Randomize** button, you'll probably have stumbled upon several color schemes you like. Click in the **Gradient Type** box and once again select **Solid** to return to where you started. This current color scheme has three colors, five stops, and sliders. You can find the sliders beneath the horizontal color gradient in the **Gradient Editor** dialog box. If you click the left-most slider, the color will be displayed in the **Color** box in the **Stops** area of the dialog box. If you click the color in the **Color** box, you will get the **Color Picker** where you can choose any color you want. Try it. Click **Cancel** to close the **Color Picker**. You can do the same thing to each of the other stops. If you were to make changes and you wanted to later apply the same settings to a new image, you have the option of naming the gradient and saving it to a file for future use.

For now, continue on with the original **Brown, Tan, Beige** gradient. If you made changes, you can return to the gradient by clicking it in the **Preset** area of the **Gradient Editor** dialog box.

■ To close the **Gradient Editor**, click **OK**. To apply the gradient, click **OK** in the **Gradient Map** dialog box. So, what do you think of the image now? Okay — that was a trick question. It does not look any better to me than it probably does to you. To give you an idea of the flexibility you have, click in the **Blend Mode** box in the **Layers** palette and choose and view each of the blend modes. I like what happens with **Multiply**, **Color Burn**, and **Linear Burn**. Select **Linear Burn**. It looks a bit too

dark and contrasty, so click in the **Opacity** box in the **Layers** palette and slide the slider to about **70%**. The image is looking pretty darn good to me now. What has happened is the grayscale image is mapped to the **Brown, Tan, Beige** gradient to add color to the image. Then, the Linear Burn layer darkens the resulting image in a similar manner as the Multiply blend mode in that it darkens the image, but it darkens the base color to reflect the blend color by decreasing the brightness. Reducing **Opacity** to **70%** reduces the amount the image is darkened. If this technical description does not make much sense to you, that is okay as a good understanding of it only helps you to more quickly narrow your options. In the end, having an "eye" for the results is needed in any case.

■ Because you created an extra layer in Step 2, you can now click the **Layer Visibility** icon in the Layers palette just to the left of the

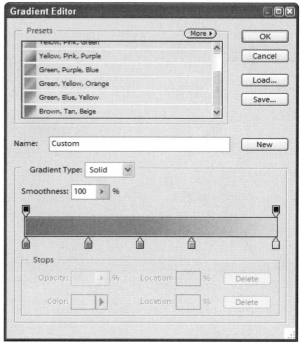

18.5

Desaturated layer to turn that layer off. The **Layers** palette should now look like the one shown in **Figure 18.6**. When you turn off the **Desaturated** layer, the effects of the Linear Burn gradient are applied directly to the original color image. Which one do you like better? I like them both! Click the **Layer Visibility** icon in the **Layers** palette just to the left of the **Desaturated** layer to turn the layer back on again.

STEP 4: MAKE COLOR AND TONAL ADJUSTMENTS

Between the **Gradient Selector**, **Gradient Editor**, and **Blend Modes**, you have a vast territory for exploration. You should not, however, let those features limit the boundaries of where you go! You can continue the transformation process by using adjustment layers to make any changes you want to color and tone.

■ Click the **black and white** layer in the **Layers** palette to make it the active layer.

■ Select **Layer** ➢ **New Adjustment Layer** ➢ **Levels** to get the New Layer dialog box; click **OK** to get the Levels dialog box. Lighten the highlights by clicking and dragging the **Highlight** slider toward the left to about **233**. Lighten the midtones by clicking and dragging the **Midtone** slider toward the left to about **1.10**. The Levels dialog box should now look like the one shown in **Figure 18.7**. Click **OK** to apply the settings.

■ Click the **Desaturated** layer in the **Layers** palette to make it the active layer.

■ Select **Layer** ➢ **New Adjustment Layer** ➢ **Photo Filter** to get the New Layer dialog box; click **OK** to get the Photo Filter dialog box. Click in the **Filter** box and choose **Warming Filter (81)** to slightly warm the image. Click **OK** to apply the settings. The final Layers palette should look like the one shown in **Figure 18.8**. When you use adjustment layers, you have lots of flexibility to go back later and make any desired changes or just to experiment further, which you can do now if you choose.

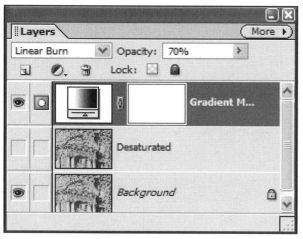

18.6

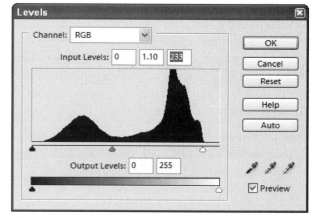

18.7

You are now ready to flatten and save the image. Don't forget to sharpen this image as it makes a colossal difference in how the image looks when printed.

In this technique, a monochromatic gradient was mapped against a grayscale version of the original. Even though there were three colors in the gradient (beige, brown, and tan), the three colors were all pretty much brown colored. To create an image where different colors are mapped against different parts of the tonal range, you simply choose different colors with the Gradient Editor. For example, you could choose a cool blue color for the shadow areas and a warm yellow for the midtones and highlights. With a bit of experimentation, you should be able to create some outstanding images.

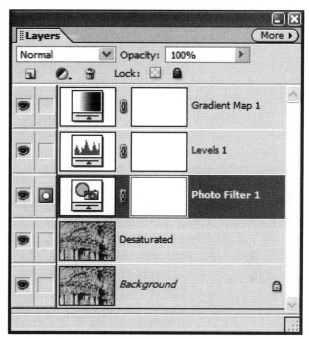

18.8

TIP

Toning black-and-white images is a wonderful way to take a whole series of photographs and make them into one similar "body of work." For example, if you shoot a dozen photos of buildings on a trip to Europe, you will likely have a dozen different colored buildings in a dozen different lighting conditions. If you were to convert them all to black-and-white photographs and then use the same toning gradient as described in Technique 18, you would have a very nice set of "matching" prints. Don't forget to save any custom Gradient Maps you create with the Gradient Editor to save time using it again on other images.

MIXING FILTERS TO CREATE FINE ART PRINTS

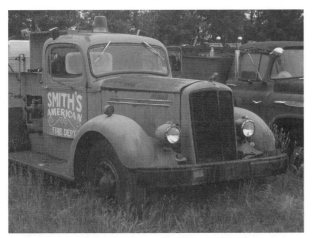

19.1

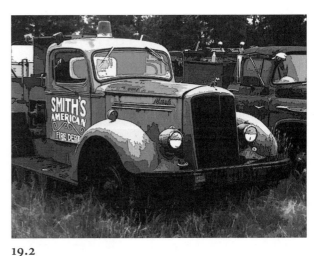

19.2

ABOUT THE IMAGE

"Smith's American Fire Dept. Truck," Nikon 950 digital camera using Fine Image Quality setting, 1,200 x 1,600 pixels, 900 Kb .jpg

The digital photo of the two fire trucks was taken with a hand-held digital camera on an overcast day — the perfect light for taking shots of subjects such as this one. The absence of bright sunlight made it easy to get a low-contrast image without the risk of getting blown-out highlights on shiny surfaces such as glass and metal. This image of a pair of old rusty fire trucks is perfect for trying all kinds of Adobe Photoshop Elements 3.0 filters — and that is just what you do in this technique.

Unlike most techniques in this book where the goal is to make a cool image, your goal in this technique is to edit the image shown in **Figure 19.1** in a number of ways so you can see firsthand how you can get more out of the Elements 3.0 filters. You will take a few steps, stop to look at the results, then take a few more and again look at the results, and so on. When you complete this technique, you will have an image like the one shown in **Figure 19.2**, and you can use the tips you learn here as you embark on a longer journey of your own to explore the limitless power of filters.

STEP 1: OPEN FILE

■ Choose **File ➤ Open** (**Ctrl+O/Command+O**) to display the Open dialog box. Double-click the **\chp03\19** folder to open it and then click the **firetrucks-before.jpg** file to select it; click **Open**.

STEP 2: APPLY CUTOUT FILTER

If you just want a good, clean graphic image, then the Cutout filter has to be one of the best. The Cutout filter has three settings and you can often get better results by preprocessing the image, which involves running another command or two on it first.

If you increase the contrast of an image before applying the Cutout filter, you will have better control over the level of detail that you have in an image. For the purposes of this technique, assume that you want a sharp, high contrast image with strong colors.

■ To increase image contrast, choose **Enhance ➤ Adjustment Lighting ➤ Levels** (**Ctrl+L/ Command+L**) to get the Levels dialog box.

■ Click the **Set White Point** eye dropper (it is the third eye dropper in the bottom-right corner of the **Levels** dialog box). Click once inside the nearly white lettering on the side of the Smith's truck to set the White point. If you don't get the results you want and you want to try another place, press **Alt/Option** and the Cancel button will turn into a Reset button; click **Reset** to start all over again. If the image seems too light or some of the highlights appear to be blown out, it's okay. This will only aid the contrasting and result in lighter, brighter colors when the Cutout filter is later used.

■ Do the same thing with the **Set Black Point** eye dropper (the first eye dropper on the left), but make sure to click inside a part of the image where you think it should be the blackest, such as inside the front left wheel well where it is all shadow.

After you click, you should notice that the shadow areas get slightly darker, which is what you want.

■ Click **OK** to apply the settings. The image now has much more contrast.

■ Choose **Filter ➤ Artistic ➤ Cutout** to get the Cutout filter in the Filter Gallery dialog box shown in **Figure 19.3**. To meet your initial objectives, set **No. of Levels** to **8** to maximize the number of colors. Set **Edge Simplicity** to **0** as you want detail, not simplified edges. Set **Edge Fidelity** to **3** to maximize the edge detail. Click **OK** to apply the filter. If you are happy with the cutout filter effects but not with the color, the next step in this technique helps you correct that.

■ From here you can take a vast number of steps with this image. Try bumping up color saturation by choosing **Enhance ➤ Adjust Color ➤ Adjust Hue/Saturation** (**Ctrl+U/Command+U**) to get the Hue/Saturation dialog box. Try adjusting the hue, saturation, and lightness using the sliders to get an image you like. I chose to set **Hue** to **+15**, **Saturation** to **+40**, and **Lightness** to **0** to get a nice richly colored image with slightly different colors. Click **OK** to apply the settings and to get an image such as the one shown in **Figure 19.4**.

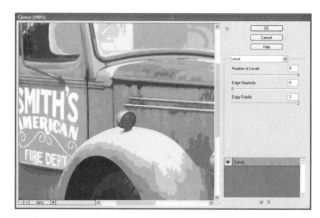

19.3

■ Create a duplicate layer by choosing **Layer** ➤ **Duplicate Layer** and click **OK**. You now have two layers in the Layers palette and the Background copy layer should be highlighted.

STEP 3: USE SELECTION BRUSH TOOL

No doubt about it — the easiest to use, and most frequently used filter effect for those new to any of the Photoshop family of products is the Poster Edges filter. If you use it, odds are good someone will look at your work and say, "Oh, you used the Poster Edges filter!" If you don't mind this — and I sometimes don't because I admit to liking the Poster Edges filter, there are times and places where it is okay to use it — you can use this filter to make some wonderful inkjet prints on fine-art paper.

■ You now want to apply the Poster Edges filter on the Background. So, click once on the thumbnail in the **Background** layer in the Layers palette to set it as the active layer.
■ Click the **Layer Visibility** icon in the left column of the **Background copy** layer to hide that layer.

One of the problems with the Poster Edges filter is that some images (such as this one) need to have different settings applied to different parts of the image. The solution is to use the wonderful and quick Selection Brush tool. Using the Selection Brush tool you can apply the optimal settings to each part of the image. In this image, you want to use one Poster Edges setting for the trucks because they have smooth tonal ranges and few details and a second setting for areas covered by grass and tree leaves because of their large amount of detail. The Selection Brush tool is as it sounds — a tool that allows you to quickly create a selection by simply painting with a brush.

■ Select the **Selection Brush** tool (**A**) by clicking it in the Toolbox.
■ Click the **Brush Presets Picker** box (the downward arrow to the right of the brush stroke image) on the Options Bar and select the **Soft Round 200 Pixels** brush. If your palette does not look like the one in **Figure 19.5**, click the menu icon (the tiny triangle on the right side of the Brushes dialog box) and select **Reset Brushes**. Click once more on the menu icon and select **Small Thumbnails**.

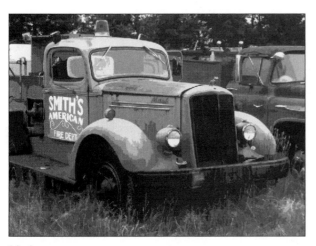

19.4

19.5

- The Options Bar should now show Size as **200 px**. For **Mode**, select **Mask**; keep **Hardness** as **0%** and **Overlay Opacity** as **50%**; and **Overlay Color** should be shown as a red color. Click now and drag your cursor to paint with a red color, much like a rubylith — the default color of the mask. Keep clicking and dragging until you paint all of the leaves and the grass. After you are done, your mask should look similar to the one shown in **Figure 19.6**.

- To turn off the mask, click in the **Mode** box on the Options Bar and select **Selection**. You now see a selection marquee showing you where you want to apply the **Poster Edges** filter to the trucks.

- Choose **Filter ➢ Artistic ➢ Poster Edges** to get the Poster Edges filter in the Filter Gallery dialog box shown in **Figure 19.7**. If you click inside the image preview box inside the **Poster Edges** dialog box, the cursor turns into the Hand tool. You can now click and drag the image to pick an area where you can best judge the settings. Here you are going to set the filter for the truck. Click and drag until you can view the Mack emblem on the side of the hood.

- Assuming that you agree that you want a nice level of posterization with medium heavy lines, try the settings of **4**, **3**, and **6** respectively for **Edge Thickness**, **Edge Intensity**, and **Posterization**. To turn the Poster Edges filter on and off to view the changes, click the eye icon at the left of the **Poster Edges** layer at the bottom-right of the **Filter Gallery** dialog box. Click **OK** to apply the settings.

- Invert the selection by choosing **Select ➢ Inverse (Shift+Ctrl+I/Shift+Command+I)**.

- Choose **Filter ➢ Artistic ➢ Poster Edges** to get the Poster Edges filter in the Filter Gallery dialog box once again. Click inside the image preview box and drag the image until you see the bottom-left corner of the image. Try setting **Edge Thickness**, **Edge Intensity**, and **Posterization** to **0**, **0**, and **5** respectively.

- Click **OK** to apply the settings, which makes the areas covered with grass and leaves have similar, but not as strong, characteristics as the portion of the image with the fire trucks.

- Choose **Select ➢ Deselect (Ctrl+D/Command+D)** to remove the selection marquee.

- To further enhance the filter you just applied, choose **Enhance ➢ Adjust Lighting ➢ Levels**

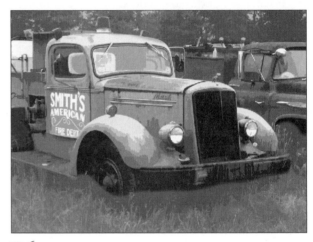

19.6

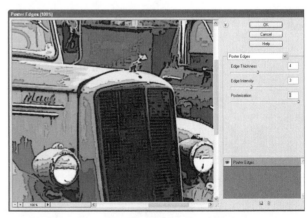

19.7

(**Ctrl+L/Command+L**) to get the Levels dialog box. Set **Input Levels** to **20, 1.00,** and **235** respectively to increase image contrast, and then click **OK**.

STEP 4: BLEND LAYERS

■ In the Background, you now have an image created with the all-too-common Poster Edges filter. On the Background copy layer, you have an image created with the Cutout filter. Now blend them to get a hybrid that will keep most people guessing as to how the image was created.

■ Click the **Background copy** layer in the Layers palette to make it the active layer. Click the **Blend Mode** box and choose **Linear Burn** as the blend mode to darken the image. Reduce **Opacity** to about **30%** to lighten the image. The **Layers** palette should now look like the one shown in **Figure 19.8**.

The image now looks entirely different. Try other blend modes and vary the **Opacity** setting. By doing this, you get a good idea of the immense number of combinations that you can put together. After you find a blend mode that you like, you can get the exact effect you want by adjusting the **Opacity**. Should you want, you can even add a third or fourth layer and another filter or two to the stacked layers. Adobe Photoshop Elements 3.0's new Filter Gallery is an

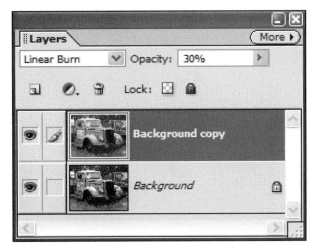

19.8

excellent feature to use to create stacked layers. Notice that you can click the **New Layer** button at the bottom of the Filter Gallery dialog box and add additional layers, each created with different filters from the Filter Gallery.

The final image is probably not one you want to print out, but with these tips, you are on your way to becoming a master of using filters. Use these tips as "starter" ideas for coming up with your own ideas on how you can get the most from Elements' filters. Before going on to the next technique, see if you can create one or more cool looking images of the two fire trucks.

DISTORTING IMAGES FOR FUN AND FOR PROFIT

20.1 (CP 20.1)

20.2 (CP 20.2)

ABOUT THE IMAGE

"Yellow-Eyed Pussy Cat," Canon EOS 1D, 180mm Macro f/2.8, f/9.0 @ ¹⁄₂₀ sec, ISO 200, 16-bit RAW format, 2,160 x 1,440 pixels, edited and converted to an 18-bit, 2,070 x 1,656 pixel, 19.6MB .tif

Talk about doing something just for the fun of it — well, that is the title of this chapter. In this technique you learn about a number of filters and features that you can use to distort images. While you will be using a few pet portraits for this technique, you can also apply the same effects to people portraits. You won't find any people portraits distorted in this book but I'm sure you can imagine how much fun it would be to distort people, too! The objective of this technique is to turn the image shown in **Figure 20.1** (**CP 20.1**) into something similar to **Figure 20.2** (**CP 20.2**).

STEP 1: OPEN FILE

■ Select **File ➢ Open (Ctrl+O/Command+O)** to display the Open dialog box. Double-click the **\ch03\20** folder to open it and then click the **cat-before.tif** file to select it. Click **Open** to open the file. If you want to work with the original RAW file, you can find it in the **\ch03\20** folder. It is named **cat-beforeRAW.TIF**.

STEP 2: MAKE EYES GREEN

When you tell human models you are taking photographs of them to use in a book to show how software can be used to distort their face, they tell you they won't sign a model release and to just forget about using a photo of them. Lucky for me, I have a cat that has always been willing to be in my books. Her demands were a little higher this time, however. Normally she just requires that I feed her well and pet her whenever she wants, but this time the extra request was that she be given green eyes. So the next step is to give in to her demands and turn her eyes green. This demand is quite useful because you'll get to learn about another cool and useful tool: the Replace Color feature.

■ To limit the color change to just the eyes, you need to first select the eyes. You could use the **Selection Brush** tool, but it works on 8-bit images only and this one is 16-bit. So, try using the **Elliptical Marquee** tool. After clicking the **Elliptical Marquee (M)** tool in the Toolbar, make sure that the **Add to Selection** option is turned on in the Options Bar.

■ Click once outside each eye and drag the selection marquee around just the yellow parts of both eyes. You don't have to be too precise — just make sure you select all the yellow.

■ Select **Enhance ➢ Adjust Color ➢ Replace Color** to get the Replace Color dialog box shown in **Figure 20.3**. Set **Fuzziness** to **200** and make sure **Image** is selected below the preview image in the dialog box. To select the yellow parts of the eyes, you can either click in the yellow in the preview box or in the image in the Elements workspace. As you click different parts of the eye, you

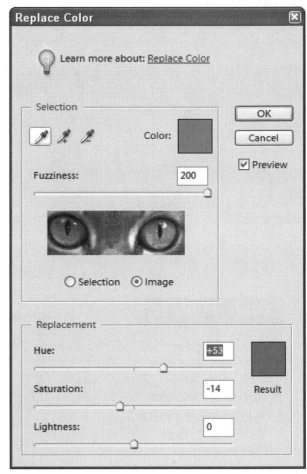

20.3

can usually improve the color selection. To change the color of the eyes to green, slide the **Hue** slider to about **+53** and the **Saturation** slider to **about −14**, and leave **Lightness** set to **0**. Click **OK** to change her eyes from yellow to green.

■ Select **Select** ➢ **Deselect** (**Ctrl+D/ Command+D**).

STEP 3: DISTORT HEAD SHAPE

■ Click the **Elliptical Marquee** tool in the **Toolbox**. Click near the ear on the left and drag the cursor down toward the right to make a selection like the one shown in **Figure 20.4**.

■ You now need to change the image to an 8-bit image as you will be using several tools that don't work on 16-bit images. Select **Image** ➢ **Mode** ➢ **Convert to 8 Bits/Channel**.

■ Select **Filter** ➢ **Distort** ➢ **Pinch** to get the **Pinch** dialog box shown in **Figure 20.5**. Set **Amount** to about **60%**; click **OK** to apply the distortion.

■ Select **Select** ➢ **Deselect** (**Ctrl+D/ Command+D**) to remove the selection marquee.

> **TIP**
>
> Select Filter ➢ Distort and take a look at all the Distort filters. Many of these are worth experimenting with on images where you want to chane the shape of all or a portion of the image. In particular, try out the Shear, Spherize, Twirl, and Liquify filters.

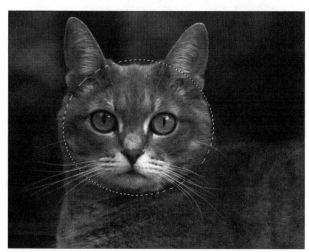

20.4

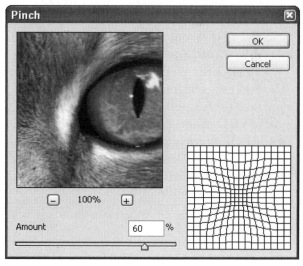

20.5

STEP 4: PERFORM MINOR PLASTIC SURGERY ON THE NOSE

■ Once again, you want to limit the effects you will be applying to just the nose part of the cat, so you will first select the nose area. One other advantage of doing a selection before using the **Liquify** filter is that it can be a RAM-demanding tool. When you work only on a portion of an image, your effects will be applied faster. Click the **Lasso** tool in the **Toolbox**. Click near the cat's nose and drag the cursor to make a selection like the one shown in **Figure 20.6**.

■ Select **Filter** ➢ **Distort** ➢ **Liquify** to get the **Liquify** dialog box shown in **Figure 20.7**. On the left side of the dialog box you will find many wonderful tools for distorting an image. All of these are worth trying on this image or another image. When you try a tool and you don't like the results, you can click the **Reconstruct** tool (**E**) and paint the image back as it was before you applied any distortion. If you want to back up one step to when you last clicked, you can press **Ctrl+Z/ Command-Z**. To reduce the size of the cat's nose, click the **Pucker** tool (**P**), which is the fifth tool down. Set **Brush Size** in the **Tool Options** area to **200**. Click once with the tool's circle cursor centered over the center of the cat's nose. The longer you hold the cursor there, the more the nose gets puckered! Don't make it too small.

■ Click **OK** to apply the effects.

■ Select **Select** ➢ **Deselect** (**Ctrl+D/ Command+D**) to remove the selection marquee.

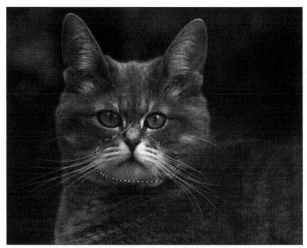

20.6

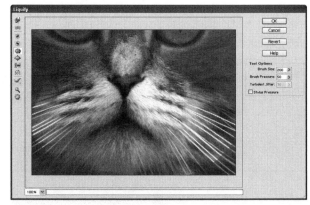

20.7

STEP 5: MAKE A PAIR OF POINTED EARS AND MAKE MORE ELEGANT EYES

■ Select **Filter** ➢ **Distort** ➢ **Liquify** to get the **Liquify** dialog box once again. Click the **Pucker** tool (**P**) and set **Brush Size** to **200**. Click and hold the tool on each ear until you make both ears pointed like the ones you see in **Figure 20.2** (**CP 20.2**).

■ Click the **Warp** tool (**W**) and drag the corner of both eyes up and away from the nose to give the cat a more slanted and elegant set of green eyes. I think this is good enough.

■ Click **OK** to apply the effects and get an image similar to **Figure 20.2** (**CP 20.2**). For those of you that thought that a dog should have been used for this technique instead of a cat, check out the dog in **Figure 20.8**. Oh yes — **Figure 20.9** shows another version of the dog. How much fun do you think he would be to walk around the neighborhood? **Figure 20.10** gives you an idea of what can be done if you are into slimming down! Before Photoshop Elements surgery, this donkey was one very fat chump.

The title of this technique is "Distorting Images for Fun and for Profit." You may be thinking, "Okay, this may be fun to someone, but how do you distort for profit?" Just think about all the photos you've taken of people who tell you they don't like the photo because it makes their chin look too big, their legs too fat, their arms too fat, or possibly even that they just look too skinny! Every day supermodels are "Photoshopped" to look like supermodels. There is no reason why you can't profit a little bit by performing some minor improvements to ordinary people who want photos that make them look the way they want to look. Trust me — money, friendship, and gratitude await you if you become an expert on the features you learned about in this technique.

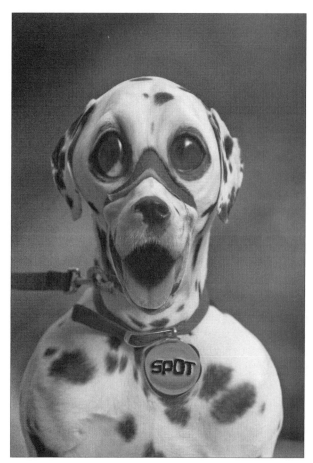

20.8

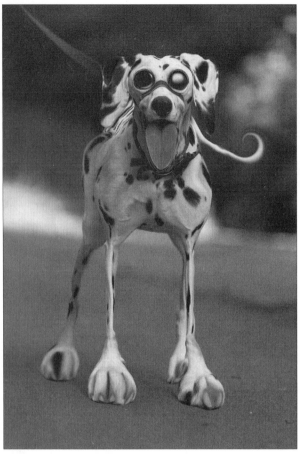

20.9

TIP

When you are looking for ways to modify the shape of elements in an image, you should first check out the tools in the Distort menu. One of the most useful distortion tools found in the Distort menu is the Liquify filter. Other tools include Pinch, Polar Coordinates, Ripple, Shear, Spherize, Twirl, Wave, and ZigZag. Other useful image shape tools can be found in the Image ➢ Transform menu. Most of these filters need to be applied to a layer and some feathering of the edges is necessary to get good effects.

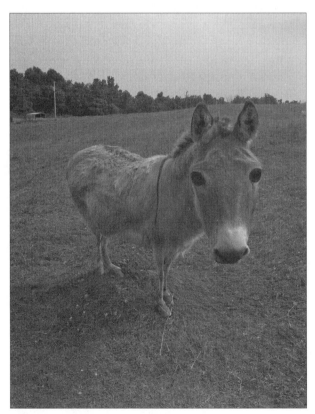

20.10

PLACING AND FORMATTING TEXT ON PHOTOGRAPHS

21.1 (CP 21.1)

ABOUT THE IMAGE

"Malena's Italian Garden Party," Canon EOS 1D Mark II, 70–200mm f/2.8 @ 200mm, f/2.8 @ ¹/₁₀₀ sec, ISO 100, 16-bit RAW format, 3,504 x 2,336 pixels, also available as a converted .jpg

The ability to add type to a photograph is a valuable skill. Whether you are designing your own wine labels, adding type to a photographic poster, putting text over an image for use as a business card, making a slide show title image, or creating an invitation to a garden party, knowing how to use the flexible set of type features in Adobe Photoshop Elements 3.0 will prove to be useful.

In this technique, you learn how to add text to make the garden party invitation shown in **Figure 21.1** (**CP 21.1**). While this is a simple task, I urge to you follow the technique step by step. Not only will you be adding text to the invitation, but you will also get a free tour of many of the type features. With this knowledge your creative talent should be sparked for your next project involving text.

STEP 1: OPEN FILE

■ Select **File ➢ Open** (**Ctrl+O/Command+O**) to
display the Open dialog box. Double-click the
\ch03\21 folder to open it and then click the **iris-
before.CR2** file to select it. Click **Open** to open
the file in Camera RAW Converter. Alternatively,
you can open **iris-before.jpg** if for one reason or
another you choose not to start off with a 16-bit
RAW file.

■ If you choose to use the RAW image file, choose
the same Camera RAW Converter settings shown
in **Figure 21.2**. Note that the **Depth** is set to **8
bits/Channel** because Elements 3.0 does not sup-
port layers, which you use in this technique. Click
OK to open the image.

STEP 2: SIZE IMAGE

■ To size the image so that two invitations can be
printed on a single 8 ½" x 11" page, select **Image ➢
Resize ➢ Image Size** to get the Image Size dialog
box shown in **Figure 21.3**.

TIP

While taking photographs, you should always
think about how you might want to use them and
also how you might frame them appropriately. If
you want a vertical print, then orient your camera
vertically. Likewise, if you plan on making a hori-
zontal print, shoot normally. If you want to make
prints on standard size photo paper, make sure
you shoot so the image can be cropped to meet
the needed height and width proportions. When
there is a chance you might want to have a photo
on a cover of a magazine, you usually need to
shoot vertically and leave open space for text.
While the photo shown in Figure 21.1 (CP 21.1)
may seem to be oddly framed, it actually was
framed to leave a large open space for text so
that the image can be used as a cover image for a
slideshow. Without some preshoot planning, you
may end up with wonderful photos, but never-
theless photos that don't suit your purposes.

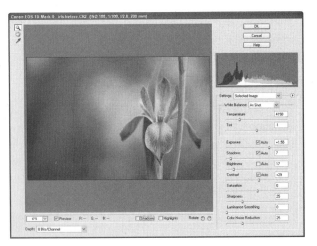

21.2

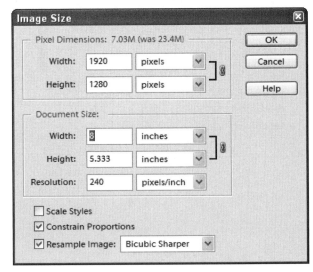

21.3

- Make sure there is a checkmark next to **Constrain Proportions** and **Resample Image**. Choose **Bicubic Sharper** as the interpolation method.
- Type **8** in the **Width** box in the **Document Size** area and make sure the **increment** is set to **inches**. **Height** will automatically be changed to **5.333 inches**. Click **OK** to resize the image.

STEP 3: ADD TEXT FOR MAIN HEADING

You'll now add the main heading text. Because the main heading text will be different from the rest of the text in terms of font, image size, and style you will first create a layer with the main heading text and then create a second layer for the rest of the text.

- Click the **Horizontal Type** tool (**T**) in the **Toolbox**.
- Depending on your screen resolution you may want to zoom the screen in to 100 percent, or just so that the image just fits on the screen. It's important to be able to clearly view the text. Either select **View ➢ Fit on Screen** (**Ctrl+0/Command+0**) or **View ➢ Actual Pixels** (**Alt+Ctrl+0/Option+ Command+0**). You can press the **Spacebar** to get a temporary **Hand** tool (**H**); then, click and drag the image so that you have a clear view of the left half of the image where the text will be placed.
- In the **Options** bar you will see that there are quite a few options. Take a minute to investigate each option. Before clicking the image with the **Horizontal Type** tool, the **Options** Bar should look similar to the one shown in **Figure 21.4**. The first group of icons showing a set of T's allows you to choose between horizontal and vertical type, and also horizontal and vertical type mask. The type mask feature is wonderful if you want to type

text and create a mask that will allow you to fill the masked area with a gradient, an image, a color, or pattern. To use the type mask feature you must first convert the **Background** into a layer (select **Layer ➢ New ➢ Layer From Background**) or be working on a layer because you cannot create a mask on the **Background**. For this technique, click the **Horizontal Type Tool** icon if it is not already checked.

- The next three options allow you to choose the font family, font style, and font size. Click in the first box and select a font family. I chose to use **Calipraph421 BT**, which you may or may not have on your system. If you don't have that font, choose one you like. Depending on the font family you choose, you may be offered a choice of font style in the next box. Common font styles are **Regular**, **Italic**, **Bold**, **Italic Bold**. Not all fonts have font styles, in which case you will not be able to select a font style. Click in the next box to select the font size. Choose **24pt** as font size.
- The next icon allows you to turn the **Anti-aliased** option on or off. Because the heading text is large, turning on the Anti-aliased option will make the edges of the text look smoother.
- The next group allows you to choose other font features such as Underline or Strike Through if those features are available for the font family you selected.
- Text alignment is the next group. You can choose from Left Align Text, Center Text, and Right Align Text. For this technique, click **Center Text**.
- Text **Leading** is the next option and it is an important option if you are placing text that will go on two or more lines. Text leading is the distance between the bottoms of the letters on two rows in terms of points, a measurement also used for font size. Generally, you will want to select

21.4

leading equal to about 1.2 times the font size you are using. For example, if you are using 14 point type, you would use 17 point leading. In this case, set **Leading** to **30 pt**. If you don't like the text after it has been placed, you can always change the **Leading**. When the heading is on a single line, it does not matter what the current setting is.

■ You can click the arrow in the **Color** box and choose a default color from one of the standard color palettes, or you can click in the **Color** box and get the **Color Picker**. For this technique, choose a color from the image, so click in the **Color** box to get the **Color Picker** shown in **Figure 21.5**. Click near the iris in the brightest yellow area to select a yellow color. Click **OK** to close the Color Picker dialog box. Your chosen yellow color should now show in the **Color** box in the Options bar.

■ With those settings made, the text can now be placed on the image. Remember that you chose to have the text centered so click in the middle of the open space to the left of the iris to set the type location. Type **Malena's Italian Garden Party**. The yellow text should now appear on the image.

Using the left and right cursor keys you can move the cursor to add or delete text. When the text is as you want it, click on the **Commit any current edits** icon (the check mark icon at the far right of the Options bar) to commit the text to a layer. To move the text, click the **Move** tool (**V**) and carefully click the text and drag it where you want it.

■ To make the text stand out from the background, you can add a shadow. Click in the **Styles** box in the Options Bar when the Horizontal Type tool is selected to get the Style Picker shown in **Figure 21.6**. If your Style Picker does not look like this one, click the menu button in the corner of the **Style Picker** and choose **Thumbnail View** from the pop-up menu. Click once more on the menu button and select **Drop Shadows**. Click the **Hard Edge** style. The heading text will now have a shadow background.

■ Now click back on the **Horizontal Type** tool (**T**) to open the Text Options Bar again. Just after the Styles box in the Text Options Bar is an icon for **Create Warped Text**; click it to get the Warped

21.5

21.6

Text dialog box shown in **Figure 21.7**. Click in the **Style** box to get a pop-up menu that lists the different styles you can choose; click **Flag**. You can now click on the sliders for **Bend, Horizontal Distortion**, and **Vertical Distortion** to modify the default settings. I chose to leave **Bend** set to **+50** and **Horizontal Distortion** and **Vertical Distortion** set to **0**. Click **OK** to apply the wave style to the heading text.

■ You have now learned about many of the text features and settings. If at any time you want to make changes to the settings for specific type, click the **Horizontal Type** tool to get the Options Bar and choose the settings you want to change. Notice that all of the settings apply to all of the text on the selected text layer and that there is now a text layer in the **Layers** palette.

STEP 4: ADD ADDITIONAL TEXT LAYER

■ To add the rest of the text, you will create a new text layer so that you can choose settings that are different than you used for the heading text.

21.7

Click the **Horizontal Type** tool (**T**) to make it the active tool. Click below the heading text in the middle of the open space to the left of the iris to set the text insertion point.

■ While you know you want a smaller font size, you do not know exactly what size you will need. So, click in the **Font Size** box and select **18 pt**. Type "**Featuring extraordinary opera, Italian family style food, pastries, wine, and elegant people**" and press **Enter/Return** at the end of each line. Press **Enter/Return** twice. Type "**Please join us . . .**" Press **Enter/Return** twice. Type "**12 January 2005 Giorgis Family Villa in Locana, Italy Noon till midnight**" and press **Enter/Return** at the end of each line.

■ You can click the text anywhere and make changes as needed. Once all the text is typed correctly, using the **Horizontal Type** tool, right-click on the text to get a pop-up menu and choose **Select All** to highlight all of the text. On a Mac, press and hold Option to get the menu. You need to spread the text out more to fill up the open space. You can click in the **Leading** box and choose a new leading; however, a much better (and decidedly cooler) trick is to place your cursor over the **Leading** icon to get a "scrubby slider." Yes, Adobe engineers really call it a scrubby slider. When the cursor is over the icon, it will change to a bidirectional arrow; click on it and move the cursor to the left or right until the text is spread out as you want it.

■ To make the text more readable, click in the **Color** box and choose black by clicking in the color box and dragging the cursor down to the bottom-right corner. Click **OK** to make the text black.

■ You can also emboss the text. Click in the **Styles** box on the Options Bar to get the Style Picker. Then click the menu icon and choose Bevels. Click **Simple Inner** to apply that effect to the text.

■ Press **Enter/Return** to commit the text layer.

■ Look at the **Layers** palette, which should now look like the one shown in **Figure 21.8**. If you need to move the heading text, click the appropriate text layer from the **Layers** palette to make it the active layer. Then use the **Move** tool (**M**) to click the actual text and move it where you want. Do the same thing to the rest of the text to place it exactly where you want it to be.

21.8

And, that concludes this chapter of "just for the fun of it" techniques. Next up: A chapter to help you make better people pictures.

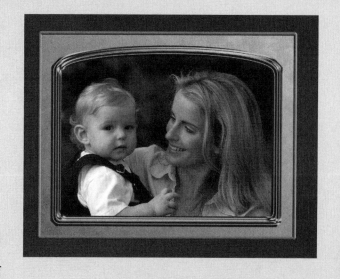

CHAPTER 4

WORKING WITH PEOPLE PICTURES

I once read that more than 80 percent of all the photos processed at one-hour photo-processing labs were photos of people. If you are one of those that enjoy taking people pictures, you'll enjoy this chapter on editing them. Technique 22 is a fun technique that converts a photographic portrait to a shaded pencil sketch. You learn how to take multiple shots of the same person and put them into a single photo in Technique 23. Making a high-key black-and-white portrait from a color photo is the topic of Technique 24, and Technique 25 offers an exceptionally good technique to add a soft-focus glamour effect. If you want to create an old-fashioned metallic frame effect, you learn how to do so in Technique 26. Technique 27 shows you how to shoot a series of group portraits and put the best faces from all the photos into a single photo. Technique 28 provides tips for beautifying a portrait of a mature woman, and Technique 29 presents a way to combine several photos to make an antique collage. If you have people photos to edit, this is a good chapter for you.

CREATING A SHADED PENCIL PORTRAIT EFFECT

22.1 (CP 22.1) 22.2 (CP 22.2)

ABOUT THE IMAGE

"Blue-Eyed Jill," Canon EOS 1D Mark II, 300mm f/2.8 IS, f/5.6 @ ¹⁄₆₀ sec, ISO 800, RAW format, converted, edited, and cropped to be a 1,200 x 1,680 pixel, 423Kb .jpg

Ever since I began using an image editor, I have found it to be challenging and fun to create different techniques that convert digital photos into more "artsy" images that resemble natural media. Technique 40 shows how to create a pen and ink sketch with a watercolor wash effect. Technique 44 presents several approaches to make line drawings from digital photos. In this technique, you learn how you can apply a shaded pencil effect to the portrait shown in **Figure 22.1** (**CP 22.1**) to create the image shown in **Figure 22.2** (**CP 22.2**).

This is a magical technique that can produce some rather outstanding images. When you have a sketch completed, you can do many other things with it such as tone the image using Hue/Saturation. You can digitally hand-paint the image, as shown in Technique 34. You can even paint back in some of the original image to make a mix between a sketch and a photograph.

STEP 1: OPEN FILE

■ Select **File ➢ Open (Ctrl+O/Command+O)** to display the Open dialog box. Double-click the **\ch04\22** folder to open it and then click the **jill-before.jpg** file; click **Open**.

STEP 2: CREATE GRADIENT LAYER

■ Select **Layer ➢ New Adjustment Layer ➢ Gradient Map** to display the New Layer dialog box; click **OK** to open the Gradient Map dialog box shown in **Figure 22.3**. Click in the gradient to

display the Gradient Editor shown in **Figure 22.4**. If your Gradient Editor does not look like this one, click **More** and choose **Small Thumbnail**. To make sure you are using the correct presets, click the **More** button and select **Reset Gradients**. Click the third gradient from the left in the top row and you should see **Black, White** appear in the **Name** box.

■ Click the **Gradient Map** dialog box title bar and move the dialog box so that you can see most of the face in the image.

■ The trick now is to set up the gradient so that the image looks like a shaded pencil sketch. To do that you need to make the center of the spectrum black with a quick transition to pure white on

22.3

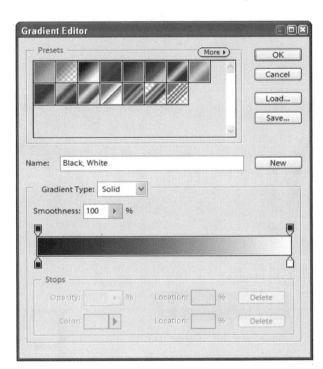

22.4

each side. Click the black **Color Stop** (the slider just beneath the spectrum at the far left) and drag it toward the middle until **Location** shows **42%**, as shown in **Figure 22.5**.

■ Click the white **Color Stop** (the slider just beneath the spectrum at the far right) and drag it toward the middle until location shows **70%**. The image is beginning to look like a shaded pencil sketch.

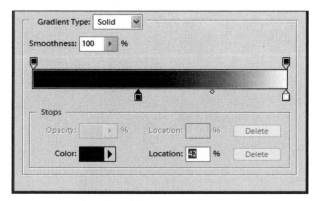

22.5

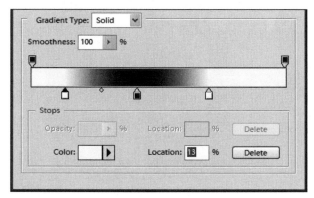

22.6

■ To make the left side of the spectrum white, click just below the spectrum to the left of the black **Color Stop** to make a new **Color Stop** and drag it until **Location** shows **13%**. The spectrum bar should now look like the one shown in **Figure 22.6**.

■ To reduce the pure white areas to show some tone, double-click the white **Color Stop** on the left to display the Color Picker shown in **Figure 22.7**. Type **252** in the **R**, **G**, and **B** boxes and click **OK**. Do the same thing to the right white **Color Stop**. Use the same value of **252**.

■ Now you need to use your artistic sense and choose how slowly or quickly the black transitions to white on both sides of the back portion of the spectrum. If you click the right white **Color Stop,** you will see a Color Midpoint represented by a tiny black diamond appear. Carefully click the diamond-shaped slider and drag it toward the left until **Location** shows **35%**. Move the slider as you watch the results on the image. Now do the same

22.7

thing on the other side of the black area. Click the left white **Color Stop** and then click the **Color Midpoint** slider that appears and drag it to the right until **Location** shows about **56%,** as shown in **Figure 22.8.** You can see the wonderful soft smearing of tones that is being created in the detail image shown in **Figure 22.9.**

■ Click **OK** to close the **Gradient Editor.** Click **OK** to close the **Gradient Map** dialog box.

22.8

STEP 3: ADD BLUE COLOR TO EYES

■ Now add a small amount of color to the image. How about adding some blue color to her eyes? Select **Layer ➢ Flatten Image.**

■ Select **Layer ➢ New ➢ Layer (Shift+Ctrl+N/ Shift+Command+N)** to display the New Layer dialog box. Click in the **Mode** box and choose **Color,** as shown in **Figure 22.10.** Click **OK** to create a new layer.

■ Click the **Foreground Color** box at the bottom of the Toolbox to summon the Color Picker. Type **81, 115,** and **214** in the **R, G,** and **B** boxes respectively, as shown in **Figure 22.11,** to select a nice blue eye color; click **OK.**

■ Click the **Brush** tool (**B**) in the **Toolbox.** Click in the **Brush Presets** box in the Options bar and choose the **Hard Round 19 Pixels** brush. Make sure **Mode** is set to **Normal** and **Opacity** to **100%.**

■ Using the **Brush** tool, paint each eye blue. If you want to fine-tune the color of the eyes, select **Enhance ➢ Adjust Color ➢ Adjust Hue/ Saturation (Ctrl+U/Command+U)** and adjust as you want. I liked the settings of **–16, –22,** and **0** for **Hue, Saturation,** and **Lightness** respectively. Click **OK** to apply the changes.

■ Select **Layer ➢ Flatten Image** to display an image that looks like **Figure 22.2 (CP 22.2).**

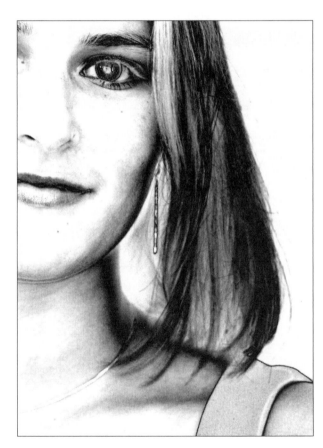

22.9

22.10

22.11

TIP

Some image editing techniques work better if they are first performed on an image that is much larger than the needed size; then, after the technique has been completed, the image is reduced in size using the Image Size command. Reducing an image can sometimes make colors blend better, or make lines become less rough, or just make the image look better in an undefined way. You may even want to apply a soft Gaussian Blur before reducing the image size to smooth the effects even more. Reducing the image size will help to make the image look slightly more sharp and smoother in tone.

PUTTING THE SAME PERSON
INTO A PHOTO MORE THAN ONCE

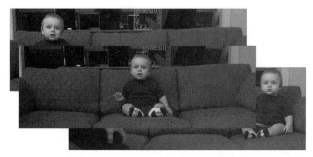

23.1

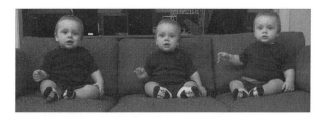

23.2

ABOUT THE IMAGE

"You Didn't Tell Me You Had Triplets!" Canon EOS 1D Mark II, 28–80mm f/2.8 @ 40mm, f/4.0 @ ¹/₃₀ sec, ISO 800, 16-bit RAW format, 3 photos converted, cropped, and edited to be 2,880 x 1,005 pixel, 230Kb .jpg

The three photos in **Figure 23.1** were taken to be digitally combined into one photo as shown in **Figure 23.2**. If you don't have a child or grandchild to make a photo like this one, put on your creative hat and just think of what other subjects you might want to use. Do you know someone that you think has three personalities? Maybe someone you know is a dad, an executive, and he rides a Harley Davidson motorcycle in strange garb every chance he gets. Ask him to dress for each of those personalities and shoot them in the same scene and put each of those personalities into a single photo. Alternatively, maybe you have a pet that you can't control and you feel like it is all over the place all the time. Take several shots of your pet and put two or more images of your pet in the same photo. Ever wanted to have a photo of a family member at different ages in the same photo — this is the technique to use. If you have a child, take a photo of him or her every year in the same room. After a few years, you could, for example, have a photo of your four year old playing in a room with two other kids. The two other kids being your child when he was three years old, and when he was two years old! Ah — the possibilities are endless.

STEP 1: OPEN FILES

■ Select **File ➢ Open** (**Ctrl+O/Command+O**) to display the Open dialog box. Double-click the \ch04\23 folder to open it. Click the first image in the folder (**baby-left.jpg**). Press and hold **Shift** while clicking the last image in the folder (**baby-right.jpg**) to select all three images. Click **Open** to open the three images. All three images will be stacked on top of each other. You can click and drag them to arrange them so that you can see all three images.

STEP 2: COMBINE ALL THREE PHOTOS

■ Make sure that part of the **baby-left.jpg** image is visible.
■ Click the **Move** tool (**V**) in the **Toolbox**.

> **TIP**
>
> Have you wanted a family portrait, but you can never seem to get all the family together at the same time? Choose a place for a family portrait that allows you to have similar light and identical settings. Shoot different family members whenever you can shoot them and then combine them using the steps shown in Technique 23. Avoid scenes that include features such as a dining table where it would be difficult if not impossible to arrange the seating, table settings, and people so that they looked like they were all shot at the same time. A good scene choice might include a living room wall with a fireplace mantel, fixed paintings, and consistent lighting. With some planning and time you can make a perfect family photo that may be better than if you tried to shoot and capture everyone smiling at the same time.

■ Click the **baby-middle.jpg** image to make it the active image. Press and hold **Shift** and click in the **baby-middle.jpg** image and drag it onto the **baby-left.jpg** image to center it precisely in the **baby-left.jpg** image. Pressing **Shift** when you drag and drop the image makes the images line up precisely.
■ Click the **baby-middle.jpg** image to make it active. Select **File ➢ Close** (**Ctrl+W/Command+W**) to close the image as it is no longer needed. When presented with a dialog box asking if you want to save the image before closing, click **No**.
■ Click the **baby-right.jpg** image to make it the active image. Press and hold **Shift** and click the **baby-right.jpg** image and drag it onto the **baby-left.jpg** image to center it precisely in the **baby-left.jpg** image.
■ Click the **baby-right.jpg** image to make it active. Select **File ➢ Close** (**Ctrl+W/Command+W**) to close it as it is no longer needed. When presented with a dialog box asking if you want to save the image before closing, click **No**. You should now have the **Background** and two layers in the Layers palette, as shown in **Figure 23.3**.

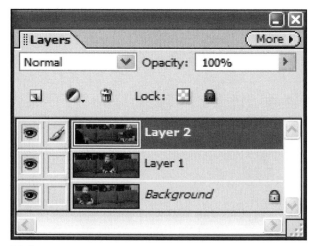

23.3

STEP 3: CUT OUT PARTS OF TOP TWO LAYERS

To reveal the baby sitting on each of three different sofa sections you must simply cut out the parts of the top two layers that are hiding the underlying baby!

- Select **View ➢ Fit on Screen** (**Ctrl+0/Command+0**).
- Click the **Rectangular Marquee** tool (**M**) in the **Toolbox**.
- Make sure that **Layer 2** is still the active layer. It should be highlighted in blue. Click just outside the top left of the image and drag the selection marquee down toward the right to select the portion of the image shown in **Figure 23.4**.
- Select **Edit ➢ Cut** (**Ctrl+X/Command+X**) to cut out the top part of the top layer and expose the baby in the next layer down. You now have a photo showing two babies.
- You'll now do the same thing to **Layer 1**, but you need to cut out only the left section of the couch to reveal the baby on the **Background**. Click **Layer 1** in the **Layers** palette to make that layer the active layer. Click just outside the top-left of the image and drag the selection marquee down toward the right to select the portion of the image showing just the left section of the coach.

- Select **Edit ➢ Cut** (**Ctrl+X/Command+X**) to cut out the top part of the top layer and expose the baby in the next layer down. The image should now look like the one shown in **Figure 23.5**. If you did not cut the right amount of the image out, simply click the previous state in the **Undo History** palette, or select **Edit ➢ Undo Cut Pixels** (**Ctrl+Z/Command+Z**) and try again.

STEP 4: MAKE ADJUSTMENTS TO EXPOSURE

When I took the photos, I did not watch the light carefully enough, as you can see that the left one-third of the image is much brighter than the right two-thirds of the image—that is not good. When I checked the EXIF data, I found that the exposure was the same for all three shots. After a closer examination of all three photos, I can see my friend was blocking the light on the last two shots as he was getting ready to catch his baby if the baby leaned forward.

With that explanation for the difference in exposure, you can now proceed to fix it. This is a good lesson as you may find that it just isn't possible in many circumstances to get the same exposure, and the "fix" here may help you later.

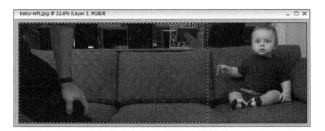

23.4

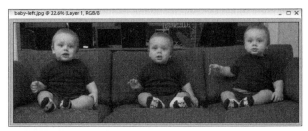

23.5

■ To make the exposure on the left side of the image match that of the right you will create an adjustment layer. First, enlarge the image so that you can clearly see the difference between the two exposures, as shown in **Figure 23.6**.

■ Click the **Background** in the **Layers** palette. Select **Layer** ➤ **New Adjustment Layer** ➤ **Levels** to display the New Layer dialog box; click **OK** to display the Levels dialog box. Click the **Midtone slider** and drag it toward the right while watching the line between the two images and stop when it disappears. A setting of **0.78** looks about right to me. The fabric on the left side of the couch now matches that of the right-side, but the left baby's face is now too saturated. You could try to fix that by adjusting the highlights, but as you used an adjustment layer, first see what happens when you apply the setting and change the blend mode. Click **OK** to apply the settings.

■ Click in the **Blend Mode** box in the **Layers** palette and select **Luminosity** to limit the **Levels** changes you just made to luminosity and not color. That is a good match now. If more changes are needed, double-click the **Levels 1** layer in the **Layers** palette, as shown in **Figure 23.7**, and change the **Levels** settings.

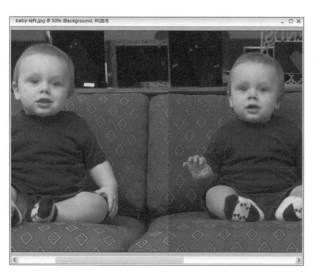

23.6

23.7

- Select **Layers ➢ Flatten Image**. You now have one image showing the same baby three times, as shown in **Figure 23.2**! If you want to make any further adjustments to the image, now is the time to make them.

I think this technique offers tremendous possibilities. What ideas do you have? If you create a cool image using this technique, please send a small .jpg image in an e-mail to me at `ggeorges@mindspring.com`. If it is a good one, I'll post it on this book's companion Web page and send you a link.

TIP

When taking photos to be merged into a single image, you should use the same exposure settings so that you don't have to make any unnecessary tonal adjustments. The best way to do this is to choose an appropriate aperature setting and have the camera's exposure meter determine the shutter speed to yield a good exposure. Make a mental note of those settings and then set your camera to manual exposure and use those settings to take pictures. This will ensure that each shot is exposed the same. Likewise, you may want to use autofocus to initally focus on your subject; then, choose manual focus to keep the focus constant to eliminate any possible differences between photos when you are shooting with a tripod and your intent is to shoot the same scene. This will prevent the autofocus feature from causing you to capture images that have different depths of field, which are a challenge to match when compositing them.

CONVERTING A COLOR PORTRAIT TO HIGH-KEY BLACK AND WHITE

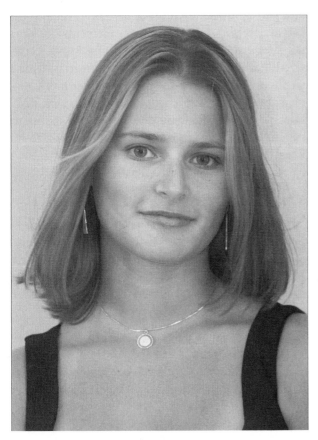

24.1

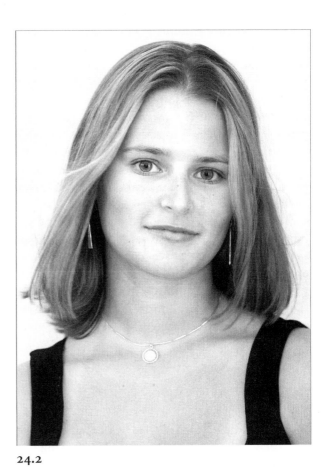

24.2

ABOUT THE IMAGE

"Blue-Eyed Jill," Canon EOS 1D Mark II, 300mm f/2.8 IS, f/5.6 @ ¹⁄₆₀ sec, ISO 800, RAW format, converted, edited, and cropped to be 1,200 x 1,680 pixel, 423Kb .jpg

I'll admit it. I've always been fascinated with the incredible photographs that are usually shown in magazines such as *Elle*, *Cosmopolitan*, *People*, *In-Style*, and other fashion and celebrity-oriented magazines. As a photographer, I enjoy looking at how today's leading photographers take portraits of beautiful and famous people. As an Adobe Photoshop user, I'm always looking for techniques that are likely to be used to make all those famous and beautiful people look as good as they do when I know that many of the pictures are often far removed from reality.

137

In this technique, you learn how to convert a color photograph into a glamorous black-and-white photo. You might be wondering what kind of tip could help you convert a color image into a black-and-white image, as the conversion can be as easy as selecting **Enhance ➢ Adjust Color ➢ Remove Color** when using Adobe Photoshop Elements 3.0. While effective in removing color, this simple approach gives you no control over what shade of gray each color becomes. For example, if you have an image with brightly colored flowers showing against rich green leaves, a simple black-and-white conversion could turn all the flowers *and* the green leaves into the same shade of gray, which would cause the flowers to become lost amidst the same-gray toned leaves.

When converting a color portrait like the one shown in **Figure 24.1**, the goal is often to choose settings that convert the skin color to be as light a tone as possible to make the face look smooth and glamorous. When using just the **Remove Color** command, you do not have this control. In this technique, you learn how to gain fine control over the conversion process to produce an image like the one shown in **Figure 24.2**.

STEP 1: OPEN FILE

■ Select **File ➢ Open** (**Ctrl+O/Command+O**) to display the Open dialog box. Double-click the **\ch04\24** folder to open it and then click the **jill-before.jpg** file; click **Open**.

The **jill-before.jpg** image is the result of having converted a RAW image file to an 8-bit .jpg file. During that process, considerable valuable picture information was lost and the image suffered some degradation when undergoing the change to the lossy .jpg format. The reason that this image is a .jpg file instead of the more useful RAW file is that the two different approaches you take here both require the use of layers. Adobe Photoshop Elements 3.0 does not support layers when working on a 16-bit image. In addition, I felt that it was important to provide a technique for .jpg images, as there are far more people shooting .jpg format than there are using RAW files. To learn more about RAW files and the many benefits of shooting in RAW mode and editing 16-bit images, read Technique 2 and Technique 4.

STEP 2: TRY THE REMOVE COLOR COMMAND

Because it is so easy to apply the Remove Color command and make a few quick adjustments with Levels, you will do that first so that you have a reference image to compare against the other two conversion techniques you learn here.

■ Select **Layer ➢ Duplicate Layer** to display the Duplicate Layer dialog box. Type **Remove Color** in the **Name** box so that you can remember how the image on this layer was created; click **OK** to create a new layer.

■ Select **Enhance ➢ Adjust Color ➢ Remove Color** (**Shift+Ctrl+U/Shift+Command+U**) to remove all color. The image should look like the one in **Figure 24.3**.

■ Your goal is to end up with an image that has good contrast with a soft light-toned face. Now

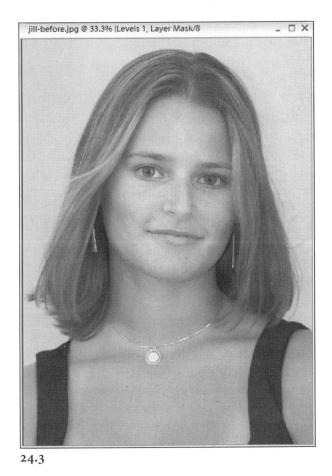

jill-before.jpg @ 33.3% (Levels 1, Layer Mask/8)

24.3

make a few simple adjustments with Levels. Select **Layer ➢ New Adjustment Layer ➢ Levels** to display the New Layer dialog box; click **OK** to display the Levels dialog box. Drag the **Highlight** slider toward the left to about **221** to create a bright white background and to lighten the face. Click the **Shadow** slider and drag it toward the right to about **29**. You can further lighten the face by clicking the **Midtone** slider and dragging it toward the left to about **1.24**, as shown in **Figure 24.4**. Click

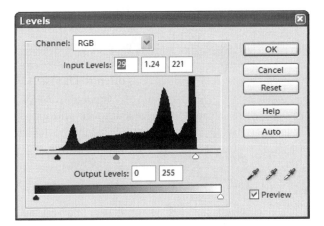

24.4

OK to apply the settings. The image should now look like the one shown in **Figure 24.5**. This will be your standard. Now see if you can do better than this by trying two more approaches.

■ Click **Levels 1** in the **Layers** palette to make it the active layer. Select **Layer ➢ Merge Down** (**Ctrl+E/Command+E**) to merge the **Levels** layer to the **Remove Color** layer.

■ Click the **Layer Visibility** icon to the left of the **Remove Color** layer to turn off the layer for now. You will later use this layer to compare the results.

You should now be looking at the original color image once again.

STEP 3: CONVERT USING GRADIENT MAP

You will now take a different approach to converting the color image to black and white that should help you get a softer tone in the highlights and make the face smoother than the one you just got using the Remove Color command.

■ Click **Background** in the **Layers** palette to make it the active layer.

■ Select **Layer ➢ New Adjustment Layer ➢ Gradient Map** to display the New Layer dialog box; click **OK** to display the Gradient Map dialog box shown in **Figure 24.6**. Click in the gradient to display the Gradient Editor shown in **Figure 24.7**. To make sure you are using the correct presets, click the **More** button and select **Reset Gradients**. Click the third gradient from the left in the top row and you should see **Black, White** appear in the **Name** box.

■ Click the **Gradient Map** dialog box title bar and move the dialog box so that you can see most of the face in the image.

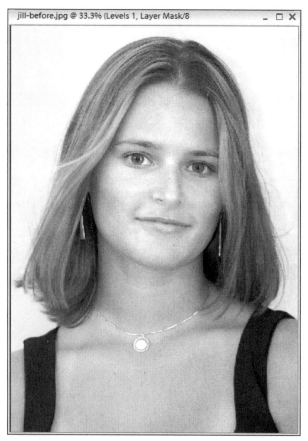

24.5

24.6

■ To force the background to turn white and to lighten the face tones, click on the right **Color Stop** (the extreme right slider beneath the gradient at the bottom of the Gradient Editor box). Slide it until **Location** shows **83%**. To darken the shadows and increase contrast, click the left color stop (the extreme left slider beneath the gradient) and drag it toward the right until **Location** shows about **5%**. Notice the tiny diamond-shaped marker between the two stops that were just set. This is a Color Midpoint. Very carefully click it and drag it toward the left until **Location** shows **40%**. This setting requires that you add a little more contrast by clicking the extreme left slider once more and moving it a little more to the right to where **Location** shows **10%**. Click **OK** to apply the settings. Click **OK** to close the Gradient Map dialog box.

■ Click the **Remove Color** layer and drag it to the top of the **Layers** palette, as shown in **Figure 24.8**. Click the **Layer Visibility** icon to the left of the **Remove Color** layer to turn it on and off to compare the results of the **Remove Color** command with the results you just got using the **Gradient Map**. You can see that you have much more control with the tonal range using the **Gradient Map** approach. If this image had more color, you would find that the Gradient Map would give you even more control over the conversion process than the **Remove Color** command. Turn off both the **Remove Color** layer and the **Gradient Map** layer by clicking the **Layer Visibility** icons to hide them both. You should now see the original color image once again.

24.7

24.8

STEP 4: CONVERT USING A LEVELS ADJUSTMENT LAYER

You are now going to try one additional color-to-black-and-white conversion technique. This time you will use a special **Levels** adjustment layer.

- Click **Background** in the **Layers** palette to make it active.
- Select **Layer ➤ Duplicate Layer** to display the Duplicate Layer dialog box. Type **Levels Conversion** in the **As** box and click **OK**.
- To keep the **Layers** palette organized so that you can easily compare the three approaches you have taken, click the **Levels Conversion** layer and drag it all the way to the top of the **Layers** palette.
- Click the **Gradient Map 1** layer and select **Layer ➤ Merge Down** (**Ctrl+E/Command+E**). Double-click the text **Background** in the **Layers** palette and type **Gradient Conversion** to name the layer with the technique used to create the image.
- Click the **Levels Conversion** layer to make it the active layer. Select **Layer ➤ New Adjustment Layer ➤ Levels** to display the New Layer dialog box. Click **OK** to display the Levels dialog box. Click **OK** to create the new layer above the **Levels Conversion** layer. You'll come back to this dialog box in a minute. You first have to remove the color before you can use the separate color channels in the Levels dialog box to convert colors to grayscale.
- Select **Layer ➤ New Adjustment Layer ➤ Hue/Saturation** to display the New Layer dialog box. Click in the box next to **Group With Previous Layer** to limit the settings to the **Levels Conversion** layer. Click **OK** to display the Hue/Saturation dialog box. Click the **Saturation**

slider and pull it all the way toward the left to **–100** to remove all of the color, as shown in **Figure 24.9**. Click **OK** to create the new layer above the **Levels Conversion** layer.

- Double-click the leftmost thumbnail image in the **Levels 1** layer in the **Layers** palette to display the Levels dialog box. First, you will adjust the contrast by moving the **Shadow** and **Highlight** sliders in each of the three color channels in toward the toes of the histogram. After that, you can make a few adjustments to the **Midtone** slider in each channel to get close to the gray conversion you want. Finally, you may need to adjust one or more of the **Shadow** and **Highlights** sliders to fine-tune the conversion.
- Click in the **Channel** box and select **Red** (**Ctrl+1/Command+1**) to display the red histogram. Click the **Shadow** slider and move it toward the right to the beginning of the toe of the

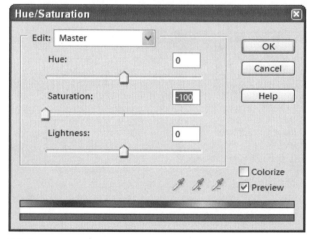

24.9

histogram until the first **Input Levels** box shows **34.** Click the **Highlight** slider and move it toward the left to the toe of the histogram. The last **Input Levels** box should now show **236,** as shown in **Figure 24.10.** Notice that the **Red** channel sliders have a more pronounced effect on the skin tone.

■ Click in the **Channel** box and select **Green** (**Ctrl+2/Command+2**) to display the green histogram. Click the **Shadow** slider and move it toward the right to the beginning of the toe of the histogram until the first **Input Levels** box shows **30.** Notice how much this slider affects the tone of the lips and the eyes. Click the **Highlight** slider and move it toward the left to the toe of the histogram until the last **Input Levels** box shows **221.** This helps to make the background lighter.

■ Click in the **Channel** box and select **Blue** (**Ctrl+3/Command+3**) to display the blue

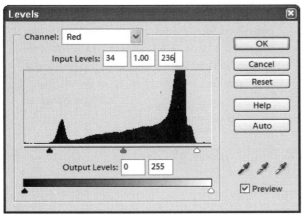

24.10

histogram. Click the **Shadow** slider and move it toward the right to the beginning of the toe of the histogram. Notice how the more you move it toward the right, the more you get an unwanted increase in contrast and undesirable detail in the face. Let's leave the **Shadow** slider set at **0** for this channel. Click the **Highlight** slider and move it toward the left to the toe of the histogram. The last **Input Levels** box should now show **225.**

■ What slider do you think will help to further lighten the face and skin tones most? If you do not want to guess, you can drag your cursor over the face, click, and hold to display the **Eye Dropper** tool. As you click and drag, you can see the color of the face tone is a pink color. That suggests that you could lighten the skin tones most easily with the **Red Midtone** slider. Click in the **Channel** box and select **Red** (**Ctrl+1/Command+1**) to once again display the red histogram. Click the **Midtone** slider and move it toward the left until the middle **Input Levels** box shows **2.0.** You can increase the contrast in the hair a bit more by clicking the **Shadow** slider and moving it toward the right to about **69.** Perfect I say. It's time to stop.

■ Click **OK** to apply the settings. Click the leftmost thumbnail in the **Levels 1** layer in the Layers dialog box and select **Layer ➢ Merge Down** (**Ctrl+E/Command+E**). Click the leftmost thumbnail in the **Hue/Saturation** layer in the **Layers** dialog box and select **Layer ➢ Merge Down** (**Ctrl+E/Command+E**). This merging combines all the settings for the **Levels** conversion technique in the **Levels Conversion** layer.

The Layers palette should now look like the one shown in **Figure 24.11**. If you click the **Layer Visibility** icon for each layer, you can then start at the top and turn each layer off to compare each different approach. Notice how much difference there is between each of these approaches and that you have so much more control when using a Gradient Map or Levels. Which image do you like best? If you were to pick the one that had the lightest glamorous look, I think the Gradient Map approach would be the winning image. On the other hand, I like the Levels Conversion image, too.

Even though these three color-to-black-and-white conversion techniques were included in a chapter on editing people pictures, these approaches can be very useful for converting any kind of color image into the grayscale image you want.

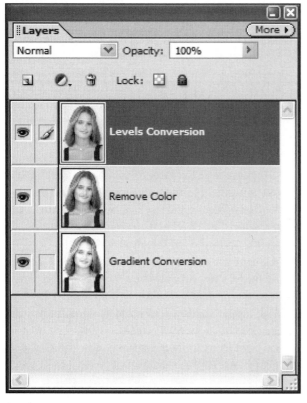

24.11

TIP

If you want to be able to control how colors are converted into shades of gray, you may want to try the wonderful Convert to B&W Pro plug-in. You can learn more about it, download a trial version, or purchase a copy at www. theimagingfactory.com. This program is highly recommended.

ADDING A SOFT-FOCUS GLAMOUR EFFECT

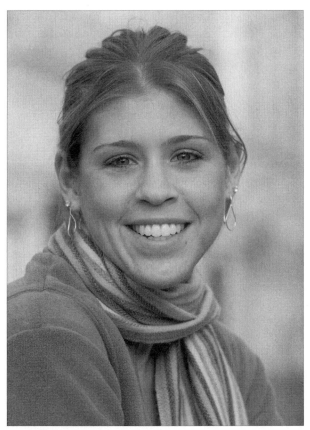

25.1 (CP 25.1)

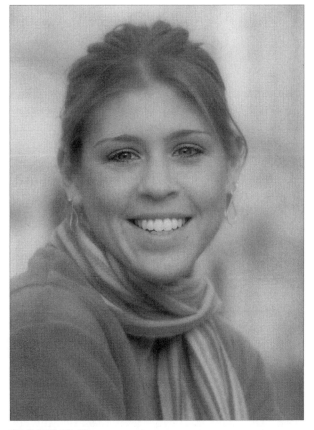

25.2 (CP 25.2)

ABOUT THE IMAGE

"Glamour at the Bellaggio," Canon EOS 1D, 70–200mm f/2.8 IS @ 130mm, f/5.6 @ $^1/_{200}$ sec, ISO 200, 16-bit RAW format, 2,160 x 1,440 pixels, converted and edited to be a 1,200 x 1,680 pixel, 8-bit, 231Kb .jpg

Soft-focused photographs produce a unique kind of image that is very flattering to subjects because you can see important details such as eyes, hair, and teeth, but the unflattering shadows that bring out undesirable skin texture, spots, bumps, and facial lines are softened to produce what has become known as a soft-focus glamour photo. Photographers have sought to achieve this desirable effect with special lenses, glass filters, special lighting, and even with Vaseline smeared on glass filters. Achieving this effect digitally is a challenge because most Photoshop techniques and plug-in filters cause blurring of important detail in the process of softening shadows. In this

technique, you learn how to achieve a wonderful soft-blur effect while retaining important detail when starting with a photo like the one shown in **Figure 25.1** (**CP 25.1**).

I must say that somebody far more clever than I am deserves the credit for the technique that you are about to learn. That person for now will go uncredited because I can't remember where I learned about the technique let alone the name of the person who came up with the brilliant idea. The technique appears be grounded in some sound mathematics because it works better than any other "soft-focus" technique that I know about and I have looked at and have tried many different actions, techniques, and plug-ins. On behalf of all of us — a very hearty, "thank you" to whomever devised this technique.

STEP 1: OPEN IMAGE

- Select **File ➢ Open** (**Ctrl+O/Command+O**) to display the Open dialog box. Double-click the **\ch04\25** folder to open it and then click the **lauren-before.jpg** file; click **Open**.

This photo was taken on a rare overcast day in front of the Bellaggio hotel in Las Vegas. It was truly a "snapshot." The young lady looked back at me facing the direction of the sun and I took the photo without any flash. The highlights in her eyes are from the sun behind the clouds. This very flattering light unquestionably helps to make the photo shown in **Figure 25.2** (**CP 25.2**) be a glamourous photo. It also shows that you do not need expensive lighting to shoot good photos. Good photos require good light and it is hard to get better light than you find outdoors on an overcast day.

STEP 2: MAKE DUPLICATE LAYER

- When the image has been softened, you will bring back some of the detail in the eyes and mouth. You therefore need a copy of the original image. Select **Layer ➢ Duplicate Layer** to display the Duplicate Layer dialog box. Type **Soft Focus** in the **As** box, as shown in **Figure 25.3**. It is this layer that you will use when applying the soft-focus effect.

STEP 3: CREATE NEW LAYER FOR BLUR

The concept of this technique is simple, but when applied to an image with Adobe Photoshop Elements 3.0 you have to repeat a 4-step process 7 times for a total of 28 steps! However, it is worth all the time it takes, as you will learn. The technique uses Gaussian Blur to soften the image by applying the blur to only the image's luminosity channel — not the color channels. To accomplish that, you have to create a series of layers, change the blend mode, apply a blur, and then flatten the image and repeat it again.

25.3

■ Select **Layer ➤ Duplicate Layer** to display the Duplicate Layer dialog box; click **OK** to create a new layer.

■ Click in the **Blend Mode** box in the **Layers** palette and select **Luminosity**, as shown in **Figure 25.4**. This is an important step, as the technique works only if you apply the **Gaussian Blur** to the luminosity channel and not to the color channels.

STEP 4: APPLY GAUSSIAN BLUR

■ Select **Filter ➤ Blur ➤ Gaussian Blur** to display the Gaussian Blur dialog box. Set **Radius** to **1.0 pixels** as shown in **Figure 25.5**. Click **OK** to apply the blur.

STEP 5: CHANGE OPACITY

■ Click in the **Opacity** box in the **Layers** palette and drag the slider to **50%**.

25.4

25.5

STEP 6: MERGE DOWN LAYER

■ Select **Layer ➢ Merge Down** (**Ctrl+E/ Command+E**) to merge the **Soft Focus copy** layer with the **Soft Focus** layer. You should now just have the **Background** layer and the **Soft Focus** layer.

STEP 7: REPEAT STEPS 3 THROUGH 6

■ You now need to repeat Steps 3 through 6, except you should use the following values for **Gaussian Blur** and **Opacity** instead of those values listed in Steps 4 and 5.

PASS	GAUSSIAN BLUR VALUE	LAYER OPACITY VALUE
2nd Blur Layer	2 pixels	33%
3rd Blur Layer	4 pixels	25%
4th Blur Layer	8 pixels	20%
5th Blur Layer	16 pixels	15%
6th Blur Layer	32 pixels	12%
7th Blur Layer	64 pixels	10%

Notice that the **Gaussian Blur** value doubles with each layer starting with the initial **1 pixel** value and doubling until it reaches **64 pixels**. The **Layer Opacity** value drops off in value from an initial value of **50%** to **10%**. The result is that the higher blur valued layers have increasingly lower **Opacity** values and you end up with a soft-blurred image like the one shown in **Figure 25.6**.

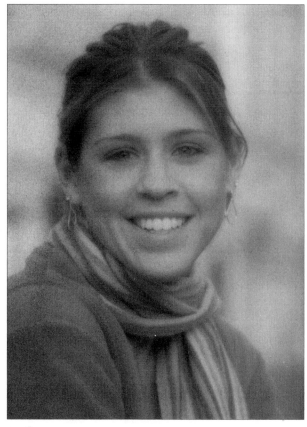

25.6

STEP 8: BRING OUT DETAILS

You now have a wonderful soft-focus glamour photo that needs a bit more detail showing in the eyes and teeth. Bringing back some detail is as easy as it is to erase part of the image.

■ Click the **Layer Visibility** icon for the **Soft Focus** layer to turn that layer off and see the

original image. Click to turn the layer back on. You can see the difference between the soft focus and the original. Pretty cool, huh?

■ Make sure that the **Soft Focus** layer is the active layer (it will be highlighted in blue); click it if it is not active. Also, make sure that the **Layer Visibility** icon is showing for the **Soft Focus** layer, too.

■ Click the **Eraser** tool (**E**) in the **Toolbox**. Click in the **Brush Presets** box in the Options bar to display the **Brush Presets** palette shown in **Figure 25.7**. If the palette does not look like this one, click the menu button found toward the upper-right corner of the palette and select **Reset Brushes** from the pop-up menu. Click the menu button again and select **Small Thumbnail**. Click the **Soft Round 65 Pixels** brush.

■ Select **View** ➢ **Actual Pixels** (**Alt+Ctrl+0/Option+Command+0**). Press the **Spacebar** and click to drag the image so that you can see most of the face.

■ Click in the **Opacity** box in the Options bar and set it to about **15%**. The Options bar should now look like the one shown in **Figure 25.8**.

■ Using the **Eraser** tool (**E**), you can now erase the blur layer to reveal the sharply focused eyes, eyebrows, and teeth from below. When erasing, you

should erase more in the middle of the eye and feather the erasing out to include the outer part of the eye and the eyebrows. You can do the same thing with the teeth and lips. If you work on one area at a time, you can use the **Undo History** palette to back up a few steps if you don't like the result you get. When you have completed erasing around the eyes and the mouth, your image should look similar to the one in **Figure 25.2** (**CP 25.2**).

25.7

25.8

ADDING A METALLIC FRAME EFFECT

26.1 (CP 26.1)

26.2 (CP 26.2)

ABOUT THE IMAGE

"Mother and Son," Canon EOS 1D Mark II, 70–200mm f/2.8 IS @ 200mm, f/5.6 @ $^{1}/_{250}$ sec, ISO 400, 16-bit RAW format, 3,504 x 2,336 pixels, converted, edited, 8-bit 874Kb .jpg

A few years ago, I spent a day visiting antique shops to look for old photographs and frames that might serve as inspiration for new Photoshop techniques. In a shop, I found several brilliant pressed metal frames. Instead of using cardboard matte in a frame like we do today, pressed metal was used. The cutout was usually a square with a curved top. Having seen many Photoshop experts spend, what is to me, a wholly unbelievable amount of time making all kinds of cool textures, mattes, and frames, I thought it should be easy to duplicate these cool-looking metallic frames — digitally.

In this technique, you take the photo of the mother and her child shown in **Figure 26.1** (**CP 26.1**) and put them in a digitally created metallic frame, as shown in **Figure 26.2** (**CP 26.2**). Even if you do not want to make prints with this kind of a frame, the technique should inspire you to make your own frames and use them on your photographs in an online photo gallery. To learn how easy it is to make an online photo gallery, read Technique 50. Well-chosen frames nearly always make a photo look better.

STEP 1: OPEN FILE

■ Select **File ➢ Open (Ctrl+O/Command+O)** to display the Open dialog box. Double-click the **\ch04\26** folder to open it and then click the **mom-baby-before.jpg** file; click **Open**.

■ Select **View ➢ Fit on Screen (Ctrl+0/Command+0)**. Then, select **View ➢ Zoom Out (Ctrl+-/Command+-)** twice to view the entire image and leave enough room to add more canvas.

STEP 2: ADD CANVAS

Because of the position of the mother and her child in the photograph, more canvas needs to be added to allow enough room for the metallic frame effect.

■ Select **Image ➢ Resize ➢ Canvas Size** to display the Canvas Size dialog box. Type **5** in the **Width** and **Height** box and make sure the increment settings for both are set to **inches**. That may be more canvas than you need, but that is okay as it is better to have too much than not enough. Make sure **Relative** is checked. Leave the **Anchor** set to default. Click in the **Canvas extension color** box and select **White**. The Canvas Size dialog box should now look like the one shown in **Figure 26.3**. Click **OK** to add more canvas. You should now have a white border around the image.

STEP 3: ADD INSIDE METALLIC FRAME

■ Select **Layer ➢ New ➢ Layer (Shift+Ctrl+N/Shift+Command+N)** to display the New Layer dialog box; click **OK** to create a new layer.

■ Click the **Rectangular Marquee** tool in the **Toolbox**. In the Options bar, make sure that the **New Selection** option is selected, that **Feather** is set to **0 px**, and **Mode** set to **Normal**, as shown in **Figure 26.4**.

■ Click just inside the left-bottom corner of the image in the blue cloth on the baby and drag the selection marquee up toward the right, as shown in **Figure 26.5**.

26.3

26.4

■ Click the **Elliptical Marquee** tool in the
Toolbox. Click the **Add to Selection** button in the
Options bar. Select **View ➢ Grid** so you have
some lines to help you add a curved top to the
rectangular selection. Carefully position your
cursor down from the top-left corner of the
rectangular selection marquee. Click and drag the
selection marquee up toward the right until the
top of the new selection marquee stops just short
of the top of the green part of the image and in
line with the marquee on the right side, as shown
in **Figure 26.6**.

■ Change back to the **Rectangular Marquee** tool
and add any selection that may be needed to make
a final selection that looks like the one shown in
Figure 26.7. If you have trouble making this selec-
tion, you can use the **Undo History** to step back in
the selection process when needed; then, try again.

■ To avoid having to go through that selection
process again, select **Select ➢ Save Selection** and
type **Inside Frame** in the **Name** box and click **OK**.

■ Select **View ➢ Grid** to turn off the grid.

26.6

26.5

26.7

■ Select **Edit ➢ Stroke (Outline) Selection** to display the Stroke dialog box. Type **150 px** in the **Width** box and choose **Outside** as shown in **Figure 26.8**. Click in the **Color** box to summon the **Color Picker**. To choose a gold color, you can either click inside the image to select a color of your choice or you can type in **248**, **236**, and **50** in the **R**, **G**, and **B** boxes, as shown in **Figure 26.9**, to use exactly the same values that I chose from the image. Click **OK** to close the Color Picker. Click **OK** to apply a gold-colored shape to the image.

■ Click the **Magic Wand** tool (**W**) in the **Toolbox** and set **Tolerance** to **0**. Make sure there is a checkmark next to **Contiguous** and that **Use All Layers** is unchecked. Select **Select ➢ Deselect** (**Ctrl+D/Command+D**) to remove the selection marquee. Click on the gold shape to select it.

■ If the **Styles and Effects palette** is not showing, select **Window ➢ Style and Effects**. Click in the first box in the **Styles and Effects** palette and choose **Layer Styles**. Click in the next box and

choose **Bevels**. Click **Wacky Metallic** to apply a wacky metallic edge, as shown in **Figure 26.10**.

■ I'd like to see the frame a bit less yellow and bright. Select **Enhance ➢ Adjust Color ➢ Adjust Hue/Saturation** (**Ctrl+U/Command+U**) to display the Hue/Saturation dialog box. Drag the **Hue** slider to about **–6**, the **Saturation** slider to about **–64**, and the **Lightness** slider to **0**, as shown in **Figure 26.11**.

26.9

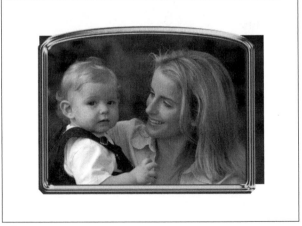

26.10

26.8

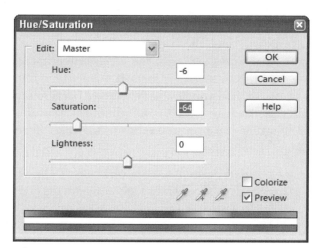

26.11

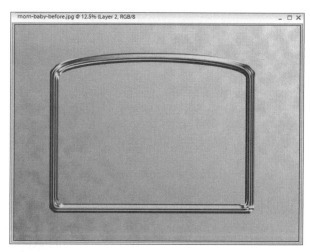

26.12

STEP 4: ADD METALLIC BACKGROUND

■ Click the **Background** layer in the **Layers** palette.

■ Select **Select ➤ Deselect** (**Ctrl+D/Command+D**) to remove the selection marquee.

■ If the **Styles and Effects** palette is not showing, select **Window ➤ Style and Effects**. Click in the first box in the **Styles and Effects** palette and choose **Effects**. Click in the next box and choose **Textures**. Double-click **Gold Sprinkles** to apply a metallic background. The new effect will be placed on a new layer named **Layer 2**. **Figure 26.12** shows the new layer.

■ Click the **Lasso** tool (**L**) in the **Toolbox**. Click in the middle of the new gold frame effect and carefully drag a selection curve all the way around the gold frame without touching the metallic background.

■ Select **Edit ➤ Cut** (**Ctrl+X/Command+X**) to cut out the metallic background that covered the part of the image showing the mother and the baby. Your image should now look similar to the one shown in **Figure 26.13**.

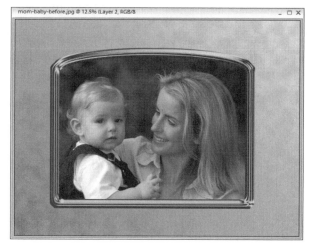

26.13

STEP 5: ADD OUTSIDE METALLIC EDGE

■ Click the **Rectangular Marquee** tool in the **Toolbox**. In the Options bar make sure that the **New Selection** option is selected, that **Feather** is set to **0 px**, and **Mode** set to **Normal**.

- Click once toward the bottom-left part of the image and drag the selection marquee up toward the right so that there is an equal amount of space on all sides between the gold metallic frame and the selection marquee.

- Select **Layer** ➢ **New** ➢ **Layer** (**Shift+Ctrl+N/Shift+Command+N**) to display the New Layer dialog box; click **OK** to create a new layer.

- Select **Edit** ➢ **Stroke (Outline) Selection** to display the Stroke dialog box. Type **50 px** in the **Width** box and choose **Outside**. Click in the **Color** box to summon the **Color Picker**. Type **150, 142,** and **103** in the **R, G,** and **B** boxes respectively; click **OK** to close the dialog box. Click **OK** to close the Stroke dialog box and add a 50-pixel border.

- Click the **Magic Wand** tool (**W**) in the **Toolbox** and set **Tolerance** to **0**; make sure there is a checkmark next to **Contiguous** and that **Use All Layers** is unchecked. Select **Select** ➢ **Deselect** (**Ctrl+D/Command+D**) to remove the selection marquee. Click in the tan-colored border you just added to select it.

- Create a new layer by selecting **Layer** ➢ **New** ➢ **Layer Via Copy** (**Ctrl+J/Command+J**). Click in the narrow tan-colored border you just added to select it one more time.

- If the **Styles and Effects** palette is not showing, select **Window** ➢ **Style and Effects**. Click in the first box in the **Styles and Effects** palette and choose **Layer Styles**. Click in the next box and choose **Bevels**. Click **Scalloped Edge** to apply a bevel effect.

- Select **Select** ➢ **Deselect** (**Ctrl+D/Command+D**).

STEP 6: CHANGE BACKGROUND COLOR

Let's now change the background color to a dark green that works well with the green in the image. We'll do this to make the metallic frame stand out, and also to show you how you can add a background color to match any background you might have on a Web page if you plan to use this frame effect in an online photo gallery.

- Click **Background** in the **Layers** palette. The **Layers** palette should now look similar to the one shown in **Figure 26.14**.

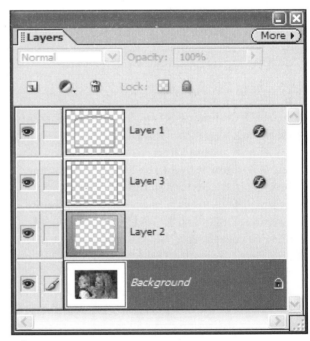

26.14

■ Click the **Rectangular Marquee** tool in the **Toolbox.** In the Options bar make sure that the **New Selection** option is selected, that **Feather** is set to **0 px**, and **Mode** set to **Normal**.

■ Click in the middle of the upper-left corner of the small outside frame and drag the selection down toward the right to make a selection like the one shown in **Figure 26.15**.

■ Select **Select** ➢ **Inverse** (**Shift+Ctrl+I/ Shift+Command+I**). Select **Edit** ➢ **Fill Selection** to display the Fill Layer dialog box shown in **Figure 26.16**. Click in the **Mode** box and choose **Color** to display the Color Picker. You can either choose a color of your choice by clicking inside the image to choose a color from the image, or

you can type **69, 77,** and **46** in the **R, G,** and **B** boxes respectively to get the color I chose. Click **OK** to close the Color Picker. Click **OK** to close the Fill Layer dialog box and fill the selection with the chosen color.

■ Click the **Layer 2** layer in the **Layers** palette to make it the active layer. Select **Edit** ➢ **Cut** (**Ctrl+X/Command+X**) to cut out the extra metallic background and reveal the green background. The image should now look like the one shown in **Figure 26.2 (CP 26.2)**. You can now flatten, crop, and size the image for your intended purpose — either as an image to make a print, or to show online in an online photo gallery.

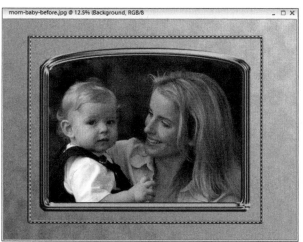

26.15

26.16

REPLACING HEADS IN A
GROUP PHOTO

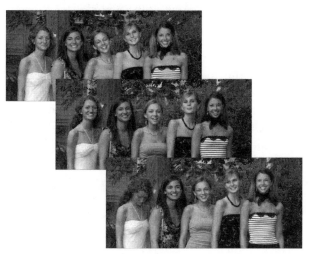

27.1 (CP 27.1)

27.2 (CP 27.2)

ABOUT THE IMAGE

"Girls' Night Out," Canon EOS
1D Mark II, 70–200mm f/2.8
IS @ 75mm, f/7.1 @ ¹/₈₀ sec,
ISO 100, 16-bit RAW format,
3,504 x 2,336 pixels, con-
verted to an 8-bit, 850Kb .jpg

When shooting a group portrait, it is often difficult to take a single photo in which every one of the subjects is happy with their facial expression. The more people in the photo the more challenging it can be even if you shoot with a digital camera that has an LCD that enables you to view each shot. So, how do you shoot just a few photos and make all your subjects happy? You shoot a few photos like those shown in **Figure 27.1** (**CP 27.1**) and then "mix and match" faces by putting the best face of each subject into a single photo, as shown in **Figure 27.2** (**CP 27.2**). In this technique, you learn how to replace faces accurately and easily.

STEP 1: OPEN FILES

■ Select **File** ➢ **Open** (**Ctrl+O/Command+O**) to display the Open dialog box. Double-click the \ch04\27 folder to open it. Click the first image in the folder (**group-1.jpg**). Press and hold **Shift** while clicking the last image in the folder (**group-3.jpg**) to select all three images. Click **Open** to open the three images. All three images will be stacked on top of one another. You can click and drag them to arrange them so that you can see the faces of the five girls in each image.

STEP 2: DETERMINE WHICH FACES TO REPLACE

Carefully examine each of the three photos and find the best facial expression of each girl. The **group-3.jpg** image is the best photo for the girl on the left and the **group-2.jpg** image has the best photo of the middle girl. The best photos of the other three girls are in **group-1.jpg**, so you should edit the **group-1.jpg**.

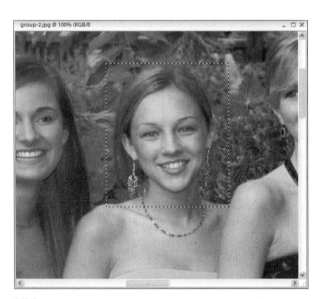

27.3

STEP 3: CUT AND PASTE FACES

■ To copy the face of the middle girl in the **group-2.jpg** image, click the image to make it the active image. Select **View** ➢ **Actual Pixels** (**Alt+Ctrl+0/Option+Command+0**) to zoom in at **100%**. Press the **Spacebar** to display the temporary **Hand** tool (**H**) and click and drag the image until you see the middle girl's face.

■ Click the **Rectangular Marquee** tool (**M**) and click and drag a selection marquee around the face, as shown in **Figure 27.3**. Select **Edit** ➢ **Copy** (**Ctrl+C/Command+C**) to copy the selection.

■ Select **File** ➢ **Close** (**Ctrl+W/Command+W**) to close the **group-2.jpg** file as it is no longer needed.

■ Click the **group-1.jpg** image and select **Edit** ➢ **Paste** (**Ctrl+V/Command+V**) to paste the selection in as a new layer.

■ Select **View** ➢ **Actual Pixels** (**Alt+Ctrl+0/Option+Command+0**) to zoom in at **100%**. Press the **Spacebar** to display the temporary **Hand** tool (**H**) and click and drag the image until you see the middle girl's face.

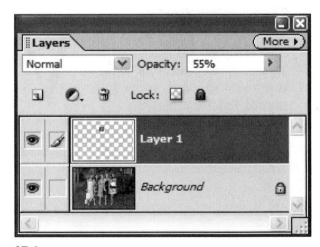

27.4

■ Click the **Move** tool (**V**) in the **Toolbox** and click the pasted selection and it drag over the middle girl's face. To make it easy to accurately overlay the replacement face, click in the **Opacity** box, in the Layers palette, and slide the slider to the left to about **55%**, as shown in **Figure 27.4**. You can now see the Background layer and the pasted selection, as shown in **Figure 27.5**.

■ It looks like you will have an easy match if you rotate the selection toward the left. Select **Image ➢ Rotate ➢ Free Rotate Layer** to display the rotation selection marquee. Click just outside the top-left handle on the selection marquee and the cursor changes to a two-headed arrow indicating that you can rotate the image. Click and rotate the image until the eyes match up as much as possible. Click inside the selection marquee to more precisely line up the eyes. It looks as though you will have an excellent face if you remove the entire inserted selection with the exception of the eyes. When you have the image lined up, press **Enter/Return** to commit the rotation.

■ Click the **Lasso** tool (**L**) in the **Toolbox** and carefully draw a selection around the eyes and the eyebrows, as shown in **Figure 27.6**. Select **Select ➢ Feather** (**Alt+Ctrl+D/Option+ Command+D**) to display the Feather Selection dialog box shown in **Figure 27.7**. Click in the **Feather Radius** box and type **5**. Click **OK** to feather the selection. Select **Select ➢ Inverse** (**Shift+Ctrl+I/Shift+Command+I**) to invert the selection. Select **Edit ➢ Cut** (**Ctrl+X/ Command+X**) to cut out all of the inserted selection but the eyes and eyebrows.

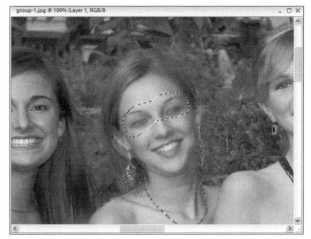

27.6

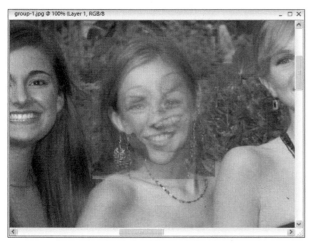

27.5

27.7

■ Set **Opacity** in the **Layers** palette to **100%**.
Toggle **Layer 1** on and off a few times by clicking
the **Layer Visibility** icon at the left of the **Layer 1**
layer in the **Layers** palette to make sure the eyes
are where they should be. You can use the **Move**
tool to make any fine adjustments to position.
Figure 27.8 shows that the closed eyes have suc-
cessfully been replaced with the open eyes.

■ Click **Layer 1** and select **Layer ➢ Flatten image**.

■ Follow the same process to copy the face of the
girl on the left in the **group-3.jpg** image and place
it in the **group-1.jpg** image. Just before you flatten
the image, add **+11 Saturation** to the inserted
selection layer to the **Red** channel using only
Hue/Saturation to add back some of the red tone
that is found in the face in the **group-1.jpg**. It
appears that the dropping sun caused a slight dif-
ference in lighting between the two pictures to
require this subtle, but important color correc-
tion. When you have completed that process, your
image should look similar to the one shown in
Figure 27.2 (**CP 27.2**).

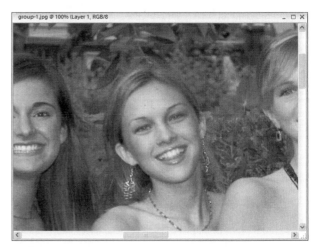

27.8

MINIMIZING THE EFFECTS OF AGING

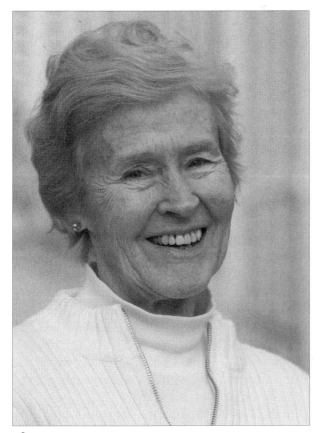

28.1

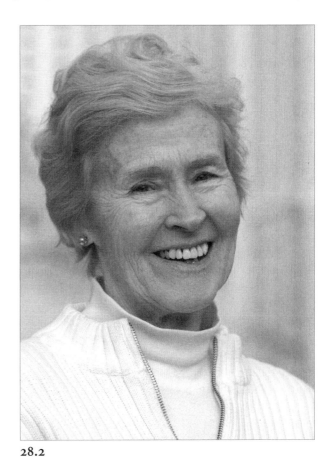

28.2

ABOUT THE IMAGE

"Graceful Aging," Canon EOS 1D, 70–200mm f/2.8 IS @ 110mm, f/5.6 @ ¹/₂₅₀ sec, ISO 200, 16-bit RAW format, converted, edited, and cropped to a 1,541 x 2,157 pixel, 293Kb .jpg

The photo of the elderly woman in **Figure 28.1** is a reasonably good photo taken in good light. However, let's see how much you can improve it. The challenges here include adjusting the tonal range, correcting color, minimizing the red blotches in the face, whitening the teeth, reducing the wrinkle lines a small amount, opening the eyes a small amount, all while keeping the nice warm colorcast that was in the original scene. With a bit of magical editing with Adobe Photoshop Elements 3.0, you can create the image shown in **Figure 28.2**. You learn how to make that transformation in this technique. You also learn many valuable tips that will help you improve many other photographs including, but not limited to, people photos.

163

STEP 1: OPEN FILE

■ Select **File ➢ Open** (Ctrl+O/Command+O) to display the Open dialog box. Double-click the \ch04\28 folder to open it and then click the **jean-before.jpg** file; click **Open**.

STEP 2: INCREASE CONTRAST

This photo, taken in late afternoon on an overcast day, already has an almost perfect tonal range for a portrait of a mature woman. However, let's see if you can add a very small amount of contrast to sharpen some of the important details and add a bit of "punch" to a flat image.

■ Because you do not want to bump up the color saturation when increasing contrast with **Levels**, you will create a **Levels** adjustment layer by selecting **Layer ➢ New Adjustment Layer ➢ Levels** to display the New Layer dialog box. As there will be quite a few different layers in this technique, type **Global Contrast** in the **Name** box. Click in the **Mode** box and select **Luminosity** to limit the **Levels** changes to just luminosity and not color, as shown in **Figure 28.3**. Click **OK** to display the Levels dialog box.

■ Slide the **Highlight** slider toward the left to about **248**. Drag the **Midtone** slider to about **0.98**. Even this small numerical change has significant effects on the image. Leave the **Shadow** slider at **0** because you don't want to make the shadow areas any darker or you'll have too much contrast in the mouth and the eyes will become too dark. The Levels dialog box should now look like the one shown in **Figure 28.4**.

28.3

■ Click **OK** to apply the subtle, but important, changes to the image. To confirm that those settings improved the image, toggle the **Layer Visibility** icon at the left side of the **Global Contrast** layer to see before and after effects.

STEP 3: CORRECT COLOR

The advantage you have here is that you know that the sweater is a white sweater and you therefore can use it for some quick color corrections. To learn more about color correction, read Technique 12 and Technique 38.

■ Before you correct color using the white sweater as a reference tone, first take a look to find the whitest point in the image. Select **View ➢ Fit on Screen** (Ctrl+0/Command+0).

■ Click **Background** in the **Layers** palette. Select **Filter ➢ Adjustments ➢ Threshold** to display the Threshold dialog box. Click and drag the slider all the way to the right and slowly back to the left while watching the white come back into the image. **Figure 28.5** shows the Threshold dialog box with **Threshold** set to **233**. **Figure 28.6** shows the image at that setting. Make a mental note of the brightest parts of the image. Click **Cancel** in the **Threshold** box as you just used the tool to find the brightest spots in the image.

28.4

■ Select **Layer** ➢ **New Adjustment Layer** ➢ **Levels** to display the New Layer dialog box. Type **Global Color** in the **Name** box and click **OK** to display the Levels dialog box.

28.5

28.6

■ Double-click the **Set White Point** eye dropper (the rightmost eye dropper in the Levels dialog box) to display the **Color Picker**. You are now going to make the brightest whites in the image have **R, G,** and **B** values of **248, 248,** and **248** respectively. Why use those settings? Because you don't want to bring about too much increase in contrast by using the pure white values of **255, 255,** and **255.** Using **248** helps to ensure that you can see detail in the white sweater when printing on most photo-quality inkjet printers. This process is known as targeting white values. Type **248** in the **R, G,** and **B** boxes, as shown in **Figure 28.7.** Click **OK** to close the **Color Picker.**

■ All that's left to make the brightest white values be **248** is to click on the part of the image where you learned there were bright white areas when you used **Threshold.** You can keep clicking until you are satisfied with the results. If you think the changes are subtle, you are correct and that is good.

■ Click **OK** to apply the settings and close the Levels dialog box. If a dialog box asks if you want to save the new target colors as defaults, click **No** to return the highlight values to **255, 255,** and **255.**

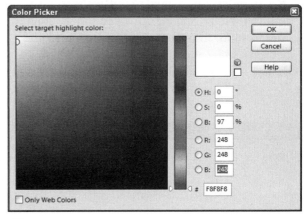

28.7

STEP 4: MINIMIZE RED BLOTCHES ON FACE

Now let's see if you can reduce the red blotches on her face. You don't want to remove them entirely as she might look too pale; just reduce the redness a small amount. When the blotches are minimized, you may find that you need to add more red to her face so she does not look too yellow.

■ You will once again use an adjustment layer. To learn more about adjustment layers and their benefits, read Technique 15. Before creating the adjustment layer, select **View ➤ Actual Pixels** (**Alt+Ctrl+0/Option+Command+0**). Press the **Spacebar** to display the temporary **Hand** tool (**H**) and click and drag the image until you can see more of the face.

■ Select **Layer ➤ New Adjustment Layer ➤ Hue/Saturation** to display the New Layer dialog box. Type **Red Blotches** in the **Name** box. Click in **Mode** and select **Color** to limit the adjustments to color and not make changes to luminosity. The New Layer dialog box should now look like the one shown in **Figure 28.8**. Click **OK** to display the Hue/Saturation dialog box.

■ Click in the **Edit** box and select **Reds** (**Ctrl+1/ Command+1**) to get the color isolation sliders to appear between the two color spectrums at the bottom of the dialog box.

■ Two sliders can be used to isolate the colors you want to change, and the other two sliders allow you to adjust the color transition area. Click the leftmost slider and slide it toward the right to bunch up all four sliders. Click the **Add to Sample**

eye dropper (the middle eye dropper with a plus sign next to it). Make sure the **Preview** is checked. Click the reddest part of the nose to center the color isolation sliders over the selected color. The color spectrum sliders should now look similar to the ones shown in **Figure 28.9**. To reduce the red blotches, click **Hue** and move the slider toward the right to about **+10**. This setting moves those blotchy red tones into the yellow spectrum, which is a prevalent color in the face thereby minimizing the contrast between the red areas and the rest of the face. Once again, this is a subtle and important change. Be aware that different monitors can show different colors and that there may be considerable difference between what you see on your screen and what I see on mine. You can continue to experiment with the sliders to more precisely select the red tones you want, and by moving the triangle sliders, you can even control the transition color area. **Figure 28.10** shows my final settings. Notice how there is a long transition toward the yellow spectrum on the right as there is a decidedly yellow tone to the image due to the light color. Click **OK** to apply the settings.

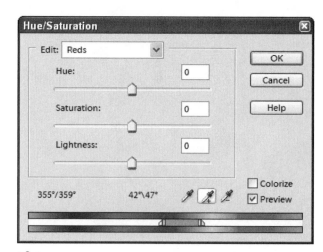

28.9

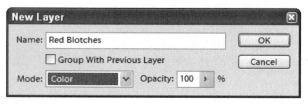

28.8

■ Notice that the **Layers** palette now has a **Background** and three adjustment layers, as shown in **Figure 28.11**. At this point, I am just about satisfied with the tone and color to flatten the image so you can do some wrinkle removal. But, because you took the extra effort to make all the earlier edits with adjustment layers, take one last good look at the image and see if you have any final color and tonal adjustments to make. My concern is that you need to add back some red. By double-clicking the **Global Color** layer in the **Layers** palette, you can fine-tune the **Levels** setting. Click in the **Channel** box and select **Red** (**Ctrl+1/Command+1**). To add more red to the image, slide the **Midtone** slider toward the left to about **1.08**. I like that setting. Click **OK** to apply these new settings. Once again, you have learned the value of using adjustment layers. To learn more about their use, read Technique 15.

■ Select **Layer** ➢ **Flatten Image** to flatten the image.

STEP 5: REDUCE WRINKLES

In my opinion, wrinkles on older people make them look distinguished and wise, or otherwise simply look their age. Now that you have my view on retouching wrinkles on older people, you should not be surprised to see that my settings will be conservative. My goal for this woman is to shorten the longer wrinkles and reduce the contrast on the rest. The approach you will take is to use a duplicate layer to remove most of the wrinkles. Then, you can use the Opacity % setting to dial back in the years! You can have it your way, I can have it my way, and the subject can have the photo look the way she wants it to.

■ Select **Layer** ➢ **Duplicate Layer** to get the Duplicate Layer dialog box; click **OK**.

■ Click the **Healing Brush** tool (**J**) in the **Toolbox**. Click in the **Size** box in the Options bar and set **Diameter** to **60 px**. Click in the **Mode** box

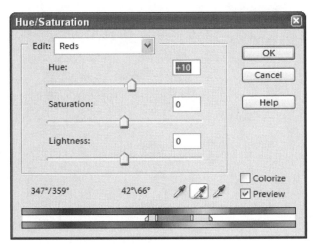

28.10

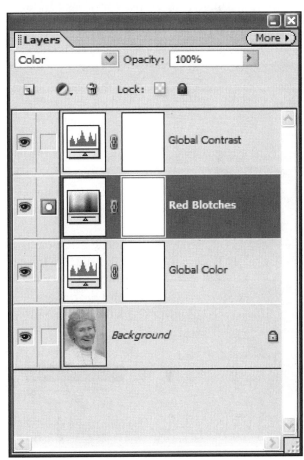

28.11

and choose **Lighten**. The Options bar should now look like the one shown in **Figure 28.12**.

■ Click **Background** in the **Layers** palette to make it active. Press **Alt/Option** and click a smooth part of the forehead to set a source texture. A good source selection may be found above the eye shown on the right.

■ Click the **Background copy** layer in the **Layers** palette to make the layer where the edits will occur — be the active layer.

■ Carefully click over the wrinkles around the left eye. Don't worry that all of the wrinkles have been removed, as you can see in **Figure 28.13**. Click in the **Opacity** box in the **Layers** palette and slide the slider until you like the amount of wrinkle removal. Being a conservative retoucher, I chose to set **Opacity** at **40%**. **Figure 28.14** shows the results of that setting.

■ When you have chosen a setting for **Opacity**, you can continue editing the wrinkles and they will now appear in a reduced form instead of being removed entirely. To check how you are doing, toggle the **Layer Visibility** icon to turn the **Background copy** on and off to view "before" and "after." The beauty of this approach is that you can, at any time, change the **Opacity** setting to increase or decrease the level of wrinkle removal. When I completed the entire wrinkle-diminishing process, I experimented with the **Opacity** slider once again and still concluded that I liked the results with **Opacity** set to **40%**.

■ When you are sure you will not want to make any other changes to the **Opacity** setting or to any wrinkles, select **Layer ➢ Flatten Image**.

28.12

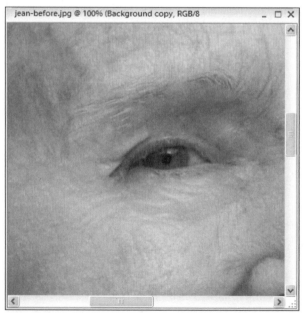

28.13

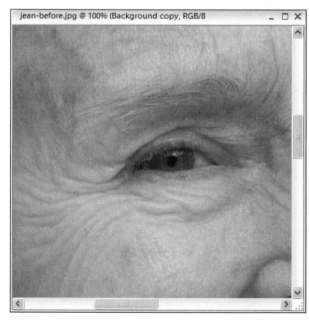

28.14

STEP 6: WHITEN TEETH

- Our final step is to whiten the teeth. Select **View ➢ Actual Pixels** (**Alt+Ctrl+0/Option+ Command+0**) to zoom in to **100%**. Press and hold the **Spacebar** to display a temporary **Hand** tool (**H**). Click and drag the image so that you can see all of the mouth.

- Click the **Lasso** tool (**L**) in the **Toolbox**. Click near the edge of one tooth and carefully drag a selection marquee around all the teeth, as shown in **Figure 28.15**. Select **Select ➢ Feather** (**Alt+Ctrl+D/Option+Ctrl+D**) to display the Feather dialog box. Type **3** in the **Feather Radius** box and click **OK** to feather the selection.

- Select **Enhance ➢ Adjust Lighting ➢ Levels** to display the Levels dialog box. Click the **Midtone** slider and drag it toward the left to about **1.24** to lighten the teeth. While it is tempting to brighten them more, they will look fake if they are overly bright. Click **OK** to apply the settings.

- To remove some of the yellow color, select **Enhance ➢ Adjust Color ➢ Adjust Hue/Saturation Ctrl+U/Command+U**) to display the Hue/Saturation dialog box. Click in the **Edit** box and choose **Yellows** (**Ctrl+2/Command+2**). Click the **Saturation** slider and drag it toward the left to about **–60**. Click **OK** to apply the settings. The teeth look wonderful now and they look natural, too. The image should now look similar to the one shown in **Figure 28.2**.

Several steps in this technique utilized layers and that is the reason why you were given an 8-bit image to use. However, if you want a challenge — you should try editing the 16-bit image found on the Companion CD-ROM in the **\ch04\28** folder. The file name is **jean-before16BIT.psd**. In each step where you previously used layers, you will have to figure out how to accomplish the same objectives without using layers. Because you have already completed the technique using an 8-bit image, you should know the settings that you used and you will therefore not need to use adjustment layers so that you can later adjust your settings. You have also learned a good setting to use for Opacity in the wrinkle-removal step, so you can complete that step without using layers too. By giving up the flexibility you get using layers you will often get better results editing 16-bit images than you will editing 8-bit images.

Bonus Points Question: What else might you want to do to improve this image? You are correct if you thought that more detail should show in the white sweater. You get another bonus point if you suggested that the image needs some mild sharpening for the target use. You get a point for suggesting that the eyes be opened slightly. A point goes to those suggesting that the dark areas around the teeth be brightened. Now you might be asking: How do you accomplish those objectives? To bring out details in the sweater, use the **Selection Brush** tool (**A**) and paint over the white sweater. Then, select **Enhance ➢ Adjust Lighting ➢ Shadow/Highlights** to display the Shadow Highlight dialog box. Drag the **Darken Highlights** up to about **15%**. To learn more about

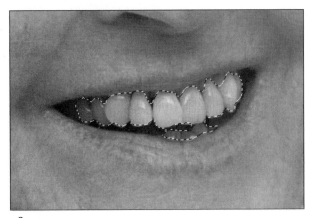

28.15

this tool, read Technique 41. To learn how to sharpen this image, read Technique 6. You open the eyes a slight amount by choosing **Filter ➤ Distort ➤ Liquify**. To learn more about the Liquify tool, read Technique 20. To lighten the dark areas around the teeth, select them with the **Lasso** tool, feather the selection, and adjust the mid-tone slider found in **Levels**. You have covered many topics in this technique. I hope you find that each of these steps will be useful when editing your own photos.

CREATING AN ANTIQUE COLLAGE

29.1 (CP 29.1)

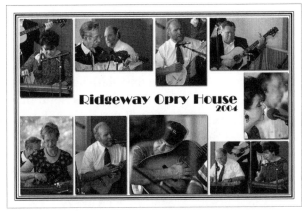

29.2 (CP 29.2)

ABOUT THE IMAGE

"Ridgeway Opry House Musicians," Canon EOS 1D Mark II with 550EX flash, multiple lenses and various exposures, nine RAW format images have been cropped (1,680 x 1,117 pixels), edited, and saved as .jpg files

The nine photos in **Figure 29.1** (**CP 29.1**) show some of the musicians that played on the opening day of the new Ridgeway Opry House in Ridgeway, North Carolina. They play blue grass, country, and gospel music on acoustic instruments every Saturday night for anyone that shows up. I took a few photos to make a collage for the Opry House wall. In this technique, you learn how to make that collage. Completing this project will help you learn some useful tips you can use to make your own collage featuring your favorite photos.

STEP 1: CREATE NEW DOCUMENT

For this project, let's create a 13" x 19" document as that is the largest paper size that fits in most large-format home/office desktop inkjet printers such as the Epson 2200 and 1280. My initial design idea was to use sepia tone for all the images to give them an antique look.

■ Select **File** ➢ **New** ➢ **Blank File** (**Ctrl+N/Command+N**) to display the New dialog box. Click in the second box after **Width** and choose **inches**, which automatically changes the box below to **inches**, too. Type **19** in the **Width** box and **13** in the **Height** box. Click in the box after **Resolution** and type **240** as that is a good choice of resolution for Epson printers, which is what I use. Click in the **Color Mode** box and choose **RGB Color** if it is not the current setting. Click in **Background Contents** and choose **White**. The **New** dialog box should now look like the one shown in **Figure 29.3**. Click **OK** to create the new 40.7MB document.

STEP 2: OPEN FILES

■ Organize the workspace before you open nine more files. Select **Window** ➢ **Palette Bin** to close the **Palette** if it is currently showing. Select **Window** ➢ **Photo Bin** to close the **Photo Bin** if it is showing. To learn more about controlling the **workspace**, **palettes**, and **Photo Bin**, read Technique 1.

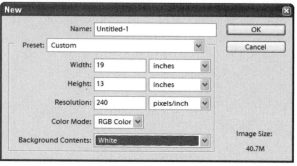

29.3

■ Select **File** ➢ **Open** (**Ctrl+O/Command+O**) to display the Open dialog box. Double-click the **\ch04\29** folder to open it and then click the **1.jpg** file. Press and hold **Shift** while clicking the **9.jpg** file to select all the files. Click **Open** to open them all in the workspace. You should now see the last opened file maximized in the workspace.

■ Click an image and choose **View** ➢ **Zoom Out** (**Ctrl+-/Command+-**) one or more times to reduce the image so that it easily fits in the upper-left corner of the workspace while leaving room for the new document. Choose **Window** ➢ **Images** ➢ **Match Zoom**. Choose **Window** ➢ **Images** ➢ **Cascade**. Click the **Untitled-1.jpg** document and drag it down toward the bottom-right corner of the workspace as shown in **Figure 29.4**.

STEP 3: PUT IMAGES IN NEW DOCUMENT FILE

■ To load all of the images into the new document that you created in Step 1, click the **Move** tool (**V**) in the **Toolbox**.

■ Click the top image (not on the document title bar) and drag it onto the white new document. Then, click back on the photo you dragged to

29.4

make it the active document again and select **File ➤ Close** (**Ctrl+W/Command+W**) to close the file as it is no longer needed. Repeat this process until you have loaded all remaining eight images into the new document file.

- Select **Window ➤ Palette Bin** to open the **Palette**.
- Select **View ➤ Fit on Screen** (**Ctrl+0/Command+0**) to make the image fill the available workspace.
- Select **Window ➤ Layers** to open the **Layers** palette if it is not already open. Your workspace should now look similar to the one shown in **Figure 29.5**.

STEP 4: ADD DECORATIVE LINES

You will now add three decorative lines to the background layer.

- Click **Background** in the **Layers** palette to make it active.
- You will now add a temporary grid that will be useful for adding decorative lines and aligning images. Before turning on the **Grid** you should first check to make sure you have the correct

settings. Select **Edit ➤ Preferences ➤ Units & Rulers** to get the Preferences dialog box. Click in the **Rulers** box and choose **inches**. Click **Next** to get the Preferences dialog box shown in **Figure 29.6**. Click in the second box after **Gridline every** and choose **inches**. Type **0.25** in the first box following **Gridline every**. In the **Subdivisions** box, type **1**. These settings will create the digital equivalent of ¼" grid paper. Click **OK** to apply the settings.

- Select **View ➤ Grid** to overlay the grid. Select **View ➤ Snap to Grid**.
- Click the **Rectangular Marquee** tool (**M**) in the **Toolbox**. Make sure that the Options bar shows that **Feather** is set to **0 px** and **Mode** is set to **Normal**.
- Click the **Default Foreground and Background Colors** icon (**D**) at the bottom of the Toolbox to set the **Foreground Color** to **black**.
- Click in the upper-left corner of the image on the intersection of the lines that are two units from the left side and two units down from the top; then, drag the selection marquee down toward the bottom-right to the intersection of the lines that are two units from the right and two units from the bottom of the image.

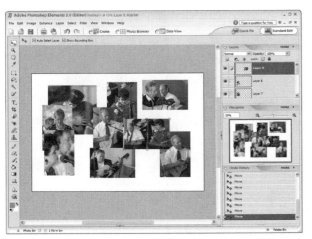

29.5

29.6

■ Select **Edit ➤ Stroke (Outline) Selection** to display the **Stroke** dialog box shown in **Figure 29.7**. Type **5 px** in the **Width** box and choose **Center** as the **Location**. **Mode** should be set to **Normal** and **Opacity** to **100%**. Click **OK** to add the stroke to the image.

■ Add one more line as you just did; only, make this line three units in from the edge of the image.

■ Now you will add one larger line in between the two lines you just created. Select **View ➤ Snap to Grid** to turn off the snap function so that you can draw a line between the last two lines. Using the **Rectangular Marquee** tool once again, click between the two lines in the upper-left corner and drag the selection marquee down to the bottom-right between the two lines.

■ Select **Edit ➤ Stroke (Outline) Selection** to display the **Stroke** dialog box. Type **20 px** in the **Width** box. Click **OK** to add the wider line in between the two other lines as shown in **Figure 29.8**.

29.7

STEP 5: ARRANGE PHOTOS

■ Click the **Move** tool (**V**) in the **Toolbox**. Make sure there is a checkmark in the **Auto Select Layer** in the Options bar and that **Show Bounding Box** is not checked.

■ Select **View ➤ Grid** to turn the grid back on. Select **View ➤ Snap to Grid** to make it easy to line up the images. Select **Edit ➤ Preferences ➤ Grid** and type **0.125** in the **Gridline every** box; click **OK** to apply a ⅛" grid, which will allow you to place the images on a smaller grid.

■ You can now click each image, which will automatically select the appropriate image layer. Then, click on the image again and drag the image where you want it. Repeat this process until you have arranged all the images as you want them. I suggest that you save yourself some time and lay them out, as shown **Figure 29.9**.

STEP 6: CROP, SIZE, AND ADJUST IMAGE POSITION

Several of the images need to be cropped, resized, and repositioned if you choose to lay them out as suggested.

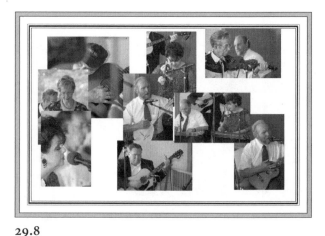

29.8

■ To resize an image, click it to select the layer that contains the image. Then, select **Image ➢ Resize ➢ Scale** to place a selection marquee around the image. Press and hold **Shift** (to maintain image proportions); then, click and drag one of the corner selection marquee handles to resize the image. When sized as you want it, press **Enter/Return** to commit the resize command.

■ To crop an image, click it with the **Move** tool (**V**) to select the appropriate layer. Click the **Rectangular Marquee** tool (**M**) in the **Toolbox**. Click the image to set the corner of the selection marquee and drag it to the opposite corner of the part of the image you want to keep. Select **Select ➢ Inverse** (**Shift+Ctrl+I/ Shift+Command+I**) to invert the selection to cut out the part of the image that is no longer needed. Select **Edit ➢ Cut** (**Ctrl+X/Command+X**) to make the cut.

■ To fine-tune the position of any images that need to be moved, click them with the **Move** tool (**M**) to select the appropriate layer. You can then click the **Up**, **Down**, **Left**, and **Right Arrow** keys to move the image 1 pixel at a time. Your image should now look similar to the one shown in **Figure 29.9**. The **Layers** palette should now look like the one shown in **Figure 29.10**.

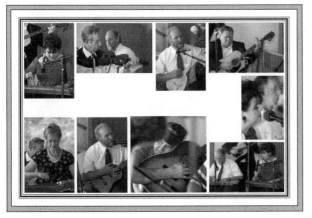

29.9

29.10

STEP 7: SEPIA TONE PHOTOS

■ Turning all of the photos to a sepia tone is a
snap! Click **Layer 9** in the **Layers** palette to make it
the active layer. Select **Layer ➤ New Fill Layer ➤
Solid Color** to display the New Layer dialog box.
Click in the **Mode** box and choose **Color**, as
shown in **Figure 29.11**. Leave **Opacity** set to
100%. Click **OK** to display the Color Picker dialog
box shown in **Figure 29.12**. Click once in the
yellow-orange part of the vertical spectrum to
display that color in the preview box. You can now
click anywhere in the preview box in the **Color
Picker** and that color is applied to the image. To
get the same sepia tone that I used, type **204**, **200**,
and **182** in the **R**, **G**, and **B** boxes respectively.
Click **OK** to tone all of the images.

**STEP 8: ADD DROP SHADOW TO EACH
PHOTO**

■ Select **Window ➤ Style and Effects** to display
the Styles and Effects dialog box shown in **Figure
29.13**. If your palette looks different, click in the
left box and choose **Layer Styles**; then, click in the
right box and choose **Drop Shadows**.

■ Click **Layer 9** in the **Layers** palette and then
click **Low** in the **Styles and Effects** palette to apply
a low drop shadow. Repeat this process until you
have a drop shadow beneath each of the nine

29.12

29.11

images. Notice that there is a Layers Styles icon on the right side of each layer now telling you that that layer has a layer style applied to it.

STEP 9: ADD TEXT

■ To add text, click the **Horizontal Type** tool (**T**) and choose your font specifications in the Options bar. When you click in the image where you want to begin placing text, a new text layer is created. Type the text and press **Enter/Return** to commit the text. To learn more about placing text in an image, read Technique 21. When you have placed the text on the image, it should look similar to the one shown in **Figure 29.2 (CP 29.2)**.

■ If you are absolutely positive that the image is as you want it now and in the future, select **Layer ➢ Flatten Image** and save your file. If you think you may want to make changes to it later, you should *not* flatten the image — instead save it as a **.psd** file with the layers intact.

That concludes the last of the eight techniques in this chapter on editing people pictures. The next chapter is a fun chapter that provides you with six creative and inspirational techniques to add more possibilities to your image-editing repertoire.

29.13

CHAPTER **5**

CREATIVE EDITING TECHNIQUES

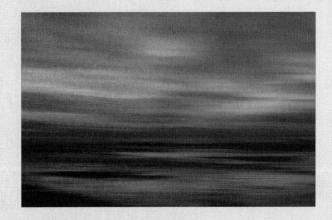

If you have used a film camera, you may have tried one or more creative shooting techniques such as shooting to create multiple exposures, panning your camera with a slow shutter speed to get an intentional blur, or other techniques that can produce some wonderful photographic effects. In this chapter, you learn how you can create these same effects and get even more control of how your photos will look by shooting digitally and taking advantage of the many features in Adobe Photoshop Elements 3.0.

In Technique 30, you learn how to pan and blur to make wonderful prints. Creating digital multiple exposures is the topic of Technique 31. Duplicating, flipping, and modifying portions of an image are covered in Technique 32. In Technique 33, you learn how to add a graduated color effect that is far superior to the graduated in-camera filter effect. Making hand-colored and digitally tinted or toned photos is the topic of Technique 34. Technique 35 shows how to add a two-color graduated tone to a print to make it into an "art-like" print.

PANNING AND BLURRING TO GET A PAINTED EFFECT

30.1 (CP 30.1)

30.2 (CP 30.2)

ABOUT THE IMAGE

"Not Your Typical San Diego Sunset," Canon EOS 1Ds, 70–200mm f/2.8 IS @ 70mm, f/11 @ ¹⁄₁₅ sec, ISO 200, 16-bit RAW format, 4,064 x 2,704 pixels, 8.4MB .TIF RAW

One of the hundreds of reasons that I love digital photography is that it allows you to experiment in so many ways. You can experiment when you shoot, you can experiment when editing, and you can experiment when printing. **Figure 30.1 (CP 30.1)** shows a photo of the San Diego coast at sunset. The brilliance of this sunset, like most good sunrises and sunsets, lasted only for a few minutes. Intentionally shooting without a tripod, I panned the camera from left to right numerous times while changing the speed of my panning and while varying the shutter speed. When the images were downloaded to a computer, I chose one with the right exposure and motion blur to make an image that looked like a modern art painting. I did some simple editing to make the image look the way that I had envisioned it: rich with colors; bright, shining highlights on the water; and soft, bold, horizontal strokes that look like they were painted with a paint brush. The results are shown in **Figure 30.2 (CP 30.2)**. What do you think? I've made a 14" x 19" print on Crane Museo paper using an Epson 2200 printer and it is magnificent.

While this image could have been created with a perfectly focused image that was taken with a camera that was mounted on a tripod, the results would not be the same. It took some experimentation when shooting and when editing. When you take digital photographs, carefully think about the entire workflow you will go through and you will take more creative and unusual photographs that will make captivating prints.

STEP 1: OPEN AND CONVERT RAW IMAGE

Don't let the file extension of .TIF fool you into thinking that this is your ordinary TIFF file. It is, in fact, a very high-resolution, 16-bit RAW file that was taken with the wonderful and rather expensive 11-megapixel Canon EOS 1Ds. To open this file you will need to use the RAW converter that is found in Adobe Photoshop Elements 3.0. If you are using an older version of Elements and you don't have access to a RAW conversion tool, you will find a .jpg version in the **\ch05\30** folder so that you may complete this technique. It is named **sunset-before.tif** and it is an 8-bit image.

■ Select **File ➢ Open** (**Ctrl+O/Command+O**) to display the Open dialog box. After double-clicking the **\ch05\30** folder to open it, click the **sunset-beforeRAW.TIF** file to select it, and then click **Open**.
■ The image will be opened in the RAW converter window shown in **Figure 30.3**. As you have the advantage of working in 16-bit mode, the objective is to make as many of the changes to the image as you can while working in the RAW converter. Click the **Shadows** slider and slide it toward the right to about **+20** to darken the image. To deepen the colors, increase saturation by clicking the **Saturation** slider and slide it toward the right to about **+15**. If you are tempted to add more saturation, you may find that your

image will make a wonderful image for displaying on a computer, but the images may be difficult to print as the colors may fall outside the color range of your printer.
■ Click **Depth** and select **8 Bits/Channel**, as you will be using layers shortly, and Elements 3.0 does not support 16-bit layers. Click **OK** to convert the image and open it in the Editor.

STEP 2: ADD MOTION BLUR

■ To get an accurate view of the effects of motion blur, select **View ➢ Actual Pixels** (**Alt+Ctrl+0/Option+Command+0**).
■ If you press and hold the **Spacebar**, the **Hand** tool (**H**) appears. You can use it to click and drag the image around in the Workspace. Notice that there are many spots, which were caused by moisture on the image sensor. You could use the Spot Healing brush tool (**J**) to clean up these spots, but most of them will disappear when you add the blur. So, for now, do not be concerned about the spots. To learn more about removing the spots and on how to "level" the image, read Technique 8.

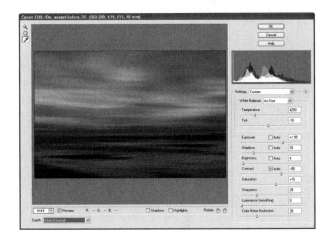

30.3

■ To add a small amount of additional motion blur, select **Filter ➢ Blur ➢ Motion Blur** to get the Motion Blur dialog box. Click in the preview box to get the Hand tool. You can now drag the image around until you find a good part of the image to view while experimenting with the settings. Make sure **Angle** is set to **0** and slide the **Distance** slider to about **25** to remove the digital noise found in the image. The Motion Blur dialog box should now look similar to the one shown in **Figure 30.4**. Click **OK** to apply the setting.

STEP 3: ADD DODGE AND BURN LAYER

The image is getting closer to what I envisioned. I'd still like to see it be a bit darker, and I want to have much brighter reflections in the sea. Adding the

highlights in the water is a little more challenging because it takes some hand painting, which you will do using a special layer so that if you paint and you don't like the effects, you can go back and try again.

■ To view the entire image, select **View ➢ Fit On Screen** (**Ctrl+0/Command+0**).
■ Select **Layer ➢ New ➢ Layer** (**Shift+Ctrl+N/ Shift+Command+N**) to get the New Layer dialog box. Type **Highlights** in the **Name** box. Click in the **Mode** box and select **Overlay**. Click in the box next to **Fill with Overlay-neutral color (50% gray)** to place a checkmark in it. The New Layer dialog box should now look like the one shown in **Figure 30.5**. Click OK.
■ Notice that the Layers palette now looks like the one shown in **Figure 30.6**. Adding an Overlay layer

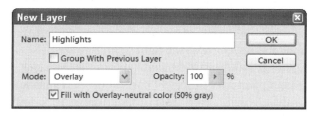

30.5

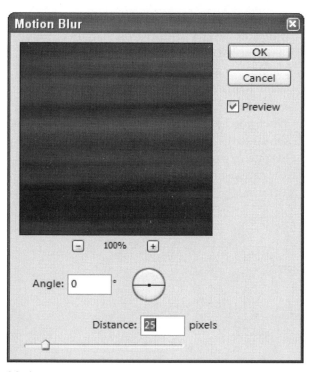

30.4

30.6

is a wonderful way to do dodging and burning. To learn more about this technique, read Technique 14. To bring out the highlights in the sea, click the **Brush** tool (**B**) in the **Toolbox.** You now need to carefully pick the brush setting so that you can slowly build up the highlights so they look natural. Click the **Foreground and Background Colors** (**D**) icon at the bottom of the **Toolbox**; then, click the **Switch Foreground and Background Colors** (**X**) to set the **Foreground** color to **white.**

■ Click in the **Brushes** box in the **Options** bar and select **Default Brushes.** Click the **menu icon** (the tiny triangle icon in the upper-right corner of the **Brushes** palette) and select **Small Thumbnail** to get a **Brushes** palette that looks like the one shown in **Figure 30.7**. Click the **Soft Round 300 Pixels** brush.

■ Check the **Options** bar to make sure that **Mode** is set to **Normal,** and click in **Opacity** and drag the slider to change the value to around **20%.**

■ You now have all the right settings to begin slowly building up the highlights in the sea. Click and paint over the bright parts of the sea to make the highlights even more pronounced. Click often so that you can undo any brush strokes you don't like by selecting **Edit ➢ Undo** (**Ctrl+Z/Command+Z**). Choosing a low **Opacity** of **20%** enables you to slowly build up the highlights. To get a quick view of the "before" and

30.7

"after" effects of your brushstrokes, click the **Indicates Layer Visibility** icon that can be found to the far left of the highlights layer in the **Layers** palette — it is the eye-like icon. Click it on and off again. Remember to click it back on if you need to continue working with the image with the **Brush.** When you are through, the highlights should look similar to the photo shown in **Figure 30.2 (CP 30.2).** Brightening of the highlights makes a remarkable improvement in the image.

STEP 4: MAKE FINAL LEVELS ADJUSTMENTS

■ I really like the image and am close to concluding that it is time to stop. But, before you stop, make a quick try at adjusting the tonal range first. Click the **Background** layer in the **Layers** palette to make it the active layer. Select **Enhance** ➤ **Adjust Lighting** ➤ **Levels** (**Crtl+L/Command+L**) to get the **Levels** tool shown in **Figure 30.8**. To brighten the highlights across the entire image, click the **highlight slider** (the white triangle found just below the histogram at the right) and slide it toward the left to where the **Input Levels** box shows **245**. After fiddling with the **Midtone slider**, I decided it was best left set to **1.0**. Click **OK** to apply the highlight setting change. Your image should now look similar to the one shown in **Figure 30.2** (**CP 30.2**).

■ Select **Layer** ➤ **Flatten Image**.

This image makes a wonderful print on a high-quality fine art paper. Because an 11-megapixel camera was used to take this photo, this image can be

30.8

used to make a huge print. At 240 dpi, it makes a print that fits nicely on 13" x 19" paper. You ought to try making a print to get the full idea of the wonderful prints that can be made with this panning and blurring technique. If you make a nice image using this technique, please e-mail me a small .jpg version to ggeorges@mindspring.com. I always welcome work done by readers.

CREATING DIGITAL MULTIPLE EXPOSURES

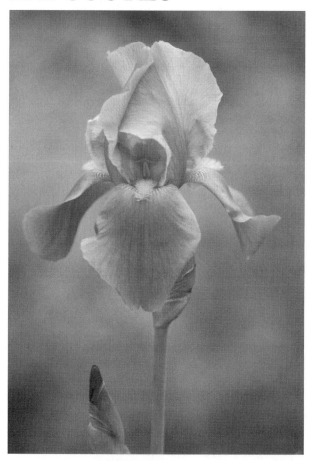

31.1

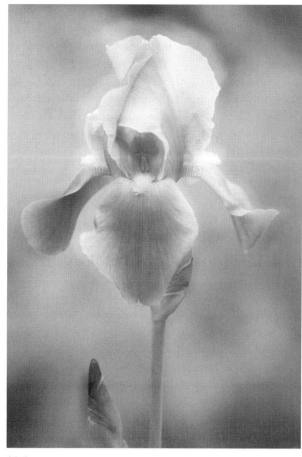

31.2

ABOUT THE IMAGE

"Purple Iris on Green #2," Canon EOS D30, 300mm f/2.8 IS, ISO 100, f/4.0 @ ¹/₁₂₅, 16-bit RAW format, 2,160 x 1,440 pixels, converted and cropped to a 1,500 x 2,100 8-bit 9.2MB .tif

One technique that film photographers use is to make multiple exposures on a single print. The results can often be wonderful. Common multiple exposure prints show one (or more) images printed over another to put different scenes into the same picture. Another technique is to shoot one photo in-focus and another out-of-focus, and then combine them. To do this technique using slide film, you would expose both slides sandwiched together to make a glowing soft-focused effect.

However, it should be noted that it takes some time and experience to get good results. You have to over-expose both slides so that they combine to give a normal exposure. This requires lots of trial and error. If you think that I'm about to say that it is much easier to take the digital approach — you are correct!

In this technique, you use the single image shown in **Figure 31.1**, which was sharply focused and shot in RAW mode. Using the RAW converter in Adobe Photoshop Elements 3.0, you make two different layers. One layer will be enlarged slightly and blurred, and the other one will be sharply focused. They can then be digitally combined to get the effect shown in **Figure 31.2**.

STEP 1: OPEN AND CONVERT RAW IMAGE

■ Select **File ➢ Open** (**Ctrl+O/Command+O**) to display the **Open** dialog box. After double-clicking the **\ch05\31** folder to open it, click the **iris-before.CR2** file to select it, and then, click **Open**. The image opens in the RAW converter.
■ To use the default settings, click in the **Settings** box and choose **Camera Default**. If the values on your screen do not match those shown in **Figure 31.3**, you need to manually set them. Make sure that **Depth** is set to **8 Bits/Channel**. Click **OK** to convert the image.

STEP 2: DUPLICATE LAYER

■ Select **Layer ➢ Duplicate Layer** to display the Duplicate Layer dialog box; click **OK** to create a new layer.

STEP 3: ENLARGE AND BLUR LAYER

■ The intent now is to add a soft glow to the iris. To do that, you first enlarge the top layer and then add some Gaussian blur. Select **Image ➢ Transform ➢ Free Transform** (**Ctrl+T/Command+T**). You should now see a selection marquee around the image with handles. In the **Options** bar, click in the **W** box (the Width box) and type **110%**, as shown in **Figure 31.4**. Click the **Maintain Aspect Ratio** icon between the **W** and **H** box to make both values **110%**. Press **Enter/Return** to increase the layer size by **110%**.
■ Select **Filter ➢ Blur ➢ Gaussian Blur** to get the Gaussian Blur box shown in **Figure 31.5**. Click in the box to get the **Hand** tool and drag and drop the image until you can clearly see the blur effects on the outside edge of the iris. Click the **Radius** slider and slide it toward the right to about **30.0 pixels**. Click **OK** to apply the blur.

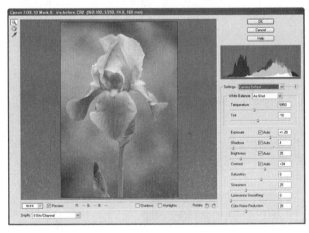

31.3

31.4

STEP 4: CHANGE BLEND MODE

■ Click in the **Blend Mode** box in the Layers palette and choose **Overlay**. You can also adjust **Opacity** by clicking in the **Opacity** box in the **Layers** palette and dragging the slider one way or the other to vary how much of the **Overlay** layer shows. For this image, I like the effects of having **Opacity** set to **90%**, as shown in **Figure 31.6**.

■ When the image is as you want it, select **Layer ➤ Flatten Layers** to flatten the image.

Some techniques lend themselves well to certain photos and not others. This technique of blending a slightly larger layer that has been blurred with a sharply focused layer works especially well on images that have small, detailed features such as a forest with leaves. Try it on larger, softer subjects such as the iris with a soft background and then try it on an image with lots of small detail, and compare the effects.

You can create digital multiple exposures in several different ways. If you plan on making a multiple exposure when you are taking the photographs, you can first shoot one photo with the image slightly out-of-focus; then, shoot a second image with the subject in focus. It is best to shoot with a tripod so that the two different images can easily be aligned. Later, when you are editing, you simply put the two photos into the same image and experiment with the Blend modes and Opacity levels. Or, as Technique 32 demonstrates, you can take one photo, duplicate the background layer, increase the image size slightly, and then change the Blend mode and adjust the Opacity setting. Several Blend modes work for this technique. Overlay, Softlight, and Hardlight usually work the best, but it is worthwhile to experiment with the other blend modes, too.

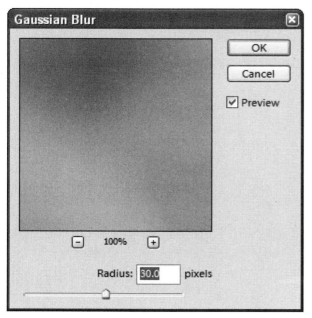

31.5

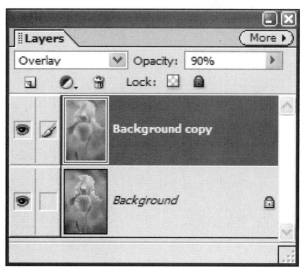

31.6

CREATING GENETIC DIVERSITY IN NATURE PHOTOS

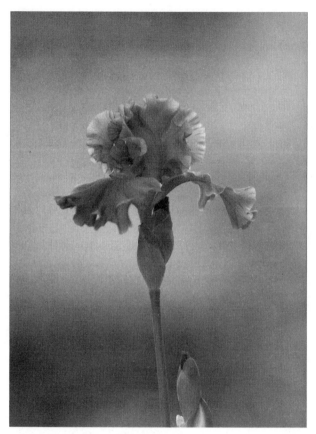

32.1

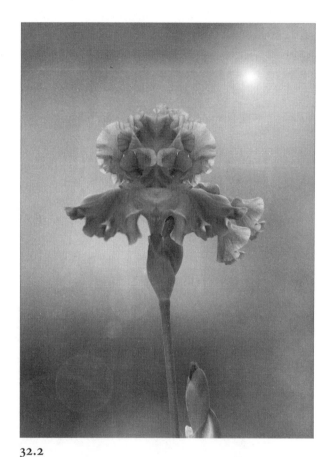

32.2

ABOUT THE IMAGE

"Iris Genetic Variation #SD1297," Canon EOS D30, 300mm f/2.8 IS, ISO 100, f/4.0 @ ¹⁄₁₂₅, 16-bit RAW format, 2,160 x 1,440 pixels, converted, edited, and cropped to a 1,500 x 2,100 8-bit, 9.2MB .tif

After a few hours shooting irises and discussing the many variations of the iris with the gardener who planted the one shown in **Figure 32.1** (**CP 32.1**), I became fascinated with the process flower growers undertake to create new variations. So, I decided to do the same kind of thing — only, you guessed it — digitally! I've now got a whole set of iris prints that exhibit way beyond natural genetic variations. It is easy to create your own genetic variation like the one shown in **Figure 32.2** (**CP 32.2**). Just pick your colors — perhaps even use a color gradation to defy the principle of capillary

action. Copy and paste bits and pieces of the flower and even remove some parts. Add an extra stem and flower, or change the size of the flower. It is all in a day's work of a digital gardener, without all the mess. Try one or more yourself. If you're good at it, you can fool some but not all the flower experts. If you are really good, even the most expert of gardeners will be looking for a watering can to water your flowers.

STEP 1: OPEN IMAGE

■ Select **File ➤ Open** (**Ctrl+O/Command+O**) to display the Open dialog box. After double-clicking the **\ch05\32** folder to open it, click the **iris-before.tif** file to select it, and then click **Open**.

32.3

STEP 2: CUT, PASTE, AND FLOP PART OF IMAGE

One fun effect that you can create to give the impression of some unnatural genetic diversity that looks real is to cut out part of an image, paste it back into the image, and then flip it 180 degrees horizontally. You can try that effect now.

■ Click the **Rectangular Marquee** tool (**M**) in the **Toolbox**. Make sure the **Options** bar mode is set to normal. Click the image and drag the selection marquee to choose a selection that looks like the one shown in **Figure 32.3**.

■ Select **Layer ➤ New ➤ Layer via Copy** (**Ctrl+J/ Cmd+J**) to paste the selected portion of the image back into the image as a new layer. The image will look exactly the same, as the copied layer has been pasted back exactly where it was copied. Now flip the image 180 degrees by selecting **Image ➤ Rotate ➤ Flip Layer Horizontal**. Make sure you do not choose **Flip Horizontal** because you don't want to flip the entire image — just the layer.

■ To slide the new flipped layer, click the **Move** tool (**V**) and press and hold **Shift** and tap the right-arrow key to quickly move the layer five pixels at a time to the right until the right half of the iris matches the left half. If you tap the arrow keys without holding the **Shift** key, the image moves one pixel at a time. Your image should now look similar to the one shown in **Figure 32.4**.

STEP 3: CUT AND PASTE PART OF IRIS BACK INTO IMAGE

Let's now see what you can do to keep part of the iris that is currently covered up by the new layer in the image.

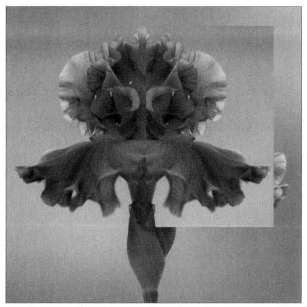

32.4

32.5

■ The **Layers** palette should now look like the one shown in **Figure 32.5**. Click on the **Layer Visibility** icon (the eye icon) at the left of **Layer 1** to turn off that layer. You can now see the entire original image. Click the **Background layer** thumbnail in the **Layers** palette to make it the active layer.

■ Click the **Magnetic Lasso** tool (**L**) in the **Toolbox**. Make sure that the **New Selection** icon is on in the Options bar. **Feather** should be set to **0 px**. A checkmark should be next to **Anti-aliased**, **Width** should be set to **10 px**, and **Edge Contrast** should be **10%**, as shown in **Figure 32.6**.

32.6

■ Click near the part of the iris that is hanging off to the right side, and carefully drag the selection marquee around that part of the iris, as shown in **Figure 32.7**. Select **Edit ➢ Copy** (**Ctrl+C/Command+C**). Select **Edit ➢ Paste** (**Ctrl+V/Command+C**) to paste the copied portion of the image back into the image.

■ For now, just click the new pasted part of the iris with the **Move** tool (**M**) and drag it down toward the right, away from the purple part of the iris.

STEP 4: REMOVE LAYER BACKGROUND

The green background on **Layer 1** now needs to be removed.

■ Click **Layer 1** in the **Layers** palette to make it the active layer. Click the **Magic Wand** tool. Click the green background next to the edge of the iris to select all of the green background that should be removed from the image showing in Layer 1. Click

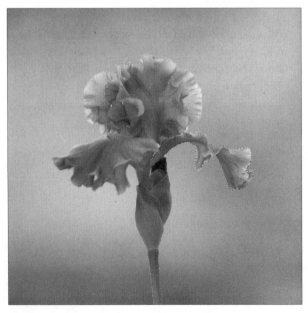

32.7

Edit ➢ Cut (**Ctrl+X/Command+X**) to cut out the unwanted background.

STEP 5: POSITION LAYER

The perfect symmetry is fun and it makes the center of the iris look like a face; see the eyes, nose, mouth, and ears? However, it is good to break up the "perfect-ness" of this image by adding a piece that is not part of the perfect symmetry.

■ Click the **Move** tool (**V**). Make sure that **Layer 2** is the active layer in the **Layers** palette by clicking it.

■ Click **Image ➢ Rotate ➢ Free Rotate Layer**. Click the upper-left handle of the selection marquee and drag it up and to the right to rotate the selected iris layer. Press **Enter/Return** to commit the layer.

■ Click the rotated iris part and move it up to where it looks natural and where it helps to break up the symmetry.

■ Depending on where you located the layer, you may need to cut parts of the layer where they don't fit. As you move the layer a small amount with the **Move** tool, notice where you need to cut out parts of the layer with one of the selection tools. To cut out unwanted parts, select those parts with one of the selection tools and then select **Edit ➢ Cut** (**Ctrl+X/Command+X**) to get an image that looks similar to **Figure 32.2** (**CP 32.2**).

STEP 6: CHANGE IRIS COLOR

■ Select **Layer ➢ Flatten Image** to merge all the parts into the Background so that you can make global color changes.

■ Select **Enhance ➢ Adjust Color ➢ Replace Color** to get the Replace Color dialog box. Set **Fuzziness** to **200**. Click the image and drag the **Eyedropper** tool around until you get as much of the purple color selected as possible. You can see how much is selected by looking at the preview box in the Replace Color dialog box. You can now adjust **Hue**, **Saturation**, and **Lightness** to get

exactly the color of iris you think your variation ought to be. I liked the effects of using +**88**, +**16**, and **0** for **Hue**, **Saturation**, and **Lightness** respectively, as shown in **Figure 32.8**. Click **OK** to apply the new color settings.

STEP 7: ADD CAMERA LENS REFLECTIONS

The new variation of iris looks pretty much like I'd like it to look. Just for fun, add some camera lens flare just to add a bit more magic to the image.

■ Select **Filter ➢ Render ➢ Lens Flare** to get the Lens Flare dialog box shown in **Figure 32.9**. Set **Brightness** to **100%**. Click **50-300 zoom** to set **Lens Type**. Click once in the upper-right corner of the thumbnail image in the Lens Flare dialog box to set the point for the lens flare, and then click **OK** to apply the effect. The image should now look like the one shown in **Figure 32.2 (CP 32.2)**.

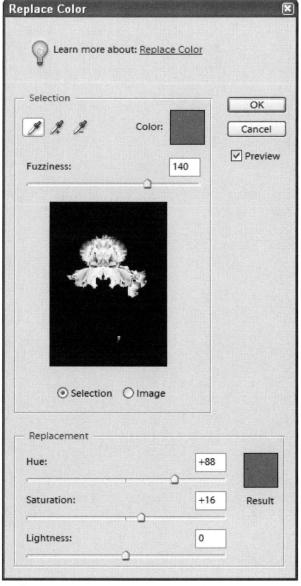

32.8

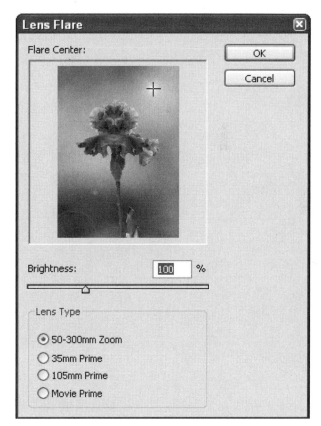

32.9

ADDING A GRADUATED COLOR EFFECT

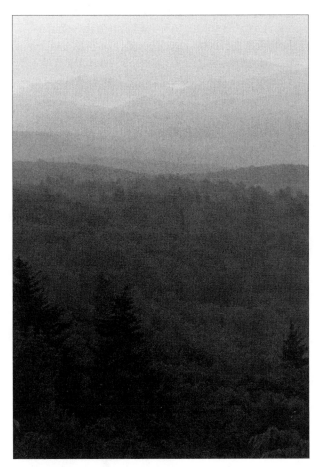

33.1 (CP 33.1)

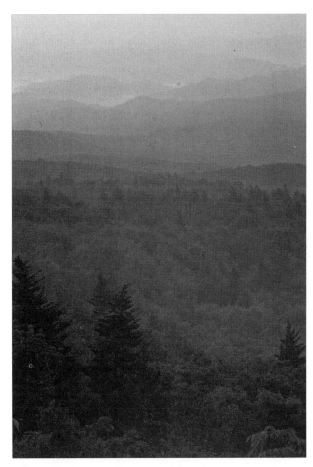

33.2 (CP 33.2)

ABOUT THE IMAGE

"Green-Blue Grandfather Mountain," Canon EOS 1D Mark II, 70–200 mm f/2.8 IS @ 100mm, f/20 @ ⅛ sec, ISO 100, 16-bit RAW format, 2,336 x 3,504 pixels, 7.3MB .CR2 (.jpg version also included)

The photo in **Figure 33.1 (CP 33.1)** was taken in late afternoon at Grandfather Mountain in North Carolina. The distant hills were covered in fog that transformed them into subtle, soft, monotone hills instead of the green rolling hills that they really were. My vision of this scene was to enhance the contrast of the distant hills and to make the green foreground trees transition into a green-blue area in the middle of the image and then into a soft blue mountain range and sky, as shown in **Figure 33.2 (CP 33.2)**.

I know there are many "purist" photographers who are quick to say, "Hey, you can't do that! It is not photography and not natural." I'm always quick to point out how some of the most respected and talented photographers have, for years, tinted their most sought-after photographs with colored filters that they attached to their lenses. Visit www.singh-ray.com and check out all the photo filters that are available and who uses them. When you also consider that these same photographers choose color film such as the remarkable Fuji Velvia to get dramatic and vivid colors, it is hard to explain why such a film-based approach might be "right" and the digital approach is "wrong." In any case, I happily color my images as I choose because I like them that way, I enjoy making them, and many people enjoy looking at them. I hope you enjoy this technique and create prints that you are proud to have created — after all, digital photography is a new art form and it allows interpretative effects like this one any time you'd like to apply them.

STEP 1: OPEN AND CONVERT RAW FILE

■ Select **File** ➢ **Open** (**Ctrl+O/Command+O**) to display the Open dialog box. After double-clicking the /**ch05/33** folder to open it, click the **gfmtn-before.CR2** file to select it, and then click **Open**.

■ The image will now be displayed in the RAW converter. Click in the settings box and choose Camera Default; then, turn off any of the **Auto** settings that have checkmarks next to them. Set **Contrast** to **+15** and **Saturation** to **+15** to add lower contrast and slightly saturate the colors. Make sure that **Depth** is set to **16 Bits/Channel**. Other settings should be as shown in **Figure 33.3**. Click **OK** to open the image in the Editor.

STEP 2: DARKEN DISTANT HILLS AND SKY

■ To show more detail in the distant hills and sky, select **Enhance** ➢ **Adjust Lighting** ➢ **Shadows/Highlights** to get the **Shadows/Highlights** dialog box shown in **Figure 33.4**. Click the **Darken Highlights** slider and move it toward the right to **16%**. Midtone contrast can be increased a slight amount by sliding the **Midtone Contrast** slider to the right to **+2**. Click **OK** to apply the settings.

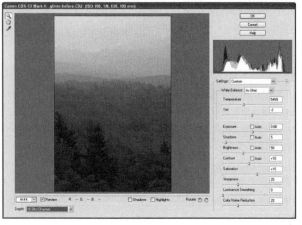

33.3

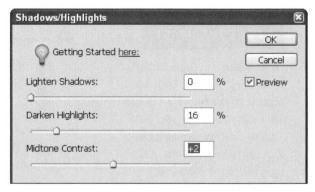

33.4

STEP 3: CONVERT TO 8-BIT

■ Because the next step is to add a layer with color, you now must convert the image to an 8-bit image because Elements 3.0 does not support layers in 16-bit mode. Select **Image ➢ Mode ➢ Convert to 8-Bits/Channel**.

STEP 4: CREATE A COLOR GRADATION LAYER

■ Select **Layer ➢ New ➢ Layer (Shift+Ctrl+N/ Shift+Command+N)** to get the New Layer dialog box; click **OK**.
■ Click the **Gradient** tool (**G**) in the **Toolbox**. Click on the tiny triangle icon in the **Gradient** box on the **Options** bar to get the Gradient Picker shown in **Figure 33.5**. You do not want to get the Gradient Editor, which you will get if you click in the gradient box itself. If the Gradient Picker does not look like this one, click the menu icon in the upper-right corner (the tiny triangle icon) on the Gradient Picker and choose **Reset Gradients**. Click once more on the tiny triangle icon in the Gradient Picker and then on the menu icon once more and choose **Small Thumbnail**. Click in the **Gradient** palette and choose the **Violet**, **Orange**

gradient (the fifth gradient from the left). Make sure that **Mode** on the **Options** bar is set to **Normal** and **Opacity** to **100%**. **Reverse** should not be checked.
■ Select **View ➢ Fit on Screen (Ctrl+0/ Command+0)** so that it is possible to control the placement of the gradient. Click just below the image and hold and drag the cursor to just above the top and slightly to the right so that the line is slightly sloped to the right to make the gradient match the landscape. The gradient should look similar to the one shown in **Figure 33.6**.

33.6

33.5

■ Click in the **Blend Mode** box in the Layers palette and choose **Color**. The Layers palette should now look like the one shown in **Figure 33.7**. You should now be able to see the gradient on the image.

STEP 5: ADJUST COLOR

■ The image as it is, is a bit on the colorful side. To modify the colors as needed, create an adjustment layer that will allow you to go back and change your settings if needed. Select **Layer ➢ New Adjustment Layer ➢ Hue/Saturation** to get the New Layer dialog box; click **OK** to get the Hue/Saturation dialog box shown in **Figure 33.8**. Set **Hue** to –155, **Saturation** to –50, and **Lightness** to –8. Click **OK** to apply the settings.

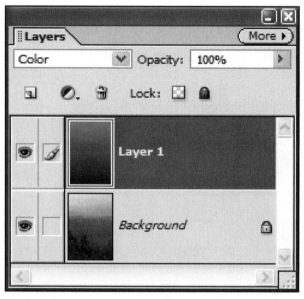

33.7

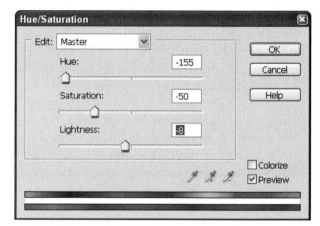

33.8

If you that are wondering why the Violet, Orange gradient was picked when the intended gradient was a blue-green gradient — the answer is simple. It is considerably easier to get a good color gradient by using a Hue/Saturation adjustment layer to modify any color to be what you want than it is to merely pick the two perfect colors out to begin with and create a custom color gradient with the Gradient Editor.

■ Bump the contrast of the entire image a slight amount using a **Levels** adjustment layer. Select **Layer ➤ New Adjustment Layer ➤ Levels** to get the New Layer dialog box; click **OK** to get the **Levels** dialog box shown in **Figure 33.9**. Set **Input Levels** to **32**, **1.00**, and **246**. Notice that you increased the contrast some, but not too much to cause the sky to become overly bright and the distant hills to have too much contrast. Click **OK** to apply the settings to get the image shown in **Figure 33.2 (CP 33.2)**.

Because adjustment layers were used for both Hue/Saturation and Levels, you can go back at any time and click on them and modify your earlier settings without having the image suffer from any unwanted image degradation, which occurs with excessive image editing. Ah, the advantage of adjustment layers — use them often.

This is a technique that can be used on many photos to create excellent images that make wonderful prints.

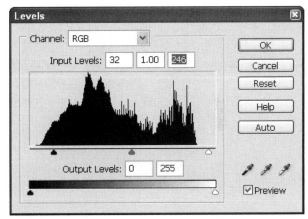

33.9

HAND-COLORING DIGITAL PHOTOS WITH DIGITAL TINTS

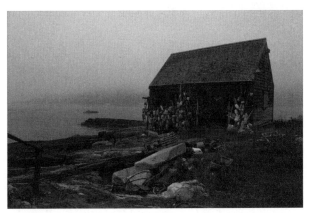

34.1 (CP 34.1)

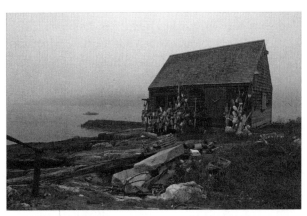

34.2 (CP 34.2)

ABOUT THE IMAGE

"Maine Crab Shack," Canon EOS D60, 16–35mm f/2.8 @ 16mm, f/11.0 @ ¹⁄₃₀ sec, ISO 100, 3,072 x 2,048 pixels, 2.5MB .jpg

Since the beginning of photography, photographers have added color to monochrome images by hand-coloring them with special photo colors. Companies such as Marshall, Eastman Kodak, Peerless, and Roehrig-Bielenberg have, over the years, offered a variety of products in varying colors and strengths for hand-coloring photographs. Some of these colors are still available as oils and pencils. You can create similar effects without using such photo colors by digitally painting with Adobe Photoshop Elements 3.0. The great news here is that you don't have to worry about having all the equipment and facilities it takes to paint; plus, you can avoid the smell. Best yet — you can make copies once you have painted a digital image. In this technique, you learn how easy it is to digitally hand-color an image. You also learn a couple of other tricks that will make your prints look wonderful.

As for some inspiration, I suggest you check out the work of one of the most well-known creators of hand-colored photographs. Jill Enfield's work has not only appeared in galleries and permanent collections all over the world, but she is also a wonderful writer and educator who has written

several must-have photography books. You can learn more about Jill Enfield and her work at www. jillenfield.com.

STEP 1: OPEN IMAGE

■ Select **File** ➢ **Open** (**Ctrl+O/Command+O**) to display the Open dialog box. After double-clicking the /ch05/34 folder to open it, click the **crabshack-before.jpg** file to select it, and then click **Open**.

STEP 2: LIGHTEN IMAGE

The first step you need to take is to lighten the image so that the colors can be seen on the tones below.

■ Select **Enhance** ➢ **Adjust Lighting** ➢ **Levels** (**Ctrl+L/Command+L**) to get the Layers palette. To increase the brightness of the highlight areas, click the **Highlight slider** (the white triangle icon just below and to the right of the histogram) and slide it toward the left to the end of the histogram. To lighten the midtones, click the **Midtone** slider and slide it toward the left a small amount. Input **Levels** in the Levels palette should now be **0**, **1.17** and **233**, as shown in **Figure 34.3**. Click **OK** to apply the settings.

STEP 3: CREATE A COLOR PALETTE

To keep the photo simple, you will now create a color palette to make choosing and controlling colors easy. Choose about six to eight colors.

■ Create a new document by selecting **File** ➢ **New** ➢ **Blank File** (**Ctrl+N/Command+N**) to get the New dialog box. Type **Colors** in the **Name** box. Click in the **Preset** box and select **2 x 3**; click **OK**.

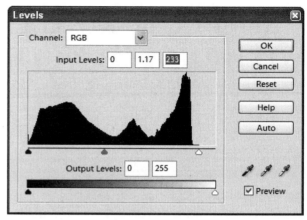

34.3

■ Click the crab shack image to make it active and select **View** ➢ **Actual Pixels** (**Alt+Ctrl+0/Option+Command+0**). Viewing the image at **100%** will make it easier to pick good colors.
■ Click the **Eyedropper** tool (**I**) in the **Toolbox**. In the Options bar, click in the **Sample Size** box and select **5 by 5 Average**. This setting will make it easy to pick good colors. Now click the red door and move the cursor around while you watch the color in the **Foreground** box at the bottom of the **Toolbox**. When you get a good red color, click the **Colors** document to make it active. Press **B** to change to the **Brush** tool and paint a small area with the red color using a brush with **Size** setting of **25px** and **Opacity** set to **100%**.
■ Click on the crab shack image again, press **I** (to get the **Eyedropper** tool), and click to select another color; then, click the **Colors** document, press **B** (to get the **Brush** tool), and paint a small area. Repeat this until you have all the colors you want to use. When you have eight to ten colors, your **Colors** document will look similar to the one shown in **Figure 34.4** only with your choice of colors instead of mine. Don't worry about matching

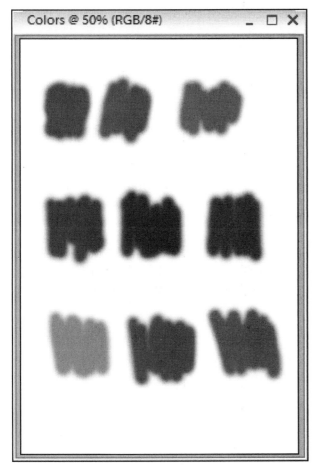

34.4

my color selection — this is a truly creative project and you don't even have to pick colors from the existing image.

Those of you that have used the **Color Swatches** palette may be wondering why I have you painting colors on a new document instead of adding the colors to a **Color Swatch**. If you are one of those wondering why, I commend you — it is a good thing to ponder. The colors were put in a new document

because you can make some simple global changes to them, which you will see in Step 7.

STEP 4: DUPLICATE BACKGROUND AND REMOVE COLOR

- Click the crab shack document window to make it the active document. Select **Layer ➤ New ➤ Layer Via Copy** (**Ctrl+J/Command+J**). You should now see **Layer 1** in the Layers palette, as shown in **Figure 34.5**.
- Select **Enhance ➤ Adjust Color ➤ Remove Color** (**Shift+Ctrl+U/Shift+Command+U**) to get a black-and-white image. To learn more about converting a color image to a black-and-white image, read Technique 7.

STEP 5: ADD TINT TO ENTIRE IMAGE

While hand-tinting black-and-white images is common, in my opinion, most colors work better with a

34.5

slightly colored monochromatic image than a black-and-white image. The colors often blend in more and look to "fit better" with the rest of the image. Try this technique and see what you think.

■ Let's add some color to this image. Select **Filter** ➤ **Adjustments** ➤ **Photo Filter** to get the wonderful new-to-Photoshop-Elements 3.0 Photo Filter dialog box shown in **Figure 34.6**. Click in the **Filter** box and select **Deep Yellow**. Make sure to turn on **Preserve Luminosity** to avoid darkening the image further. Click next to **Color** and then slide the **Density** slider up to about **35%** to get a nice yellow-toned image. Click **OK** to apply the settings.

STEP 6: LIGHTEN SHADOWS

■ I like the image, but the dark shadow areas where some of the color will need to be applied are still too dark to allow much color to shine through. So, lighten the shadows a small amount. Select **Enhance** ➤ **Adjust Lighting** ➤ **Shadow/Highlights** to get the Shadow/Highlights dialog box shown in **Figure 34.7**. Click the **Lighten Shadows** slider and drag it to about **15%**. Click the **Midtone Contrast** slider and slide it to about **+4**. Click **OK** to apply the settings.

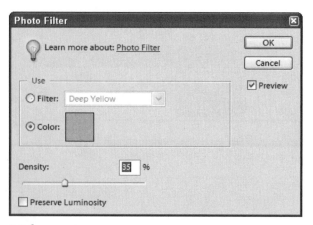

34.6

STEP 7: MAKE GLOBAL CHANGES TO COLORS

Now you can do some really, really cool and creative coloring. In Step 3, I said there would be good reason to take the time to create a separate **Colors** document instead of using **Color Swatches**, or even more simply just using the colors in the original document. As this tinting technique is about using your creative sense of color, your **Colors** document will be of great help.

■ To make global changes to the **Colors** document, click it to make it the active document. Select **Enhance** ➤ **Adjust Color** ➤ **Adjust Hue/Saturation** (**Ctrl+U/Cmd+U**) to get the Hue/Saturation dialog box. To suit my color preference for the crab shack image using the colors I selected, I wanted to both lighten the colors and to increase the saturation a small amount. So, I set **Hue** to **+3**, **Saturation** to **+9**, and **Lightness** to **+20**, as shown in **Figure 34.8**. Your choice of settings is likely to vary depending on the colors you chose and your artistic intent. Once you have the colors you want, click **OK** to apply the color changes. Be careful to not use bold, bright, rich colors if you want to have a hand-colored photo effect. Those new to the hand-tinting process often use colors that are way too bold. Traditional hand tinting is usually done with subtle colors that blend into the photograph.

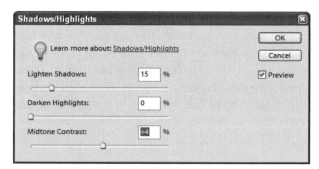

34.7

STEP 8: PAINT EACH COLOR ON ITS OWN LAYER

Now comes the fun part. You have a wonderful color palette. You have a wonderful toned image of the famous Maine crab shack. And, you now get to paint in the color. The process of adding color is quite easy. While you could just paint on a single layer, it is wise to paint each color on its own layer, rather than painting all the colors on the same layer, or even worse — over the tinted image.

■ Make sure you first click the crab shack image to make it the active image. Create a new layer by selecting **Layer ➢ New Layer** (**Shift+Ctrl+N/ Shift+Command+N**). Type the color name in the **Name** box. Click in the **Mode** box and choose **Color**; click **OK**.

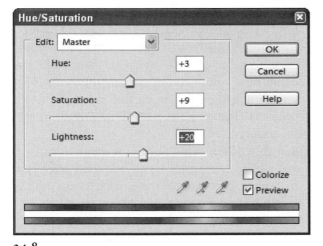

34.8

When doing fine-detailed painting, or dodging and burning, it is best to use a pen tablet. Some of the better pen tablets are made by Wacom (www.wacom.com). Wacom offers several models in many different sizes starting at around $200. A 6" x 8" Intuos2 tablet is perfect for digital photographers with limited desk space. One significant benefit of a pen tablet over a mouse is that many pen tablets such as the Intuos2 tablets are pressure-sensitive, which gives you far more control over brushstrokes. If you are using a pen tablet you have to enable pen tablet support and choose appropriate settings for your task. The figure below shows the Tablet Options palette that can be accessed from the Options bar when the Brush tool is selected. Notice that the amount of pressure you apply to the pen can control brush size, opacity, roundness, and more. A pen tablet really makes it fun to paint, and to dodge and burn digitally.

■ If you forget to select **Color** as the **Mode** in the preceding step, click in the **Blend** mode box in the **Layers** palette and choose **Color**, as shown in **Figure 34.9**. It is very important that you not miss this step. You must select the **Color** mode!

■ Click the **Eyedropper** tool (**I**) and click the color you want to use in the Colors document.

■ Click the crab shack image to make it the active window.

■ Click the **Brush** tool (**B**) and choose an appropriate size brush from the **Brush** palette that is accessed from the **Options** bar. Make sure that **Mode** is set to **Normal** and **Opacity** is set to **100%**.

■ When painting, it is best to work at **100%** view mode by selecting **View ➢ Actual Pixels** (**Alt+Ctrl+0/Option+Command+0**) and to have an uncluttered screen. Paint in the color. Anytime you want to remove some of the paint, click the **Eraser** tool (**E**) and erase the unwanted paint. Continue painting until you have used all the

colors you selected and you have finished painting all that you want to paint. When painting, relax and your results will look better. You don't have to paint every item in your painting the same color as it was in the original photograph. Paint to make your work look good.

STEP 9: MAKE FINAL COLOR ADJUSTMENTS

Once you have painted all the color you want in the image, you can go back and fine-tune each color—and, that is the reason why you added a new layer for each color. For example, assume that the grass is a bit too green for the image.

■ Click the **Green 1** layer in the **Layers** palette to make it the active layer.

■ Select **Layer ➢ New Adjustment Layer ➢ Hue/Saturation** to get the New Layer dialog box shown in **Figure 34.10**. Make sure to click in the box next to **Group With Previous Layer**. This feature limits the color adjustments you make to *just* the green layer. Click **OK** to get the Hue/Saturation dialog box. You can now make any adjustments you want including changing the color and the saturation to just the green color. Click **OK** to apply the settings.

■ You could also add a second, or even a third, green color layer with a slightly different green and mix the new greens with the existing greens in the grassy areas to get a more realistic grass. If you want a more muted color, you can add a gray layer above a color layer and adjust **Opacity** to reduce color intensity. If you use layers for new colors and adjustment layers to make changes, you can always go back and fine-tune any colors until the image is as you want it. When all colors are as you want them to be, flatten the image by selecting **Layer ➢ Flatten Image**.

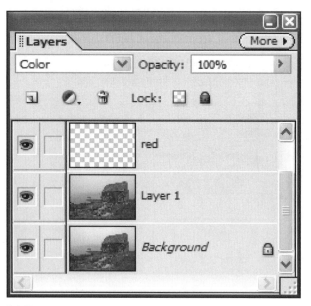

34.9

Figure 34.11 shows the final Layers palette with adjustment layers for both the Green 1 and Red layers. Notice that there is also a copy of the original image at the bottom of the palette. This background image is useful because it enables you to see the original colors. To view Background, you will need to click the **Layer Visibility** icon to the left of color layers. Click the icons again to once again view the final colored image.

> **TIP**
>
> If you have an image that has colors that are too bold or too heavily saturated, you can tone the colors down by selecting Layer ➢ New Fill Layer ➢ Solid Color to get the New Layer dialog box. Change the Mode to Color and click OK to get the Color Picker. Choose a light gray tone from the far left of the color box and click OK. You can then adjust how much you want to tone down the colors by adjusting Opacity in the Layers palette. This technique can result in an image with nicely muted colors that work well together.

34.10

34.11

MAKING A TONED ART PRINT

35.1 (CP 35.1)

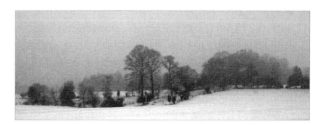

35.2 (CP 35.2)

ABOUT THE IMAGE

"Snow Camp, NC Snow Storm," Canon EOS D30, 28–80mm @ 34mm, f/11.0 @ ¹/₁₆₀ sec, ISO 100, JPEG format, 2,160 x 1,440 pixels, 691Kb .jpg

Many good photographers will tell you that they get some of their best photographs in the worst kinds of weather. Taking this to heart, I headed out in an awful snowstorm in North Carolina to a small town called Snow Camp to get some great photographs. Snow Camp really is the name of the town. If you don't believe me, look on a map just outside Pittsboro near Chapel Hill, North Carolina. It just sounded like a good place to be on a bad snow day, especially given that you rarely see any snow here in North Carolina.

Figure 35.1 (CP 35.1) was one of many photos of farms that I took that day. What would you do with a folder full of gray images like that one? This technique teaches you what I did. I wanted to adjust the tonal range so that the snow looked white, while the image still looked like there was heavy snowfall. I also wanted to add some color to it as if the snowstorm was very isolated and the distant horizon was enjoying a rich, warm sunset. The results are shown in Figure 35.2 (CP 35.2). The image makes a wonderful inkjet print when printed on a fine-art matte paper.

STEP 1: OPEN FILE

■ Select **File ➤ Open** (**Ctrl+O/Command+O**) to display the Open dialog box. After double-clicking the **/ch05/35** folder to open it, click the **snowcamp-before.jpg** file to select it, and then click **Open**.

STEP 2: ADJUST TONAL RANGE AND REMOVE COLOR

■ The challenge in editing this image is to work with the limited picture information in the 8-bit JPEG file, while not losing too much detail when making the needed extreme stretch of the tonal range. In order to be able to view the histogram while editing, select **Window ➤ Histogram** to show the Histogram palette if it is not already showing. It should initially look like the one shown in **Figure 35.3**. Click the **Histogram** palette and move it out of the way of the image as much as is possible. When editing an image with such narrow tonal range, it is wise to monitor the effects of your editing steps to make sure you don't end up with a posterized image, unless that is your intent.

■ Select **Enhance ➤ Adjust Lighting ➤ Brightness/Contrast** to get the Brightness/Contrast dialog box shown in **Figure 35.4**. Set **Brightness** to **+13** and **Contrast** to **+80**. Notice how many gaps there are in the tonal range, as shown in the histogram in the Histogram palette. These gaps signal that the image has become very posterized. This means that parts of the image are covered with single tones as opposed to smooth gradations. Later in this technique, you fix this by applying a gradation. Click **OK** to apply the settings.

35.3

35.4

STEP 3: REMOVE COLOR

■ To desaturate the image, select **Enhance ➤ Adjust Color ➤ Remove Color** (**Shift+Ctrl+U/Shift+Command+U**) to get a black-and-white image.

STEP 4: REMOVE SPOTS

When using a digital SLR camera such as the Canon EOS D30 that was used for taking the photo in this technique, you will occasionally get spots on the image sensor. This is especially true when changing lenses in a cold environment such as a snow storm. Therefore it should be no surprise that you must now remove some nasty spots.

■ Click the **Healing Brush** tool (**J**) in the **Toolbox**. Click in the **Brush** box in the Options bar and select a **90 px Diameter** brush size. Make sure that **Mode** is set to **Normal**, and set **Source** to around **Sampled**. Select **View ➢ Actual Pixels** (**Alt+Ctrl+0/Option+Cmd+0**) to enlarge the image to **100%**. Temporarily select the **Hand** tool (**H**) by pressing and holding the **Spacebar;** click the image and drag it so you can see the top-left part of the image. To set a source point, press and hold **Alt** and click on the image where there are no spots, but where the image is similar to where you want to replace spots. Click each of the spots with the **Healing Brush** tool (**J**) to remove the spots. You may need to click several times on some of the larger spots. Press and hold the **Spacebar** to once again get the **Hand** tool (**H**); click and drag the image toward the right so you can find and remove more spots. Continue this process until you have checked the entire image and have removed all of the spots.

STEP 5: CROP IMAGE

■ I like this image as a short and wide panorama, so crop it now before you apply a color gradient. Select **View ➢ Fit on Screen** (**Ctrl+0/Command+0**) to shown the entire image. Click the **Crop** tool (**C**) in the **Toolbox**. Click **Clear** in the Options bar to clear all settings. If the document window is not already maximized, click the **Maximize** button in the upper-right corner of the document window (on a PC).

■ Using the **Crop** tool, click just outside the image near the bottom-left corner and drag the selection marquee up and toward the right to select a portion of the image that looks similar to the one shown in **Figure 35.5**. Press **Enter/Return** to commit the crop.

STEP 6: ADD COLORED GRADIENT LAYER

■ Select **Layer ➢ New ➢ Layer (Shift+Ctrl+N/ Shift+Command+N)** to get the New Layer dialog box; click **OK**.
■ Click the **Gradient** tool (**G**) in the **Toolbox**. Click the triangle icon in the **Gradient** box in the Options bar to get the Gradient Picker shown in

35.5

35.6

Figure 35.6. (Do not click in the **Gradient** box because you will get the Gradient Editor, which is not what you want.) If the Gradient Picker does not look like this one, click the menu icon in the upper-right corner (the tiny triangle icon) on the Gradient Picker and choose **Reset Gradients**. Click the menu icon once more and choose **Small Thumbnail**. Click in the **Gradient Picker** and choose the **Violet**, **Orange** gradient (the fifth gradient from the left on the top row). Click the **Linear Gradient** icon in the **Options** palette and make sure that **Mode** is set to **Normal** and **Opacity** to **100%**. **Reverse** should not be checked and **Dither** should be checked.

■ Select **View** ➢ **Fit on Screen** (**Ctrl+0/Command+0**) so that it is possible to control the placement of the gradient. Click just below the image and hold and drag the cursor to just above the top and slightly to the right so that the line is slightly sloped to the right to make the gradient match the landscape with the brighter light coming from the upper-right corner of the image. The gradient should look similar to the one shown in **Figure 35.7**.

■ Click in the **Blend Mode** box in the **Layers** palette with **Layer 1** chosen as the active layer and choose **Screen**. The Layers palette should now look like the one shown in **Figure 35.8**. You should now be able to see the gradient on the image. Look in the Histogram palette. Notice that the histogram shown in **Figure 35.9** is now much smoother than it was. One of the benefits of having applied a color gradient is that you were able to "fix" the previously poor histogram.

STEP 7: MAKE FINAL COLOR AND TONAL ADJUSTMENTS

■ Select **Enhance** ➢ **Adjust Color** ➢ **Adjust Hue/Saturation** (**Ctrl+U/Cmd+U**) to get the

35.7

35.8

Hue/Saturation dialog box. Set **Hue** to **–3**, **Saturation** to **+18**, and **Lightness** to **–5** as shown in **Figure 35.10**. This will increase the color saturation and reduce image brightness a small amount. Click **OK** to apply the settings.

■ Select **Layer** ➢ **Flatten Image** so that you can make one last adjustment to the entire image.

■ Select **Enhance** ➢ **Adjust Lighting** ➢ **Brightness/Contrast** to once again get the Brightness/Contrast dialog box. Leave **Brightness** set to **0** and set **Contrast** to **+31**. Click **OK** to apply the settings. You now have a much bolder image with rich colors that will look wonderful when printed on matte paper.

35.9

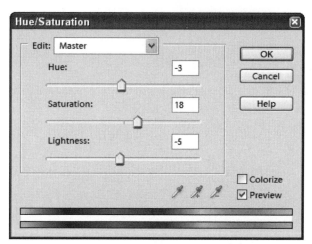

35.10

■ Click the **triangle** icon to update the histogram view in the Histogram palette. Considering the amount of editing you have done to this image, the histogram is not too bad. Given the characteristics of this image and because of the bright glowing sun and the soft snow effect, this histogram and the image are just fine.

■ You now have a nice sun glow coming from the distant horizon and a nice cool purple color in the shaded area of the lower part of the hill. Your image should now look similar to the one shown in **Figure 35.2** (**CP 35.2**).

As the sun sets in that image, it also signals the end of this chapter. Next up is a chapter on editing still life photos. If you've got something to sell on eBay, get it out, take a few photos, and get it sold for top dollar.

6

EDITING STILL-LIFE PHOTOS

Y ou can take still-life photos to make fine art, to record or document a subject, to use for illustration purposes, to sell something at an online auction, or for many other purposes, too. In this chapter, you learn in Technique 36 how to make a perfect photo to help sell something on eBay. In Technique 37, you see how easy it can be to hand-paint a background, and then you set up a still life scene to make an image that can be used to make a fine art print. Technique 38 covers the all-too-important topic of getting *accurate* color. Before learning how to correct color, you first learn what accurate color is and the importance of your photographic intent.

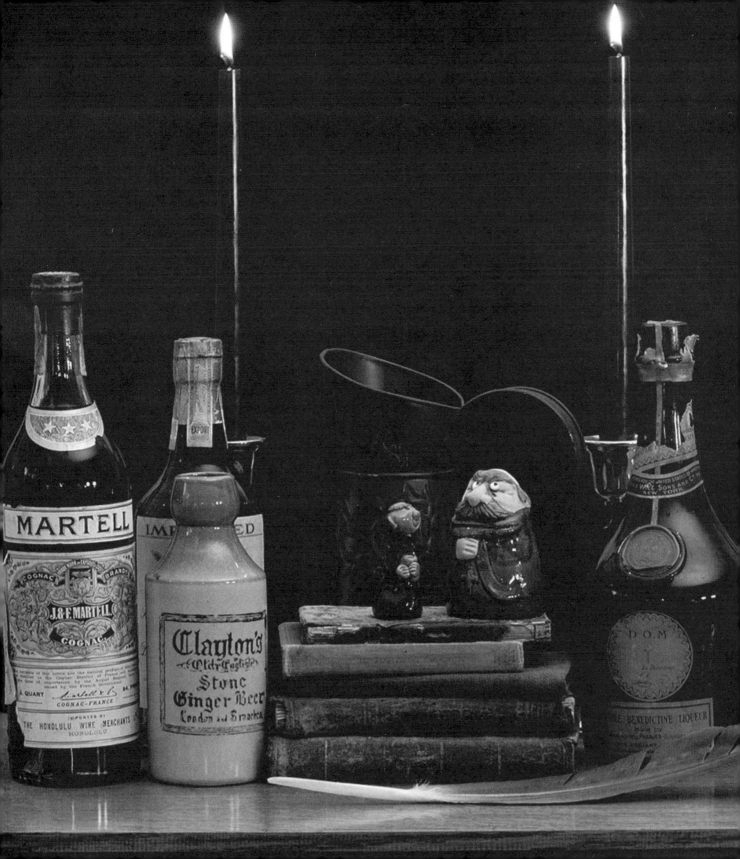

MAKING A PERFECT PHOTO FOR EBAY

36.1 (CP 36.1)

36.2 (CP 36.2)

ABOUT THE IMAGE

"Canon EOS1v for eBay," Canon EOS 1D Mark II, 50mm f/1.4, f/11 @ 1.3 sec, ISO 100, 16-bit RAW format, 3,504 x 2,336 pixels, converted to an 8-bit 259Kb .jpg

When you want to sell something online at such sites as eBay, you can dramatically increase the success of your sale and the amount you get by including high-quality photos. The photos need to be well lit and well exposed so that they show sufficient detail to let prospective buyers feel comfortable that they are buying a good item. While many inexpensive to expensive lighting equipment solutions are available for creating photos for online auctions, you can get excellent results by shooting in good available light and by performing a few editing steps with an image editor such as Adobe Photoshop Elements 3.0.

Some of the best light for shooting objects for eBay is outdoor light on a slightly overcast day. Because the entire sky works like one large light box, it is easy to shoot without getting lots of unwanted shadows. If you need a small amount of light to bring out some detail or to light areas that are in shadow, try using an on-camera flash if your camera has one.

In this technique, you learn how to edit the photo in **Figure 36.1** (**CP 36.1**) and end up with the photo in **Figure 36.2** (**CP 36.2**). Incidentally, I can't help but remark that the camera shown (a Canon EOS 1v) may become known as the best 35mm film camera that was ever built. With the incredible growth in sales of digital cameras and the fun they are to use, can you imagine why 35mm camera vendors would continue to invest in R&D for new film models? I can't either. Shooting with a digital camera is simply — wonderful!

STEP 1: OPEN FILE

■ Select **File ➢ Open** (**Ctrl+O/Command+O**) to display the Open dialog box. After double-clicking the **\ch06\36** folder to open it, click the **camera-before.jpg** file to select it; then click **Open**. If your camera can save images in the RAW format, I strongly suggest that you use it because you will end up with better images — every time. To learn more about RAW images and how to convert them, read Technique 2 and Technique 4. Because many digital cameras do not have RAW shooting capabilities, or because you may be using an image editor that does not have the ability to convert the CR2 RAW image, in this technique, you work with an already converted .jpg image.

Just in case you like working with RAW images, you can find the original **camera-before.CR2** RAW file in the **/ch06/36** folder on the companion CD-ROM.

STEP 2: DETERMINE EDITING STEPS

Before you make any edits, first decide what needs to be done. The background should be mostly white with a few shadows to give the image some dimension. The camera body needs to be a little lighter to show more detail. The image needs to be cropped and sized to meet the eBay picture size requirements, and it needs some sharpening for display as a Web image. The image currently looks to have a cool (or blue) tone, and I'd prefer to warm it up by making the subtle light tone warmer (or more toward the red color range) simply because I prefer a warm tone.

STEP 3: CROP IMAGE

■ Because the only use of this photo will be for display on a Web page, crop it to make it a smaller file, which will make the editing process quicker. As eBay allows images up to 400 x 300 pixels and supersize images up to 800 x 600 pixels, first crop the image to be 800 x 600 pixels. After the image has been edited, you can duplicate it and reduce the copy to get a 400 x 300 pixel image too.

■ Click the **Crop** tool (**T**) in the **Toolbox**. Type **800 px** in the **Width** box and **600 px** in the **Height** box. These settings will give the image the proportions of 800 x 600 but not necessarily 800 x 600 pixels. Type **1** in the **Resolution** box. The Options bar should now look like the one shown in **Figure 36.3**.

■ To crop tightly around the image, click once just to the upper-left of the camera and drag the selection marquee down toward the right to select an area similar to the one shown in **Figure 36.4**. To center the selection marquee on the camera body, click inside the selection marquee and drag it to where you want it. You can also press the arrow keys to move the selection marquee 1 pixel at a time. Press **Enter/Return** to commit the selection. The image is now 800 x 600 pixels.

36.3

CP 3.1

Technique 3: Photo-Editing Workflow

Workflow is the process you undertake when you edit a digital photo. The edit steps you take *and* the order of those steps are important.

CP 3.2

CP 4.1

Technique 4: Converting RAW Files
Shooting in RAW file format gives you many benefits including the ability to edit in 16-bit mode, which ultimately results in a better-looking image.

CP 4.2

Technique 6: Sharpening Digital Photos
Digital photos taken with a digital camera are usually soft due to digitization process.
Most digital photos can be dramatically improved by sharpening them with an image editor.

Technique 8: Sizing, Leveling, Cropping and More

There are many edit steps that must be taken to make an image look as good as it can look. Sizing, leveling, cropping, and removing unwanted marks from dust on an image sensor are just a few of these steps.

CP 8.1

CP 8.2

CP 9.1

Technique 9: Fixing Improperly Exposed Images with QuickFix

Underexposed and overexposed digital photos can sometimes be fixed quickly with Adobe Photoshop Elements 3.0's QuickFix. It is surprising how well it works sometimes.

CP 9.2

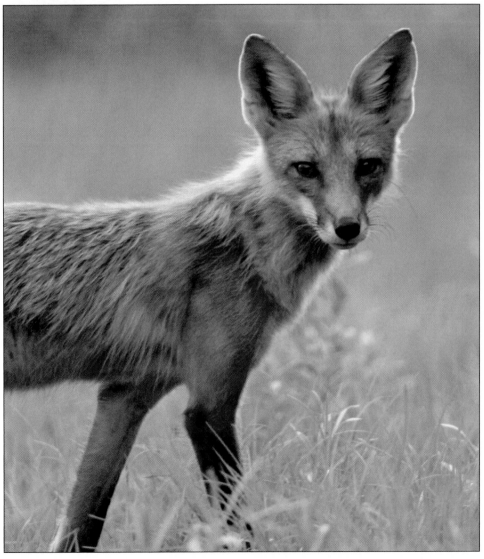

Technique 10: Adding Density and Contrast with Levels

There are a variety of Elements features that can be used to darken an image and to increase image contrast. Choosing the most effective one and using it properly to avoid posterization is important.

CP 10.1

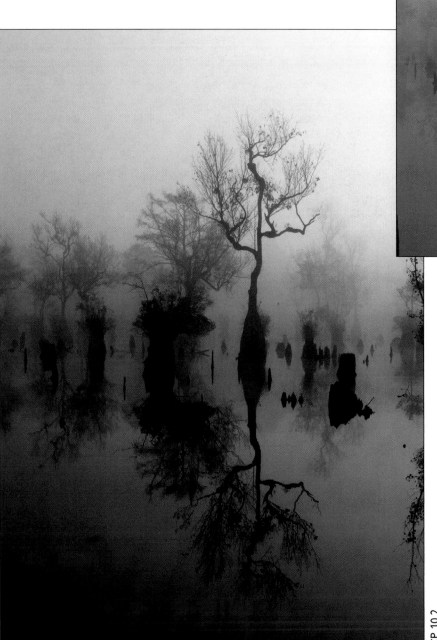

CP 10.2

Technique 12: Controlling Targeted Colors

When you want to control just one, or a few colors in an image, you can do so by using one of the many color adjustment tools in Adobe Photoshop Elements 3.0.

CP 12.1

CP 12.2

Technique 13: Adjusting Color

Getting accurate color where a neutral tone has the same red, green, and blue values can be done in several ways. Choosing the best approach requires expertise or experimentation.

CP 13.1

CP 13.2

Technique 15: Non-Destructive Image Editing

After applying a series of edit steps you may wish that you could go back and make changes to early steps. Using a non-destructive image editing process will allow you to do so without any penalty in terms of image degradation.

CP 15.1

CP 15.2

Technique 16: Dramatically Alter Color

When you want rich, bold, wild colors, Adobe Photoshop Elements 3.0 can help you turn ordinary photos into exciting images that draw attention.

CP 16.1

CP 16.2

CP 18.1

Technique 18: Toning Images with Multi-Color Gradients

Using color gradients is a very powerful way to tone a black and white image. A customized color gradient can enable you to have cold tones in the shadow areas of your image and warm tones in the midtone and highlight areas.

CP 18.2

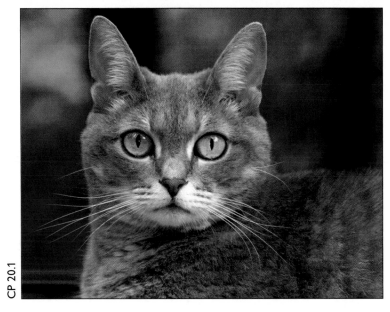

CP 20.1

Technique 20: Creating Cartoon-like Pet Portraits

Realistically altering the face of this cat is just practice for more useful things. Use these tips to remove a double chin, trim a waistline, reduce the thickness of an arm, and you will make your people subjects very happy.

CP 20.2

CP 21.1

Technique 21: Placing and Formatting Text
Breathe new life into your Web forms by moving your static help text into dynamic tool tips.

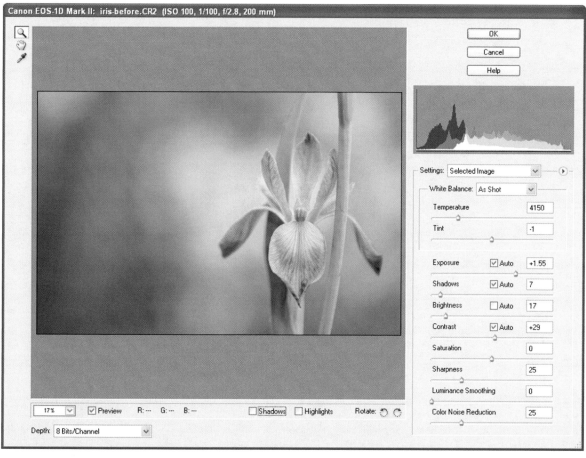

CP 21.2

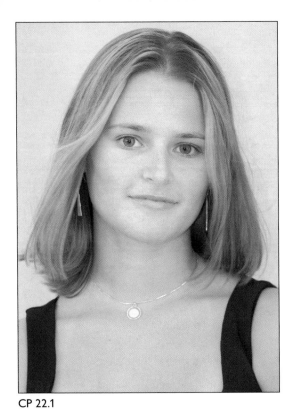

CP 22.1

Technique 22: Creating a Shaded Pencil Portrait Effect

Transforming a portrait or other image into an image that looks like a shaded pencil drawing is part of the possibilities when using the Color Gradient Map.

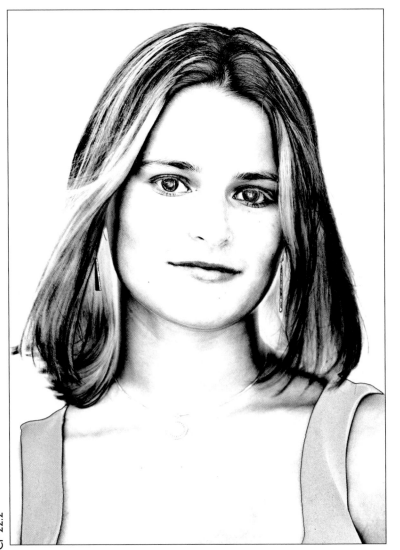

CP 22.2

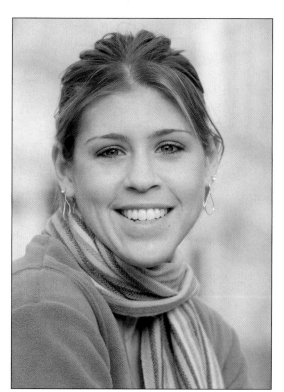

CP 25.1

Technique 25: Adding a Soft-Focus Effect

Getting a soft-focused portrait is often the goal of photographers and their subjects. Use this technique to do it digitally.

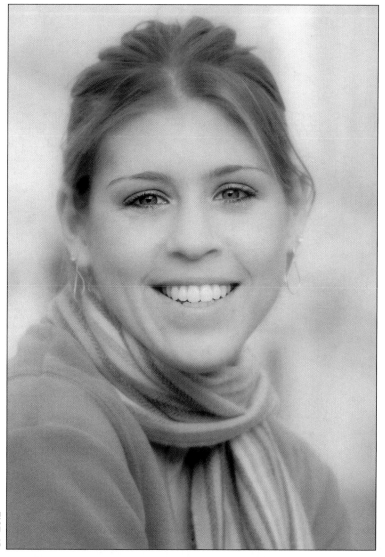

CP 25.2

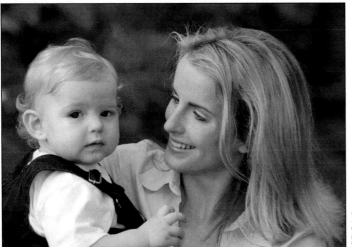

CP 26.1

Technique 26: Adding a Metallic Frame Effect

Do you need a new and creative way to frame your photos? Try this metallic frame effect.

CP 26.2

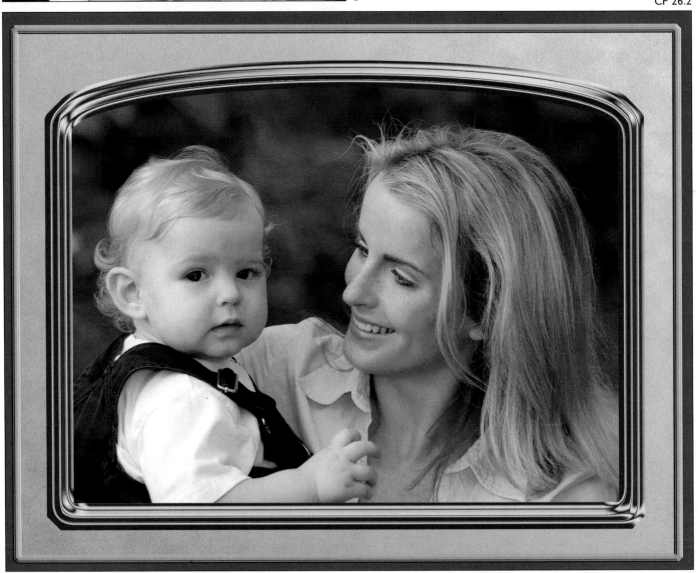

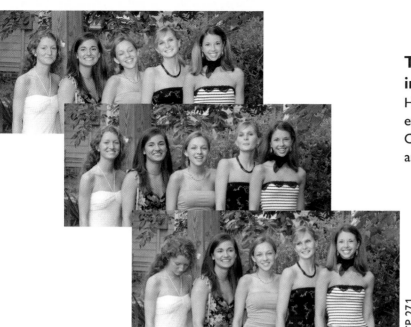

Technique 27: Replacing Heads in a Group Photo

How many shots do you have to take to get everyone in a group photo smiling? Too many! Or, you can shoot a few and replace the heads and faces to get one perfect photo.

CP 27.1

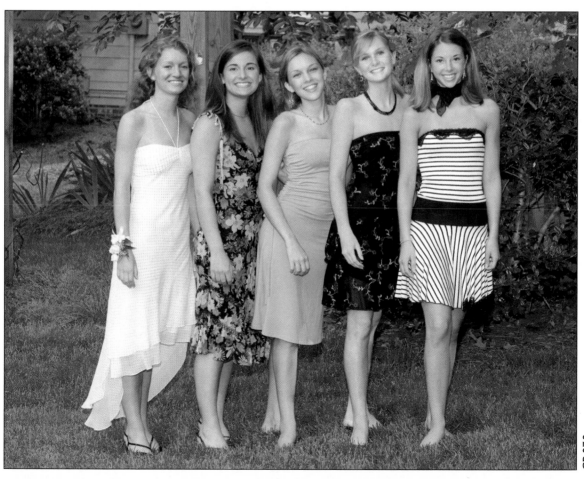

CP 27.2

Technique 29: Creating an Antique Collage

Making a collage is a wonderful way to make a large print that shows multiple photographs. Use this technique to make an antique photo collage—quickly.

RIDGEWAY OPRY HOUSE
2004

CP 30.1

Technique 30: Pan and Blur to Get a Painted Effect

If you want to create an almost painted look to an image, try panning your camera when it is set to a slow shutter speed. Then, use your image editor to enhance the effect.

CP30.2

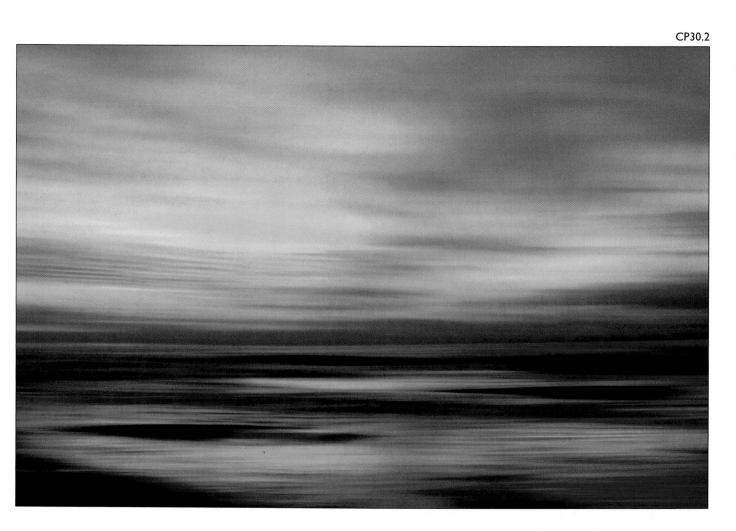

Technique 32: Creating Genetic Diversity in Nature

This technique shows you how to genetically alter the look of a flower, but the tips you learn can be used for many other purposes too.

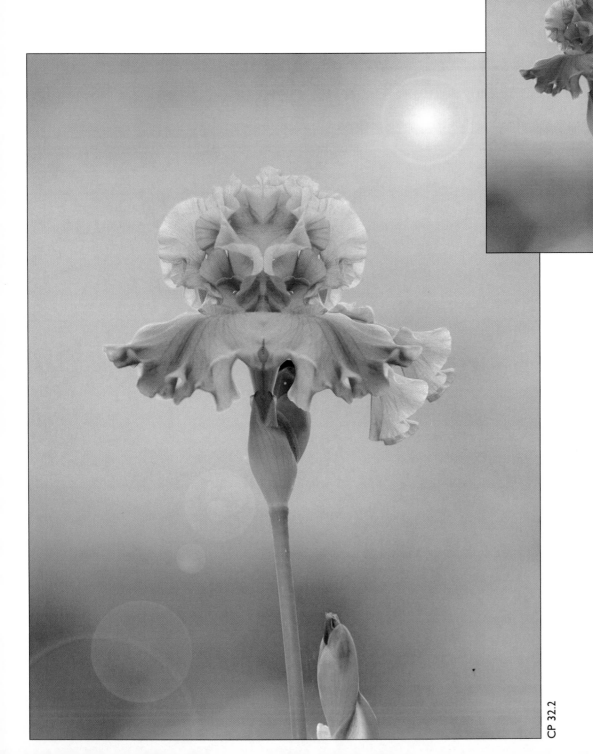

CP 32.1

CP 32.2

Technique 33: Adding a Graduated Color Effect

You no longer need to use a graduated neutral-density filter on your camera to get this effect. Applying a gradient with this technique will make it possible for you to get an even more realistic effect.

CP 33.1

CP 33.2

Technique 34: Hand-Coloring Photos with Digital Tints

One of the particularly fun and easy things to do with black and white photos is to paint them digitally with Adobe Photoshop Elements 3.0. Taking the right approach gives you lots of flexibility and reversibility when painting.

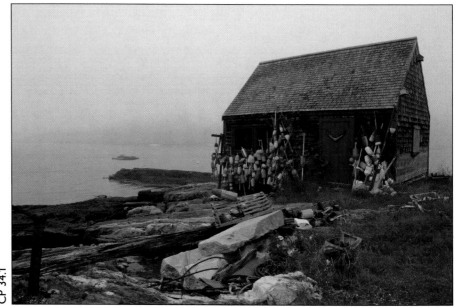

CP 34.1

CP 34.2

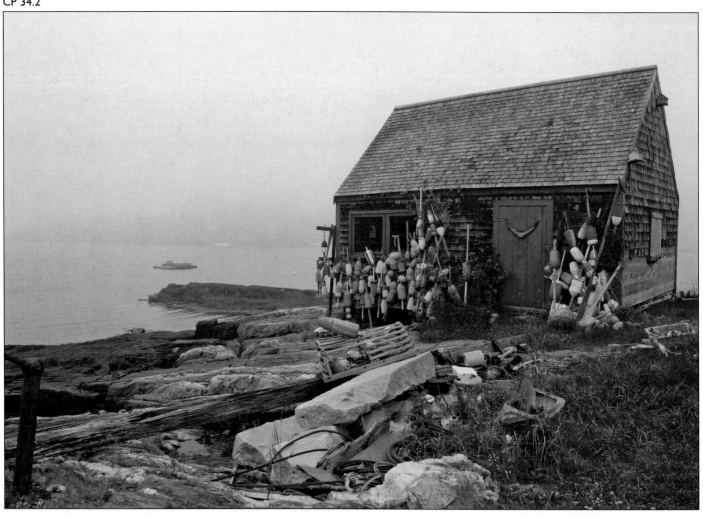

CP 35.1

Technique 35: Making a Toned Art Print

The more image editing you do, the more you realize that there is a good image lurking
in almost every image if you know how to edit it, as seen in this image of a farm.

CP 35.2

Technique 36: Making a Perfect Photo for eBay

Learning how to edit a digital photo to use on an online auction site such as eBay is worth good money to you. Well-photographed and -presented merchandise sells well and for more money than those products that are shown in poorly taken photographs.

CP 36.1

CP 36.2

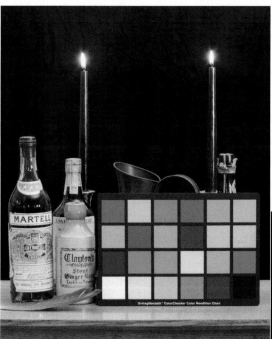
CP 38.1

Technique 38: Shooting and Editing to Get Accurate Color

If you want accurate color without all the color casts that you may get from available light and any artificial light you may be using—shoot with a reference card. Click, click, and click with an image editor and you have accurate color.

CP 38.2

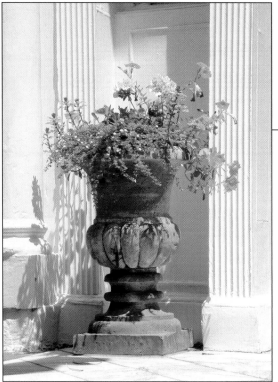

CP 40.1

Technique 40: Creating a "Pen and Ink" Sketch with a Watercolor Wash

Yes, you can even take an urn on a front porch and turn it into a realistic-looking pen-and-ink sketch complete with a watercolor wash in the colors you choose.

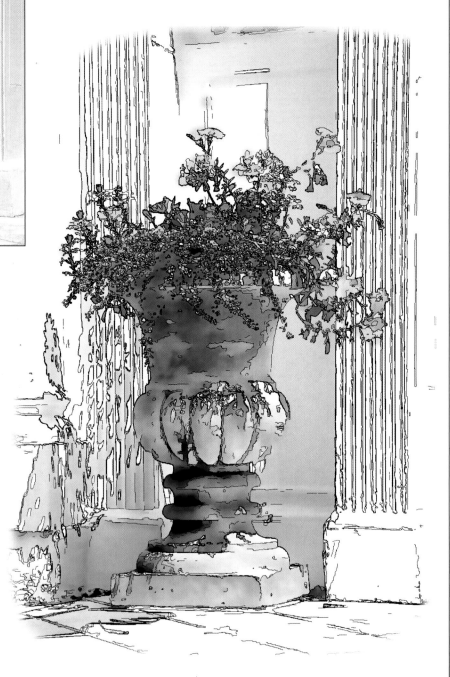

CP 40.2

CP 41.1

Technique 41: Revealing Detail in Shadows and Highlights

One of the most difficult photographic challenges is to capture a scene and show detail in both the shadows and highlights. Many of Elements 3.0's features help you to do just that.

CP 41.2

CP 42.1

Technique 42: Using Filters to Create Fine Art Prints

Applying Elements 3.0's filters in creative ways can often result in images like this one that make excellent prints when printed on fine art paper.

CP 42.2

Technique 43: Creating Depth of Field

Would you like to have a large 20" x 20" print to put on your wall? If so, consider making a poster-sized print using multiple images like this one featuring water lilies. Online photo-processing services offer poster-sized prints for around $22.

Duke Gardens Water Lilies
Photography by Gregory Georges - 2004

Technique 47: Deconstructing a Digitally Made Scrapbook Album Page

Want to learn how a scrapbook pro makes award-winning digital scrapbooks? This technique shows you how to deconstruct this "facing-page" scrapbook page.

CP 47.1

CP 47.2

CP 50.1

CP 50.2

Technique 50: Creating an Online Photo Gallery

If you are shooting and editing digital photos, you ought to be sharing your work online. This technique shows you how easy it is to create an online gallery.

"After" Photos from *50 Fast Digital Photo Techniques*

The companion CD-ROM contains screen-resolution PDF files for all *50* of the techniques found in Gregory Georges' *50 Fast Digital Photo Techniques,* the first edition of this book, which was published in 2000. These are a few of the "after" images from that book.

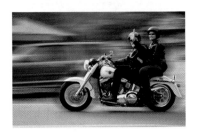

STEP 4: ADJUST TONAL RANGE AND MAKE BACKGROUND WHITE

■ Select **Enhance ➤ Adjust Lighting ➤ Levels** (**Ctrl+L/Command+L**) to get the Levels dialog box. Click the **shadow slider** (the black triangle near the bottom-left of the histogram — not the black triangle below the Output Levels spectrum) and drag it toward the right to about **13** to increase contrast and make the black camera body black.

> **TIP**
>
> Each online auction site has specific size requirements for images. For example, at the time of this writing, eBay allows images up to 400 x 300 pixels. For an additional cost, it also allows images up to 800 x 600 pixels. These supersize pictures cost $0.75 extra. You can also purchase a Picture Pack, which allows you to have up to 6 pictures for $1.00, or for $1.50 you can have between 7 and 12 pictures.

■ Click the **highlight slider** (the white triangle near the bottom-right of the histogram) and drag it toward the left to about **200** to make the background near-white and to further increase contrast.

■ Click the **Midtone slider** and drag it toward the left a small amount to **1.06** to lighten the midtones to reveal more detail in the camera body. The Levels dialog box should now look like the one shown in **Figure 36.5**.

■ Click **OK** to apply the settings. The image now looks much, much better. The blue tone has even been improved to the point where you don't need to bother making any additional color changes.

STEP 5: DUPLICATE AND SIZE NEW IMAGE

■ In Technique 3 and Technique 6 you learned how important it is to sharpen an image *after* all other editing has been completed and when the image has been sized for its intended use. So, you now need to duplicate the image so that you have one image that is sized to be 400 x 300 pixels and one that is 800 x 600 pixels. Click **File ➤ Duplicate** to

36.4

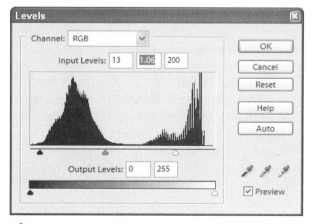

36.5

get the Duplicate Image dialog box. Type **400x300** in the **As** box and click **OK** to create a copy.

■ Click **Image** ➢ **Resize** ➢ **Image Size** to get the Image Size dialog box. Make sure that **Constrain Proportions** and **Resample Image** are checked. In the **Pixel Dimensions** area, click in the **Width** box and type **400** and **Height** will automatically be changed to **300** — just what you want.

■ Click in the **Resample Image** box and choose **Bicubic Sharper**, which is the best interpolation method for down-sampling an image for use on a Web page. Your Image Size dialog box should now look like the one shown in **Figure 36.6**. Click **OK** to resize the image.

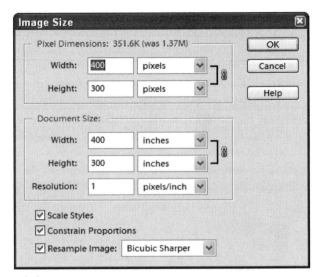

36.6

STEP 6: SHARPEN BOTH IMAGES

■ Now, sharpen the image. Select **View** ➢ **Actual Pixels** (**Alt+Ctrl+0/Option+Command+0**) to show the image at 100 percent as it is best to view an image at full size when determining the best sharpening settings.

■ Select **Filter** ➢ **Sharpen** ➢ **Unsharp Mask** to get the Unsharp Mask dialog box. When sharpening low-resolution Web images, it is typically best to use a high **Amount** value and a very low **Radius** value. Set **Radius** to **.3** pixels and **Amount** to **400%**. You can see the effects in both the preview window and in the image in the workspace. Now, click the **Amount** slider and slide it toward the left until you like the sharpening effect. I thought **250%** was just about right. To view the "before" and "after" effects, click **Preview** in the **Unsharp Mask** dialog box. Your Unsharp Mask dialog box should now look like the one in **Figure 36.7**. Click **OK** to apply the settings.

■ Now do the same thing with the 800 x 600 pixel image. Make sure to view the image at **100%**. Setting **Amount** to **350%** and **Radius** to **0.3 pixels** looks just about right to me. To learn more about image sharpening, read Technique 6.

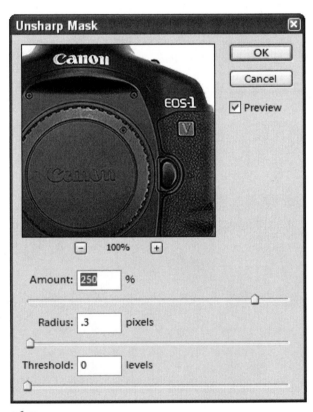

36.7

STEP 7: SAVE IMAGES

■ Your editing is now complete and you are ready to save the images for use on a Web page. While you may think you should use the Save As feature, you are close — but, not quite correct. You will get a better image for use on a Web page by using Save for Web. Save for Web has far more setting choices than Save As and it is has been purposefully designed to optimize images for display on Web pages. Select **File ➢ Save for Web (Alt+Shift+Ctrl+S/Option+ Shift+Cmd+S)** to get the Save for Web dialog box.
■ Click in the left preview box and drag the camera until you can see the EOS-1 logo in the 800 x 600 pixel image. This is a good area to view while choosing image compression settings. The

goal is to select the smallest image size you can while not allowing any visible image degradation due to excessive image compression. In the **Preset** box, choose **JPEG Medium**. Just beneath the right image you will see that the image will be around 54KB with these settings. Now carefully look for differences between this image and the one you get when you select **JPEG Low** in the **Preset** box. The image is now 31.38KB. As there is not that much difference in size and because I don't like the small amount of loss in the texture of the rubberized part of the camera body, change the **Preset** back to **JPEG Medium**. If you want to have even finer control over image quality and image size, you can click in the **Quality** box and choose a numerical setting from **0** to **100** instead of just the five choices you have in the preset box (e.g. **Low, Medium**). Your Save for Web dialog box should now look similar to the one shown in **Figure 36.8**.
■ Click **OK** to apply the settings. You now have a wonderful 800 x 600 image to use to get top dollar at an online auction site.
■ Do the same thing to the 400 x 300 pixel image. My choice of compression quality setting for this image is **JPEG High**. At this higher setting the image still weighs in under 31KB because it is a smaller image.

> **NOTE**
>
> Two main categories of digital image files are used in digital photography: compressed images and non-compressed images. Examples of non-compressed image files are RAW files (usually) and .bmp. Non-compressed image files are large files. In contrast, compressed files are files that have had a mathematical algorithm applied to them to reduce the file size. The .jpg file format is the most commonly used compressed image file format. When compressing an image file, the picture information is simplified to make the file size smaller, which can cause loss of picture information and a reduction in overall picture quality. The more the image size is reduced, the more likely the image will suffer some image degradation. So, when you use Save As, or Save for Web, and you rewrite the file as a .jpg file, you are creating a smaller image file. Both of these features allow you to choose an acceptable balance between file size (small files download faster than large files) and level of image compression (more highly compressed images usually suffer from more noticeable image loss).

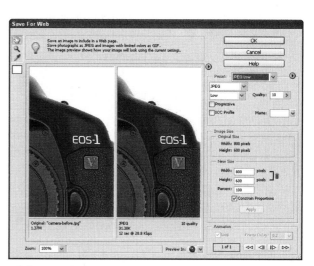

36.8

CREATING A FINE ART STILL-LIFE PHOTO

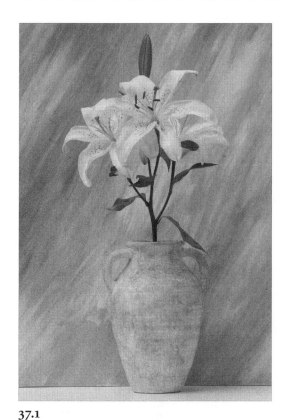

37.1

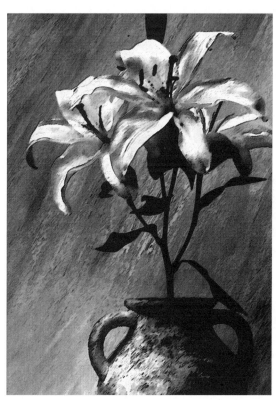

37.2

ABOUT THE IMAGE

"Day Lilies in a Vase," Canon EOS 1D Mark II, 70–200mm f/2.8 IS @ 150mm, f/16 @ ⅛ sec, ISO 100, 16-bit RAW format, 2,236 x 3,504 pixels, converted to a 16-bit 48.6MB .tif

Creating still life scenes and then photographing them can be fun. With still life scenes, you have complete control over the scene; you can shoot, adjust, and shoot again until you get a photograph the way you want. If you live in a place where winters are cold and it is no fun to shoot outside, create still life inside. You can also create wonderful still life that can be used to make fine art photographs. My friend Larry Berman and his wife have made wonderful still-life photographs for years. They find inexpensive objects in junkyards and at flea markets. They then paint the objects, set up scenes, take photographs, and successfully sell them at art shows. Take a look at some of their work at www.bermanart.com. Then, pick your objects, set up a scene, and start shooting.

In this technique, you learn a slight variation to photographing a still-life scene. My daughter Lauren loves painting with acrylic paints. She first painted a background on a stiff board; then she bought inexpensive flowers at the grocery store and took photographs of the flowers in front of the background board she painted. She then did some creative editing with Adobe Photoshop Elements 3.0 to transform the photograph in **Figure 37.1** to the one in **Figure 37.2**. Read on to learn the editing steps she took.

STEP 1: CREATE SCENE AND TAKE PHOTOGRAPH

Many photographers have the talent to pick objects and create wonderful scenes. However, many of those same photographers incorrectly believe it hard to light their subjects well. That is not the case. The scene in **Figure 37.2** was taken outside on an overcast day. The vase and flowers were placed on a matte board that was placed on a chair. The painted background was leaned up against the back of the chair as shown in **Figure 37.3**. In other words — don't stress over lighting. Use good light, which you can find outdoors.

You should also not avoid making your own backgrounds to make your photos more exciting. The background in **Figure 37.4** was painted with artist's acrylic paint within 15 minutes. The board is a stiff matte board and my daughter used a 1½" paint brush for the acrylic paint. Simple up and down strokes with mixed paint can produce wonderful backgrounds. You can read about creative ways to create backgrounds in *50 Fast Digital Photo Techniques*, which is included on the Companion CD-ROM in PDF format.

STEP 2: OPEN FILE

■ Select **File ➤ Open** (**Ctrl+O/Command+O**) to display the Open dialog box. After double-clicking the **/ch06/37** folder to open it, click the **vase-before.tif** file to select it; then click **Open**. This

is an 8-bit image. If you decide that you'd like to work with a 16-bit RAW image, you can find the RAW file in the **\ch06\37** folder. It is named **vase-before.CR2**. **Figure 37.5** shows the RAW settings that were used to create the **vase-before.tif** image.

STEP 3: CROP IMAGE

■ One of the nice things about shooting with an 8-megapixel camera is that you have enough resolution that you can usually crop part of the image and still have plenty of pixels left to make a large-sized print. Let's crop this image to be 7" x 10". Click the **Crop** tool (**T**) in the **Toolbox**. On the **Options** bar, type **7 in** in the **Width** box and **10 in** in the **Height** box. Make sure there is no value in the **Resolution** box.

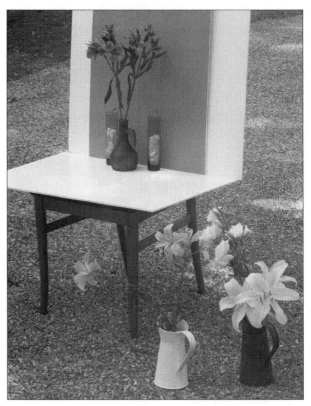

37.3

37.4

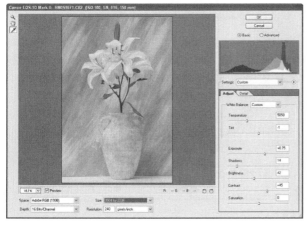

37.5

■ Click in the upper-left corner and drag the selection down toward the bottom-right to select a portion of the image like the one shown in **Figure 37.6**.

■ Press **Enter/Return** to commit the crop. Select **View ➢ Fit on Screen** (**Ctrl+0/Command+0**).

STEP 4: ADD A FEW FILTERS

Some people wouldn't consider using any of the filters that can be found in Filter Gallery, while others happily use them to create effects that make nice

37.6

prints for their walls. If you are one of those in the first group, try this technique and make a print before you say, "I'll never use the Poster Edges and Rough Brush filters!" Applying a series of filters can often provide some nice effects.

- To increase the contrast, select **Enhance ➤ Adjust Lighting ➤ Brightness/Contrast** to get the **Brightness/Contrast** dialog box. Set **Brightness** to **+2** and **Contrast** to **+17**; click **OK**.
- Select **Filter ➤ Artistic ➤ Dry Brush** to get the **Filter Gallery** dialog box shown in **Figure 37.7**. Set **Brush Size** to **2**, **Brush Detail** to **8**, and **Texture** to **2**.
- In the bottom corner of the dialog box, you will see a box that lists the **Dry Brush** filter as being the current filter. Directly below that is an icon to the left of the garbage can icon — that is the **New Effect Layer** icon; click it to add a new effect layer.
- Click the down arrow found to the right of the Effects box to get a pop-up menu; click **Sumi-e**. Set **Stroke Width** to **9**, **Stroke Pressure** to **3**, and **Contrast** to **9**. The Filter Gallery should now look like the one shown in **Figure 37.8**. Notice that you can click on the **Sumi-e** layer, drag it below the **Dry Brush** layer, and get an entirely different effect. If you do drag it, make sure to drag it back. Click **OK** to apply all the settings.

STEP 5: MAKE FINAL ADJUSTMENTS

- Once again, select **Enhance ➤ Adjust Lighting ➤ Brightness/Contrast**. This time set **Brightness** to **–16**, and **Contrast** to **+20**; click **OK**. This makes the white parts of the flower brighter and more contrasty against the rest of the image. It should be noted that these are pretty severe changes that could cause considerable damage to a normal photographic image; however, for this more painterly image, it is just fine.
- One last change. Tweak the colors by selecting **Enhance ➤ Adjust Color ➤ Adjust Hue/Saturation (Ctrl+U/Command+U)**. You can now change the colors to suit your taste. I like the results of setting **Hue** to **–10**, **Saturation** to **+5**, and **Lightness** to **0**. With these settings, you have a bright, rich orange image with bright white flowers. Click **OK** to apply the settings. The image should now look like the one in **Figure 37.2**.

Even if you are not particularly impressed with this image, take the time and spend the money to print this image using a photographic inkjet printer on a matte paper. Some of the less desirable filter "effects" blend in and you end up with a rather nice image, I think.

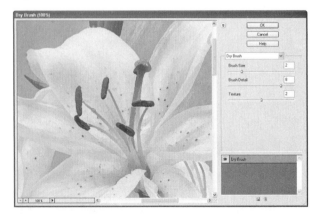

37.7

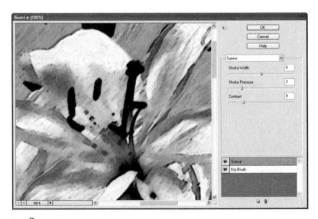

37.8

SHOOTING AND EDITING TO GET ACCURATE COLOR

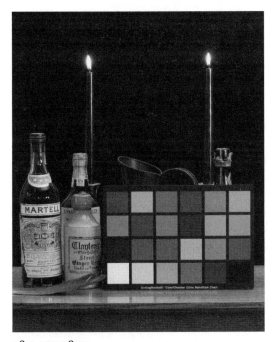

38.1 (CP 38.1)

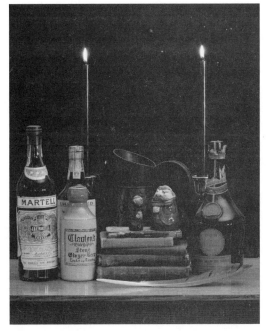

38.2 (CP 38.2)

ABOUT THE IMAGE

"Candles, Bottles, Books and Monks," Canon EOS 1d Mark II, 70–200mm f/2.8 IS @ 70mm, f/11 @ 1.3 sec, ISO 100, RAW setting, 2,236 x 3,504 pixel image converted to a 1,886 x 2,400 pixel 16-bit 25.9MB .tif

Nothing is more frustrating in digital photography than struggling to get *accurate color*. Before going any further, let's be clear about what "accurate color" refers to. Accurate color is the color of an object when light that does not have a color cast is used to light the subject. In other words, if a pure white object is photographed in a room lit by incandescent light, accurate color for that object would be white and not a yellow-tinted color caused by the incandescent light.

It is important to note that accurate color is not always desirable. If you have learned how wonderful the "golden glow" from near-sunset light can be and you work hard to shoot in that light, you will know that a color-cast at times can be preferable to that of accurate color. Likewise, the image shown in **Figure 38.1** (**CP 38.1**) has a nice warm glow that was created with incandescent and candle light. **Figure 38.2** (**CP 38.2**) shows the same image

that has been color-corrected to show *accurate* color — that is where pure white would be — you guessed it — pure white, with no yellow color cast caused by the incandescent lighting.

On those occasions where you know in advance that you will want accurate color, you should first take a photo that includes a color reference card under similar lighting conditions as your final shots. One such card is the GretagMacbeth ColorChecker Color Rendition Chart. **Figure 38.3** shows the large version of the ColorChecker, which can be purchased at most professional photography stores or online at one of the online stores such as B&H Photo (`www.bhphoto.com`) for about $75. A less expensive alternative is the WhiBal White Balance Reference Card available at `www.rawworkflow.com/products/whibal`. The smaller version is $40. In this technique, you learn how to get accurate color when using the GretagMacbeth ColorChecker when shooting in RAW or JPEG file format.

COLOR CORRECTING RAW FILES

When you take photos using the RAW file format, you have an opportunity to quickly and easily get accurate colors with Adobe Camera RAW. In the first part of this technique, you learn how to use Adobe Camera RAW. Later in this technique, you learn how to correct JPEG images.

When using the ColorChecker, you want to first determine the Camera RAW settings that are needed to get accurate color on an image that contains the ColorChecker. Then, you can open up one or more images that were shot under the same lighting conditions that do not have a ColorChecker in them and apply the settings from the first image.

STEP 1: OPEN RAW FILE WITH COLORCHECKER

■ Select **File ➤ Open** (**Ctrl+O/Command+O**) to display the Open dialog box. After double-clicking the **/ch06/38** folder to open it, click the **bottles-before-mc.CR2** file to select it; then click **Open** to open the image in the Camera RAW Converter dialog box. Click the **Rotate Left** icon just beneath the image to orient the image vertically. Click in the **Zoom** box and select **Fit In View** to display the entire image. **White Balance** should be set to **As Shot** which will cause **Settings** to become **Custom**. The Camera RAW dialog box should now look like the one in **Figure 38.4**.

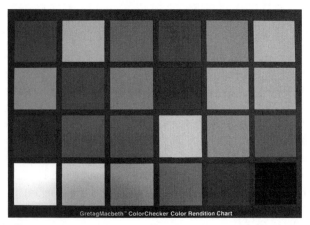

38.3

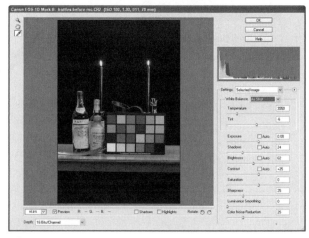

38.4

STEP 2: CHECK COLOR

■ Click the **White Balance** tool (**I**), which is in the upper-left corner of the dialog box. Drag it over the white square at the bottom-left of the ColorChecker in the image, but do not click on the square. Notice that the **R, G,** and **B** values for this supposedly white box are shown just beneath the image. They should be close to **248, 232,** and **205** respectively. These values indicate that there is much more red than green, and even more red and green than blue. If this were accurate color, the **R, G,** and **B** values would be equal. Instead they are very unequal, which confirms what you can see in the image.

STEP 3: CORRECT COLOR

■ Now see if you can correct the color. Using the **White Balance** tool (**I**), click the gray box that is just to the right of the box that should be pure white in the ColorChecker in the image, as shown in **Figure 38.5**. Instantly, you will see that the warm yellow color-cast is gone and the image has

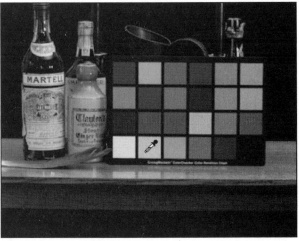

38.5

much more accurate color. Now, when you drag the **White Balance** tool (**I**) over the white square in the ColorChecker, you will see that the **R, G,** and **B** values are nearly equal.

STEP 4: MAKE OTHER CHANGES TO SETTINGS

■ Now that the color has been corrected, you can make any other additional changes you want to the Camera RAW settings. The histogram shows that the image is pretty-well exposed. Increasing **Exposure** is likely to push the histogram off the right side of the chart, which would cause unwanted "blown-out" highlights. So, to lighten the image, click the **Brightness** slider and slide it toward the right to about **75**. Click **OK** to open the image.

STEP 5: CORRECT COLOR IN IMAGE WITHOUT COLORCHECKER

■ Now that you know what settings to use to make accurate color, select **File ➤ Open** (**Ctrl+O**/**Command+O**) to display the Open dialog box. After double-clicking the **/ch06/38** folder to open it, click the **bottles-before.CR2** file to select it; then click **Open** to open the image in Camera RAW.

■ Click in the **Settings** box and choose **Previous Conversion**. There you have a color-corrected image with the increased **Brightness** and **Saturation** settings applied that you chose in Step 4. Click **OK** to open the image. More importantly, you have a color-corrected image without any color reference card showing in the image! It is an easy process: Shoot with a color reference card, correct color using an image with the card, open up additional image shot in the same light, and apply the settings you got from correcting the color of the image with the color reference card.

COLOR CORRECTING JPEG FILES

When you shoot using a photo file format other than RAW, you won't have the option to use the Camera RAW **White Balance** tool to correct color. Instead, you should either use the **Levels** tool or possibly the **Auto Color Correction** tool.

STEP 1: OPEN JPEG FILE

■ Select **File** ➢ **Open** (**Ctrl+O/Command+O**) to display the Open dialog box. After double-clicking the /**ch06/38** folder to open it, click the **bottles-before-mc.jpg** file to select it; then click **Open**.

STEP 2: CORRECT COLOR

■ This time, you will use Levels to get accurate color. Select **Enhance** ➢ **Adjust Lighting** ➢ **Levels** (**Ctrl+L/Cmd+L**) to display the Levels dialog box shown in **Figure 38.6**. Click the **Set Black Point** eye dropper (the left-most eye dropper) and click in the black square on the ColorChecker shown in the image. Click the **Set White Point** eye dropper (the right-most eye dropper) and click in the

white square in the ColorChecker. Click the **Set Gray Point** eye dropper (the middle eye dropper) and click in the middle gray box that is the fourth one from the left (or you can try the third box from the left too). The image should have fairly accurate color now. The Levels dialog box should now look similar to the one in **Figure 38.7**. Click **OK** to apply the settings.

Now, let's see how well you corrected this .jpg image. Select **Window** ➢ **Info** to make the **Info** palette viewable. Click the **Eye Dropper** tool (**I**) and drag the cursor across the bottom gray squares in the ColorChecker. If the image was perfectly color corrected, the **R**, **G**, and **B** values would be read the same in each of the gray squares. For example, the light gray square to the right of the white square might show **R**, **G**, and **B** values of **227, 227,** and **227**. While many of the values are close, some are not as close as they should be; but, they still give us an image with fairly accurate color.

Now I have a bit of bad news. Adobe Photoshop Elements 3.0 does not offer any way to save the values you get when using the **Levels** tool you used in Step 2. This means that it is not possible to apply the **Levels**

38.6 38.7

WARNING

Using a GretagMacbeth ColorChecker Color Rendition Chart as discussed in Technique 38, is a quick and accurate way to remove color casts so that a photo accurately reflects the original colors. However, you may not always want to remove a color cast. If you intentionally shot a photo in early morning or late evening light, or in candlelight, or in other desirable lighting conditions — you will generally have a color cast. In these and other cases, such color casts may be desirable, and you therefore will not want to correct the color as you will remove the color cast while attempting to accurately reflect the original colors.

settings you got from correcting the image with the ColorChecker to another image without the ColorChecker that was shot in similar lighting conditions. This means that you need to find a small

place in your image to place the ColorChecker so that it can be cropped, or cloned, out after the image has been color corrected. Sadly, I have to inform you that this is just one of many reasons why you may want to upgrade to the more expensive full version of Photoshop. If you are committed to not upgrading, a good workaround is to create a **Levels Adjustment Layer** and merely drag it from a corrected image to any image you want to correct, assuming they were shot in similar light.

Another option you have for color correcting an image is to use the **Enhance ➤ Auto Color Correction** (**Shift+Ctrl+B/Shift+Command+B**) feature, and then adjust the tonal range using **Levels**. Often the **Auto Color Correction** feature will work surprisingly well. When it does not work as well as you'd like, try shooting with a ColorChecker in your image. You can learn more about correcting color when you do not have the luxury of using a ColorChecker in Technique 12.

Now you know how to get accurate color when that is what you are seeking. In the next chapter, you learn some tips and techniques that are just fun to use on the images included on the companion CD-ROM and on your own images.

CHAPTER 7

TIPS AND TECHNIQUES YOU'LL ENJOY

This is the chapter that contains all the cool "miscellaneous" tips and techniques that don't fit neatly under the other chapter headings, but still need to be in the book because you're likely to enjoy using them. You learn how to make a large black-and-white print from a very tiny image in Technique 39. The "pen and ink" sketch with a watercolor wash technique shown in Technique 40 is one of my favorites. Technique 41 shows you how to reveal details in shadows and highlights when they are lost in high-contrast scenes. Getting more from filters is the topic of Technique 42. Technique 43 shows you how to create a 20" x 30" poster featuring your photographs. The last technique, Technique 44, describes in detail several different approaches for converting your digital photos into line drawings.

MAKING A LARGE B&W PRINT FROM A SMALL JPEG

39.1

39.2

ABOUT THE IMAGE

"Mack Truck Hood Ornament,"
Canon EOS 1D, 100mm Macro
f/2.8, f/3.5 @ ¹/₂₅₀₀ sec, ISO 200,
2,160 x 1,440 pixels, edited,
cropped, and converted to
102 x 128 pixel, 8.8Kb .jpg

Have you ever wanted to make a large print from a tiny .jpg? Or, have you had a reasonably sized color image that was not in focus, but is well exposed and features an excellent subject? Or, maybe you would like a large print made from just a tiny piece taken from a large image. In each of these cases, you can use this technique to make pretty good to wonderful, large black-and-white prints. Using this technique, I have made many outstanding prints from 13" x 19" and up from tiny images as small as 128 x 128 pixels. You have to try this one to believe it! If you have a large image, you would almost certainly use it, but such an image is not always available and in those cases this technique can be useful.

Figure 39.1 shows a photo from my extensive collection of automobile and truck hood ornaments. All right, keep the chuckles down there—while it may sound to you like a funny subject to shoot, I've been shooting hood

237

ornaments for years. I especially like the Mack Truck hood ornaments! I have a Mack Truck hood ornament calendar all ready to submit to Mack Trucks one day when time permits. For this technique, you take this tiny 8.8Kb color .jpg image and make a 12" x 15" black-and-white print.

STEP 1: OPEN FILE

■ Choose **File ➢ Open (Ctrl+O/Command+O)** to display the Open dialog box. Double-click the **\ch07\39** folder to open it and then click the **ornament-before.jpg** file to select it. Click **Open** to open the file.

STEP 2: REMOVE COLOR

■ Choose **Enhance ➢ Adjust Color ➢ Remove Color (Shift+Ctrl+U/Shift+Command+U)**.

STEP 3: REMOVE JPEG ARTIFACTS

■ This step is not always needed, but when it is, it is a very important step. Sometimes, if you don't use a small amount of Gaussian blur, you will get enlarged versions of any JPEG artifacts when you get to Step 4. If you have an image that has undergone an excessive amount of JPEG compression, you can apply a very small amount of blur to remove some JPEG artifacts or to soften the image into smooth tonal ranges. Select **Filter ➢ Blur ➢ Gaussian Blur** to get the Gaussian Blur dialog box shown in **Figure 39.3**. Set **Radius** to a low number such as **0.2** to **0.7** pixels. For this image, use **0.3**; click **OK** to close the dialog box. After upsampling the image in Step 4, you may want to step back and change this setting to get the right balance between smooth gradations and an overly soft

image. The less Gaussian Blur you have to use, the sharper your final image will be.

STEP 4: UPSAMPLE IMAGE

How about creating the largest image possible from a smaller image that can be printed on a 13" x 19" piece of paper? Once again, let's assume that the print will be made on an Epson printer, and that you need only 240 dpi to get a great print.

■ Select **Image ➢ Resize ➢ Image Size** to get the Image Size dialog box shown in **Figure 39.4**. Notice that this upsampling miracle will start with a tiny 102 x 128 pixel image.

■ Make sure there is a checkmark next to **Constrain Proportions** and **Resample Image**. **Resample Image** should be set to **Bicubic Smoother**, which is the best interpolation algorithm to enlarge images such as this one because it will keep the image sharper than the alternatives.

39·3

■ Type **360** in the **Resolution** box in the **Document Size** area; make sure **pixels/inch** is selected. Why use 360? Because it is an even increment (1.5 times) more than the 240 dpi that Epson recommends as a minimum for their commonly used photographic printers.

■ Type **18** in the **Height** box (that gives you a .5" border) in the **Document Size** area; make sure **inches** is selected. Notice that **Width** automatically changes to **14.344** inches, which is more than your 13" wide paper will allow. So, type **12"** in the **Width** box (once again leaving a .5" border) and **Height** will automatically change to **15"**. Your final image will be 12" x 15", which fits nicely on a 13" x 19" paper. Click **OK** to apply the settings.

The image is now a 67.7MB image with 4,320 x 5,421 pixels set to print at 360 dpi. Given that you started with an 8.8Kb image, that makes this a 2,574 percent increase in image size!

STEP 5: ADD DIGITAL NOISE

Next, you'll add some digital noise that looks like grain in a photographic print made in a traditional wet darkroom. But, before you do, you need to first take a good look at the image at 100 percent zoom to make sure you don't have any unpleasant effects left over from unwanted JPEG artifacts, or other image defects.

■ Select **View ➤ Actual Pixels** (**Alt+Ctrl+0/ Option+Command+0**) to view the image at **100%**. Press and hold the **Spacebar** to get the **Hand** tool (**H**). Click the image and drag it around to look for any areas that might not have a smooth tonal range. This image looks pretty good to me, except I don't like the dark line that runs around the dog. My hope is that it is so narrow that it won't be visible when a print is made. **Figure 39.5** shows a detail of the dog's head.

39.4

39.5

■ To add digital grain, select **Filter ➤ Noise ➤ Add Noise** to produce the Add Noise dialog box shown in **Figure 39.6**. Make sure that **Monochromatic** is checked; otherwise you will have multicolored digital noise. Click **Uniform** and then **Gaussian** while watching the image to see which **Distribution** you like best. Generally, I like Gaussian better and do so for this image, too. Click the **Amount** slider and move it between **8%** and **15%** to find a fine dot pattern that reveals a dot texture, but not too much. I like **12%**. Remember that this image will be printed at 360 dpi, so fine dot detail like this will become almost unnoticeable.

■ When you are happy with the settings, click **OK** to apply them.

STEP 6: ADJUST TONAL RANGE

■ Select **View ➤ Fit on Screen** (**Ctrl+0/Command+0**) to view the entire image.
■ If you are not happy with the tonal range for example, it is too dark or too light, now is the time to use the Levels tool to make any adjustments. This image is just fine as it is, I think. **Figure 39.7** shows a portion of the image enlarged to show the digital noise.
■ To make the noise look more like a high-ISO, high-contrast image select **Enhance ➤ Adjust Lighting ➤ Brightness/Contrast** to summon the Brightness/Contrast dialog box. Set **Contrast** to **+25**; click **OK** to apply the settings. Using a **+25** setting, you will be forcing some of the image toward pure white.

STEP 7: PRINT IMAGE

Throughout this book I sometimes mention that some images need to be printed in order to see the effect you've created. The limitations of the printing press used to print this book often make the

39.6

39.7

completed images look entirely different than what they look like when printed on an inkjet printer at full size. This advice is never truer than it is here for this image. Even if you don't take the time to go through all the steps, you must take a few minutes and print out the final image to see what it looks like. You can find the "after" image in the **\chap07\39** folder. It is named **ornament-after.jpg**. This is a very useful and fun technique that can be applied to very tiny Web images, small-megapixel camera images, or even a small part of an image that has been removed from a large image. Try it! However, be aware that it will not work on all images and the results you get are soft (i.e., not sharply focused) images. Low-contrast images with smooth tonal ranges will give you the best results.

TIP

Technique 39 shows you how to make an excellent black-and-white print from a tiny .jpg image. When trying this technique, if you do not have a particularly good image, you should make it larger than is needed and after you have added digital noise and adjusted the tonal range, you can the reduce the image size. This technique, like many techniques, does not work equally well on all images. Images with smooth tonal ranges, soft backgrounds, and minimal detail are the best images for this technique.

CREATING A "PEN AND INK" SKETCH WITH A WATERCOLOR WASH

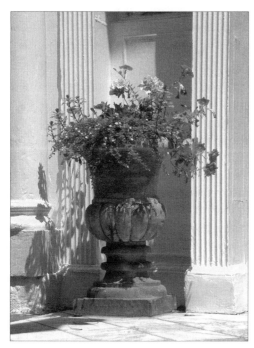

40.1 (CP 40.1)

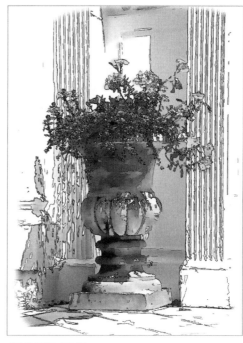

40.2 (CP 40.2)

ABOUT THE IMAGE

"Flowering Urn on a Porch," Nikon 950, f/2.8 @ 50mm, f/8 @ ¹/₁₂₅ sec, ISO 100, 1,600 x 1,200 pixels, cropped and converted to 1,152 x 1,600 pixels, 5.8MB .tif

I included this technique in the first edition of *50 Fast Digital Photo Techniques*, and in fact, it was the technique that prompted me to write a series of step-by-step books. If you have completed it before, go ahead and skip it. If not, try it out — it has been proven to be great fun for tens of thousands of readers.

Of all the different art media there is, I particularly like watercolor paintings with their often-blurry edges and transparent colors. Very loose "pen and ink" sketches with loosely defined shapes and lines with lots of character are also at the top of my favorites list. I think the looseness of these two types of artwork is what appeals to me. They can be suggestive and yet leave enough undefined to allow your imagination to fill in the remaining parts, quite like reading a book versus seeing a movie made from the same story.

The photograph in **Figure 40.1** (**CP 40.1**)shows an urn that I found on the front porch of a fancy home in Charleston, South Carolina. You might

not think that it is possible to turn this digital photo-graph into a fine art quality print on watercolor paper, but it is, as can be seen in **Figure 40.2 (CP 40.2)**. This is one of the many images in this book that just doesn't look as good printed in the book compared to what it looks like printed full-size on quality, textured fine art paper with a photo-quality inkjet printer — it really does look quite fine.

This technique shows how to transform a digital photo into a watercolor-like image and a pen-and-ink sketch, and then how the two can be combined to become a pen-and-ink sketch with a watercolor wash. After completing this technique with the urn image you should then try it on one or more of your own photos. I think you will like the results.

STEP 1: OPEN FILE

■ Choose **File** ➤ **Open** (**Ctrl+O/Command+O**) to display the Open dialog box. Double-click the **\ch07\40** folder to open it and then click the **urn-before.tif** file to select it. Click **Open** to open the file.

STEP 2: DUPLICATE LAYER

■ As both a watercolor painting and a "pen and ink" sketch are needed, you need two layers. Duplicate the background layer by choosing **Layer** ➤ **Duplicate Layer**. When the Duplicate Layer dialog box appears, type in **Pen and Ink** to name the image, as shown in **Figure 40.3**, and then click **OK**.

40.3

STEP 3: TRANSFORM ONE LAYER INTO A WATERCOLOR PAINTING

Adobe Photoshop Elements 3.0 does have a water-color filter, but in most cases, I find that it makes the images too dark with too many odd-looking brush strokes. Therefore, you'll use another approach.

■ Click the **Background** layer in the Layers palette to make it the active image.
■ Click the **Indicates Layer Visibility** icon in the left column in the **Pen and Ink** layer to hide the top layer. The Layers palette should now look like the one shown in **Figure 40.4**.
■ Choose **Filter** ➤ **Artistic** ➤ **Dry Brush** to get the **Dry Brush** filter in the Filter Gallery dialog box. Click in the preview window and drag the image around until you can see a few flowers. Begin exper-imenting with the settings for **Brush Size**, **Brush Detail**, and **Texture**. I used **2**, **8**, and **1**, as shown in **Figure 40.5** because they have a nice painted look. Click **OK** to apply the settings.

To soften the brush strokes and make them look more like a watercolor wash, use a blur filter.

40.4

■ Choose **Filter ➤ Blur ➤ Smart Blur** to get the Smart Blur dialog box shown in **Figure 40.6**. Try using a **Radius** of **10** and a **Threshold** of **50**. Also, make sure you have **Quality** set to **High** and that **Mode** is set to **Normal** before clicking **OK** to apply the settings.

For this particular image, these few steps produce a realistic-looking watercolor. After using many images and trying many different techniques to create water-color paintings, I've concluded there are many variables and settings for each of many different techniques. Always keep in mind that what works on one image, may work poorly on another. In general, these steps work well on images that are about 1,600 x 1,200 pixels in size and that have been taken with a digital camera using a low ISO setting.

On larger files and when photographs have been scanned with a flat-bed scanner or negatives or slides have been scanned with a film scanner, the same techniques work well if you first apply a light **Gaussian blur** to the image. The larger the files, the better this technique seems to work, provided that the image is a good-quality image with minimal grain. Sometimes, you may also find that an image can be made to look more like a watercolor painting if you apply some of these filters more than once. Experimentation is the key to getting what you want.

STEP 4: TRANSFORM SECOND LAYER INTO A "PEN AND INK" SKETCH

The next step is to turn the "pen-ink" layer into a "pen and ink" sketch. While most Photoshop experts use and recommend the Find Edges filter to make line drawings, I usually get much better results with a hidden option in the Smart Blur filter. The results as you'll see can be quite outstanding.

■ Click the **Pen and Ink** layer to make it the active image.

■ Choose **Enhance ➤ Adjust Color ➤ Remove Color** (**Shift+Ctrl+U/Shift+Command+U**) to remove all color.

40.5

40.6

■ Choose **Filter ➤ Blur ➤ Smart Blur** to once again get the Smart Blur dialog box. This time, set **Quality** to **High** and **Mode** to **Edge Only**.

Finding settings that show the vertical lines on the columns while not adding too many lines around the flowers is important. To do this, click in the preview box inside the Smart Blur dialog box and drag the preview image until you see the column.

■ Try setting **Radius** to **25** and **Threshold** to **35**. Click **OK** to apply the settings. Have patience as the Smart Blur filter can take some time to process.

■ You may be surprised to see what now looks like white lines on a black ink scratchboard, but this is okay — choose **Filter ➤ Adjustments ➤ Invert** (**Ctrl+I/Command+I**). Now you see black lines on a white background sketch, as shown in **Figure 40.7**.

STEP 5: BLEND LAYERS

At this point, you have learned two techniques and have two entirely different images made from the same digital photo — a watercolor-like image and a "pen and ink" sketch. You now want to combine these two layers.

■ Click the **Pen and Ink** layer to make it the active layer.

■ Using the Layers palette, click in the **Blend Mode** box and choose **Multiply**. Leave **Opacity** set to **100%**. The Layers dialog box should now look like **Figure 40.8**.

STEP 6: MAKE FINAL COLOR ADJUST-MENTS AND ADD YOUR SIGNATURE

Now is the time to make a few creative color adjustments.

■ To lighten the image, use an adjustment layer so that you can go back and make changes if desired.

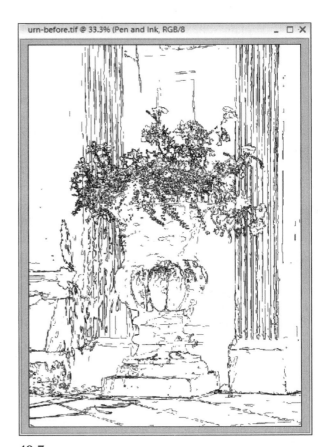

40.7

Choose **Layer** ➢ **New Adjustment Layer** ➢ **Levels** to get the New Layer dialog box. Click **OK** to display the Levels dialog box. Set **Input Levels** to 5, **1.50**, and **170**, as shown in **Figure 40.9**. Click **OK** to apply the settings.

■ The final step is to adjust the colors, as you'd like them. As you have both Adobe Photoshop Elements 3.0 and an artistic license of your own, try making the image turquoise, purple, and green with yellow flowers, as shown in **Figure 40.2 (CP 40.2)**! Once again, to allow you the opportunity to go back and change your settings, use another adjustment layer to make changes to the colors. Choose **Layer** ➢ **New Adjustment Layer** ➢ **Hue/Saturation** to get the New Layer dialog box; click **OK** to get the Hue/Saturation dialog box. Set **Hue**, **Saturation**, and **Lightness** to **120**, **0**, and **0**, as shown in **Figure 40.10**. Click **OK** to apply the settings.

Because you used adjustment layers, you can now go back and double-click the **Levels 1** or **Hue/Saturation** layers and make changes to the settings until you get the results that you want. You may also try using some of the other color commands, such as **Color Balance** or even **Replace Colors** if you want to replace the yellow flowers with another color.

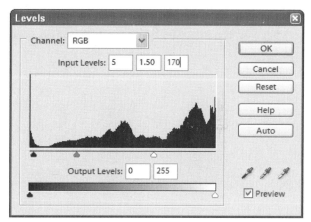

40.9

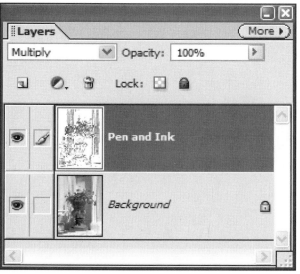

40.8

40.10

Also, don't forget to add your signature—it adds a nice touch to your painting. To add your signature use the Horizontal Type tool and choose a hand-written style font such as John Handy LET, or you can use the Pencil Tool and a mouse (or pen tablet if you have one) to sign the image. If you want, you can also hand-paint more of the flowers yellow. Some of them seem to be lacking a bit of color on the left side of the image. A good tool for painting the flowers is one of the watercolor brushes. You also may want to put a soft edge on the image by using a soft eraser on both

the ink layer and the painted layer. Save your file and it is ready to be printed.

While this image looks reasonably good on a computer screen, it *really* looks exceptional when printed on a fine art watercolor paper with a photo-quality inkjet printer. I used an Epson 2200P printer and the Epson Watercolor Paper—Radiant White—and the print is excellent and archival. Printing on quality fine art paper is essential to getting a print that you'll be proud to frame.

REVEALING DETAIL IN SHADOWS AND HIGHLIGHTS

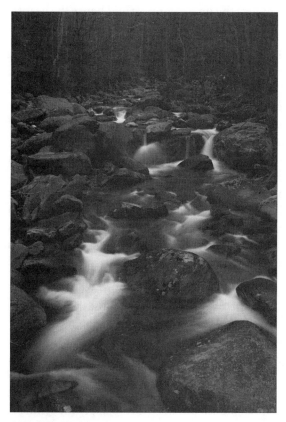

41.1 (CP 41.1)

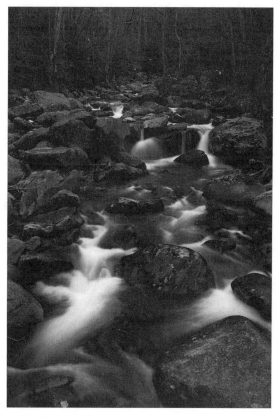

41.2 (CP 41.2)

ABOUT THE IMAGE

"Tennessee Mountain Stream," Canon EOS 1d, 28–70mm f/2.8 at 28mm, ISO 200, f/20 @ 1.4 sec with 3-stop ND filter, 1,656 x 2,488 pixels, image has been converted from RAW to a 16-bit .tif, 24.1MB

One of the more difficult challenges in photography is to show detail in both the shadows and highlights when there is extreme contrast in the scene. In the photograph of the mountain stream in Tennessee shown in **Figure 41.1 (CP 41.1)**, there is a full range of tones from very dark to almost pure black tones, to the near white tones of the flowing stream. Today's digital camera image sensors simply aren't able to capture all the tonal range that exists in such a scene, nor can today's best film cameras. However, you can bring back the detail in the shadows, while maintaining the detail in the bright water using one of Adobe Photoshop Elements 3.0's new features.

249

This new and extremely useful feature is the Shadow/Highlight tool, which was used to create the image shown in **Figure 41.2** (**CP 41.2**). Notice how there is now detail in the trees at the top of the image and in the rocks in the rest of the image. Also, notice the good detail in the stream and that during the process of bringing out the detail in the shadows, I did not push the bright stream into pure white where detail would be lost. Because this technique is primarily about tonal range, you will convert the image to grayscale and add a slight tone at the end of the technique.

STEP 1: OPEN FILE

■ Choose **File ➢ Open** (**Ctrl+O/Command+O**) to display the Open dialog box. Double-click the **\ch07\41** folder to open it. Click the **stream-before.tif** file; click **Open** to open the file.

STEP 2: CONVERT IMAGE TO BLACK AND WHITE

■ Select **Enhance ➢ Adjust Color ➢ Remove Color** (**Shift+Ctrl+U/Shift+Command+U**).

STEP 3: APPLY SHADOW/HIGHLIGHT FILTER

■ Before making adjustments to the tonal range, it is a good practice to first open the **Histogram** so that you can see the effects your settings have on the image. Select **Window ➢ Histogram** if the **Histogram** is not already showing.
■ Select **Enhance ➢ Adjust Lighting ➢ Shadow/Highlights** to get the Shadow/Highlights dialog box shown in **Figure 41.3**. This filter should be used with care as it can destroy the tonal range if the settings are too severe. Likewise, even small changes can dramatically improve an image by

revealing hidden details in shadows and highlights. Click the **Lighten Shadows** slider and drag it toward the right to about **7%**. While it is tempting to drag it more, a higher percentage will reduce the image contrast and hence the beauty of this photograph.

If your intent was to show more detail in the bright silky-smooth water, you could now move the **Darken Highlights** slider toward the right. Try it. However, in doing that you will again reduce the image contrast that is a strong feature of this photograph. You should note that the Darken Highlights setting is available and can be very powerful for revealing detail highlights in a similar way to what you just did for the shadows. A small percentage change in Darken Highlights can bring out folds and texture in a white shirt even though it is shown in bright light, or wispy white clouds in an overly bright sky can be made more pronounced.

■ Now click the **Midtone Contrast** slider and move it toward the right to adjust the Midtone contrast. Again, a small percentage change can result in substantial change. A **+5%** change looks about right to me. Click the **Preview** box to turn off the settings and look carefully at how much this image has improved. Click the **Preview** box to turn preview back on. Click **OK** to apply the settings.

41.3

■ Before you continue, carefully check to see if you have pushed any areas of the photo to pure white where the R, G, and B numbers are all 255. When I took this photo, I made every effort not to over-expose the highlights. To check for pure white in the image, click the **Eyedropper** tool (**I**) and make the **Info** palette visible by clicking **Window** ➢ **Info**. Click in the **Sample Size** box in the **Options** bar and select **3x3 Average**. The brightest parts of the image can be found in the lightest parts of the water. Drag the **Eyedropper** tool over those bright parts and watch the **R, G,** and **B** values in the **Info** palette. I was able to find two places where I now have RGB values of 255, as shown in **Figure 41.4**. However, they are very tiny, insignificant areas and are not likely to affect print quality. So, for now, continue on and make a print, which is always the best way of determining if "blown-out" highlights are acceptable or not. The challenge here is that you also are faced with a tradeoff — you either get important details in the shadow area and a few "blown-out" highlights, or you have to forgo bringing back shadow detail to avoid the "blown-out" highlights.

■ Take a quick look at the histogram. Click the **Uncached Refresh** icon to refresh the histogram to reflect the changes you just made with the **Shadow/Highlights** filter. you still have a nice smooth histogram.

STEP 4: INCREASE IMAGE CONTRAST

■ Now let's see if you can further increase the impact of this image by increasing contrast between the dark rocks and the flowing water without pushing the newly revealed detail back into shadows. Select **Enhance** ➢ **Adjust Lighting** ➢ **Levels** (**Ctrl+L/Command+L**) to get the Levels dialog box shown in **Figure 41.5**. Click the **Shadow Input** slider and slide it toward the right to about **10**. Click the **Midtone** slider and slide it toward the right to about **0.95**. Click **OK** to apply the settings. You now have much better contrast in the shadows and you still can see the detail in the dark rocks and in the trees at the top of the image.

41.4

41.5

STEP 5: SHARPEN IMAGE

■ Sharpening is a very important step for this image. After selecting **View ➢ Actual Pixels** (**Alt+Ctrl+0/Option+Command+0**), select **Filter ➢ Sharpen ➢ Unsharp Mask** to get the Unsharp Mask dialog box shown in **Figure 41.6**. Set **Amount** to **275%**, **Radius** to **.6 pixels**, and **Threshold** to **0 levels**. Click **OK**. While these setting may appear to be a little too sharp on your screen, they do make a good print. To learn more about sharpening an image, read Technique 6.

STEP 6: TONE IMAGE

■ Let's complete this image by toning it. Select **Filter ➢ Adjustments ➢ Photo Filter** to get the Photo Filter dialog box shown in **Figure 41.7**. Click in the **Filter** box and select **Deep Yellow**. Make sure **Preserve Luminosity** is checked. The default setting of **25% Density** is just fine. Click **OK** to apply the settings.

You now have a nice warm-toned, sharpened, high-contrast image that should make an excellent print. After making a print on an Epson 2200 printer using Epson Enhanced Matte Paper, I checked carefully to see how noticeable the blown-out highlights were in the two bright patches of the stream. They are barely noticeable—and the print is still very nice. This technique helps to illustrate three important points: When taking photographs with a digital camera, make sure not to over-expose the highlights, use the RAW file format if your camera supports it, and monitor the histogram while editing and use the Info palette for checking for the nasty patches of white. Remember that pure white is acceptable for spectral highlights, which are areas of bright reflection on shiny objects and water.

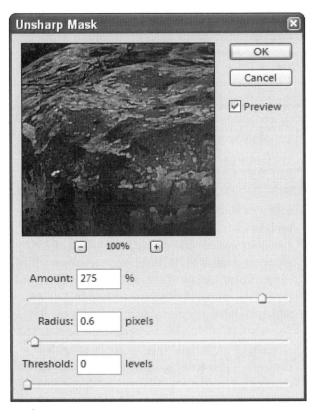

41.6

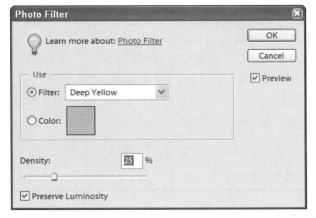

41.7

41.8

41.9

TIP

When should you shoot in RAW and edit in 16-bit mode? Anytime your intent is to get the best possible image you can. When you shoot RAW, your camera will write 16-bit image files instead of the more common 8-bit image files. 16-bit images have far more picture information and consequently they are less likely to suffer from image degradation during the editing process. For example, if you were to use Technique 41 on a 16-bit version of the stream photo, you would get a nice smooth histogram as shown in Figure 41.8. Figure 41.9 shows the histogram when the same edit steps are applied to the same image in 8-bit mode. The gaps you see in Figure 41.9 indicate that some of the smooth tonal ranges have been changed into solid tones. This posterization effect is generally unacceptable and can be avoided using a 16-bit image if one is available. The downside of shooting in RAW and editing in 16-bit mode is that you will be saving and working on much larger files. These larger files not only consume more hard drive space, but they also require more RAM, and much more computer processing cycles to edit.

USING FILTERS TO CREATE FINE ART PRINTS

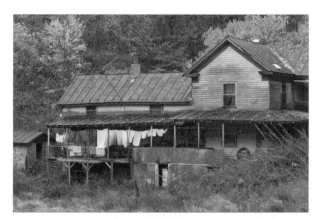

42.1

42.2

ABOUT THE IMAGE

"Virginia Country Farm House"
Canon D30, 28–70mm f/2.8
@ 58mm, ISO 100, f/7.1 @ ⅛
sec, 2,160 x 1,440 pixels, Fine
image quality, 2.3MB .jpg

The photo of the country farmhouse shown in **Figure 42.1** was taken in Virginia on a freezing, rainy day. One of the neighbors told me some local folklore about the house. The story is that the house contains some rather significant distillery capabilities. The color of the laundry is a coded message that tells what is brewing and invites friends to drop in for a drink. I don't know if the story is true, but I wouldn't knock on the door to ask!

Anyone that takes photographs knows that you can try as hard as possible to take great photos with each click of the exposure button. Yet, later on you find out that you didn't get the shot you had hoped for. One of the exciting things about using a digital image editor such as Adobe Photoshop Elements 3.0 is that you can often fix those not-quite-right photos. Or even more — you can apply a half-dozen filters and end up with a good print you are pleased to have made. This technique shows how a few commonly used filters can be combined to create an image that makes a nice print, as shown in **Figure 42.2**.

STEP 1: OPEN FILE

■ Choose **File ➢ Open** (**Ctrl+O/Command+O**) to display the Open dialog box. Double-click the **\ch07\42** folder to open it and then click the **farm-house-before.jpg** file to select it. Click **Open** to open the file.

STEP 2: SOFTEN IMAGE

To dramatically change the character of this digital photo, you are going to apply a few filters to soften the edges and add depth to shadows.

■ Zoom to 100 percent by **View ➢ Actual Pixels** (**Alt+Ctrl+0/Opt+Command+0**).

■ Press the **Spacebar** to get the **Hand** tool, and then click the image and drag it up toward the right until you can see the red shirt on the laundry line. Also, look at the brown grass in the bottom-left corner of the image. As you apply effects to the image, check both of these areas to make sure the settings you are choosing are effective for both of these areas.

■ Choose **Filter ➢ Blur ➢ Smart Blur** to get the Smart Blur dialog box shown in **Figure 42.3**. Move your cursor over the preview image in the Smart Blur dialog box and the cursor will change into the Hand tool icon. Click and drag the image so that the red shirt on the laundry line shows in the middle of the preview box.

■ In the Smart Blur dialog box, set **Quality** to **High** and **Mode** to **Normal**. Try using a

Threshold setting of **25.0** and then begin sliding the **Radius** slider to get nice, soft tones. I found a **Radius** setting of **3.0** to be just about right. When finished, click **OK** to apply the blur.

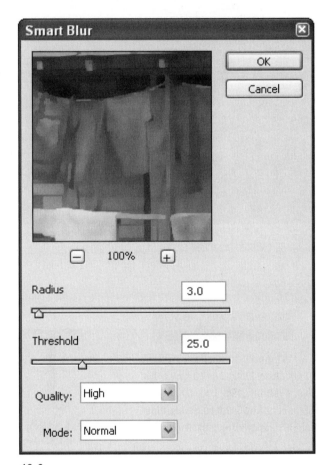

42.3

■ Choose **Filter** ➤ **Artistic** ➤ **Poster Edges** to view the Poster Edges filter in the Filter Gallery dialog box shown in **Figure 42.4**. To view more of the image, click the expand preview button just to the left of the **OK** button. Once again, click inside the preview box and drag the image around until you can see the red shirt on the laundry line and then look at an area where there are leaves. Experiment with different settings to make sure there are enough dark edges, but not so many that the edges dominate the image. Try setting **Edge Thickness**, **Edge Intensity**, and **Posterization** to **1**, **1**, and **6** respectively. Click **OK** to apply the effect.

STEP 3: DARKEN THE IMAGE

One way to darken an image without getting a posterization effect like you can get when using Levels is to duplicate a layer and then blend it with itself by using the **Multiply** blend mode. By darkening the image, you will get an image with richer colors.

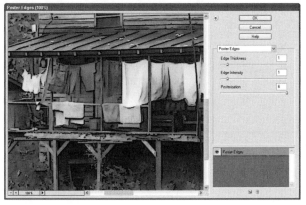

42.4

■ To darken the image, select **Layer** ➤ **Duplicate Layer** to open the Duplicate Layer dialog box; click **OK** to create a new layer. Click in the **Blend Mode** box in the Layers palette and choose **Multiply**. Set **Opacity** to **65%**. The Layers palette should now look like the one shown in **Figure 42.5**.

■ Flatten the image by choosing **Layer** ➤ **Flatten Image**.

STEP 4: MAKE FINAL COLOR AND TONE ADJUSTMENTS

Now increase color saturation and try to add some "punch" to the image to make the cabin stand out from the background.

■ Select **Enhance** ➤ **Auto Color Correction** (**Shift+Ctrl+B/Shift+Command+B**) to improve the overall color.

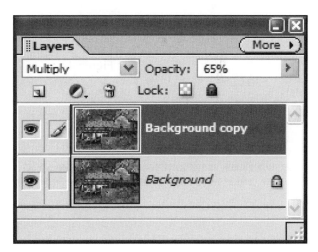

42.5

■ Choose **Enhance** ➤ **Adjust Color** ➤ **Adjust Hue/Saturation** (**Ctrl+U/Command+U**) to get the Hue/Saturation dialog box shown in **Figure 42.6**. Set **Hue** to **0**, **Saturation** to **25**, and **Lightness** to **0**. To increases the saturation of just the yellows, click in the **Edit** box and choose **Yellows**. Set **Saturation** to **+25**. If you want to make any other changes to selected colors, now is the time to do it. If you make a few adjustments and you want to start all over, press **Alt** (**Option**) and the **Cancel** button changes to **Reset**. Click **Reset** to reset all the settings when you are in the Hue/Saturation dialog box. Click **OK** to apply the settings.

■ The image now needs some "punch," so increase contrast and brightness. Choose **Enhance** ➤ **Adjust Lighting** ➤ **Brightness/Contrast** to get the Brightness/Contrast dialog box shown in **Figure 42.7**. Set **Brightness** to **–11** and **Contrast** to **+20**. Click **OK** to apply the settings.

■ Choose **Layer** ➤ **Duplicate Layer** to get the Duplicate Layer dialog box; click **OK**.

■ Choose **Filter** ➤ **Blur** ➤ **Gaussian Blur** to get the Gaussian Blur dialog box. Set **Radius** to **4.0** and click **OK**.

■ Click in the **Blend Mode** box in the Layers palette and select **Luminosity** as the blend mode. Set **Opacity** to **40%** to provide overall softening to the image. Select **Layer** ➤ **Flatten Image**.

■ It still needs something. Let's open up the shadows. Select **Enhance** ➤ **Adjust Lighting** ➤ **Shadow/Highlights**. Click the **Lighten Shadows** slider and slide it toward the right to about **+25**. Click **OK**. There — you're done.

That completes this image and this technique — that is unless you are inclined to do some more tweaking.

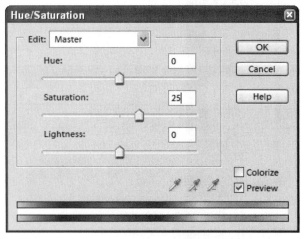

42.6

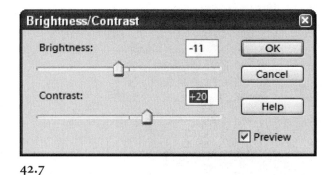

42.7

MAKING YOUR OWN 20" X 30" PHOTO POSTER

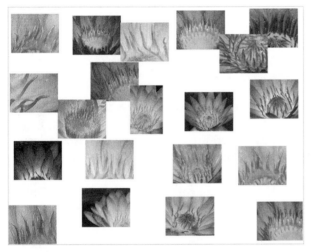

43.1 (CP 43.1)

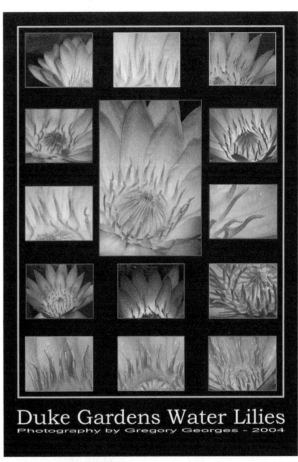

43.2 (CP 43.2)

In my opinion one of the best bargains in digital photography is a 20" x 30" poster print. A large poster is an excellent way to fill up empty space on your wall. Online photo-printing services such as Ofoto (www.ofoto.com) and Shutterfly (www.shutter fly.com) offer 20" x 30" prints for under $25. You can have them mailed to you in a protective mailing tube a few days after you upload the digital file to their Web site. Equally inexpensive 20" x 30" frames are available at the large discount stores such as Costco or Wal-Mart.

In this technique, you will learn how to take the photos shown in **Figure 43.1** (**CP 43.1**) and use them to make the 20" x 30" poster shown in **Figure 43.2** (**CP 43.2**). As you will be using up to fourteen photographs to make the poster, you will find that you have plenty of image resolution to make a high-quality 20" x 30" print you'll be proud to hang on your wall.

STEP 1: CREATE NEW DOCUMENT

Many of the consumer-oriented, online printing service Web sites recommend that you have an image that is at least 3 megapixels or larger to make a 20" x 30" print. However, 300 dpi (for Fuji Frontiers) or 320 dpi (for Noritsu printers) is the recommended dpi for the printers they typically use. Since you will be creating a new document from scratch, you have high-quality images to use, and you will be adding text to the image, you should create a document with 300 dpi. If you find that your computer is too slow, or you don't have sufficient RAM or hard drive space, you can create a document with considerably less than 300 dpi and still get a good-quality print.

- To create a 20" x 30" document at 300 dpi, select **File ➤ New ➤ Blank File** (**Ctrl+N/Command+N**) to get the New dialog box shown in **Figure 43.3**. Type **Lily Poster** in the **Name** box. Type **20** in the **Width** box and make sure increment is set to inches. Type **30** in the **Height** box. Type **300** in the **Resolution** box and make sure that increment is set to pixels/inch. Click in the **Background Contents** box and select **Black**. **Color Mode** should be set to **RGB Color**. Notice that you are creating a 154.5MB image that is 6,000 x 9,000 pixels! Click **OK** to create the document.
- Select **Edit ➤ Fill Layer** to get the Fill Layer dialog box. Click in the **Use** box and choose **Black**; click **OK**.

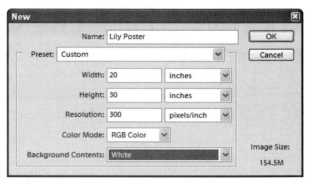

43.3

STEP 2: SET UP GRID AND RULERS

- If the rulers are not currently displayed, select **View ➤ Rulers** (**Ctrl+R/Command+R**) to turn them on.
- If a grid is not currently displayed select **View ➤ Grid**. Select **View ➤ Snap to Grid** if there is not already a checkmark next to Snap to Grid.
- Select **Edit ➤ Preferences ➤ Units & Rulers** to get the Preferences dialog box. Click in the **Rulers** box and choose **inches**. Click **Next** to get the Preferences dialog box shown in **Figure 43.4**. Click in the **Color** box and choose **Light Gray**. Click in the **Style** box and choose **Dots**. Click in the **Gridline every box** and type **1** and set **increments** to **inches**. Click in the **Subdivisions** box and choose **4**. Click **OK** to apply the settings. Your new document should now look similar to the one shown in **Figure 43.5**. Notice you have a ¼" grid of white dots against the black background to help you place text, lines, and images. With the snap feature turned on the selection marquee and images you are placing will snap to the grid.

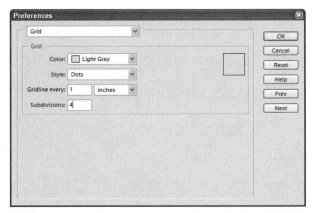

43·4

43·5

STEP 3: PLACE ONE IMAGE

Before adding a decorative border line that can be helpful for placing images, first place one image that can be used as a source for picking border line colors.

- Choose **File ➢ Open** (**Ctrl+O/Command+O**) to display the **Open** dialog box. Double-click the **\ch07\43** folder to open it and then click the **lily-01.jpg** file to select it. Click **Open** to open the file.
- Click on the **Move** tool (**V**). Click in the lily image and drag it on to the **Lily Poster** document. Place it in the middle of the image.
- Click on the **lily-01.jpg** image and select **File ➢ Close** (**Ctrl+W/Command+W**) to close the file as it will no longer be needed.

STEP 4: ADD OUTSIDE BORDER LINE

- Click the **Eyedropper** tool (**I**) in the **Toolbox**. Click on the yellow part of the lily image that you just placed and move the cursor around while you watch the **Foreground Color** box at the bottom of the Toolbox. Try to select a bright, bold yellow color, which can be used for the border line that will encompass all the images.
- Click on **Background** in the Layers palette so that you place the yellow border line on the Background.
- Click on the **Rectangular Marquee** tool (**M**) in the **Toolbox**. Make sure that the **New Selection** icon is checked in the Options bar and that **Feather** is set to **0 px**, and **Mode** is set to **Normal**.
- Select **Window ➢ Images ➢ Maximize Mode** to maximize the image.
- Select on the **Zoom Out** or **Zoom In** icon until the **Zoom** size reads **12.5%**. At this size you should be able to easily see the grid dots. Click in the **Selection Box** in the **Preview** window in the Navigator and drag it down toward the

bottom-right so that you can view the bottom-right corner of the image. The Navigator should now look similar to the one shown in **Figure 43.6**.

■ The objective now is to place a selection marquee 1 inch from the top, 1 inch from the left, 1 inch from the right, and 4 inches from the bottom. This selection will be used to add the decorative border line. Using the **Rectangular Marquee tool (M)**, click on the intersection of four grid squares up, and one from the right as shown in **Figure 43.7**. Drag the selection up toward the left corner of the image and the image should automatically scroll when your cursor reaches the top of the workspace; release the cursor button after placing the cursor on the grid point that is 1 inch down from the top and in 1 inch (4 dots or one square) from the left (4 dots or one square).

■ Select **Edit ➢ Stroke (Outline) Selection** to get the Stroke dialog box shown in **Figure 43.8**. Type **30 px** in the **Width** box. The color should be the yellow color you picked earlier. Click on **Center** and leave **Mode** set to **Normal**. Click **OK** to apply a yellow decorative border to the image. Select **Select ➢ Deselect** (**Ctrl+D/Command+D**) to remove the selection marquee.

43.7

43.6

43.8

STEP 5: PLACE PHOTOS

Twenty photos featuring water lilies are included on the Companion CD-ROM in the \ch07\43 folder. Each of these images has been edited and cropped to have 10 x 8 width-height proportions; but their resolution varies. This means that you will have to size each photo as you place them. The design shown in **Figure 43.2** (**CP 43.2**) has one large image that is 10 inches tall, and thirteen photos that are 4.5 inches wide — all at 300 dpi. When you place the smaller images, put them ½ inch inside the yellow border line.

Because of the large image you are working on and the fact that you will have 16 layers and a background, I suggest that you open, resize, place, and close one image at a time to conserve on memory, disk space, and computer processing cycles.

- Choose **File ➢ Open** (**Ctrl+O/Command+O**) to display the Open dialog box. Double-click the \ch07\43 folder to open it and then click the **lily-16.jpg** file to select it. Click **Open** to open the file. This photo should be placed in the upper-left corner as shown in **Figure 43.2** (**CP 43.2**).
- Select **Image ➢ Resize ➢ Image Size** to display the Image Size dialog box. Click in the **Width** box and type **4.5** and set **increments** to **inches**. Make sure that you set **Resolution** to **300 pixels/inch**! Turn on **Constrain Proportions** and **Resample Image**. Click in the **Resample Image** dialog box and choose **Bicubic Sharper** as it is the best algorithm to use to down-sample a photographic image. The **Image Size** dialog box should now look like the one shown in **Figure 43.9**. Click **OK** to resize the image.
- Click the **Move** tool (**V**) in the **Toolbox**. Click on the **lily-16.jpg** image and drag it on to the **Lily Poster** image. Carefully position it as shown in **Figure 43.10**.

- Click on the **lily-16.jpg** image and select **File ➢ Close** (**Ctrl+W/Command+W**) to close the file as it will no longer be needed.
- Repeat this step for each of the remaining photos.

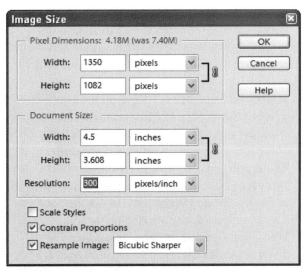

43.9

43.10

STEP 6: ADD BORDERS

■ Click on **Move** tool (**V**) in the Toolbox. Make sure that there is a check mark next to **Auto Select Layer** and **Show Bounding Box**. These options allow you to pick a layer by simply clicking on an image and then the selected image will show a bounding box to confirm that you have selected the image. Click on the top-left lily photo to make it the active layer.

■ Click on **Eyedropper** tool (**I**) in the **Toolbox**. Click in the selected lily photo to select a contrasting color to use for the border for that photo. The color you select will become the **Foreground Color** and you can see it in the **Foreground Color** box at the bottom of the **Toolbox**.

■ Click on **Magic Wand** tool (**W**) in the **Toolbox**. Click just outside the selected photo to select the transparent part of the layer. Select **Select** ➢ **Inverse** (**Shift+Ctrl+I/Shift+Command+I**) to invert the selection to just the photo. You should now see a selection marquee around the selected photo.

■ Select **Edit** ➢ **Stroke (Outline) Selection** to get the **Stroke** dialog box. Type **15 px** in the **Width** box. The Color box should show the color you selected with the Eyedropper tool. To place the border outside the selection marquee, click **Outside**. **Blending** should be set to **Normal**. The Stroke dialog box should look like the one shown in **Figure 43.11**. Click **OK** to apply a colored border.

■ Select **Select** ➢ **Deselect** to remove the selection marquee.

■ You should repeat this step for each of the remaining photos. Take care in choosing the border color to work well with each of the photos. The easy way to repeat this process is to learn the shortcut keys for each action. This makes the process simple and quick: **V**, **I**, select color, **W**,

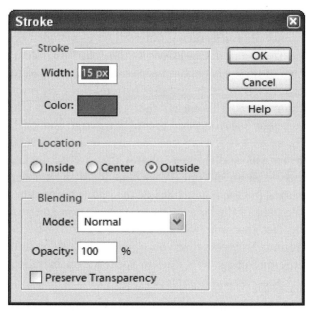

43.11

Select ➢ Inverse, Edit ➢ Stroke — that's it! Select Select ➢ Deselect and repeat again for the next photo.

STEP 7: ADD TEXT

■ Click on **Background** in the **Layers** palette to make it active.

■ Click on the **Horizontal Type** tool (**T**) in the **Toolbox**. Click in the **Font Family** box in the **Options** bar and select a font such as **Bookman Old Style**, or another similar font if you do not have that font. Set the **Font Style** to **Regular**. Click in the **Font Size** box and choose **72 pt**. Click on **Left Align Text**. Click in the **Color** box and choose **White**. The Options bar should now look similar to the one shown in **Figure 43.12**.

| T | T IT ᵀT ᵢT | Bookman Old Style ⌄ | Bold ⌄ | 72 pt ⌄ | aₐ | T T T ᵀ | ▐▐▐ | ▲ (Auto) ⌄ | Color: | Style: ◨ ⌄ | ⊥ ᵢT |

■ Click below the yellow borderline and type the heading text: **Duke Gardens Water Lilies**. Click on the **Commit Current Edits** icon (the checkmark at the far-right of the Options bar). Press and hold **Shift** and click on one of the selection marquee handles and stretch the text to be as long as the width of the yellow border line. You can click in the text and drag it to position it. You can also tap the **Up**, **Down**, **Right**, and **Left Arrow** keys to move the text one pixel at a time.

■ Do the same thing for the second line of text only choose a simple **Font** like **Arial** or **Helvetica** and set **Font Size** to **36 pt**. Using the **Horizontal Type** tool, type in the last line of text. I chose to type: **Photography by: Gregory Georges – 2004**. After committing the text, click on one of the handles (without pressing **Shift** to keep the text proportions the same) on the end of the selection marquee and drag the text out to the same length as the main title text. After some alignment and sizing your text should look like the text in **Figure 43.13**.

■ Provided that you are satisfied with the poster, you can now select **Layer ➢ Flatten Image** to dramatically reduce the file size (it is now around 150MB). Your final image should look similar to the image shown in **Figure 43.14** (**CP 43.2**).

Good poster design is art. Now that you know how to place images on a poster, try a more creative design of your own. Choose from the 20 water lilies in the companion CD's **\ch07\43** folder and make your own design. The choice of layout, border effects, font design, background color, and texture are all important aspects of a poster. If you produce a nice design, I'd like to see it if you'd like to send me a small .jpg image with the longest side not more than 600 pixels. Send it to `ggeorges@mindspring.com`.

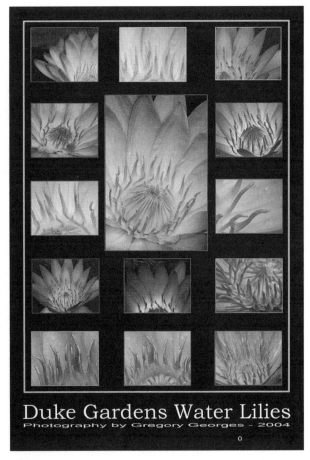

43.14

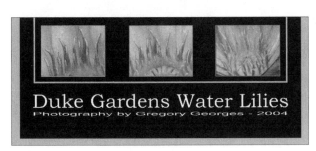

43.13

44

CREATING A LINE DRAWING USING A DIGITAL PHOTO

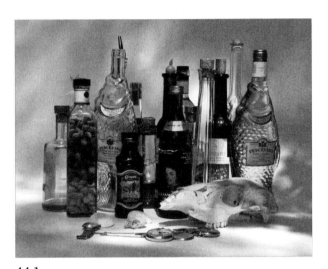

44.1

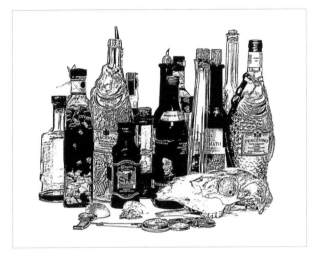

44.2

ABOUT THE IMAGE

"Olive Oil Bottles," Canon D30, 28–70mm f/2.8 @ 50mm, f/16 @ ¹/₄₀ sec, ISO 100, RAW setting, original 2,160 x 1,440 pixel image edited, cropped, and upsampled 2x to 2,400 x 1,920 pixels, 13.2MB .tif

Because a line drawing is generally the first of a progression of steps taken to create nearly all artwork, it seems reasonable to spend a few pages of this book on several different techniques for creating line drawings. A line drawing created from a digital photograph can be used for many purposes. Just as most inkjet printers can print on fine art paper, it is possible to print a line drawing on fine art paper and use it to begin a traditional media painting. Digital photos turned into line drawings can also be used as the starting sketch for a digital painting. Line drawings can also be incorporated into other digital techniques, as shown in Technique 40, where a digital photograph is turned into a very elegant "pen and ink" sketch with a watercolor wash.

As the line drawing is so important for both traditional media and for digital art, you look at three different approaches to create line drawings. These three approaches not only help ensure that you can get a successful line drawing from most digital photos, but they also allow you to vary the style of the lines in your digital drawings.

While it is possible to make line drawings from a grayscale digital photo by applying a single filter, the five-step process outlined here may lead to far superior results. This process is the basis for the following three line drawing techniques — the only significant difference is that each of the three different techniques uses a different "find edge" filter: Find Edges, Poster Edges, or Smart Blur filters.

1. Convert image into a grayscale image by choosing **Enhance ➤ Adjust Color ➤ Remove Color** (**Shift+Ctrl+U/Shift+Command+U**) or by choosing **Enhance ➤ Adjust Color ➤ Adjust Hue/ Saturation** and then setting **Saturation** to **–100**.
2. Pre-process the image to get optimal results from the filter that is to be applied to find edges. As most of the edge-finding filters work on contrast, you can often get much better effects by adjusting contrast either by choosing **Enhance ➤ Adjust Lighting ➤ Brightness/Contrast** or **Enhance ➤ Adjust Lighting ➤ Levels** (**Ctrl+L/Command+L**). Some images have so much texture that it is difficult to differentiate the texture edges from the important edges. In this case, you may be able to reduce some of the texture by experimenting with either the Gaussian Blur or Median (found in the Filter ➤ Noise menu) filters. You may have to experiment with both filters and several different settings until you get the results that you want.
3. Apply an edge-finding filter that creates lines. Although you have many filters to use to find edges, you will use the Find Edges, Smart Blur, and Poster Edges filters. I generally get the best results with the little-known Edges Only feature in the Smart Blur filter. Having said that, you still ought to try the other two filters as they, too, can produce great results and possibly exactly the effects that you want.
4. Adjust the resulting line drawing to improve contrast and remove undesirable effects. Depending on the image and the results of the prior three steps, you may have some work to do

to clean up your line drawing. The results you want can help you decide what is needed. You may want to use the Levels, Threshold, or Brightness/ Contrast filters to increase the darkness of the lines and remove unwanted artifacts. The Eraser tool can be used to remove "spots." Large areas containing spots may be selected by using one of the many selection tools and then deleted all at once.
5. Apply one or more filters to add character to the lines. After you have lines where you want them — and no additional spots, dots, or other unwanted artifacts, you can use one or more filters to add character to the lines. My favorite character-adding filters are the Poster Edges and Dark Stroke filters. There are other useful filters, but these two can add lots of character to your lines — try them. If you don't get what you want after applying them once, apply them more than once or use them in combination.

By now, unless you are like me and you appreciate a quality line drawing made with lines that have lots of character, you're probably thinking I'm a bit over the top on this one! Nevertheless, read on because these line creation techniques can be exceedingly useful as they can be the basis for some outstanding work. You first use the Find Edges and Poster Edges filters, and then you use the Smart Blur filter.

FIND EDGES FILTER APPROACH TO CREATING A LINE DRAWING

The Find Edges filter is possibly the most commonly used filter for creating line drawings, but the filter results in lines made with shades of gray because Find Edges makes low-contrast areas white, medium-contrast areas gray, and high-contrast areas black. It also turns hard edges into thin lines and soft edges into fat lines. The result is a line drawing that is very different from the thin lines that you get by using the Smart Blur filter. It can, however, transform some digital photos into some pretty cool line drawings.

STEP 1: OPEN FILE AND REMOVE COLOR

■ Choose **File ➢ Open (Ctrl+O/Command+O)** to display the Open dialog box. Double-click the **\ch07\44** folder to open it and then click the **bottles-before.tif** file to select it. Click **Open** to open the file.

■ Choose **Enhance ➢ Adjust Color ➢ Remove Color (Shift+Ctrl+U/Shift+Command+U)**.

After a quick look at the histogram for this image, I decided not to experiment with the Brightness/Contrast and Levels filters. Some preprocessing may improve the ability of the Find Edges filter to find edges and get your desired effects. This is covered in more detail in the Smart Blur technique.

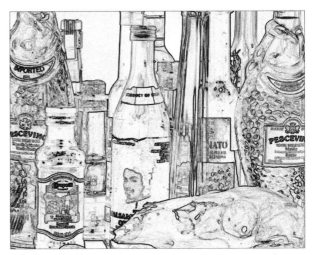

44.3

STEP 2: FIND EDGES AND CREATE LINES

■ Choose **Filter ➢ Stylize ➢ Find Edges** to apply the Find Edges filter.

After applying the Find Edges filter you have a decent line drawing, except it will have lines that are made of three shades of grays—not just black lines. You can see the results in the drawing shown in **Figure 44.3**.

44.4

STEP 3: REMOVE SOME LINES AND MAKE THE REST BLACK

■ Choose **Filter ➢ Adjustments ➢ Threshold** to get the Threshold dialog box shown in **Figure 44.4**. Move the slider until you get a good line drawing. I chose to set the **Threshold Level** to **175**. Click **OK** to apply the setting.

STEP 4: CLEAN UP THE DRAWING

■ Click the **Eraser** tool (**E**) in the **Toolbox** and drag the cursor over the few stray marks that need to be removed. The final line drawing is shown in **Figure 44.5**.

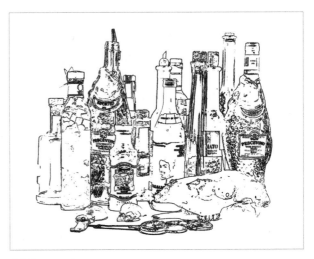

44.5

POSTER EDGES FILTER APPROACH TO CREATING A LINE DRAWING

The Poster Edges filter reduces the number of colors (or shades of gray) in an image according to your chosen settings. Besides drawing lines between contrasting edges, it also shades areas, which means it does not directly create a line drawing, which means you will have to do some further editing to get a line drawing. This filter does require some experimentation to get good results.

STEP 1: OPEN FILE AND REMOVE COLOR

- Choose **File** ➢ **Open** (**Ctrl+O/Command+O**) to display the Open dialog box. Double-click the **\ch07\44** folder to open it and then click the **bottles-before.tif** file to select it. Click **Open** to open the file.
- Choose **Enhance** ➢ **Adjust Color** ➢ **Remove Color** (**Shift+Ctrl+U/ Shift+Command+U**).

STEP 2: ADJUST LEVELS

- Choose **Enhance** ➢ **Adjust Lighting** ➢ **Levels** (**Ctrl+L/Cmd+L**) to view the Levels dialog box. For this image, try setting **Input Levels** to 15, 1.70, and **220**; click **OK**. These settings were used because you want to both lighten the image and increase image contrast to make it easier for the Poster Edges filter to find edges to be used for creating lines.

STEP 3: FIND EDGES AND CREATE LINES

- Choose **Filter** ➢ **Artistic** ➢ **Poster Edges** to display the Poster Edges filter in the Filter Gallery dialog box shown in **Figure 44.6**. Try setting **Edge Thickness**, **Edge Intensity**, and **Posterization** to 1, 10, and 6 respectively for this image to get good edge lines. Click **OK** to apply the filter.

STEP 4: REDUCE SHADES OF GRAYS AND SOME LINES

After applying the Poster Edges filter, you begin to see a semblance of a line drawing. Now you need to remove some of the shades of gray and some lines.

- Choose **Filter** ➢ **Adjustments** ➢ **Posterize** to open the Posterize filter dialog box shown in **Figure 44.7**. Set **Levels** to 2 and then click **OK** to apply the filter. These settings result in only two tones: black and white with no shades of gray.

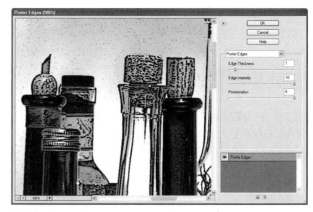

44.6

STEP 5: REMOVE SOME LINES AND MAKE THE REST BLACK

You are just about done; you need to remove some lines and all the unnecessary background must go.

■ Click the **Eraser** tool (**E**) in the **Toolbox** to select it. Click in the **Brush Presets** box on the **Options** bar and select the **Hard Round 19 Pixels** brush. Carefully erase a path of the unwanted dots all around the outside edge of the objects.
■ Click the **Lasso** tool (**L**) in the **Toolbox** to select the **Lasso** selection tool. Click and drag the selection marquee around the objects where you just erased a path. After the selection is complete, choose **Select** ➢ **Inverse** (**Shift+Ctrl+I/Shift+Command+I**) to invert the selection.
■ Choose **Edit** ➢ **Cut** (**Ctrl+X/Command+X**) to delete all of the remaining unwanted dots in the background. You can see the results of this technique in **Figure 44.8**.

SMART BLUR FILTER APPROACH TO CREATING A LINE DRAWING

Due to Smart Blur's Radius and Threshold settings and its ability to make very fine lines, this filter has become my favorite for creating line drawings. After you have lines where you want them, you can use several other filters to change the character of the lines.

STEP 1: OPEN FILE AND REMOVE COLOR

■ Choose **File** ➢ **Open** (**Ctrl+O/Command+O**) to display the Open dialog box. Double-click the **\ch07\44** folder to open it and then click the **bottles-before.tif** file to select it. Click **Open** to open the file.
■ Choose **Enhance** ➢ **Adjust Color** ➢ **Remove Color** (**Shift+Ctrl+U/Shift+Command+U**). You can use the **Brightness/Contrast** or **Levels** filters to adjust the contrast in the image; however, use it as is. This image is an especially good one to use to create a line drawing, as it requires little work to get excellent results.

44.7

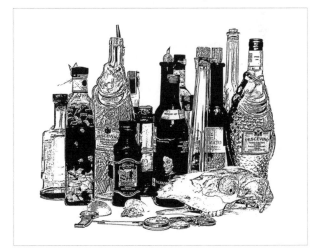

44.8

STEP 2: FIND EDGES AND CREATE LINES

■ Choose **Filter ➤ Blur ➤ Smart Blur** to view the Smart Blur filter dialog box shown in **Figure 44.9**. Set **Quality** to **High** and **Mode** to **Edge Only**.

■ The preview box in the Smart Blur dialog box shows white lines on a black background. Click the preview window and drag it until you find an area on a bottle where you want to make sure you have the right level of line detail. Begin sliding the **Radius** and **Threshold** sliders around until you get enough detail in the image — but not too much.

■ Try using a **Radius** setting of **5.0** and a **Threshold** setting of **20.0**. Click **OK** to apply the settings. Using **5.0** and **20.0** as the settings for **Radius** and **Threshold** produces a line drawing with as few lines as is needed to outline the bottles and some of the ingredients. Increasing the **Threshold** setting increases the number of lines and adds increasing detail to the drawing. Depending on the desired effects, a higher setting can create an even more visually interesting line drawing — more of a "loose sketch" than a mere line drawing. Click **OK** to apply the settings.

■ Invert the white lines on a black background image by choosing **Filter ➤ Adjustments ➤ Invert** (**Ctrl+I/Command+I**).

After applying the **Smart Blur** filter, you have an excellent line drawing, as shown in **Figure 44.10**. This drawing has very fine lines and can be used as a sketch to begin a painting or other kind of artwork.

STEP 3: INCREASE THE WIDTH OF THE LINES

■ To make the lines darker and wider, choose **Filter ➤ Artistic ➤ Poster Edges** to open the **Poster Edges** filter in the Filter Gallery dialog box shown in **Figure 44.11**. Set **Edge Thickness**, **Edge Intensity**, and **Posterization** to **10, 0**, and **0** respectively and click **OK** to apply the settings.

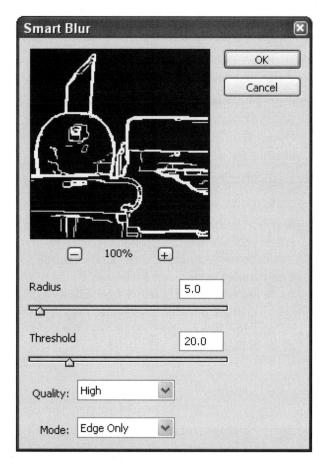

44.9

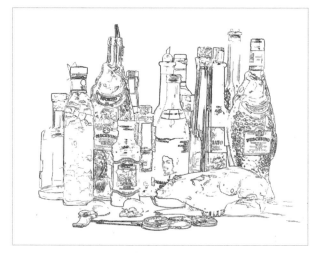

44.10

The results of applying the **Poster Edges** filter are shown in **Figure 44.12**. If you want even thicker and bolder lines, apply the **Poster Edges** filter once or twice more.

■ Make the lines even bolder so that they look like they were created with a marker. Choose **Filter ➤ Brush Strokes ➤ Dark Strokes** to get the Dark Strokes dialog box shown in **Figure 44.13**. Try using a setting of **5**, **6**, and **2** for **Balance**, **Black Intensity**, and **White Intensity** respectively, which results in the image shown in **Figure 44.14**.

If you don't get the results you want from any of these "find edges" filters, I suggest you investigate the possibilities of the Trace Contour, High Pass, and Glowing Edges filters. You can also use the Brush tool to manually paint in lines to take away from the calculated feel created by the filters.

Okay — enough of these line drawing techniques and this chapter. The next chapter covers all you need to know to make really fancy scrapbook album pages.

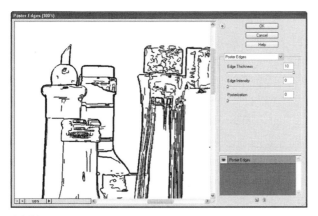

44.11

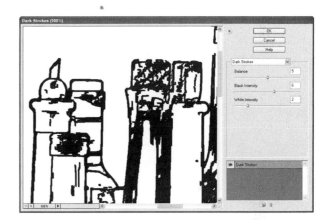

44.13

44.12

44.14

CHAPTER 8

CREATING SCRAPBOOK ALBUM PAGES

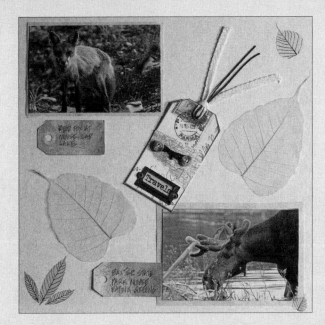

A ccording to "The National Survey of Scrapbooking in America 2004," released by *Creating Keepsakes*, a scrapbook magazine, the U.S. scrapbook industry will see sales reach $2.55 billion in 2004! Close to 25 percent of all households have scrapbooked in the last 12 months. If you are shooting and editing digitally, then my bet is that you are likely to want to make a few scrapbook pages of your own.

In Technique 45, you learn how you can use your digital camera and Adobe Photoshop Elements 3.0 to make copies of your traditional paper-based scrapbook album pages. Technique 46 shows you how easy it can be to create a simple scrapbook page from scratch. You'll then deconstruct a sports album page digitally created by scrapbook design expert Cheryl Barber in Technique 47.

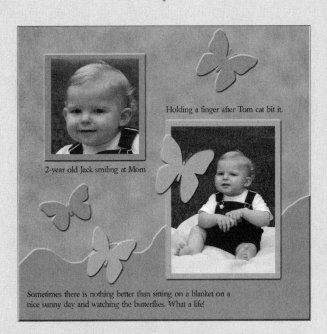

2-year old Jack smiling at Mom

Holding a finger after Tom cat bit it.

Sometimes there is nothing better than sitting on a blanket on a nice sunny day and watching the butterflies. What a life!

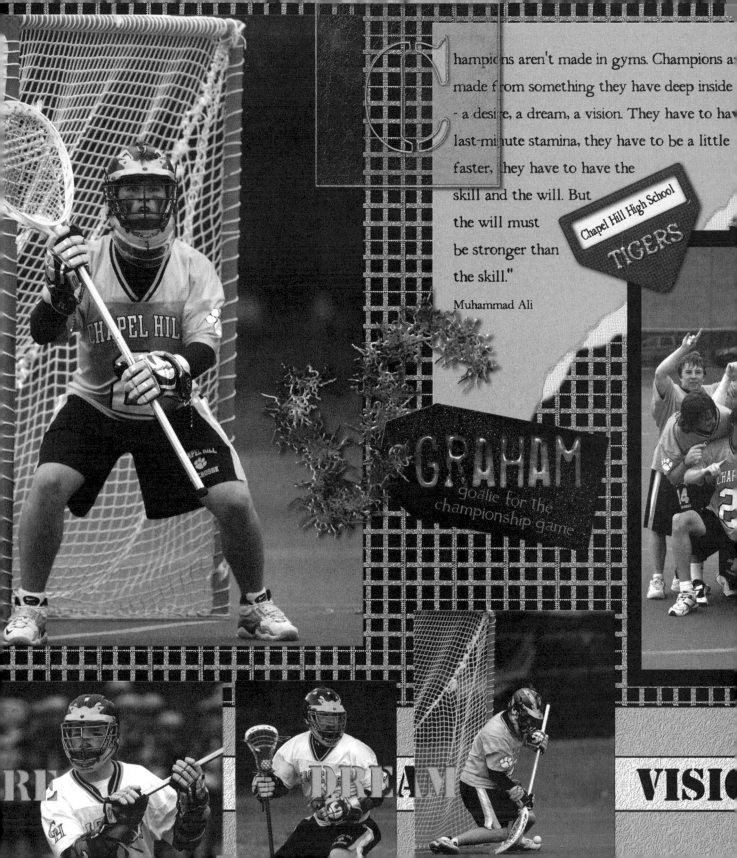

"Champions aren't made in gyms. Champions are made from something they have deep inside - a desire, a dream, a vision. They have to have last-minute stamina, they have to be a little faster, they have to have the skill and the will. But the will must be stronger than the skill."

Muhammad Ali

Chapel Hill High School
TIGERS

GRAHAM
goalie for the
championship game

RE

DREAM

VISIO

MAKING COPIES OF TRADITIONAL SCRAPBOOK ALBUM PAGES

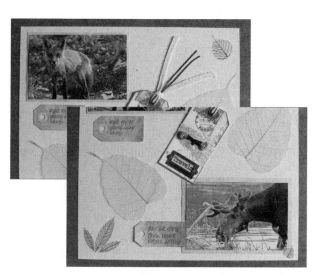

45.1

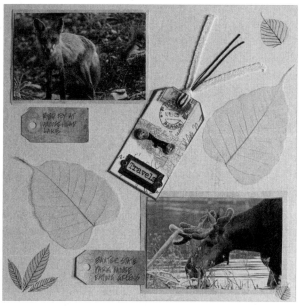

45.2

ABOUT THE IMAGE

"Maine 2000 Trip," Canon EOS 1D Mark II, 50mm f/1.4, f/4 @ ¹⁄₈₀ sec, ISO 100, 16-bit RAW format, 3,504 x 2,336 pixels, 8-bit .jpg files also included

No doubt about it—traditionally made, hands-on, paper-based scrapbook pages can be wonderful. Because of all the elements you can add such as buttons, fabrics, tags, clippings, and much more, your pages can not only feature wonderful photographs, but they can have texture and depth that makes them fun to view. The downside to creating traditional paper-based scrapbooks is that it is just about as much work to make each copy of the scrapbook as it was the original. So, when you are making a family scrapbook and you want to give a copy to several family members, your workload may be more than you want. That is, unless you follow this technique!

You can make excellent copies of traditionally made, paper-based scrapbook pages by taking photographs, or by scanning each page—and then editing the images, and printing them out on archival paper using an inkjet

277

printer. One complicating factor is that you may find that you need more resolution to make a good print than your digital camera offers. Or, you may decide to use a desktop flatbed scanner to get digital images to use to make copies. But, you may find that the scanning bed is not wide enough to scan an entire page.

In this technique, you learn how to use Adobe Photoshop Elements 3.0 to combine the two images shown in **Figure 45.1** into the single image shown in **Figure 45.2**. Using the second image, you can print a quality, high-resolution copy — one that even shows excellent texture and depth!

STEP 1: DETERMINE IMAGE SIZE

The first step in making copies of a paper-based scrapbook is to determine the size of the image that you need. In this example, assume that you want to make 12" x 12" prints, which is the original size of the scrapbook page shown in **Figure 45.2**. Also assume that you are using the wonderful Epson 2200 inkjet printer, which is a pigment-based inkjet printer and one of the best available to make archival prints.

To make good prints, Epson printers need at least 240 pixels per inch (ppi). Doing a little math, you learn that you need an image that is 2,880 x 2,880 pixels. That is 12" x 240 ppi or 2,880 pixels. If you are using another printer from another vendor, you should check to see what your printer vendor recommends as the minimum ppi. While many Canon and HP printers recommend a minimum 300 ppi, you can often get excellent prints with less resolution. You may want to experiment if you find that getting the full recommended ppi forces you into taking several more scans or photos of each page to meet that minimum recommended ppi. Sometimes, the tradeoff in quality is worth the effort it takes to make the extra scans, or take the extra photos.

STEP 2: SCAN OR TAKE DIGITAL PHOTO-GRAPHS OF YOUR SCRAPBOOK PAGES

You can get the digital images that you need to make printed copies of your traditional paper-based scrapbooks by scanning them with a desktop flatbed scanner, or you can use your digital camera. If you have the choice between a flatbed scanner and a digital camera, you may want to experiment with both to make a decision based upon the amount of time it takes to make the images, and the quality of prints that you get.

If your scrapbook pages are 8½" x 11", you likely can scan a full scrapbook page in a single pass. Depending on the megapixel count of your digital camera, you may or may not have enough pixels to get the needed resolution with a single photograph. However, if your scrapbook pages are the standard 12" x 12" pages, you may find that your pages don't fit on the scanner bed and that you need two or more photos to get the resolution needed to make a 12" x 12" print. Not to worry! Adobe Photoshop Elements 3.0 has a Photomerge feature that allows you to take two or more digital photos or scans of a scrapbook page and then merge them into a single image.

The images that are used for this technique were taken with an 8-megapixel digital camera. Even with an 8-megapixel camera, it took two shots to get enough pixels to make the required 2,880 x 2,880 ppi image you need. A tungsten work light that was purchased at a hardware store was used to add the shadows and overall light. If you use a digital camera to take photos of your paper-based scrapbook pages, here are a few tips to help you get better images:

- Make sure you tack or tape the scrapbook pages to a flat, rigid surface so that they remain flat when you take photographs.
- Shoot with the slowest ISO setting your camera offers to minimize digital noise that is caused by higher ISO settings.

- Shoot with your camera mounted on a rigid tripod. Avoid using any more center extension tube than is needed. The use of a center extension tube generally increases the chance of camera shake and a blurred image.

- Make sure you use the same camera settings (focus, shutter speed, and aperture) each time you take a photo in a series that will be combined to make a single page.

- Take every step you can to ensure that the camera is still when shooting. Pressing the shutter release button can often cause your camera to move while the shutter is open, which causes the image to be blurred. To reduce this movement, use your camera's delayed timer feature so that the camera can take a photo without you having your hands on it.

- If your camera has a mirror-lockup feature, use it to further reduce camera shake.

- Because it is important to get images that show album pages with corners that are 90 degrees, you must keep the camera lens plane parallel with the scrapbook page you are shooting. The easiest way to do this is to place your scrapbook page on a rigid board and then place it on or against a wall.

- When you need to shoot more than a single photo to capture an entire page, use a support so that you can easily move your page up (or over) the needed distance to get additional images.

- Choose a well-lit space to shoot where there is an even light across the scrapbook page.

- If you want to capture the dimension in your scrapbook pages, you need to have a light shining on the pages from a 30-degree angle to add a small shadow line to any elements or texture that your page might feature. A good choice of inexpensive lights can be found at home improvement supply stores. Tungsten work lights with adjustable stands are excellent and using them helps to minimize any effort you may need to take to color correct your images.

- If you don't have good lights and you don't want to buy any, you can get very good results by shooting outdoors on a slightly overcast day.

- Don't be overly concerned about some light falloff (where one side of a page looks darker or lighter than the other side) across the page as it makes the page look more like a traditional page in natural light.

- When shooting photographs to be merged, shoot so that you overlap the images by at least one-third to one-half, which makes merging the final images much easier.

Okay — so, that was a long list of tips. However, they are worth reading and following, as they will help you to get better photos. After you've made a quality copy of a scrapbook album page or two, doing the rest is easy. If you'd like to learn more about taking photographs with a digital camera, you may want to read my book *50 Fast Digital Camera Techniques*.

STEP 3: OPEN FILES

- Select **File ➤ Open** (**Ctrl+O/Command+O**) to display the Open dialog box. After double-clicking the **\ch08\45** folder to open it, click the **bottom-of-page.jpg** file to select it. Press and hold **Ctrl/Command** and click the **top-of-page.jpg** file to select both images. Click **OK** to open both files. Both of these images are 8-bit .jpg images that have been converted from RAW files that you can find in the **\ch08\45** folder.

STEP 4: DIGITALLY STITCH IMAGES

- To digitally stitch the two images together, select **File ➤ New ➤ Photomerge Panorama** to get the

Photomerge dialog box shown in **Figure 45.3**. Press and hold **Ctrl/Command** and click the files shown in the Source Files box to select the two files that were opened in Step 3.

■ Click **OK** to begin the merge process. You should now see the images merged in the preview

box in the Photomerge dialog box shown in **Figure 45.4**. If Photomerge had difficulties matching one or more images, you can click them and arrange them as needed. Make sure that the **Snap to Image** box is not checked; otherwise, you won't be able to arrange your images as needed. Also make sure that **Settings** is set to **Normal**. If you have taken good photos under consistent lighting, your images should blend well; if not, you can click **Advanced Blending** and see if that feature improved the stitched image. Click **OK** to stitch the images.

45.3

STEP 5: CROP STITCHED IMAGE

■ To crop the image, click the **Crop** tool (**C**) in the **Toolbox**. Type **12 in** in the **Width** and **Height** box in the Options bar. Clear any value that may be in the **Resolution** box. The Options bar should now look like the one shown in **Figure 45.5**.

■ Click just inside the upper-left edge of the scrapbook album page and drag the selection marquee down toward the right to select as much of the page as is possible. When you have a selection marquee, you can click inside the marquee and drag it. Or, you can tap the arrow keys to move the marquee 1 pixel at a time. You can also resize the selection marquee by clicking and dragging the handles in the corners of the marquee.

■ Press **Enter/Return** to apply the crop.

45.4

45.5

STEP 6: EDIT IMAGE

Now is the time to perform any edits to the image that may be needed. If you take time and effort to take good photographs of your scrapbook album pages, you will have very little image editing to do.

■ In this case, you have a nice crop where the sides of the photographs are parallel to the edges of the album page. If you use a camera lens that adds distortion or you shoot without taking care to make the face of the lens parallel to the album page you are shooting, you will end up with an "out of square" album page. To fix this kind of distortion, select **Image ➢ Transform** and select one of the transform features such as **Free Transform** (**Ctrl+T/Command+T**) or **Perspective**.

■ If your original album page has photographs that are dark to begin with and they show up dark in your digital photo, you still need to make some tonal corrections with tools such as **Levels** (see Techniques 9, 10, and 11). First select the photographs using the **Rectangular Marquee** tool (**M**). Then invert the selection to select everything but the photographs. Then apply your edits.

■ As is the case with most digital photos, this image does need to be sharpened. Before sharpening you should first do what? Yes — make sure you zoom in on the image to 100 percent by selecting **View ➢ Actual Pixels** (**Alt+Ctrl+0/Option+ Command+0**). Select **Filter ➢ Sharpen ➢ Unsharp Mask** to get the Unsharp Mask dialog box shown in **Figure 45.6**. I liked the results of setting **Amount** to **200%**, **Radius** to **.7 pixels**, and **Threshold** to **2 levels**. To learn more about image sharpening, read Technique 6.

STEP 7: RESIZE AND SAVE IMAGE FILES

■ To properly size the image, select **Image ➢ Resize ➢ Image Size** to view the Image Size dialog box shown in **Figure 45.7**. The image should be

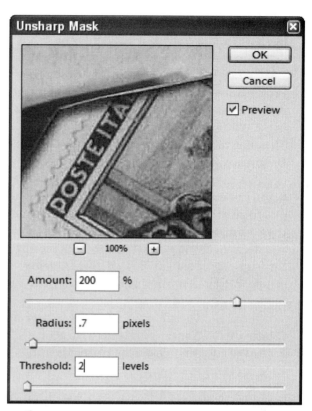

45.6

45.7

approximately 3,200 x 3,200 pixels depending upon where you cropped it. In Step 1, you determined that you needed an image that was 2,880 x 2,880 pixels. Make sure that **Constrain Proportions** is checked and that **Resample Image** is checked and set to **Bicubic Sharper**. Type **2880** in the **Width** box in the **Pixel Dimensions** area. The same value is automatically entered into the **Height** box. Type **240** in the **Resolution** box and click **OK** to apply the settings.

■ You can now save your image. While it would be best to save the file in the .tif or .psd file format as those formats are non-lossy formats you can, if you need smaller files, also save the file in the .jpg format using a **Medium** or **High** image **Quality** setting. Before saving the image, you must first flatten it by selecting **Layer ➢ Flatten Image**. To save the file in the .tif format, select **File ➢ Save As** (**Shift+Ctrl+S/Shift+Command+S**) to get the Save As dialog box. Click in the **Format** box and choose **TIFF**. Type in an appropriate file name, choose a folder, and click **Save**.

You should now have an excellent image that can be used to make a 12" x 12" print on an Epson or other brand printer. **Figure 45.8** shows a small portion of the full-size image. Because a light shining across the page from the right side created shadows when the original photos were taken, you now notice that there is a good sense of depth on the edges of the tags, photos, and paper.

With that one page completed, you can see how easy it would be to make multiple copies of an entire scrapbook. It is as easy as shoot, Photomerge, perform a small bit of editing, and make prints!

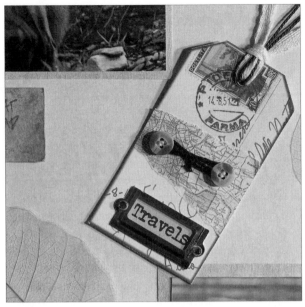

45.8

TIP

You can use Adobe Photoshop Element 3.0's Photomerge tool to digitally stitch two or more images together seamlessly. If you need more image resoution than you can get with just two images, take four pictures (in a 2 x 2, or larger if needed, pattern) and let Photomerge Panorama automatically stitch them together. To get the best stitching results make sure you take photos that overlap by as much, or more than, one-third of the image. This overlap is necessary to get good results.

CREATING A BASIC SCRAPBOOK ALBUM PAGE

46.1 (CP 46.1)

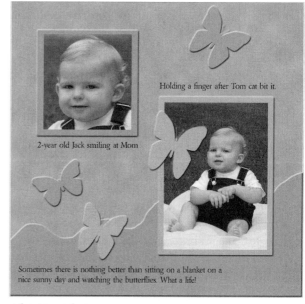

Holding a finger after Tom cat bit it.

2-year old Jack smiling at Mom

Sometimes there is nothing better than sitting on a blanket on a nice sunny day and watching the butterflies. What a life!

46.2 (CP 46.2)

ABOUT THE IMAGE

"A Day in the Park," Canon EOS 1D Mark II, 70–200mm f/2.8 IS @ 70mm, f/14 @ ¹⁄₆₀ sec, ISO 100, 16-bit RAW format, 3,504 x 2,336 pixels, cropped, edited, and converted to an 8-bit .jpg

It surprised me when I learned that scrapbooking is a multibillion dollar industry. Many, many people have gotten into documenting their family histories, trips, and other important events and are hard at work preserving their photographs. If you are one of those people and you want to use a computer to create stylish scrapbook album pages, this technique is a useful and fun one for you.

Making a scrapbook album page using Adobe Photoshop Elements 3.0 is easy. Sure, you need to have some design skill and a reasonable sense for choosing colors, patterns, textures, and shapes — but, you don't have to be a design expert to create wonderful scrapbook pages that can be enjoyed for generations.

In this technique, I show you how easy it is to create a basic scrapbook design, add stamps, add digital photos like those shown in **Figure 46.1** (**CP 46.1**), and add depth to all of the elements on a page. After you have completed this technique and have a page that looks similar to the one shown in **Figure 46.2** (**CP 46.2**), you should be able to pick a few of your own favorite photos, decide on a theme, and then create your first digital scrapbook album page.

STEP 1: PLAN LAYOUT

Assume the target printer has a recommended 240 ppi and that you are making the page to fit in a standard 12" x 12" scrapbook. The goal is to take the photos shown in **Figure 46.1** (**CP 46.1**) and crop and size them so they can be printed out and placed on the scrapbook page shown in **Figure 46.2** (**CP 46.2**).

STEP 2: CREATE NEW PAGE

- With a quick bit of math, you find that you need an image that is 2,880 x 2,880 pixels (240 ppi × 12" = 2,880). To create the new image, select **File ➤ New ➤ Blank File** (**Ctrl+N/Command+N**) to get the New dialog box shown in **Figure 46.3**. Type **2880** in the **Width** and **Height** boxes, and make sure increments for both are **pixels**. Type **240** in **Resolution** and make sure the increment is **pixels/inch**. Alternatively, you could set **Width** to **12 inches**, **Height** to **12 inches**, and **Resolution** to **240 pixels/inch** and get the same results. **Color Mode** should be set to **RGB Color** and **Background Contents** should be set to **White**. Click **OK** to create the new document.

STEP 3: CREATE BACKGROUND

- Adobe Photoshop Elements 3.0 offers several tools for creating backgrounds. You can select **Edit ➤ Fill Layer** to open the Fill Layer dialog box shown in **Figure 46.4**. If you click the **Use** box and select **Pattern**, you can then choose from a number of different palettes of patterns such as **Canvas**, **Watercolor**, **Slate**, **Stone**, and many others. Click in the **Custom Pattern** box to get one of the palettes such as the **Artist Surfaces** palette shown in **Figure 46.5**. But, let's try another technique. Click **Cancel** to close the Fill Layer dialog box.
- Fill the image with a soft, cloud-like background made of soft pink and blue. To select the two colors, double-click the **Set Foreground Color** icon at the bottom of the **Toolbox** to get the **Color**

46.3

46.4

46.5

Picker shown in **Figure 46.6**. Type **132, 167**, and **220** in the **R, G**, and **B** boxes respectively to select a baby blue color; then, click **OK**. Now double-click the **Set Background Color** icon at the bottom of the **Toolbox** to get the **Color Picker** again. This time, type **233, 149**, and **194** respectively in the **R, G**, and **B** boxes to get a pink color; click **OK**.

■ Select **Filter ➤ Render ➤ Clouds** to fill the background with the two colors.

STEP 4: CREATE NEW BLUE LAYER

■ Now add a new layer and fill it with blue. Select **Layer ➤ New ➤ Layer** (**Shift+Ctrl+N/ Shift+Command+N**) to display the Layer dialog box; click **OK**.

■ Click the **Lasso** tool (**L**) in the **Toolbox**. Click the image toward the bottom-left and create a selection like the one shown in **Figure 46.7**.

■ Select **Edit ➤ Fill Selection** to get the Fill Layer dialog box. Click the **Use** box and select **Foreground Color** to pick the blue color. Click **OK**. The selection area is now filled with the blue color.

■ To add an edge to the layer, open the **Styles and Effects** palette by selecting **Window Styles and Effects**. Click in the **Category** box and select **Layer Styles**. Click in the **Library** box and click **Bevels** to get the palette shown in **Figure 46.8**.

46.7

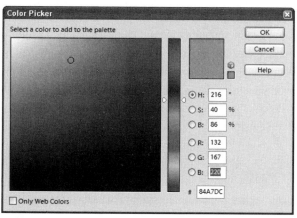

46.6

46.8

Click the **Simple Emboss** style to add a nice soft bevel. Select **Select ➢ Deselect** (**Ctrl+D/Command+D**) to remove the selection.

■ Click the **Styles and Effects** palette and move it out of the way of the image, but leave it open as you will be using it again shortly.

STEP 5: ADD PHOTOS

■ Select **File ➢ Open** (**Ctrl+O/Command+O**) to display the Open dialog box. After double-clicking the **\ch08\46** folder to open it, click the **baby1.jpg** file to select it. Press and hold the **Ctrl/Command** key and click the **baby2.jpg** file to select both images. Click **OK** to open both files.

■ Click the **Move** tool (**V**) in the **Toolbox** and then click the **baby1.jpg** file to make it the active file. Click in the image and drag the cursor onto the background image to place the baby image in your newly created album page.

■ To reduce the size of the photo, select **Image ➢ Resize ➢ Scale**. Press and hold **Shift** and click one of the corner selection marquee handles to reduce the size of the image. Pressing **Shift** keeps the width and height proportions the same as the original. If you want to move the image, you can click inside the selection marquee and drag the image where you want it. Press **Enter/Return** to commit the size change.

■ Do the same thing to the second image. If you want to crop the image, you can do so using the **Rectangular Marquee** tool (**M**). After making a selection, select **Select ➢ Inverse** (**Shift+Ctrl+I/ Shift+Command+I**); then select **Edit ➢ Cut**.

STEP 6: ADD BACKGROUND PAPER TO EACH PHOTO

■ Your **Layers** palette should now look like the one shown in **Figure 46.9**. Let's first add a pink paper layer beneath the photo that shows the

entire baby. In the **Layers** palette, click **Layer 1**, which should be the layer with the beveled blue element. Select **Layer ➢ New ➢ Layer** (**Shift+Ctrl+N/Shift+Command+N**) to display the New Layer dialog box; click **OK**.

■ Select **Edit ➢ Fill Layer** to view the Fill Layer dialog box. Click in the **Use** box and select **Background Color** to pick the pink color; click **OK**. You should now have a pink layer.

■ Click the **Rectangular Selection Marquee** tool (**M**) in the **Toolbox**. Click the **Add to Selection** icon in the Options bar. Carefully click and drag a selection marquee around each of the two photos while leaving a nice pink border, as shown in **Figure 46.10**.

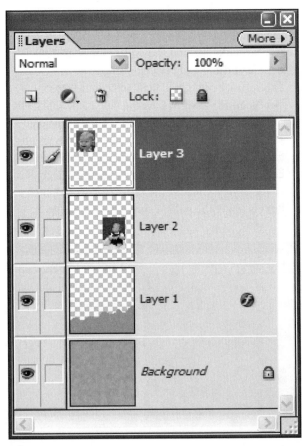

46.9

- Select **Select** ➢ **Inverse** (**Shift+Ctrl+I/ Shift+Command+I**) to reverse the selection. Select **Edit** ➢ **Cut** (**Ctrl+X/Command+X**) to remove the extra pink background. Your image should now look like the one in **Figure 46.10**.
- To add a shadow to the pink backgrounds, click the **Simple Outer** style in the **Styles and Effects** palette.
- You now should do the same thing to add a background to the second image.

STEP 7: ADD TEXT

- Click the **Horizontal Type** tool (**T**) in the **Toolbox**. Click the image where you want to add text. In the Options bar, choose a font style and set size to about **24 pt**. The **Foreground Color** will be the color of the text. If you want a different color, you can select it by clicking the **Color** box in the Options bar, or by changing the **Foreground Color** at the bottom of the **Toolbox**. Type the text

you want displayed and press **Enter/Return** to commit the text. If you want to move the text, use the **Move** tool (**M**). To learn more about using text read Technique 21.

- Notice that you can press **Enter/Return** to get a new line of text. Also, the text can be set to be left- or right-justified, as well ascentered. If you add one or more lines, you need to set the **Leading** on the Options bar to be at least the size of the font you are using.
- When you have all the text on the image where you want it, you can reduce the number of layers by clicking the **Link** icon to the left of all the text layers in the **Layers** palette; then select **Layer** ➢ **Merge Linked** (**Ctrl+E/Command+E**).

STEP 8: ADD STAMPS

Some common features of traditionally made paper-based scrapbooks are the stamps, tags, and other elements that are usually glued onto a scrapbook page. Now let's add a few simple elements to the page. How about adding three or four butterflies?

- Click the **Cookie Cutter** tool (**Q**) in the **Toolbox**. Click in the **Shapes** box in the Options bar to display the Shapes palette shown in **Figure 46.11**. If the palette looks different, click the triangle icon in the

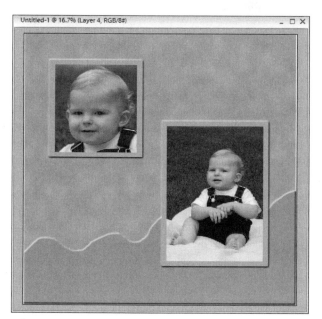

46.10

46.11

upper-right corner and select **Small Thumbnail**. Click the triangle icon once again and select **Animals**. Click the **Butterfly 2** icon. It is very important that you remove any checkmark that might be in the **Crop** box on the Options bar as shown in **Figure 46.12**, or you will crop out all of the scrapbook page that is not covered by the stamp!

■ You now need to make a new blue layer for several of the butterflies. Because you want the butterflies to be on the very top layer, click the very top layer in the Layers palette (it should be **Layer 3**). Select **Layer** ➤ **New** ➤ **Layer** (**Shift+Ctrl+N/ Shift+Command+N**) to summon the New Layer dialog box; click **OK**. Select **Edit** ➤ **Fill Layer** to display the Fill Layer dialog box. Click the **Use** box and select **Foreground Color** to pick the blue color. Click **OK** to create the new blue layer.

■ Using the **Cookie Cutter** tool (**Q**), click in the image and drag the cursor to form the size and shape of butterfly you want. You can also type values in the boxes in the Options bar to pick a preset size or an angle of rotation. When the butterfly looks the way you want, press **Enter/Return**. If needed, you can click in the butterfly with the **Move** tool (**V**) and move it where you want it.

■ To add a bevel, click on the **Simple Outer** style in the Styles and Effects palette that you used earlier. To add more stamps, create a new layer for

46.12

each one and fill the layer with the background color you want. After you have all the stamps sized and placed where you want them, you can merge them all into a single layer and apply a Styles and Effects effect to them. To merge the layers, use the **Link** feature in the **Layers** palette and select **Layer** ➤ **Merge Linked** as you did with the text in Step 7. Your final page should look similar to the one shown in **Figure 46.2** (**CP 46.2**).

STEP 9: FLATTEN LAYERS AND SAVE FILE

■ When you have all the text, layers, stamps, and everything else you want where you want it, you can select **Layer** ➤ **Flatten Image** to flatten all of the layers. You can then save the page to a file that is much smaller than if you had not flattened it. Or, if you want to make changes later, make sure to save the file as a .psd file and make sure you check the box next to **Save Layers**.

While I'm quick to agree with those who claim that this scrapbook album page won't win any design awards, you have to give me credit for using this technique to give you a good tour of many of the Adobe Photoshop Elements 3.0 features that are useful for making a good scrapbook album page. You have learned how to work with layers, add photos, add stamps, add background papers, and add bevels to various elements and this is just the beginning. With that knowledge alone, you can create some wonderful scrapbook album pages like those found in Technique 47.

DECONSTRUCTING A DIGITALLY MADE SCRAPBOOK ALBUM PAGE

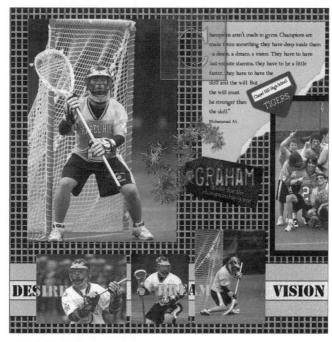

47.1 (CP 47.1)

ABOUT THE IMAGE

"State Championship Lacrosse Team," The original 3,600 x 3,600 pixel, 113MB .psd file has been resized to be 800 x 800 pixels, 4.3MB .psd file with 29 layers turned off.

In Technique 46, you learned how to quickly create a simple, yet fun scrapbook page. In this technique, you are going to do something different than you did in every other technique in the book. In the other 49 techniques in this book, you always created something. In this technique, you deconstruct something! That "something" is a wonderful sports scrapbook album page that was created by the talented scrapbook designer Cheryl Barber.

After you spend some time deconstructing one of the two pages shown in **Figure 47.1** (**CP 47.1**), and you use the skills that you learned in Technique 46, you should have most of the knowledge that you need to create outstanding scrapbook albums of your own. You can learn more about Cheryl Barber of CB Digital Design and her work on her Web page at www.cbdigitaldesigns.com. If for no other reason, I highly recommend that you take a few minutes to visit her site for inspiration. It is amazing to see how she creates so many wonderful, realistic, and traditional-looking scrapbook album pages — and all digitally!

STEP 1: OPEN FILE

■ Select **File ➤ Open** (**Ctrl+O/Command+O**) to display the Open dialog box. After double-clicking the **\ch08\47** folder to open it, click the **left-page.psd** file to select it; click **OK** to open the file. This file was purposefully saved with all 29 layers turned off, so do not be surprised to see a blank page.

STEP 2: TURN ON EACH LAYER

■ Open the **Layers** palette if it is not already showing by selecting **Window ➤ Layers**. The Layers palette should look like the one shown in **Figure 47.2**.

■ Starting from the bottom of the Layers palette, click each layer to see what was added to the image. As you turn each layer on, notice how easy it is to click and move each of the elements with the **Move** tool (**M**). Using adjustment layers, you can also make any adjustment to any photo layer you want. You can also add any special effects to layers such as shadow and texture effects. Making complex scrapbook album pages is really no more difficult than making simple ones like the one in Technique 46, except they take more time and require more work. You will also learn that it is very important to have a clear vision of how you want your album page to look before you start creating it. You will save yourself much time and will end up with better album pages if you do some advance planning.

STEP 3: OPEN TAG FILE

If you plan on making complex album pages like the one shown in this technique, or you want to use some of the same elements in more than one page or album; you should create separate files for those elements. You can then select, copy, and paste them into any album page you want. For example, take a quick look at the wonderful tag that Cheryl created (see **Figure 47.3**).

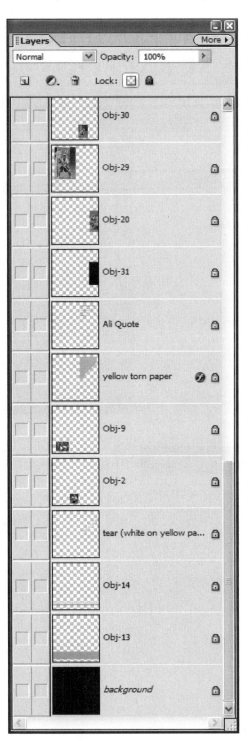

47.2

■ Select **File** ➢ **Open** (**Ctrl+O/Command+O**) to display the Open dialog box. After double-clicking the **\ch08\47** folder to open it, click the **tag.psd** file to select it; click **OK** to open the file. This file contains five layers, as you can see in **Figure 47.4**.

Notice how important it is to save each layer when you construct an element like the tag. Saving the file in the .psd format with all the layers allows you to go back and change the text, or color, or whatever else you want to change—to use on a new page. You should also note how the image is nothing but layers. There is no background layer so the tag sits on a transparent background, which lets it be dropped onto any album page with ease.

I hope that you have enjoyed deconstructing this album page.

You've now completed the scrapbooking chapter. When you complete the other techniques in this book, you should be well on your way to creating many outstanding pages for your own scrapbook albums. In the next chapter, you learn how to create your own online photo gallery. After you complete the next (and last) chapter in this book, you will also be ready to design scrapbook album pages that not only make wonderful printed copies, but can also be uploaded to the Internet so that all your friends and family can view them, too.

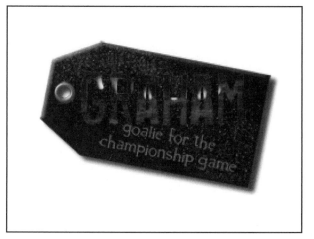

47.3

TIP

When you want to create two scrapbook album pages that will be facing each other — called a spread (like the one shown in Figure 47.1 (CP 47.1) — you should first create a "double-wide" page. After you add the key elements that will be on both pages, you can cut the image into two halves and save them as separate .psd files. Working on a single page file with lots of layers will be much quicker than working on an image file that is double the size.

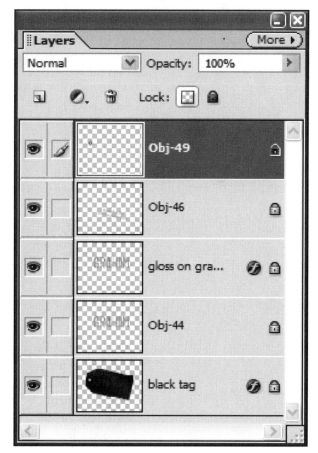

47.4

CHAPTER 9

BUILDING AN ONLINE PHOTO GALLERY

Y ou can share your photography in many ways. Until recently, making prints was the most common way to share photos. Now, in the age of the Internet, sharing photographs digitally via e-mail and posting them onto Web sites is the increasingly preferred way of displaying photographs. In fact, a growing percentage of photographs are shown on the Internet and never get printed. Not only is it inexpensive to share them in this manner, but people all over the world can view your photographs.

This chapter provides you with the techniques to create your own online photo gallery. In Technique 48 you learn how to create the perfect Web image. Technique 49 shows you the steps you need to take to create a Web page mask that allows you to quickly and creatively display your photos. The final technique of the book, Technique 50, shows you how you can create your own online photo gallery.

CREATING THE PERFECT WEB IMAGE

48.1

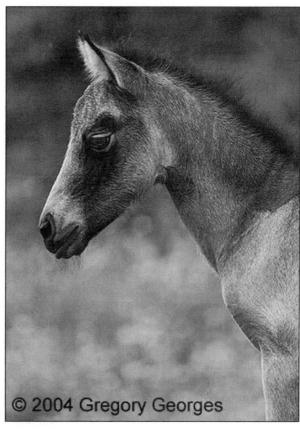

© 2004 Gregory Georges

48.2

No doubt about it — you can quickly and easily create an image to be placed on a Web page using commands such as Save For Web, or even Save As. But there is much more to creating excellent images that display well on a Web page than merely saving them as a .jpg image using one of these commands. In this technique, you learn all the steps you need to take to make excellent images that have been optimized specifically for viewing on a Web page. The images will also include information that identifies the image as yours as well as titles, shooting information, and so on.

295

For this technique, you use a photo of a highly entertaining one-day-old Chincoteague pony. This image has been converted from a RAW format file to a .tif format and it has been resized so that the longest side is 1,600 pixels. Some editing was done to the image. When the image was converted using Camera RAW, care was taken not to sharpen the image as you can get better results by applying sharpening once the image has been sized for the Web page. After you have completed this technique, you will understand how the images used in Technique 50 were prepared.

STEP 1: OPEN FILE

■ Select **File ➢ Open** (**Ctrl+O/Command+O**) to display the Open dialog box. After locating the **\ch09\48** folder, double-click it to open it. Click **pony-before.tif** and then click **Open** to open the file.

STEP 2: CROP AND SIZE IMAGE

One of the first decisions you need to make when preparing images that will be displayed on a Web page is what size they should be. The two most common computer screen resolutions are 800 x 600 and 1,024 x 768. What you generally don't want to do is make Web images that require the viewer to have to scroll up and down to see the whole image. For this reason, choose a resolution that can be easily viewed on a majority of computer screens. A common and easily viewable image resolution is one that is not more than 640 pixels wide and no more than 480 pixels tall.

■ The first step is to crop the image. Click the **Crop** tool (**C**) in the **Toolbox**. Click **Clear** on the Options bar to clear any existing settings. Crop the image so that it's 5" x 7". Type **5 in** in the **Width** box and **7 in** in the **Height** box. Maximize the image if it is not already maximized and make sure the entire image is visible by selecting **View ➢ Fit on Screen** (**Ctrl+0/Command+0**).

Click and drag the selection marquee so that you crop the image to look similar to the one shown in **Figure 48.2**. Press **Enter/Return** to commit the crop.

■ To resize the image to the final size needed for the Web page, which is an image that fits within a 640 x 480 pixel rectangle, select **Image ➢ Resize ➢ Image Size** to display the Image Size dialog box shown in **Figure 48.3**. Make sure that **Constrain Proportions** is checked. Click in the **Height** box under **Pixel Dimensions** and type **480**. Notice that **Width** is automatically changed to keep the proportions equal to a 5" x 7" image. **Width** is now **343**.

■ New to Adobe Photoshop Elements 3.0 is a new interpolation algorithm for down-sizing images. This new algorithm keeps your image sharper when it is down-sized. Make sure there is a check-mark next to **Resample Image** and click in the box to select the new algorithm: **Bicubic Sharper**. Click **OK** to resize the image. Even though you have chosen Bicubic Sharper as the mathematical algorithm to resample the image, you are not actually sharpening the image — that you will do in the next step.

48.3

STEP 3: SHARPEN IMAGE

■ Now that the image is at its final size, you can sharpen it. To see the sharpening results and choose the best settings, select **View ➢ Actual Pixels (Alt+Ctrl+0/Option+Command+0)** to view the image at **100%**. Select **Filter ➢ Sharpen ➢ Unsharp Mask** to display the Unsharp Mask dialog box shown in **Figure 48.4**. As this image was shot to intentionally get a soft background, you need to choose sharpening settings that just sharpen the pony. For Web images, I usually start with a high **Amount** setting of around **300** to **400** and a low **Radius** setting of about **0.3** pixels. For this image, I found that the results were good when **Amount** was set to **150%**, **Radius** to **0.3**, and **Threshold** to **0** to bring out the

detail in the pony's hair. Click **OK** to apply the settings. To learn more about sharpening an image, read Technique 6.

STEP 4: ADD FRAME OR OTHER IMAGE ENHANCING FEATURES

Depending on how you want your photos to look, the design of the Web gallery, and the Web page's background color, you may want to add a frame or just a simple line around your image. When you use the Web Photo Gallery feature, there is an option to automatically add a border line around each image. However, if you plan on adding extra canvas as described in the next step, you need to add a line before you run Web Gallery.

■ If you want to add a colored line around your image, select **Select ➢ All (Ctrl/Command+A)** and then **Edit ➢ Stroke (outline) Selection** to display the Stroke dialog box shown in **Figure 48.5**. In this dialog box you can choose the **Width** of the stroke in pixels and the **Color** of the border line.

48.4

48.5

Make sure to set **Location to Inside** so all of the line shows on the image. In this case, the image will be placed against a white background, so choose **white** as the color and set **Width** to **1 px**. Click **OK** to add a white line around the image. Click **Select ➢ Deselect** (**Ctrl+D**/**Command+D**) to remove the selection marquee.

Adding a border line to your image helps to separate it from the background. For example, if you intend to display a high-key photo featuring a subject shot against a white background, the image would not have visible edges if it were displayed on a Web page with a white background. Also, a simple border line often enhances an image if it is correctly sized and if the color works well with the image.

TIP

To improve the way your images are displayed on a Web page you can add matte borders and even frames that look like real picture frames. Check out the framing choices found in the Styles and Effects palette. You will find Cut Out, Simple Outer, Low, Soft Edge, Spatter Frame, Wild Frame, and even Fire.

STEP 5: ADD CANVAS TO PREVENT "IMAGE JUMPING"

If you have viewed a Web photo gallery where the height and width sizes vary between images, you may have noticed text, images, and navigation features that "jump" as you move between images. To avoid this annoying effect, you simply need to add each of your images to a background image that has the width of the widest image, and the height of the tallest image. As you will be using a Web page design for images that fit in a 640 x 480 pixel rectangle, you need to add this image to a white 640 x 480 pixel canvas.

■ Select **Image ➢ Resize ➢ Canvas Size** to display the Canvas Size dialog box shown in **Figure 48.6**. If **pixels** is not the increment setting in the box after **Width**, click in the box and select **pixels**. Type **640** in the **Width** box. Make sure to uncheck **Relative** — this is very important! Leave the **Anchor** set to the default center box. Click the **Canvas extension color** box and select **White**. Click **OK** to add white canvas. Your image should now look like the one in **Figure 48.7**; it will be 640 x 480 pixels. If you had a horizontal image, it

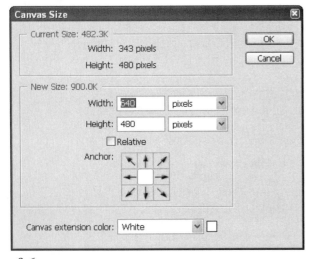

48.6

48.7

would look like the one in **Figure 48.8**. Notice that a small amount of white has been added to the top and bottom of the image to make it fit the 640 x 480 pixel space.

STEP 6: ADD COPYRIGHT AND OTHER INFORMATION TO THE IMAGE FILE

Anyone with even limited experience of sharing photos on the Internet is aware that images do get copied and used by others without permission. While it is nearly impossible to stop such action, you can at least add your copyright and contact information to each image you post on a Web site.

■ Select **File ➢ File Info** (**Alt+Ctrl+I/ Option+Command+I**) to display the dialog box shown in **Figure 48.9**. Here you can add all kinds of information. Many of these fields contain information that can be used with the Web Photo Gallery making it easy to add information to an image once and then have Web Photo Gallery automatically place it on a Web page. You can add, or not, any information you'd like to the file, but each time you post images to a Web site you ought to set **Copyright Status** to **Copyrighted** and type copyright information in the **Copyright Notice** box. To insert a © symbol, press and hold **Alt** while typing **0169** (on the Mac, press **Option+G**). Add a year and your name. It is also wise to add your Web site address if you have one so that viewers may contact you if they want to do so. Click **OK** to place this information into the image file.

When you set the **Copyright Status** to **Copyrighted**, many imaging applications indicate that the image is copyrighted by showing the © symbol in the title bar, as you can see in **Figure 48.10**. Notice the tiny © symbol just to the left of the filename.

48.8

48.9

48.10

STEP 7: ADD A VISIBLE WATERMARK OR COPYRIGHT TEXT TO THE IMAGE

You can add two types of watermarks to your images. The first is an invisible watermark such as those that are embedded into the image by the Digimarc plug-in. To learn more about the Digimarc service, visit `www.digimarc.com`. You can also add a visible watermark or text to your image. Adobe Photoshop Elements 3.0's Web Gallery has a feature that automates the process of placing text on each image. However, this feature is automated and it does not let you change text color or text location. Therefore you may find that the text either distracts the viewer from viewing your image or it is not visible because it is a color that blends in with the image color.

■ To add text to an image, click the **Horizontal** (or **Vertical**) **Text** tool (**T**) in the **Toolbox**. Click in the text Options bar and choose the font and font color you want. Click on the image where you want the text, and begin typing. When you have completed the text, press **Enter/Return** or click the **Commit** icon in the Options bar. You can select the **Move** tool (**V**) and click and drag your text to exactly where you want it. Click **Layer ➢ Flatten Image**. To learn more about placing text on an image, read Technique 21.

STEP 8: SAVE THE IMAGE AS A .JPG FILE

■ Select **File ➢ Save For Web** (**Alt+Shift+Ctrl+S/ Option+Shift+Command+S**) to display the Save For Web dialog box shown in **Figure 48.11**. Save For Web not only gives you lots of settings options to optimize your image, but it also lets you view "before" and "after" images so that you can get the

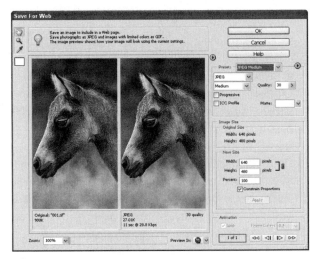

48.11

best balance between image size and image quality when choosing compression level. Click in the Zoom box at the bottom-left of the dialog box and choose **100%** to see the image as it will be displayed on a Web page. Click in the **Preset** box and choose **JPEG Medium**. The image on the left is the original image. The image on the right shows how the image looks with the settings you've chosen. Below the second image you can read file size. This image is now about **27Kb** — a good file size for quick downloading. Click **OK** to save the image and then click **Save** again to save the image in the folder you want.

No doubt about it — taking all these steps for each of your images is work. However, it is well worth your time as your images will look better, download faster, and be more protected from copying than if you did not add copyright information. If you create lots of Web images, you may want to consider upgrading to the full version of Photoshop as it offers Actions. All the steps you need to take to create Web images can be automated and saved as an Action, which saves you a tremendous amount of time and increases accuracy. Actions are wonderful time-savers!

WARNING

No matter how hard you work, or what techniques you use to protect images you display on the Internet from being used without your permission or knowledge, you will not be successful if someone really wants the images. Many photographers take great effort and expend lots of time trying all kinds of techniques to prevent the copying and use of their images without their permission. Such techniques include adding a roll-over image with text to each image, placing each image as the background image, adding expensive digital copyright "signatures," or using one of many Java scripts to prevent images from being copied from a Web page and used without permission. In all these cases, the use of a free or inexpensive screen capture utility gives anyone quick access to your images.

If you truly do not want to have your images downloaded and used by unauthorized users, there are really only two reasonable choices. Place images on your Web site that are too small to be useful for other purposes, or simply do not upload your work to the Internet. If you want to make it possible for people to visit your Web site to enjoy your work, you should make it as easy as possible for them to navigate and view your images. Otherwise, they are likely to leave and never return.

CREATING A WEB PAGE COLLAGE MASK

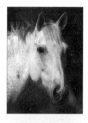

49.1

49.2

"What's New on Our Farm?" Six digital photos taken with several different digital cameras, all files saved as .tif files that are approximately 214 x 300 pixels

Many art stores, frame shops, and photo stores offer pre-cut collage matte boards, which makes it easy to display multiple photos on a single matte board. This technique shows you how to create a similar collage digitally using a collage mask. The advantage to this approach is that you can create a collage mask once and then use it each time you need to display new photos.

Figure 49.2 shows the results of using a collage mask to display the six farm photos shown in **Figure 49.1** on a Web page. The predefined collage mask used for this image can be found on the companion CD-ROM. If you need a collage mask for print purposes, you need to create a higher resolution mask yourself. To learn how to make a higher resolution version, or to make one of your own designs, follow the instructions in Step 1. Otherwise, skip to Step 2 and use the predefined mask.

STEP 1: CREATE COLLAGE MASK

Figure 49.3 shows the layout of the collage you can find on the companion CD-ROM. It was easily created in just a few minutes with Adobe Photoshop Elements 3.0. It consists of three layers: the background layer, the collage mask layer, and a text layer for the page title.

The steps for creating the collage mask are as follows:

■ Select **File ➢ New ➢ Blank File** (Ctrl+N/ **Command**+N) to display the New dialog box. As this particular collage mask is created for a Web page, size it to be **800 x 600** pixels with **Resolution** set to **72**. Set **Background Contents** to **White**. Click **OK** to create the image.

■ Select **Layer ➢ Duplicate Layer** to create a mask layer. Type **Mask Layer** in the **As** box in the Duplicate Layer dialog box; click **OK** to create the layer.

■ Select **View ➢ Grid** to turn on the grid to make it easy to align openings in the mask.

■ Using the **Rectangular Marquee** and **Elliptical Marquee** tools with **Add to Selection** selected in the Options bar, select each area to be masked (on the **Mask Layer**).

■ After all the "openings" have been selected, cut them out by selecting **Edit ➢ Cut** (**Ctrl+X**/ **Command+X**).

■ To add the drop shadow effect, select **Window ➢ Styles and Effects** to display the Styles and Effects palette. Click in the top-left box in the Styles and Effects dialog box and choose **Layer Styles**. Click in the next box and choose **Drop Shadows**. Click once on the **Low** style icon to apply the style effect.

■ Click the **Text** tool (**T**) and type any heading text you may want. Use the **Move** tool (**M**)to place the text exactly where you want it.

That's it — your collage mask is now ready for photos to be placed beneath each opening. If you save the file with layers as a .psd file, you will be able to open the file and add new photos to it any time you want to change the images.

STEP 2: INSERT DIGITAL PHOTOS

■ If you did not create your own collage mask in Step 1, choose **File ➢ Open** (**Ctrl+O/Command+O**) to display the Open dialog box. Double-click the **\ch09\49** folder to open it and then click the **collage-mask.psd** file to select it. Click **Open** to open the file. You should now have an image that looks like the one shown in **Figure 49.3,** and the Layers palette should look like the one shown in **Figure 49.4**.

■ Six farm images can be found in the **\ch09\49** folder. The original, full-size farm photos were cropped, edited, and resized to prevent them being saved twice as a .jpg image and suffering from image degradation. They were then saved as **.jpg** files by using the Save for Web feature. To open all six images at once, choose **File ➢ Open** (**Ctrl+O/⌘+O**) to display the Open dialog box. Double-click the **\ch09\49** folder to open it. Press and hold **Ctrl** (⌘ on the Mac); then click each file named **image-1.tif** through **image-6.tif** to select them all. Or, you can click the first image, and then press **Shift** and click the last image to select the first and last and each image in between. Click **Open** to open all the files into the workspace.

■ Select **Window ➢ collage-mask.psd** to make the collage image the active image. Click **Background** in the Layers palette to make it active.

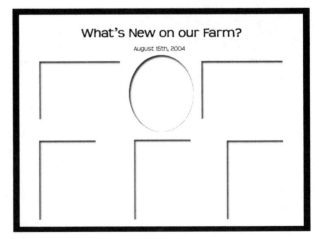

49.3

■ Click the **Move** tool (**V**) in the **Toolbox**.

■ To insert the first photo, click **image5.tif** to make it the active image and drag it onto the **collage-mask.psd** image. An easy way to select each of the photos is to use the **Photo Bin**. To learn more about Photo Bin, read Technique 1. Using the **Move** tool, click and drag the image so that it shows through the center elliptical opening.

■ To resize the pony image (not the entire collage image), select **Image ➢ Resize ➢ Scale** to get bounding boxes around the image. Press and hold **Shift** (to maintain image height and width proportions) and click and drag on one of the corner handles to scale the image to fit in the opening. At any time, you can also release the mouse button and click inside the image and drag it where you want it. To continue resizing the image, press **Shift**, and then click on a handle and continue resizing until it fits as you want. When the image is properly sized press **Enter/Return**, or click on the **Commit Transform** icon on the Options bar.

■ Continue the process of adding and sizing images to the collage until all images have been

correctly positioned. After you place all of the images, the Layers palette shows the Background, the Mask Layer, and six image layers, plus the title and sub-title text layers, as shown in **Figure 49.5**.

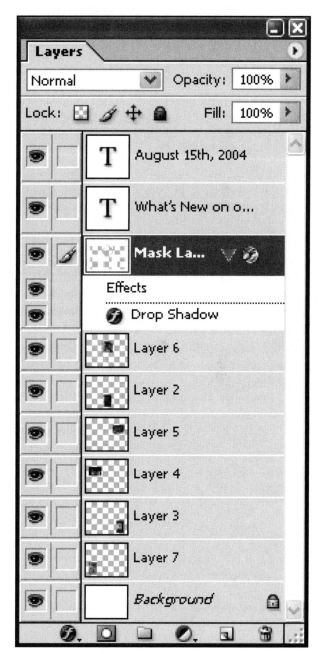

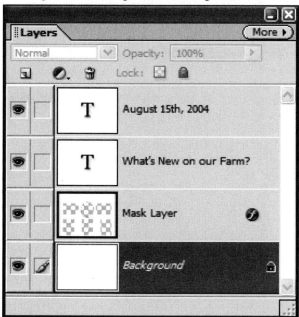

49.4 49.5

Depending on how you select and position the images, you may find that one or more images overlaps another image. If this occurs, make sure **Auto Select Layer** is turned on by clicking in the box next to it in the Options bar. Then, click the overlapping image by using the **Move** tool to select it. Click the **Lasso** tool; then click and draw a selection marquee around the part of the image that you want to remove. Choose **Edit ➢ Cut** (**Ctrl+X/Command+X**) to cut the overlapping part of the image. Or, you may be able to drag and drop layers in the **Layers** palette so that the order of the images eliminates the overlapped image problem.

STEP 3: FLATTEN IMAGE AND SAVE AS A NEW FILE

- Choose **Layer ➢ Flatten Image**.
- To save as an optimized .jpg file to be used on a Web page, choose **File ➢ Save For Web** (**Alt+Shift+Ctrl+S/Option+Shift+Command+S**) to display the Save For Web dialog box shown in **Figure 49.6**. Click in the **Preset** box and select the **JPEG Medium** setting. Click **OK,** name the file, and then pick an appropriate folder. Click **Save** to save the file.

The image is now a mere 44.13Kb and is ready to be placed on a Web page. **Figure 49.2** shows how the image looks in an Internet browser. If you had to create such an image each week for weekly action photos, or each month for monthly updates to what's new on a farm, or for a similar routine image replacement, you would simply need to open the collage mask and drag and drop images — it is that easy.

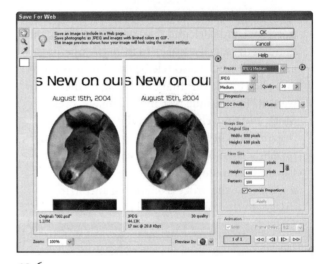

49.6

CREATING AN ONLINE PHOTO GALLERY

50.1 (CP50.1)

50.2 (CP50.2)

One significant benefit of using digital photos is that they can easily be shared online. As more and more people have regular access to the Internet, displaying your photographs online makes them available to a large worldwide audience. Adobe Photoshop Elements 3.0's Web Photo Gallery feature makes it remarkably easy to create an online photo gallery as most of the repetitive and tedious tasks are all automated. Over 30 Web page designs are available in Web Photo Gallery. If none of them suit your needs, you can use an HTML editor to modify the style sheets or the completed HTML pages to suit your own design requirements.

In this technique, you use Web Photo Gallery to create an online gallery for the set of twelve Las Vegas photos shown in **Figure 50.1 (CP 50.1)**. Before you start creating the Web gallery, you may want to take a quick look at the completed gallery so that you will have a better understanding of the many options that are available when using Web Photo Gallery. Assuming that you copied the contents of the companion CD-ROM to your hard drive as recommended in the Introduction, you can find the Web gallery in the **\ch09\50\gallery** folder. On a PC use Explorer; on a Mac use Finder

to double-click the **\ch09\50\gallery** folder to open it. Then, double-click the file **index.htm** to view the completed Web gallery in your system's default browser as shown in **Figure 50.2 (CP 50.2)**

STEP 1 (PC ONLY): SELECT PHOTOS AND RUN WEB PHOTO GALLERY

When using Adobe Photoshop Elements 3.0 on a PC, you can only access the Web Photo Gallery from the Photo Browser, which is not available for the Mac.

■ Assuming you are already in the Editor, click the **Photo Browser** icon on the menu bar to display the Photo Browser. If you have not already imported the technique images found in the **\ch09\50** folder into **Photo Organizer**, you must do so now. To import the images, select **File ➢ Get Photos ➢ From Files and Folders** (**Ctrl+Shift**) to get the Get Photos from Files and Folders dialog box shown in **Figure 50.3**. Click in the **Look in** box and find the **\ch09\50** folder. Press and hold **Shift** and click on the first file and then on the last file to select all 12 image files. Click **Get Photos** to import the files into Photo Browser. You should now see all of the imported images in the Photo Browser as shown in **Figure 50.4**.

■ To select all 12 images, select **Edit ➢ Select All** (**Ctrl+A**).

STEP 1 (MAC ONLY): SELECT PHOTOS AND RUN WEB PHOTO GALLERY

■ Select **File ➢ Browse Folders** (**Shift+Cmd+O**) to get the File Browser. In the Folders area of the File Browser, click on the **\ch09\50** folder to select the folder where the 12 images are stored. In the **File Browser** menu (not the Elements' Editor menu) select **Edit ➢ Select All** (**Cmd+A**) to select all 12 images. The File Browser should now look similar to the one shown in **Figure 50.5**.

50.4

50.3

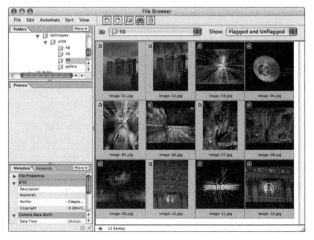

50.5

STEP 2: RUN WEB PHOTO GALLERY

■ On a PC, click on the **Create** icon in the Photo Browser to get the Creation Setup screen. Click on **Web Photo Gallery** and then **OK** to get the Adobe Web Photo Gallery dialog box shown in **Figure 50.6**.

■ On a Mac, you get to Web Photo Gallery by selecting **Automate ➤ Web Photo Gallery** from the **File Browser** menu. The Mac Web Photo Gallery dialog box is slightly different in layout from the PC version and you need to select **Selected Images from File Browser** in the **Use** box to choose the 12 photos selected in Step 1. Otherwise, Mac users can choose similar settings to those as follows.

■ Click in the **Gallery Style** box and choose **Vertical Frame**. You now see a thumbnail image that shows you what that style looks like.

■ Click the **Banner** tab if it is not already showing. Type in a title, subtitle, and e-mail address as you choose. Click on the **Browse** button following the **Destination** box to choose a folder for the Web gallery files that will be created. You will get a **Browse for Folder** dialog box, which will allow you to choose a drive and folder, and to make a new folder if one is needed. Click **OK** to return to the Adobe Web Photo Gallery dialog box. The Banner tab area should now look similar to the one shown in **Figure 50.7**.

50.6

50.7

■ Click the **Thumbnails** tab. Click in the **Thumbnail Size** box and choose **Medium**. You can choose the **Font** and the font **Size** in the Captions area. Click next to **Filename** to have the filename be displayed below each thumbnail. The **Thumbnails** tab area should now look similar to the one shown in **Figure 50.8**.

■ Click the **Large Photos** tab. Because the digital photos that will be displayed in the gallery have already been sized and saved as a 400 x 400 pixel .jpg file with a black background, you should remove any checkmark from the **Resize Photos** box. One of the really useful Web Photo Gallery settings can be found in the Settings area. If you take the time to add a caption to each file (this can be done easily using **Photo Organizer** on a PC or **File Info** on a Mac), then if you place a check mark next to **Caption** — the gallery will be created with the captions written below each of the photos. As there are some captions in the files, turn on the **Caption** feature. The Large Photos tab area should now look similar to the one shown in **Figure 50.9**.

■ Click the **Custom Colors** tab, shown in **Figure 50.10**. The default color scheme for the Vertical Frame style has a white background. For this technique, use a black background and change the other colors to work with the black background as follows: Set **Background** to **black**, **Text** to **white**, **Link** to **yellow**, **Banner** to **black**, **Active Link** to **Red**, and **Visted Link** to **white**.

■ Click **Save** to create the Web photo gallery shown in **Figure 50.2** (**CP 50.2**).

50.9

50.8

50.10

APPENDIX A
WHAT'S ON THE CD-ROM

This appendix provides you with information on the contents of the CD that accompanies this book. For the latest and greatest information, please refer to the ReadMe file located at the root of the CD. Here is what you will find:

- System Requirements
- CD-ROM Installation Instructions
- What's on the CD
- Troubleshooting

SYSTEM REQUIREMENTS

Make sure that your computer meets the minimum system requirements listed in this section. If your computer doesn't match up to most of these requirements, you may have a problem using the contents of the CD.

FOR WINDOWS 9X, WINDOWS 2000, WINDOWS NT4 (WITH SP 4 OR LATER), WINDOWS ME, OR WINDOWS XP:

- PC with a Pentium processor running at 120 Mhz or faster
- At least 32 MB of total RAM installed on your computer; for best performance, we recommend at least 64 MB
- Ethernet network interface card (NIC) or modem with a speed of at least 28,800 bps
- A CD-ROM drive

FOR MACINTOSH:

- Mac OS computer with a 68040 or faster processor running OS 7.6 or later
- At least 32 MB of total RAM installed on your computer; for best performance, we recommend at least 64 MB

CD-ROM INSTALLATION INSTRUCTIONS

If you have a Windows PC, simply insert the CD and browse to "My Computer." Double click on the drive that represents your CD-ROM drive to view the content. To copy the technique image files onto your Mac's hard drive, open the CD-ROM icon that appears on your desktop when the disk is inserted.

1. For the best performance, copy the files on this CD onto your internal hard disk. Make sure that your hard disk has enough space to accommodate all the files you want to install. A good place might be your Documents folder.

2. Look for a ReadMe document in the folder with any installable demonstration software. If this document is present, it should contain installation instructions if any are necessary and other useful information including copyright information.

WHAT'S ON THE CD

The following sections provide a summary of the software and other materials you find on the CD.

IMAGE FILES FOR THE 50 TECHNIQUES

All "before" and "after" images for each of the 50 techniques are on the CD in the folder named:

\Techniques

The images for each chapter are found in the chapter subfolders. For example, images for Chapter 5 could be found in the folder:

\Techniques\ch05\

Each chapter folder contains individual technique folders for each technique in that chapter. For example, the images for Technique 33 can be found in the folder:

\Techniques\ch05\33.

EBOOK VERSION OF 50 FAST DIGITAL PHOTO TECHNIQUES

The complete text of Gregory Georges' *50 Fast Digital Photo Techniques* (the previous edition) is on the CD-ROM in the Adobe Portable Document Format (PDF). You can read and search through the file with the Adobe Acrobat Reader, which is also included on the CD, and available as a free download from `www.adobe.com`.

The PDF file also contains all the illustrations, diagrams, and complete text of all the techniques shown in the book. The file is provided for you here as a convenient, searchable reference tool. You may not reproduce this material in any way, in any media, for any other purpose. Please respect the intellectual property of others and the investment in time and resources that went into creating this work for you.

TROUBLESHOOTING

If you have difficulty installing or using any of the materials on the companion CD, try the following solutions:

- **Turn off any anti-virus software that you may have running.** Installers sometimes mimic virus activity and can make your computer incorrectly believe that it is being infected by a virus. Be sure to turn the anti-virus software back on later.
- **Close all running programs.** The more programs you're running, the less memory is available to other programs. Installers also typically update files and programs; if you keep other programs running, installation may not work properly.
- **Reference the ReadMe.** Please refer to the ReadMe file located at the root of the CD-ROM for the latest product information at the time of publication.

If you still have trouble with the CD, please call the Customer Care phone number: (800) 762-2974. Outside the United States, call (317) 572-3994. You can also contact Wiley Customer Care by e-mail at techsupdum@wiley.com. Wiley will provide technical support only for installation and other general quality control items; for technical support on the applications themselves, consult the program's vendor or author.

APPENDIX B
COMPANION WEB SITE

A companion Web site has been created especially for this book at `www.reallyusefulpage.com/50Photo1`.

WHAT IS ON THE SITE?

- Updates and corrections to this book.
- "50 Techniques" Readers' Image Gallery — View the work of other readers and share your best work too! If you have created an outstanding image that you would like to share with others, please e-mail a .jpg file version to `curator@reallyusefulpage.com`. Make sure that the images that you e-mail fit within a 640 x 640 pixel space and that they are under 75KB. Future editions of this book may contain images submitted to this gallery. Permission will be requested and credit will be given to those who submit images.
- A really useful list of online photography and image editing resources including Photoshop plug-ins.
- FAQ (Frequently Asked Questions) section for getting answers to common questions.
- Recommended book reading list to further your skills.
- List of online galleries that you might like to visit.

JOIN AN ONLINE FORUM

The author of this book has created and hosts an online forum at Yahoo! Groups for readers of his books, as well as anyone else that has an interest in digital photo editing. To join, visit `http://groups.yahoo.com/group/digital-photo-editing`.

Subscribe to the e-mail service to participate. You can post images and share tips and techniques with other readers of this book. There will even be an occasional online chat session, to which you will be invited.

CONTACT THE AUTHOR

Gregory Georges, the author of this book, welcomes comments from readers. He may be contacted by e-mail at `ggeorges@reallyusefulpage.com`, or occasionally on AOL IM under the Buddy Name DigitalGregory. His Web site is `www.reallyusefulpage.com`. Although he reads all e-mail, the heavy volume makes it difficult to respond to all messages.

APPENDIX C
INCLUDED PDF TECHNIQUES

The complete *50 Fast Digital Photo Techniques* book (the previous edition) is included on the Companion CD-ROM in PDF format. If you do not already have Adobe Acrobat Reader to view the PDF files, you may download it free of charge at www.adobe.com. The following is a list of the techniques that are included:

Chapter 1: Creating a Master Image
Technique 1: Getting Your Image into Shape
Technique 2: Removing Dust & Scratches
Technique 3: Adjusting Color and Saturation
Technique 4: Improving Tonal Range and Image Contrast
Technique 5: Removing a Color Cast
Technique 6: Sharpening Images
Technique 7: Fixing and Replacing "Stuff"

Chapter 2: Quick & Easy Techniques
Technique 8: Creating a Graphic Art Image
Technique 9: Creating a Poster-like Image
Technique 10: Painting with the Sumi-e Brush
Technique 11: Making a Brush-like Painting
Technique 12: Using Multiple Filters to Create a Unique Image

Chapter 3: Image Coloring Techniques
Technique 13: Changing Colors
Technique 14: Adding Light and Atmosphere
Technique 15: Changing the Color of Image Elements
Technique 16: Performing Radical Color Transformation
Technique 17: Using a Monochromatic Scheme
Technique 18: Getting Color from a Second Image

Chapter 4: Combining Two or More Images
Technique 19: Combining Two or More Images
Technique 20: Adding Objects to an Image
Technique 21: Making a Panorama by Stitching Images
Technique 22 Putting Sky from One Image into Another
Technique 23: Cloning One Image into Another
Technique 24: Creating a Photomontage

COLOPHON

This book was produced electronically in Indianapolis, Indiana. Microsoft Word 2000 was used for word processing; design and layout were produced using QuarkXPress 4.11. The typeface families used are: Chicago Laser, Minion, Myriad, Myriad Multiple Master, Prestige Elite, Symbol, Trajan, and Zapf Dingbats.

Acquisitions Editor: Mike Roney
Project Editor: Timothy J. Borek
Technical Editor: Richard Lynch
Copy Editor: Nancy Rapoport
Permissions Editor: Laura Moss
Production Coordinator: Maridee Ennis
Composition: Sean Decker, Joyce Haughey, Jennifer Heleine, Susan Moritz, Brian H. Walls
Proofreading and Indexing: Vickie Broyles and Joan Griffitts

INDEX

WILEY PUBLISHING, INC.
END-USER LICENSE AGREEMENT

READ THIS. You should carefully read these terms and conditions before opening the software packet(s) included with this book "Book". This is a license agreement "Agreement" between you and Wiley Publishing, Inc. "WPI". By opening the accompanying software packet(s), you acknowledge that you have read and accept the following terms and conditions. If you do not agree and do not want to be bound by such terms and conditions, promptly return the Book and the unopened software packet(s) to the place you obtained them for a full refund.

1. **License Grant.** WPI grants to you (either an individual or entity) a nonexclusive license to use one copy of the enclosed software program(s) (collectively, the "Software") solely for your own personal or business purposes on a single computer (whether a standard computer or a workstation component of a multi-user network). The Software is in use on a computer when it is loaded into temporary memory (RAM) or installed into permanent memory (hard disk, CD-ROM, or other storage device). WPI reserves all rights not expressly granted herein.

2. **Ownership.** WPI is the owner of all right, title, and interest, including copyright, in and to the compilation of the Software recorded on the disk(s) or CD-ROM "Software Media." Copyright to the individual programs recorded on the Software Media is owned by the author or other authorized copyright owner of each program. Ownership of the Software and all proprietary rights relating thereto remain with WPI and its licensers.

3. **Restrictions on Use and Transfer.**

 (a) You may only (i) make one copy of the Software for backup or archival purposes, or (ii) transfer the Software to a single hard disk, provided that you keep the original for backup or archival purposes. You may not (i) rent or lease the Software, (ii) copy or reproduce the Software through a LAN or other network system or through any computer subscriber system or bulletin-board system, or (iii) modify, adapt, or create derivative works based on the Software.

 (b) You may not reverse engineer, decompile, or disassemble the Software. You may transfer the Software and user documentation on a permanent basis, provided that the transferee agrees to accept the terms and conditions of this Agreement and you retain no copies. If the Software is an update or has been updated, any transfer must include the most recent update and all prior versions.

4. **Restrictions on Use of Individual Programs.** You must follow the individual requirements and restrictions detailed for each individual program in the About the CD-ROM appendix of this Book. These limitations are also contained in the individual license agreements recorded on the Software Media. These limitations may include a requirement that after using the program for a specified period of time, the user must pay a registration fee or discontinue use. By opening the Software packet(s), you will be agreeing to abide by the licenses and restrictions for these individual programs that are detailed in the About the CD-ROM appendix and on the Software Media. None of the material on this Software Media or listed in this Book may ever be redistributed, in original or modified form, for commercial purposes.

5. **Limited Warranty.**

 (a) WPI warrants that the Software and Software Media are free from defects in materials and workmanship under normal use for a period of sixty (60) days from the date of purchase of this Book. If WPI receives notification within the warranty period of defects in materials or workmanship, WPI will replace the defective Software Media.

 (b) WPI AND THE AUTHOR(S) OF THE BOOK DISCLAIM ALL OTHER WARRANTIES, EXPRESS OR IMPLIED, INCLUDING WITHOUT LIMITATION IMPLIED WARRANTIES OF MERCHANTABILITY AND FITNESS FOR A PARTICULAR PURPOSE, WITH RESPECT TO THE SOFTWARE, THE PROGRAMS, THE SOURCE CODE CONTAINED THEREIN, AND/OR THE TECHNIQUES DESCRIBED IN THIS BOOK. WPI DOES NOT WARRANT THAT THE FUNCTIONS CONTAINED IN THE SOFTWARE WILL MEET YOUR REQUIREMENTS OR THAT THE OPERATION OF THE SOFTWARE WILL BE ERROR FREE.

 (c) This limited warranty gives you specific legal rights, and you may have other rights that vary from jurisdiction to jurisdiction.

6. **Remedies.**

 (a) WPI's entire liability and your exclusive remedy for defects in materials and workmanship shall be limited to replacement of the Software Media, which may be returned to WPI with a copy of your receipt at the following address: Software Media Fulfillment Department, Attn.: 50 Fast Digital Photo Techniques with Photoshop Elements 3, Wiley Publishing, Inc., 10475 Crosspoint Blvd., Indianapolis, IN 46256, or call 1-800-762-2974. Please allow four to six weeks for delivery. This Limited Warranty is void if failure of the Software Media has resulted from accident, abuse, or misapplication. Any replacement Software Media will be warranted for the remainder of the original warranty period or thirty (30) days, whichever is longer.

 (b) In no event shall WPI or the author be liable for any damages whatsoever (including without limitation damages for loss of business profits, business interruption, loss of business information, or any other pecuniary loss) arising from the use of or inability to use the Book or the Software, even if WPI has been advised of the possibility of such damages.

 (c) Because some jurisdictions do not allow the exclusion or limitation of liability for consequential or incidental damages, the above limitation or exclusion may not apply to you.

7. **U.S. Government Restricted Rights.** Use, duplication, or disclosure of the Software for or on behalf of the United States of America, its agencies and/or instrumentalities "U.S. Government" is subject to restrictions as stated in paragraph (c)(1)(ii) of the Rights in Technical Data and Computer Software clause of DFARS 252.227-7013, or subparagraphs (c) (1) and (2) of the Commercial Computer Software - Restricted Rights clause at FAR 52.227-19, and in similar clauses in the NASA FAR supplement, as applicable.

8. **General.** This Agreement constitutes the entire understanding of the parties and revokes and supersedes all prior agreements, oral or written, between them and may not be modified or amended except in a writing signed by both parties hereto that specifically refers to this Agreement. This Agreement shall take precedence over any other documents that may be in conflict herewith. If any one or more provisions contained in this Agreement are held by any court or tribunal to be invalid, illegal, or otherwise unenforceable, each and every other provision shall remain in full force and effect.

Wait, there's more.

With twenty-five years of experience, Gregory Georges has gathered too many tips to fit in just one book.

0-7645-2500-X 0-7645-7212-1 0-7645-4174-9

Also available

50 Fast Digital Photo Projects
0-7645-7447-7

50 Fast Digital Photo Techniques
0-7645-3578-1

50 Fast Photoshop 7 Techniques
0-7645-3672-9

WILEY
Now you know.
wiley.com